Art and Myth of the Ancient Maya

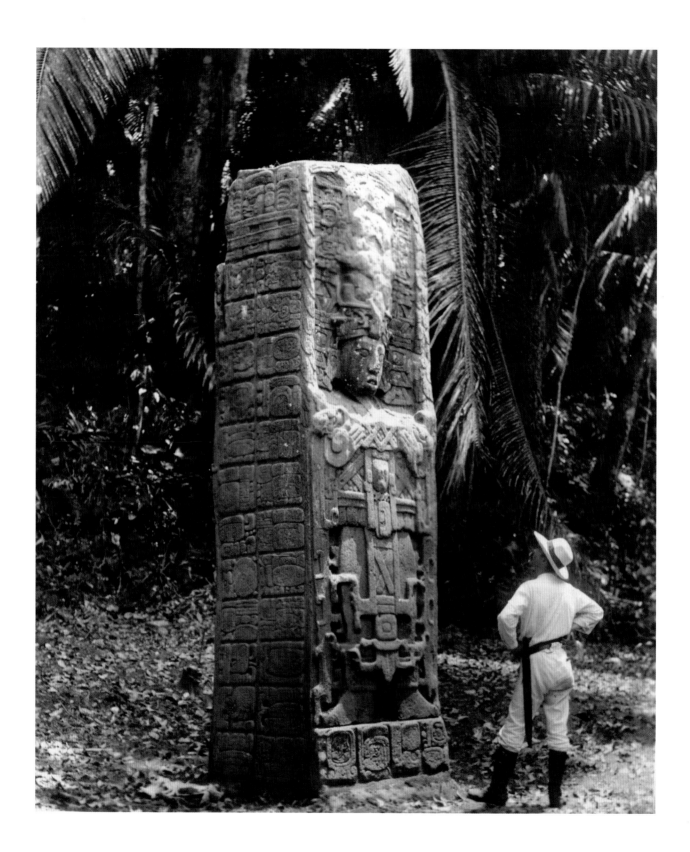

Art and Myth of the Ancient Maya

Oswaldo Chinchilla Mazariegos

Yale University Press New Haven and London

Published with the assistance of the Frederick W. Hilles Publication Fund of Yale University.

yalebooks.com/art

Designed by Leslie Fitch
Set in Crimson and Source Sans Pro type by Leslie Fitch

Printed in China by 1010 Printing International Limited

Library of Congress Control Number: 2016940998
ISBN 978-0-300-26387-9

A catalogue record for this book is available from the British Library.

10 9 8 7 6 5 4 3 2 1

Cover: Mural painting, Las Pinturas Sub-1, San Bartolo, Guatemala (details of fig. 74)

Frontispiece: Quiriguá Stela C. Photograph by Alberto Valdeavellano, ca. 1915 (fig. 15)

Para mi esposa, Silvia, y mis hijos,
Oswaldo Esteban y Ana Silvia, con amor

CONTENTS

ACKNOWLEDGMENTS

My research on Mesoamerican myths began during my tenure as curator of the Museo Popol Vuh, where I had the privilege of working with an outstanding collection of ancient Maya ceramic vessels with mythical representations. This book builds partly on a previous volume I wrote, *Imágenes de la Mitología Maya* (2011), which delved into the mythical themes represented on selected objects from the Museo Popol Vuh collection. The contents of chapters 6 to 9 in this volume were originally outlined in that book. Chapters 4, 5, and 6 also incorporate content from articles that I published previously in the journals *Ancient Mesoamerica, Estudios de Cultura Maya,* and *Estudios de Cultura Náhuatl.*

A Junior Faculty Fellowship from Yale University allowed me to devote adequate time to write this book, which is published with assistance from the Frederick W. Hilles Publication Fund of Yale University. I owe special thanks to Justin Kerr, who waived all charges for his photographs to honor the memory of his late wife, Barbara. Jorge Pérez de Lara, Michel Zabé, Nicholas Hellmuth, Dmitri Beliaev, Dennis Jarvis, Inga Calvin, Guido Krempel, Inés de Castro, and Hernando Gómez Rueda also allowed me to reproduce their valuable photographs. For similar reasons, I thank Daniel Aquino, director of the Museo Nacional de Arqueología y Etnología in Guatemala City; Diana Magaloni and Megan O'Neil, from the Los Angeles County Museum of Art; and Susana Campins, from the Museo Vigua de Arte Precolombino y Vidrio Moderno in Antigua Guatemala. I am thankful for the assistance of Juan Antonio Murro at Dumbarton Oaks, and María Teresa Uriarte and Teresa del Rocío González Melchor at the Instituto de Investigaciones Estéticas UNAM). In addition, Bruce Love, Heather Hurst, Lucia Henderson, David Stuart, Alexandre Tokovinine, and Christophe Helmke allowed me to reproduce their fine artwork, while Leticia Vargas de la Peña shared unique images from Ek' Balam. Valentina Glockner Fagetti and Samuel Villela Flores kindly shared unpublished narratives that were especially relevant for this book. Numerous colleagues and friends provided comments and insights or contributed in various ways to this volume, although the final outcome is my sole responsibility. I thank Bárbara Arroyo, Karen Bassie-Sweet, Edwin Braakhuis, Claudia Brittenham, Laura Alejandra Campos, Víctor Castillo, Michael Coe, Jeremy Coltman, Enrique Florescano, Julia Guernsey, Christophe Helmke,

Stephen Houston, Timothy Knowlton, Alfredo López Austin, Camilo Luin, Mary Miller, John Monaghan, Jesper Nielsen, Barbara de Nottebohm, Guilhem Olivier, Dorie Reents-Budet, Karl Taube, Alejandro Tovalín, Ruud van Akkeren, and Erik Velásquez. At Yale University Press, I thank Katherine Boller for her enthusiastic welcome to my proposal, and Tamara Schechter, Heidi Downey, Sarah Henry, and Laura Hensley for their editorial input.

❖ ❖ ❖

This paperback reprinting was made possible through the continued support of the Frederick W. Hilles Publication Fund at Yale University. Minor changes address typographical errors, update hieroglyphic readings, and provide new information on the locations of the illustrated objects. These updates benefit from information provided by Cristina Vidal Lorenzo, David Stuart, Frauke Sachse, Marc Zender, Liwy Grazioso of Museo Miraflores, James Doyle at the Metropolitan Museum of Art, and Bryan Just at the Princeton University Art Museum. Figures 12, 41, 54b, 71, and 73 were redrawn or edited for this reprint, and I thank my son, Oswaldo Chinchilla Villacorta, for his collaboration in this task.

To a large extent, my arguments depend on the accuracy of translations from numerous Mesoamerican languages. I employed the available editions of colonial texts and modern narratives, and whenever possible I contrasted translations of important passages. For the Popol Vuh, I used the modern English translations by Dennis Tedlock and Allen J. Christenson. Especially useful were Christenson's and Munro Edmonson's transcriptions with parallel translation, and Michela E. Craveri's recent Spanish translation, which features abundant lexical notes. In this volume, I quoted passages from both Tedlock's and Christenson's translations, while providing alternate translations in the endnotes.

Following usual conventions used in Maya epigraphy, transliterations of hieroglyphic collocations appear in boldface, using lowercase for syllabic signs and uppercase for logograms. Transcriptions that approximate the reconstructed phonetic spelling of hieroglyphic terms appear in italics.

In general, I respected the orthography of indigenous words in the original sources, instead of opting for modern standardized orthographies. For example, I use the orthography of Francisco Ximénez's manuscript for the names of characters from the Popol Vuh. Unless otherwise noted, I made all translations from Spanish to English.

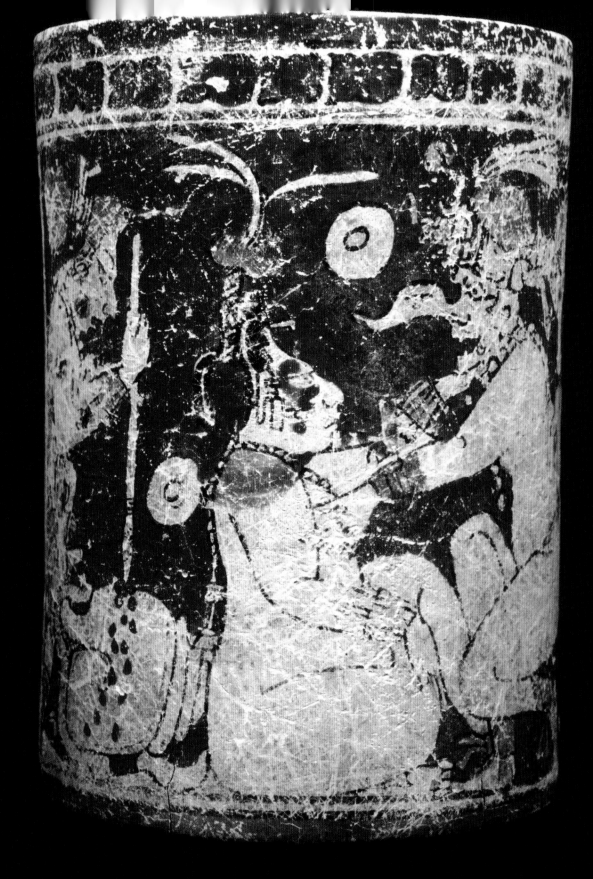

Introduction

The pale bodies of four characters—perhaps originally five—stand out against the dense, red background of a lowland Maya ceramic vase, created more than twelve centuries ago (fig. 1). Despite its age, the object preserves considerable detail, except for a section that suffered erosion and, perhaps for that reason, was not recorded in the available photographs. While subtly detailed, the characters are somewhat disproportionate and awkward—nothing can explain the woman's left foot showing under her right knee, while the leg is flexed forward. More than anatomical accuracy, the composition is about interaction among the participants, who engage with each other, forming a lively and meaningful scene. There is a story behind these figures involving an old god seated on a throne, a woman who interacts with a long-nosed partner, and a young man with spotted skin. But there is no associated narrative that would help modern observers to reconstruct the unfolding of the story.

In multiple ways, this vase—hereafter designated as the "Bleeding Conch" Vase—condenses the challenges faced by students of ancient Maya mythology. Its original provenance and present whereabouts are unknown. It was likely found in an archaeological site in the Maya Lowlands and extracted by looters who kept no record of its context and associations. Its shape and painting style allow us to date it to the Late Classic period, but we are missing the basic pieces of information that would help archaeologists to derive inferences about the people who created the object, used it, perhaps traded it, and, eventually, placed it in a secluded deposit—a burial chamber or cache offering—where it endured the ages without shattering to pieces.[1] When photographed in the 1970s, it had not suffered the fate of many similar vessels that have undergone aggressive and often fanciful modifications by modern restorers, sometimes to the point of casting doubt on their usefulness as sources for iconographic study.[2]

The painted scene was clearly based on a mythical theme. The trained eye can readily recognize some of the characters as gods and goddesses known from multiple representations, although the overall scene has no exact parallel in the known corpus of Maya art. Like Attic vase painters from ancient Greece, ancient Maya ceramic artists developed an elaborate pictorial language to represent subjects chosen from a rich trove

FIGURE 1
The Bleeding Conch Vase, Late Classic, lowland Maya area. Present location unknown.

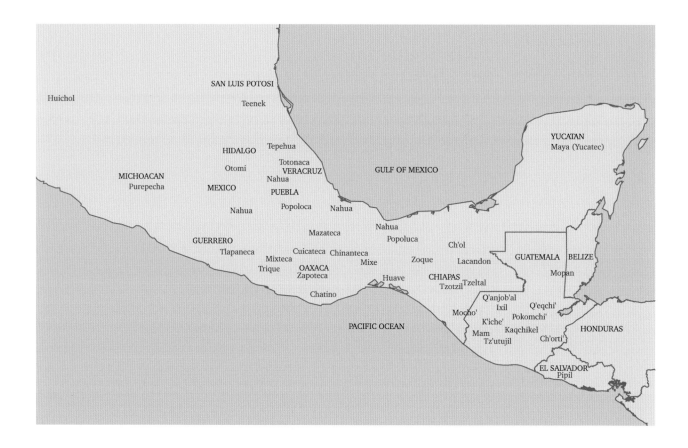

The following text labels appear on the map:

Huichol

SAN LUIS POTOSI
Teenek

YUCATAN
Maya (Yucatec)

Tepehua
HIDALGO
Otomi
Totonaca
VERACRUZ
Nahua

GULF OF MEXICO

MICHOACAN
Purepecha
MEXICO
PUEBLA
Nahua
Popoloca
Nahua

Nahua
Popoluca
Ch'ol

Mazateca

GUERRERO
Tlapaneca
Cuicateca Chinanteca
Mixteca
Mixe
Zoque
Lacandon

GUATEMALA | BELIZE

Trique
OAXACA
Zapoteca
Huave
CHIAPAS
Tzotzil Tzeltal
Mopan

Chatino
Q'anjob'al
Ixil
Q'eqchi'
Mocho'
Pokomchi'
K'iche'
PACIFIC OCEAN
Mam
Kaqchikel
HONDURAS
Tz'utujil
Ch'orti'

EL SALVADOR
Pipil

FIGURE 2

Map of Mesoamerica, showing the location of the ethnolinguistic communities mentioned in this book.

of mythical beliefs and narratives. The participants were gods whose actions created the conditions for life and provided paradigms for human sociality. Their deeds inspired some of the most elaborate examples of Maya ceramic art. Similar topics were sometimes represented on mural paintings and sculptures, but the majority of known depictions are preserved on pottery.

The creators and users of these vessels would have required little explanation about the underlying plots that were readily recognizable for them. Like their Greek counterparts, Maya ceramic artists frequently labeled characters with name tags, but only rarely accompanied their work with textual annotations, interspersed to fill background spaces. This vase has no name tags, so our hopes of identifying the characters depend on comparisons with other representations. The band of signs that runs around the rim is repetitive and does not conform a readable text. When readable, similar bands on other vases contain dedicatory phrases that state their ownership, provide details about their intended function (in cylindrical vases, usually for various types of cacao beverages), and sometimes contain the name of the scribe and painter who created the object. Such texts provide no clue about the subject matter of the scenes below.[3]

There is no ancient written account of the myth that inspired this vase. Maya scholars miss the advantage enjoyed by students of Attic vases, who benefit from extensive epics

and dramas that were roughly contemporary with the artworks.[4] In contrast, Classic Maya hieroglyphic texts on mythical topics are preciously brief, reflecting the limited scope and purpose of the inscriptions that have reached us. They provide minute samples of a wealth of myths that were transmitted orally, memorized and recited by ritual specialists, performed in ritual pageant, and probably written down in bark paper books that did not survive the passage of time.

PROBING MAYA MYTHOLOGY AND ART

In this book, I probe the interpretation of mythical subjects represented in ancient Maya art, and the challenges posed by the dearth of textual sources that would shed light on the myths that inspired them. In the absence of contemporary texts, scholars have made considerable use of later accounts, written shortly after the Spanish conquest. Pathbreaking work by Michael D. Coe first revealed significant correspondences with the Popol Vuh, an extensive narrative written by indigenous authors in the K'iche' language of highland Guatemala in the mid-sixteenth century.[5] This approach has yielded important results, but it has also raised criticism related to the assumption that Maya mythical beliefs continue unbroken across millennia, bridging across historical turning points, and crisscrossing geographic and linguistic barriers. To an even greater degree, unresolved queries about continuity or discontinuity complicate attempts to link ancient imagery with the rich inventory of myths that are still recounted orally and have been recorded in writing since the early twentieth century. The resilience of religious beliefs in Mesoamerican communities is widely acknowledged, but the search for correspondences between recently recorded stories, the myths of the Popol Vuh, and those represented in ancient Maya art is fraught with difficulties, and the results are often unconvincing.

To a large extent, the diversity of opinions derives from a lack of explicit statements about the methods the authors of previous contributions employed to trace links between ancient images and colonial or modern textual sources. Intuitive approaches prevail in much of the literature, and there are few attempts to develop explicit methodologies or apply those developed elsewhere in the world. A related problem involves shortcomings in the published textual records. While the Popol Vuh and other major texts are available in modern translations into English and Spanish, myths recorded in modern communities are widely scattered and often hard to access. The quality of available translations is uneven, and the narratives are often dissociated from their social and cultural contexts. Even in the case of the Popol Vuh, there is an appalling shortage of scholarly work from philological, historical, or ethnographic perspectives. While a broad and detailed understanding of textual sources is requisite for iconographic interpretation, students of ancient Maya art rarely go beyond the standard translations or engage in comparative analysis and exegesis of the available texts.

This book departs in many ways from prevailing interpretations. Yet it is grounded in broadly acknowledged premises. Scholars have long noted that the Maya shared essential cultural features with neighboring peoples throughout Mesoamerica (fig. 2). A common religious tradition is one of the clearest defining traits of Mesoamerican civilization; despite the geographic distance, linguistic diversity, and variety of local customs, Mesoamerican peoples shared basic religious beliefs and ritual practices. In his groundbreaking book, *The Myths of the Opossum: Pathways of Mesoamerican Mythology* (1993), Alfredo López Austin outlined a theoretical and methodological approach to Mesoamerican myths. In his comparative exploration of narratives recorded across the area, he reached beyond the bewildering array of characters and incidents found in every variant to isolate the "nodal subjects" that lie at the core of mythical beliefs.

In this book, I apply López Austin's methodology to the study of ancient Maya art. Rather than taking the Popol Vuh as a static, authoritative source on Maya myths, I compare the narratives contained in that text with parallel stories recorded throughout Mesoamerica, in search of nodal subjects. I reject the possibility of identifying unambiguous, one-to-one correspondences between the characters and incidents represented in ancient Maya art and those narrated in the Popol Vuh or any other text; at the same time, I build on the proposition that significant correspondences can be found at the level of the myths' nodal subjects. Comparative analysis of the available textual narratives is requisite to identify their nodal subjects, explain their links with ancient imagery, and grasp their meaning in the context of ancient Mesoamerican religion and society.

This approach grew from my dissatisfaction with current views that either reject the possibility of interpreting ancient Maya mythical imagery in light of the Popol Vuh and modern narratives, or take these sources uncritically, assuming that the myths remained largely unchanged. The former position is fruitless, while the latter leads to unreliable results. Briefly stated, I do not regard Maya mythical imagery as derived from a unified set of beliefs that eventually came to be recorded in the Popol Vuh. Instead, I see this imagery as derived from a wide array of mythical versions that circulated in ancient Maya communities, whose nodal subjects were also shared by other Mesoamerican peoples.

The scope of this search brings ancient Maya myths closer to their counterparts in other regions of Mesoamerica. This is consistent with the proposition that Maya religion and mythology are grounded in the "Mesoamerican Religious Tradition," a term coined by López Austin to designate the historical process that links together the religious beliefs and practices of Mesoamerican peoples, from ancient times to the present. While generally attentive to parallels among mythical episodes recorded in diverse communities, scholars have often explained them in terms of the diffusion of religious beliefs, generally coming from various regions in Mexico to the Maya area in relatively late times. Following López Austin, I see them as derived from the common, very ancient origins of Mesoamerican religion as a whole, coupled with intense and sustained interregional

interaction through millennia. Sometimes considered in isolation, Maya myths are best understood as Mesoamerican myths. This book highlights the shared structures and meanings found throughout the area, while acknowledging the diversity of regional and temporal manifestations.

The first two chapters of this book describe in more detail the theoretical and methodological approach outlined above. Subsequent chapters apply those principles to Mesoamerican myths and their representations in ancient Maya art. In the first chapter, I explore the dichotomy between image and text, and review the methodological problems involved in the use of various kinds of texts to interpret ancient Maya mythical imagery. The aim is neither to trace the history of Maya iconography nor to honor the work of all contributors, but rather to examine the major issues confronted by previous researchers and explain the rationale behind my approach. I review López Austin's studies of Mesoamerican religion and myth, as well as the ways in which I apply his insights to the study of ancient Maya imagery.

The second chapter explores textual and pictorial sources, including pottery, mural paintings, and hieroglyphic texts. I stress the brevity and selective content of mythical passages in the hieroglyphic inscriptions, which largely focus on the divine patrons of lowland Maya ruling houses. While contemporary with the mythical scenes portrayed on Classic pottery, they shed little light on them. I compare the available passages with the Popol Vuh and other colonial texts, which are considerably longer and more detailed. Nevertheless, I point out that the colonial texts shared basic concerns with the hieroglyphic texts. Both centered on the origins and rise of ruling dynasties that traced their origins back to mythical times.

Throughout this book, I engage in substantial discussion of passages from the Popol Vuh. An overarching reflection concerns the peculiarity of the K'iche' text, which departs in many ways from common patterns in Mesoamerican myths. Chapter 2 also delves into the historical context of the Popol Vuh, which I consider critical to assess its links with ancient Maya imagery. Further sections examine colonial Nahua texts and modern narratives, the bearing of Christianity on the latter, and these texts' parallels and contrasts with the Popol Vuh.

Major cosmogonic processes, such as the origin of the earth, rise and fall of successive eras, and creation of the first people, were seldom portrayed in ancient Maya art, if at all. They are known mostly from the narratives of colonial and modern peoples, which describe beliefs that had great antiquity in the area, and are comparable to scattered passages in the hieroglyphic inscriptions and the codices. Chapter 3 examines Maya cosmogony and its correspondences with related beliefs from other Mesoamerican regions. The contents of this chapter derive largely from colonial and modern sources, while comparisons with passages in the Palenque tablets—which contain the longest mythical records in

the hieroglyphic inscriptions—suggest that the nodal subjects of Classic Maya myths were broadly consistent with those of colonial and modern Mesoamerican myths.

Widespread Mesoamerican narratives recount the deeds of young heroes who confronted powerful foes and emerged victorious, generally through cunning and magic. The more elaborate versions describe the heroes' origin and the fate of their mother and father, and delve into their confrontations with their grandparents and older siblings. Chapters 4 through 9 focus on the heroes' overlapping stories, which are linked together in temporal, genealogical, and thematic ways.

The exploration of sexuality in myths and artistic representations is an important component of this book. In Mesoamerican narratives, sexual encounters—often achieved through magic, and sometimes involving violence—are not always explicit. The Popol Vuh, in particular, employs subtle metaphors that can only be understood by comparison with parallel passages in other narratives, and by recourse to ethnographic insights that reveal the deeper meaning of seemingly innocuous phrasings. Chapter 4 explores a ubiquitous passage that involved the abduction or impregnation of a tightly guarded maiden, against the will of her parents. Sometimes leading to the birth of heroes, the maiden's plight was a highly significant subject with multiple meanings related to the fertility of the earth, sexuality and reproduction, sickness and healing, and femininity and the related arts of spinning and weaving.

Chapter 5 pursues related themes, focusing on the antagonistic grandmother, who was eventually vanquished by the young heroes in struggles that frequently involved sexual assault. Old goddesses were rather infrequent in Classic Maya art, but nevertheless, the extant representations are consistent with their role as patronesses of childbirth and midwifery. Equally pervasive was their aggressive personality, and sometimes their aggressive sexuality. These old goddesses overlapped considerably with the primeval monsters whose clashes with the sun and moon heroes are discussed in Chapter 6. Best known among the latter are the great avian beings that, despite their downfall, were favorite subjects in pre-Columbian art and were closely identified with ancient Maya rulership. I show that these great birds were often coupled with feminine, terrestrial counterparts who were no less threatening, and were finally overcome by the heroes. Their defeat was crucial for the rise of the luminaries and the coming of humanity.

The rise of the sun and the moon was a turning point in Mesoamerican cosmogony, which set the order of time and space and marked the advent of the present era and its inhabitants. In Chapter 7, I discuss the basic duality that lies at the center of Mesoamerican sun and moon myths, and explore its probable expression in ancient Maya art. Specifically, I discuss the contrasting attributes of God S and the Maize God, which correspond in many ways with those of Mesoamerican solar and lunar heroes. I also discuss the frequent pairing of Gods S and CH, and the correspondences of God S, God CH, and the Maize God with the heroes of the Popol Vuh and other groups of young gods in modern myths. The Maize God's myths were among the favorite subjects of

ancient Maya artists. Chapter 8 centers on Mesoamerican maize heroes and their links with the ancient Maya Maize God. Key features include the god's youthfulness and his aquatic associations, which are normal attributes of Mesoamerican maize heroes. In chapters 7 and 8, I question the generally accepted interpretation of the ancient Maya Maize God as being a counterpart of the Hero Twins' father in the Popol Vuh.

The final chapter focuses on the fate of the father of the hero or heroes. In widespread versions, his son unsuccessfully attempts to bring him back to life. The father's failure to be resuscitated explains the origin of human death. I discuss versions in which the father became a deer—another form of death, which brought him close to the beings of a former era—and propose correspondences with ancient Maya representations of God S and God CH with a shrouded deer.

The conclusion may be disconcerting for readers who expect a coherent reconstruction of ancient Maya mythology. I do not offer a unified, master narrative—an approach that would run counter to the central arguments of this book. On the contrary, I seek to uncover the range of variations present in Mesoamerican myths, and the ways in which such variations can be perceived in ancient Maya art. The interpretations that I propose reflect the flexibility and disjointedness of Mesoamerican myths, while highlighting the common subjects that link them with representations in ancient Maya art.

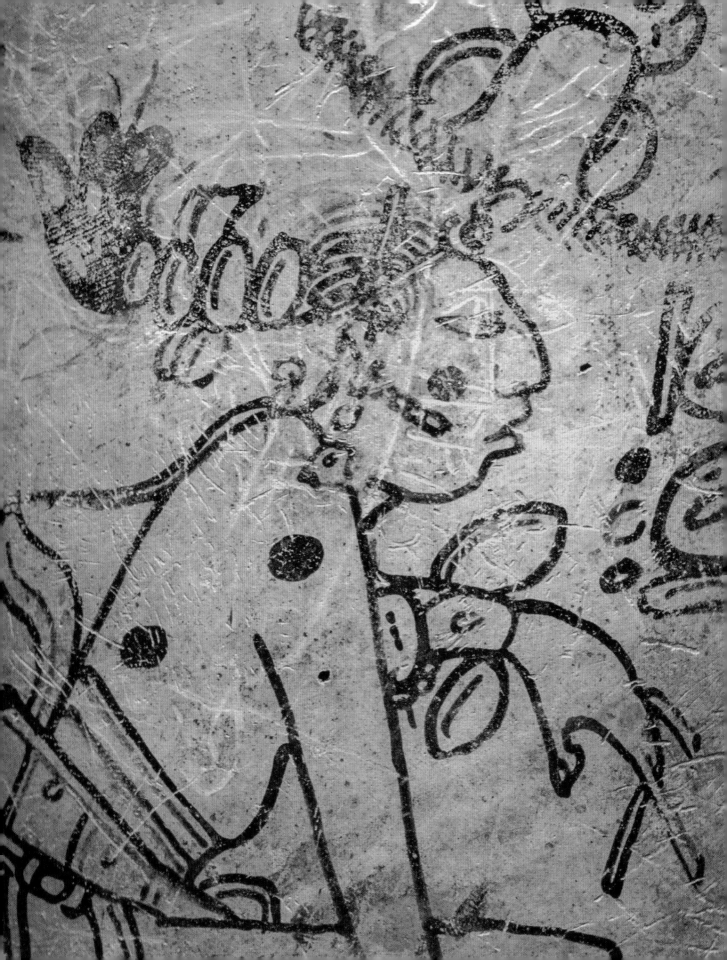

1 Image and Text

The images of clay and stone lead us to believe that behind each detail there is a series of actions attributed to invisible beings. How does one separate myth from image?
—Alfredo López Austin

The vivid, enthralling deeds of mythical characters portrayed in ancient Maya art offer glimpses of a wealth of beliefs and narratives that were known to the artists and their patrons. At the outset of his treatise on Mesoamerican mythology, López Austin wondered about the meaning of pre-Columbian images and called for interpretations that reached beyond mechanical correspondences with the available texts: "the possibility of reconstructing a mythological order that can be compared, in a reciprocal process of elucidation, to the iconographical one."[1] The challenge for modern interpreters is to decode the visual images and trace their links—or lack of them—to the available textual narratives.

This challenge is compounded by the spatial and temporal separation of images and texts, which are rarely conjoined in the same media, and only infrequently traceable to roughly contemporary communities from discrete geographic regions. More often, scholars work with discrete, widely separated sources that, nevertheless, may relate to each other in complex ways.[2] The correlation of colonial and modern texts with mythical images in Preclassic and Classic Maya art is far from straightforward. This chapter examines the theoretical and methodological issues involved in the process.

THE ICONOGRAPHY OF MYTHS

Efforts to link the painted scenes on Classic Maya vessels with mythical narratives began many decades ago. In 1939, Eric Thompson offered an explanation of a vase found by Thomas Gann at a site in southern Quintana Roo, not far from the Río Hondo.[3] Thompson perceived correspondences between the animals depicted on the vase and the characters from a narrative that he had collected among the Q'eqchi' and Mopan of San Antonio, Belize. In an episode of that story, the sun hero devised a stratagem to find his wife, the moon, who had fled from him to the town of the vultures, where she was

Portrait of God S. Detail of Vase K1607, Late Classic, lowland Maya area. Present location unknown.

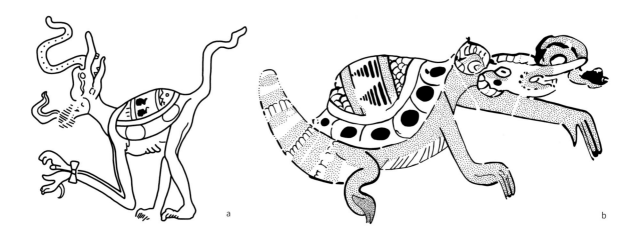

a

b

FIGURE 3

Armadillos with ringed carapaces, eating snakes or worms: (a) Detail of vase from the Río Hondo region, Quintana Roo, Mexico, Late Classic; (b) Detail of Vase K2993, Late Classic, lowland Maya area.

living with their chief. To get there, he hid inside a deer carcass and sent a blowfly to attract vultures, which would take him to the residence of their master. Thompson identified one of the animals depicted on the vase as a deer, even though it departed markedly from usual conventions. To explain the divergences, he suggested that it combined the animal's features with those of the hidden sun hero (fig. 3a).

Half a century later, H. E. M. Braakhuis employed the same mythical narrative to interpret the "Ten Gods" Vase, originally published and labeled as such by Michael D. Coe (fig. 4). In his own description, Coe saw one of the animals on this vase as a "grossly bloated deer" with two insects sitting on top. He suggested that the axe-wielding god standing behind had just cut the insects' mandibles. A red swath near the animal's front leg was blood from the wounded insects. Coe offered no further explanation for this group, although he linked other sections of the vase with passages from the Popol Vuh.[4]

Braakhuis based his interpretation on the Q'eqchi' myth, complementing Thompson's San Antonio text with a parallel version from Senahú, Guatemala, compiled by Mario de la Cruz Torres. For him, the bloated animal represented the deer carcass of the story, and the insects corresponded to the blowflies of the Q'eqchi' story. However, he noted that the animal's head did not correspond to a deer, and instead suggested a predatory cat, likely a puma. Braakhuis suggested that the puma head belonged to the sun hero, who pulled his head out of the deer carcass. He went on to relate other sections of the vase with corresponding characters and episodes of the Q'eqchi' narratives.[5]

These interpretations exemplify the challenges confronted by students of Maya iconography, which begin with the identification of objects and beings that are often difficult to recognize. Is the animal represented on the Ten Gods Vase a deer, a puma, a composite, or something else? This is a basic level of analysis, characterized as "pre-iconographic description" in Erwin Panofsky's influential studies of European Medieval and Renaissance art. In Panofsky's scheme, pre-iconographic description derives from direct observations, aided by the observer's personal experience and verified through familiarity with artistic conventions and stylistic trends. Pre-iconographic description provides a basis for proper "iconographic analysis." This deeper level of inquiry cannot

FIGURE 4

Rollout photograph of the Ten
Gods Vase (Vase K555), Late
Classic, lowland Maya area.
Present location unknown. At
center, two insects lie on a bloated
quadruped while Chahk wields
an axe.

be achieved from direct observation alone, but instead requires knowledge of literary sources. Panofsky added a third level of analysis—"iconographic interpretation," also labeled as "iconology"—that concerns a search for deeper meanings related to culture and psychology.[6]

While subsequently revised and amended in various ways, Panofsky's method provides a useful framework for the study of Maya art.[7] At the outset of their work, Thompson, Coe, and Braakhuis confronted the challenge of identifying the animals represented on each vessel and offered solutions based on their previous experiences with Maya artistic conventions. The links that they proposed with mythical narratives—corresponding to Panofsky's "iconographic analysis"—depended on the accuracy of their pre-iconographic identification of those creatures. With the benefit of hindsight, their observations can be tested in two ways: (a) by comparison with additional examples that may help to define the distinctive features and range of variation of the animal figures and the scenes as a whole; and (b) by searching for hieroglyphic captions that may actually name animals of the same kind in other examples.

In Thompson's time, the Río Hondo Vase was unique.[8] In a 1988 catalog, John B. Carlson noted its resemblance to an unprovenanced vase in the same painting style, which depicted a similar group of animals.[9] The counterpart of Thompson's "deer" in that vase is a carapaced quadruped biting a snake or worm (see fig. 3b). This is likely an armadillo, distinguished by the carapace with three main divisions, a scaly head, and a thick, ringed tail. The animal in the Río Hondo Vase shares the same kind of carapace and the snake or worm in its mouth, although its undulating tail and long legs are unnatural, suggesting a composite. While the identity of this fantastic animal is uncertain, the comparison of both vases makes Thompson's pre-iconographic identification of the animal as a humanized deer untenable; this undermines his iconographic analysis of the scene in terms of the Q'eqchi' sun and moon myth.

Similar criteria can be applied to the characters in the Ten Gods Vase. Comparisons with other examples allowed Braakhuis to identify the axe-wielding god as Chahk, a major Maya god related to lightning, rainstorms, and warfare. The decipherment of hieroglyphic

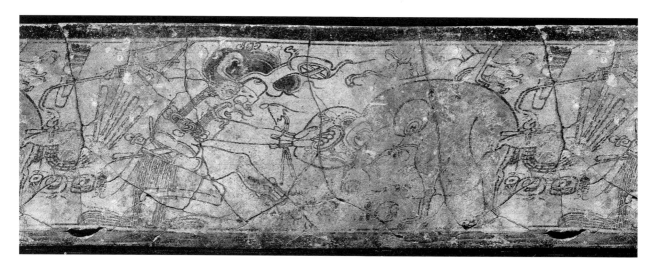

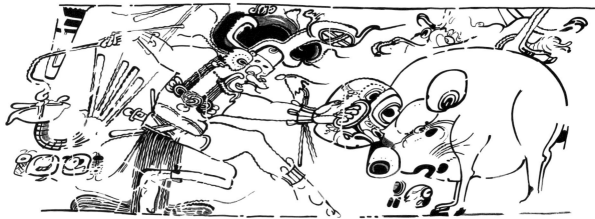

captions associated with his portraits in other contexts confirmed that the god's Classic period name was Chahk, corresponding well with Yucatec rain and storm gods described in early colonial texts and modern ethnographic records.[10] Comparisons also shed light on the bloated animal that Coe saw as a deer, and that Braakhuis saw as a deer carcass with a puma head. Consider a codex-style vase that shows a voluminous animal with an insect lying on its back (figs. 5, 6). The insect can be recognized as such by the abdominal appendage, skinny legs, and deathly face that are commonly associated with insects in Maya art. The analogy with the Ten Gods Vase, not obvious at first glance, is strengthened by the presence of Chahk, who wields a handstone and an axe, apparently ready to strike the insect.

Chahk is not obviously present in another, badly eroded vase that, nevertheless, still preserves enough details for the viewer to recognize the insect lying on the back of a voluminous animal with a jaguar head (figs. 7, 8). A flying creature bites the animal's forehead, while holding the stem of a flower with its long, pointed beak. The beak is avian, but the membranous wings with *ak'ab* markings belong to an insect. This creature seems to

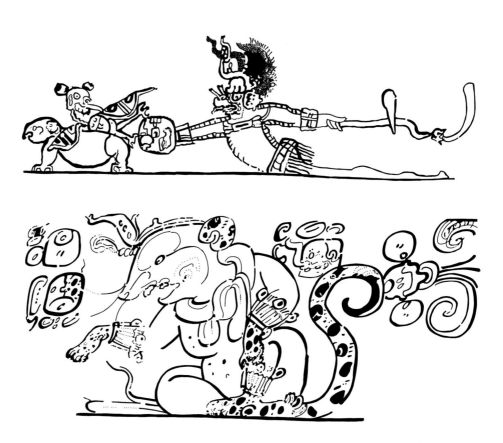

FIGURE 9

Detail of Vase K1223, Late Classic, lowland Maya area. Chahk wields his axe against a flying insect lying on the back of a tapir.

FIGURE 10

Detail of Vase K1253, Late Classic, lowland Maya area. The name tag reads "*tihl u wahy k'ahk ti' suutz'*" ("tapir, it is the wahy [of] K'ahk Ti' Suutz'").

combine the features of a hummingbird and a mosquito, two flying animals that overlap significantly in Maya art.[11] Additional examples show more variations. On a small codex-style bowl, Chahk is ready to strike a winged insect lying on the back of an animal that, in this case, is naturalistically portrayed as a tapir (fig. 9). Overpainting may have obscured some details on Vase K8177, which shows God N presiding over the scene, while a human impersonator plays the role of Chahk, ready to strike a humanlike baby on the back of a voluminous mammal. The composition approximates the Ten Gods Vase, in which the enthroned god Itzamnaaj seems to witness the actions of Chahk and the animals, while conversing with a seated dog.

While there are hieroglyphic captions on some of these vases, they do not appear to designate the bloated quadruped. Nevertheless, the combined attributes of jaguar and tapir bring this animal close to a mythical creature that is named with hieroglyphic captions in a number of vessels (fig. 10). Nikolai Grube and Werner Nahm read the captions as *tihlal hix* ("tapir jaguar").[12] This fantastic animal usually has jaguar paws and tail, while the head combines the attributes of a jaguar and a tapir, although the tapir attributes are not easily recognizable. The bloated animal in the Ten Gods Vase and related examples does not have jaguar paws or tail; nevertheless, we may entertain the hypothesis that it is a variant of the tapir jaguar, or perhaps another creature that also combined the attributes of both animals.

Various kinds of insects were represented on this group of vases. Some of them are winged, while others are not; some have prominent abdomens, while others do not. They generally adopt the characteristic pose of babies in ancient Maya art—lying on their back like human babies, with flexed arms and legs.[13] The scenes bear an intriguing similarity with an important group of codex-style vases that show Chahk wielding a handstone and an axe, seemingly ready to strike a baby jaguar that lies on the face of a personified mountain. The analogy might be insignificant—Chahk could play similar roles in unrelated mythical passages—were it not for the fact that some of the baby jaguar vases also feature variations of the tapir jaguar and the insect. A prominent example on Vase K521 has been generally identified as a dog, or sometimes a "jaguar-dog."[14] It may in fact be a tapir jaguar, with a firefly hovering above (fig. 11). There are reasons to ask whether these closely related mythical scenes were variations of each other, or whether "Chahk and a baby insect on the back of a tapir jaguar" was a parody of the seemingly graver "Chahk and the baby jaguar on a mountain." They may also be episodes of a longer mythical narrative in which Chahk struck babies of different kinds. Significantly, human infants were the preferred victims offered to the gods of rain and the earth in Postclassic highland Mexico.[15]

These comparisons show that, despite a vague resemblance, the bloated animal is not a deer and, therefore, the Ten Gods Vase has no clear correlates with the Q'eqchi' sun and moon myth. Nevertheless, the consistent repetition of similar characters relating to each other in similar ways in this group of vases suggests that this is indeed an episode from a longer mythical narrative, whose unfolding is unknown. In the absence of textual records of such a narrative, the possibilities of further iconographic analysis in Panofsky's terms are limited.

NARRATIVE FROM IMAGES

Faced with a dearth of textual sources that can be clearly linked to ancient artworks, students of pre-Columbian art often attempt to glean meaning from the ancient images themselves. Moche pottery painting from the north coast of Peru is largely centered on mythical themes, yet there are no associated written records and the connections with colonial and modern narratives are distant, although not entirely absent. Christopher Donnan and his collaborators concluded that Moche art contained variations of a small range of "themes," or recurrent representations of events or activities performed by specific characters defined by their consistent attributes. They identified themes through comparisons of multiple objects that displayed parallel scenes involving distinct participants in analogous settings, who interacted with each other in similar ways. In some cases, themes included multiple, related activities that suggested sequences of events, although it often proved difficult to discern their proper order. Nevertheless, several authors have interpreted Donnan's themes as episodes of long narrative sequences. Jeffrey Quilter and Jürgen Golte have outlined approaches to the reconstruction of lost narratives through

FIGURE 11

Rollout photograph of Vase K521,
Late Classic, lowland Maya area.
Metropolitan Museum of Art, New
York. Chahk wields his axe against
the baby jaguar lying on a moun-
tain. Note the tapir jaguar and fire-
fly to the observer's right.

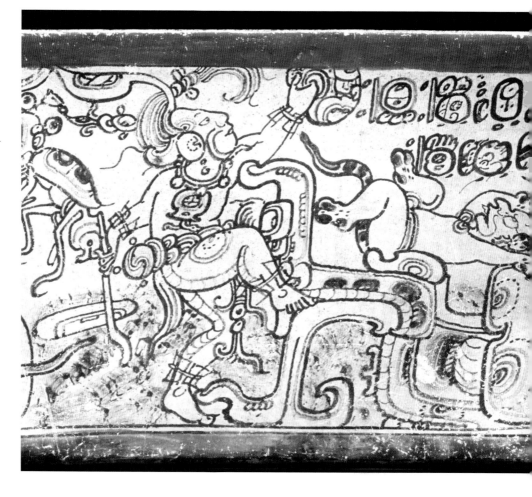

careful analysis of overlapping themes in multiple objects. Key objects that portray two
or more themes in apparent sequence offer keys to the reconstruction; in some cases,
the interpretation can be reinforced through comparisons with colonial and mod-
ern narratives.[16]

 While not acknowledged as such, similar approaches have been loosely applied to
Maya ceramic iconography. Francis Robicsek and Donald Hales ordered a large number
of codex-style painted vessels according to thematic groups, and speculated that the works
were based on the pages of lost codices. They attempted to reconstruct narratives by
ordering thematic groups sequentially. Michel Quenon and Geneviève Le Fort proposed
a reconstruction of the Maize God myths, based on overlapping scenes represented on
ceramic vessels. They identified four major episodes that corresponded to pictorial themes
and proposed a sequential order, taking cues from vessels that featured two or more epi-
sodes together. Other scholars have also attempted to reconstruct mythical narratives
from seriated groups of vessels that seemingly follow temporal progressions.[17]

 The intuitive deductions that prevail in the study of Maya ceramics contrast with
the more systematic approaches applied to Moche art. Quilter's methodology was partly

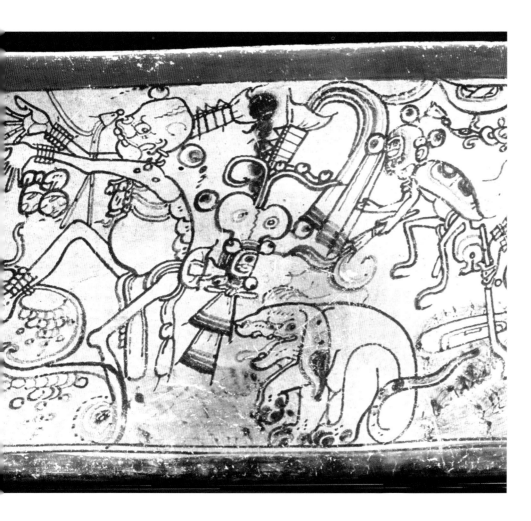

based on Kurt Weitzmann's study of the methods used by ancient Greek and Roman artists to render narratives as pictorial representations.[18] Weitzmann distinguished three methods. The first are "simultaneous" representations, in which artists condensed several moments of a narrative into a single scene. The characters perform two or more actions that do not happen at once in the narrative. There is no repetition of characters, while temporal distinctions are largely disregarded. The second are "monoscenic" arrangements composed of a series of discrete scenes, each one corresponding to one moment in the narrative. Multiple scenes with reappearing characters are needed to represent the unfolding events, and spatial distinctions between individual scenes are more or less marked. The third are "cyclic" arrangements, in which an uninterrupted sequence of scenes with repeating characters guides the viewer through the narrative's temporal and spatial sequence.[19]

These methods were not completely distinct from each other. Cyclic representations sometimes conflated sequential actions by a single character, shifting time and space and thus approximating the simultaneous method. Long narratives were illustrated by selecting scenes that were important and easy to understand. They could be

ordered sequentially, but sometimes the artists chose to highlight major passages by placing them prominently in the available space, while locating lesser events in secondary locations, not necessarily ordered in a temporal sequence. In a more recent discussion, Susan Woodford noted that artists often chose to illustrate the climactic moment of a story. However, in some cases the representation of an earlier or later moment can effectively convey the message in subtle and artistically interesting ways. Such cases provide fewer clues to the observer, and a detailed familiarity with the narrative's unfolding is indispensable to understand them.[20]

Weitzmann also discussed objects that condense distantly related episodes of long narratives, such as various episodes involving Hercules or Perseus in ancient Greek art. While involving the same character, wide temporal gaps separate the episodes from each other and, therefore, they do not conform a continuous narrative. Moreover, discrete objects may include scenes from diverse narratives that were nevertheless related by their common origin (for example, scenes taken from various works by a single writer) or by their common theme (for example, various scenes illustrating mythical love episodes).[21]

Some of these principles are documented in Maya art. While analyzing ball game imagery, Mary Miller and Stephen Houston showed that sequential events were often conflated in a single image. Moreover, discrete representations may evoke a series of earlier or later events that were understood as part of a sequence.[22] Thus, a fully dressed warrior holding a half-naked prisoner by the hair conflated the moment of the war encounter, the prisoner's capture (the only event that was usually recorded in associated texts), and his triumphal display by the victor in a ceremonial setting. Such depictions also evoked the captive's eventual sacrifice, which in actuality might take place long after his capture.

In the Ten Gods Vase, the scene that shows Chahk ready to strike the baby insects on the back of the tapir jaguar is part of a larger representation that includes three pairs of interacting characters: (a) Chahk and the tapir jaguar; (b) the enthroned god Itzamnaaj conversing with a seated dog; and (c) God S shooting a humanized bird, identified as a vulture by Coe (see fig. 4). The participants are major gods in the Maya pantheon. Itzamnaaj is an old, venerable god, frequently shown seated on a celestial throne, like a king presiding over his court. God S is a young god, characterized by the black spots that taint his skin. He is often portrayed as a hunter with a blowgun, and the white headband is a frequent attribute. Coe suggested that God S and his frequent companion, God CH, were counterparts of Hunahpu and Xbalanque, the Hero Twins of the Popol Vuh.[23]

Braakhuis agreed that the three scenes on the Ten Gods Vase were related to each other sequentially—in Coe's words, as "three acts of a single drama." Yet the temporal sequence is not obvious. Coe published a rollout photograph by Justin Kerr, in which Itzamnaaj and the dog appear in the middle of the composition. However, in Classic Maya vase paintings, enthroned lords usually occupy a paramount position, to

the observer's right. If that were the case in this vase, the scene that shows God S shooting the vulture should go first, while the dog conversing with Itzamnaaj would be last in the sequence. Conceivably, the three episodes may be simultaneous, all occurring under the gaze of the enthroned Itzamnaaj.[24]

Coe proposed that the Ten Gods Vase showed the vulture falling on its back after being shot by the standing God S, who points his blowgun at the bird's head. That remains a cogent possibility, although the bird is not necessarily falling back; instead, its posture may be interpreted as that of a baby. The curved back, folded legs, and raised arm with bent hand are all distinctive of babies in Maya art. Thus, the vase may portray two episodes that involved gods attacking babies. In one of them, God S shot a baby vulture in the forest—the location is indicated by the presence of a tree, whose trunk is conventionally depicted as the head of the Pax God, with a white heron perched on top.[25] In the second episode, Chahk struck baby insects on the back of the tapir jaguar. Both episodes happened in the presence of Itzamnaaj or were somehow overseen by the enthroned god. Potentially, these interpretations cast new light on the vase, but none is securely established. The hieroglyphic captions remain opaque, and there are no parallel examples that might help to understand the unfolding of the Ten Gods Vase.

Long pictorial narratives are uncommon in Maya art, although they are prevalent in other regions of Mesoamerica. The Postclassic Mixtec codices encoded long dynastic accounts in *res gestae,* a term used by Elizabeth Boone to designate pictorial narratives constructed as uninterrupted series of scenes, joined together by the participants' actions.[26] Dates were indicated, but they were not the main guiding principles of the narrative. The characters moved forward in time through shifting locations indicated by place names, allowing readers to follow the sequence of their actions across time and space. No accounts of this kind are known among the Maya. The short sequences of events represented on selected ceramic vessels suggest that longer pictorial narratives may have been painted in books, as Robicsek and Hales suspected, but the task of reconstructing them from the discrete, self-contained scenes painted on multiple vessels is fraught with difficulties. The problem is compounded even further by the dearth of provenance information and accurate dating for many vessels. In any case, reconstructed narratives remain uncertain without the independent support of textual sources.

NARRATIVE FROM TEXTS

Thompson's use of a modern myth to interpret the Río Hondo Vase was not questioned in his own time. He did not need to justify his assumption that the story he recorded in the 1920s was grounded in ancient beliefs, going back to the Classic period and beyond. Correlates with the Popol Vuh and other texts from Yucatán and highland Mexico reinforced his impression of the myth's antiquity. These assumptions became controversial in the 1960s, when George Kubler questioned the use of colonial textual sources to interpret

the art and religion of Classic and Preclassic Mesoamerica. Borrowing concepts from Medieval European art history, he applied Panofsky's principle of disjunction, which refers to the attribution of new meanings to old artistic forms and the use of new artistic forms to represent meanings rooted in old cultural traditions. Panofsky described how ancient Greek and Roman artistic models were invested with Christian meanings in Medieval Europe and, conversely, how literary themes from antiquity came to be represented by new forms that had little resemblance to classical models. Kubler questioned the assumption that Mesoamerican cultures remained stable across significant ruptures such as the downfall of the Classic cities. He also believed that Spanish colonization and the introduction of Christianity had thoroughly transformed indigenous cultures, erasing most traces of Mesoamerican cultural and religious concepts. He favored the use of "intrinsic evidence" derived from the ancient artworks themselves or from contextually related archaeological materials, without recourse to analogies based on historical or ethnographic testimonies from later periods.[27]

Kubler's rejection of analogy proved to be an interpretive dead end. By disavowing the use of written sources from later periods, he dismissed any possibility of iconographic interpretation of pre-Columbian art in Panofsky's sense, and the alternatives that he proposed did not lead to productive inferences about the content and meaning of Mesoamerican art. Despite Kubler's skepticism, multiple archaeological, ethnographic, and ethnohistorical studies show that his arguments about radical disjunctions in Mesoamerican religion before or after the Spanish conquest are untenable.[28] Yet his critique stimulated scholars to reflect on the premises behind the use of textual and ethnographic sources. Rather than invalidating these sources, disjunction poses a methodological problem that should not be overlooked in iconographic studies. As Terence Grieder noted, neither continuity nor disjunction can be assumed; the relative bearing of both processes should be assessed in each particular case. In his words, "Rather than denying us access to ancient meanings, it clarifies the method by which they may be studied."[29] In a recent assessment, Stephen Houston and Karl Taube rejected Kubler's sweeping denial of continuity of meaning in Maya art. Rather than viewing disjunction as a radical rupture, they saw it as being composed of a series of complementary processes that include the addition and loss of graphic and narrative elements, together with shifts in the associated meanings. Each of these processes may have a distinct bearing on interpretation.[30]

More than a thousand years separate the Q'eqchi' myth that Thompson recorded in San Antonio, Belize, from Classic period narratives. While the myth was collected in the Maya Lowlands, Thompson thought that it was brought to the area by recent Q'eqchi' migrants from the northern Guatemalan Highlands, adding further degrees of geographic and linguistic separation.[31] He only published an English version and provided no clue to evaluate its reliability in comparison with his informants' Q'eqchi' or Spanish narratives. Nevertheless, comparisons with parallel narratives show that the myth's nodal subjects

reappear throughout Mesoamerica. There is no doubt that Thompson's rich and detailed account is the product of deeply rooted beliefs. Recent works have explored evidence of related beliefs in ancient Maya art and religion.[32]

Thompson's use of this myth to interpret the Río Hondo Vase was misleading, not because the text that he employed was unrelated to ancient Maya beliefs, but because he assumed that the narrative he recorded in San Antonio in the 1920s was basically identical to an ancient version that was known to the Classic Maya artist who painted the vase. This assumption led him to propose one-to-one correlations between the characters represented on the vase and the protagonists of the twentieth-century myth, and to infer that the vase could represent a textual passage from this particular myth. Similar premises have often been applied to the interpretation of Maya mythical representations, producing results that are sometimes revealing and stimulating, but questionable because they depend on the unverified assumption of absolute continuity.

In response to Kubler's critique, Janet Berlo underlined the need to distinguish among different types of textual sources. She distinguished "conjoined texts," which were linked to the artworks by their creators, from "discrete texts," which are removed by temporal, geographic, or ethnic barriers from visual images, and yet may prove relevant for their study. Examples of conjoined texts include the inscriptions on Classic Maya stone monuments, which often—but not always—have correspondences with the characters and events portrayed on the same media. Yet the correspondences are never complete. Conjoined texts inform the observer about certain aspects of the associated images, but they do not explain them with detail, nor do they fully convey the messages that are encoded in them. Text and image become indistinguishable from each other in "embedded texts," a third type in which textual meanings are inextricably merged with the images themselves. Examples in Maya art include cases in which the elements of headdresses conveyed the phonetic reading of the name of the individuals who wore them.[33]

While Berlo centered her discussion of discrete texts on colonial period sources, recent scholars have extensively employed ancient Maya hieroglyphic texts to interpret images that are not conjoined in the same media. The label *tihlal hix*, written next to the mythical animal on a ceramic vessel, is an example of a conjoined text, but it becomes a discrete text when applied to a representation of the animal that is not directly labeled as such on another object. Many degrees of separation are possible. Contemporary texts from the same sites or regions where the images appear can be contrasted with texts from other regions or time periods. The former are clearly closer, and presumably more significant to the interpretation of the images. As the distance grows, the links between text and image become progressively thinner and the chances of erroneous association increase. Nevertheless, a strict adherence to conjoined texts would preclude any form of comparison or generalization, producing only isolated interpretations that would be irrelevant to each other.

The importance of hieroglyphic texts has increased in recent decades, at the pace of the decipherment and discovery of previously unknown examples. However, colonial and modern texts form a much more substantial corpus of discrete texts related to Maya mythology. This is a highly heterogeneous group that ranges from documents written by indigenous authors in their own languages to records produced by external observers from colonial times to the present. Mythical narratives compiled in the colonial and modern periods are often grounded in ancient beliefs, even though they do not preserve pristine versions of myths that have remained unchanged through time. There is considerable evidence about the resilience of Mesoamerican religion and mythology, but the search for meaning in pre-Columbian art should go beyond simple correlations between particular characters or passages from colonial or modern narratives and ancient representations in Classic or Preclassic artworks.

Mythical narratives are inherently fluid. In the Tzotzil town of San Pedro Chenalhó, Chiapas, ethnographer Calixta Guiteras Holmes noted: "Two contradictory tales can be told about the same event, and the same myth can be told differently by each one of several informants, and the differences are never frowned upon as long as they do not detract from the tale."[34] Variations were regarded as natural, since the stories were transmitted along family lines. However, some narrators had the reputation of knowing more than others. There is no reason to doubt that similar variations prevailed in ancient Maya communities and were likely reflected in artistic representations as well as oral and written narratives.

A related question involves the relevance of discrete texts compiled in other Mesoamerican regions for the interpretation of ancient Maya religion and iconography. In a pioneering comparative assessment of Maya myths, published in 1970, Thompson noted elements of the Q'eqchi' sun and moon myth that appeared in narratives compiled in various communities of southern Mexico, and compared mythical passages from the Popol Vuh with sixteenth-century texts from highland Mexico. In fact, decades before, George Foster had noted analogies between the Popol Vuh and modern Yucatec myths, in his compilation of Sierra Popoluca oral narratives from southern Veracruz. He was unable to resolve whether the stories were partly derived from Maya sources, or whether they originated from other sources that were common to both regions.[35] Later compilations have revealed abundant analogies that bring together narratives collected across Mesoamerica, in ways that suggest a derivation from ancient, common sources, reinforced by sustained contacts that transcended regional, linguistic, and political distinctions through millennia. Mesoamerican peoples share a unified religious tradition, distinguished by generalized explanations about the origin of the world, the gods, humanity, and social institutions that become manifest in mythical narratives. Maya mythology and religion are best understood within this framework.

THE MESOAMERICAN RELIGIOUS TRADITION

Despite centuries of Christian influence, the essential unity of Mesoamerican religion has persisted until the present in traditional communities across the region. As explained by López Austin, this unity does not imply homogeneity; instead, it incorporates a broad diversity of local beliefs and ritual practices, extending to the level of cities, communities, and social segments that have their own deities, origin myths, and religious celebrations. Despite such diversity, they share basic concepts about the structure and dynamics of the cosmos, calendric systems, concepts about the human body and human life, broadly extended cult practices, a basic pantheon, a core complex of mythical beliefs, and key iconographic symbols.[36] López Austin coined the term "Mesoamerican Religious Tradition" to describe a historical process that probably coalesced in early communities during the Archaic period, and was sustained and enriched by intensive contacts among Mesoamerican peoples through the centuries. Long-distance trade and population movements—whose frequency and intensity are often underestimated—mediated these contacts, which resulted in constant feedback among distant populations who spoke different languages and lived in diverse geographic settings.

The exchange of ideas and practices among a diversity of peoples is key to understanding the common features of Mesoamerican religion, but it is equally important to emphasize its common origins. In López Austin's words, "This religion emerged as a whole, not as a mere aggregate of pieces gathered from all corners of Mesoamerica." He questioned the attribution of gods or ritual practices to particular regions or communities, often based on literal readings of texts explaining origins as conceived by sixteenth-century peoples. Foreign gods were commonly adopted or imposed, but they are better understood as "existing gods presented under new names, or hitherto minor avatars of the Mesoamerican pantheon, rather than foreign gods bursting upon the scene with the arrival of the newcomers."[37] In a similar way, Mesoamerican myths are sometimes believed to originate in a particular region, from which they were later adopted elsewhere. Such views generally fail to appreciate the complexity and temporal depth of the connections, which likely extend far beyond the earliest pictorial or textual records. Mesoamerican myths are better understood as derived from a common core of very ancient beliefs that diverged in multiple regional variants. They spread and influenced each other through multiple exchanges mediated by traders, invaders, and migrants. In this sense, López Austin agreed with Thompson's comment that "the elements of Mexican and Maya mythology can not be fitted together like the pieces of a jigsaw puzzle, but they can be integrated into flocculent masses incapable of clean-cut division."[38]

Mesoamerican mythology and religion are the products of a common history that spans the Spanish conquest and colonization. The introduction of Christianity resulted in adjustments that included the abandonment of some of the most important ritual practices of pre-Columbian times (such as human sacrifice, the ball game, and the overt use

of Mesoamerican sacred books), the adoption of a host of Christian sacred characters, the input of Christian sacred history, and the introduction of elements of Spanish and, to a lesser extent, African religious folklore. López Austin conceived the Mesoamerican Religious Tradition as a historical process that comprises (a) Mesoamerican religion properly, which ended with Spanish conquest, and (b) colonial religion, which emerged from the fusion of Mesoamerican religion and Christianity, beginning in the sixteenth century and extending to the present. Contemporary religion is markedly different from its pre-Columbian precedents, yet the central concepts of the Mesoamerican Religious Tradition endured the transition of the Spanish conquest to varying degrees across the region.

Myths lie at the core of the Mesoamerican Religious Tradition. López Austin highlights their resilience, which is implied in his definition:

> Myth is a historical act of production of social thought, immersed in currents of long duration. It is a complex act, and its elements adhere to, and are organized chiefly around, two mutually dependent nuclei. The first is a causal and taxonomic concept with holistic aspirations, which attributes the origin and nature of individual beings, classes, and processes to conjunctions of personal forces. This is the nucleus of belief. This concept affects the actions and thoughts of human beings about themselves and their surroundings. It is expressed in actions scattered throughout social life. The second nucleus consists of tales, which express conjunctions of personal forces as sequences of social events. This nucleus is formed as narrative, principally in the form of oral tales.[39]

Elsewhere, López Austin analyzed myths as aggregates that have solid nuclei and flexible parts, proposing: "The solid nuclei of myth are protected by the cushioning of its ductile parts to such a degree that its life is prolonged through centuries and even millennia." The distinction becomes clear in his discussion of the "heroic" and "nodal subjects" of mythical narratives. The former refer to the incidents that compose the narrative thread, the heroes' actions, and the circumstances in which they occur. These are "vivid, colorful stories, almost impossible to repeat in the same way in every version of the myth."[40] Nodal subjects correspond to the underlying narrative structures, which tend to remain stable in different versions of a myth. He added a third category, "nomological subjects," which refers to major creative processes and cosmic laws that are articulated in myths. López Austin offered only brief explanations of this deeper level of abstraction and made it clear that the nodal subjects were the most important of the three. They form the central axis of myths and tend to remain stable, despite the innumerable variations found in every narrative.

Nodal subjects can be identified through the comparison of multiple versions of myths in search of "synonymies," or parallel episodes that can be recognized as variations of each other, despite their superficial disparities. The comparison of synonymous

passages in related myths provides a basis from which to discriminate persistent themes that transcend the heroic subjects, revealing underlying narrative structures and deeper levels of meaning.[41]

The Q'eqchi' sun and moon myth provides a convenient example. Numerous versions have been recorded since Thompson's time. In most, the sun hero hid in a deer carcass to attract the attention of the vultures. However, one version mentions a dog carcass, while in another the hero wrapped himself in a bag of blood from a turkey, chicken, or dog.[42] Eventually, he reached the town of the vultures, where he sought to regain his wife—who would become the moon—and defeat the evil lord who kept her. Thompson's informants identified this lord either as a king vulture or as "a big devil with four eyes and four horns."[43] Other variants mention an undescribed devil or simply an evil man. In Thompson's narrative, the hero used magic to cause the lord a bad tooth-ache, then disguised himself as a curer and induced the aching lord to sleep. However, in another version, it was the unfaithful wife who suffered a toothache. They finally managed to escape, and shortly thereafter they took their place in the sky.

Such variations do not subvert the myth's basic narrative structure, which has remained essentially unchanged in narratives compiled in Q'eqchi' communities of Guatemala and Belize throughout a century. The resilience of the myth's nodal subjects is strikingly revealed by their presence in narratives from more distant regions and dates, which may appear unrelated at first glance. Mesoamerican solar and lunar myths fre-quently include passages in which the heroes defeated monstrous creatures that pretend to be the sun, or that opposed the rise of the luminaries, keeping the world in darkness. Such beings often had an avian form, although they are also described as serpents or simply as unidentified monsters.[44] One such character is Seven Macaw, who pretended to be the sun of a former era, according to the sixteenth-century K'iche' version of the Popol Vuh. After shooting him with a blowgun and causing him a terrible toothache, the heroes dis-guised themselves as curers and defeated the monster by extracting his shining teeth and bright eyes. Outside the Maya area, the extraction of the teeth takes a startling turn in a Mixtec story from Guerrero.[45] The sun and moon heroes first killed a monstrous serpent with seven mouths and extracted its bright eyes. Then they confronted a powerful woman who had teeth in her vagina. After inducing her to sleep, the lunar hero extracted her vagi-nal teeth and raped her, before following the sun hero into the sky.

This important passage and its multiple variants will be further discussed in later chapters. Suffice it to note at this point that the stories are markedly dissimilar at the level of heroic subjects. The episode occurred before the advent of the sun, but the Q'eqchi' narratives give no attention to the prevailing darkness, which is explicitly mentioned in the K'iche' and Mixtec stories. The solar and lunar heroes were male in the latter, whereas the Q'eqchi' heroes were man and wife. The moon's unfaithfulness in the Q'eqchi' myth is obviously absent in the other stories, although they do contain

important sexual allusions. The Mixtec story presents two characters who opposed the sun and the moon, but a closer examination shows that the K'iche' and Q'eqchi' stories subsume the attributes of both into a single character. The myths are not identical, and each of them contains meanings that are specific to their historical and social contexts. Despite these differences, they share synonymies that include the opposition between the solar and lunar heroes and one or several monstrous beings; their inducement of sleep as a stratagem to defeat their foes; and the overlapping themes of toothache and tooth extraction. Ultimately, these passages relate to the defeat of the primeval monsters that opposed the rise of the sun and the moon, a nodal subject of major significance in Mesoamerican myths.

The heroic subjects of Classic Maya mythical narratives cannot be assumed to correspond closely with those of colonial period texts or modern narratives. The variations are not necessarily due to major disjunctions at the end of the Classic period or at the time of the Spanish conquest. Instead, they are inherent to the constant adaptation of mythical discourse to changing historical circumstances, and the discourse's reformulation through oral forms of transmission. Yet the variations are not random, because they are built around the nodal subjects that, following López Austin, form the stable core of myths.

MYTHS IN NARRATIVE, TEXT, PERFORMANCE, AND IMAGE

In his definition of *myth,* López Austin emphasized the overarching role of mythical beliefs, understood as collective memories composed of the uneasy union of individual understandings that are neither homogeneous nor static. He wrote: "Myth-belief is social knowledge, an interrelationship of separate beliefs acted out in the context of different practices. . . . The shifting totality of coincidences and oppositions constitutes the totality of mythic belief."[46] Beliefs become manifest in everyday human behavior, but there are major venues for the formulation and transmission of mythical beliefs, which include narratives and ritual performances. To explain their relationship, López Austin visualized a triangle with a dominant vertex occupied by mythical beliefs, with narratives and rituals located in the other vertices. Derived from mythical beliefs as their ultimate source, narrative and ritual are strongly linked but not dependent on each other, each maintaining its own structures, media, functions, and history. The scheme can be magnified to include other dimensions. Without excluding other modes of expression, text and image can be placed in additional vertices, in a symmetrical relationship with narrative and performance (fig. 12).

In ancient and modern times, mythical narratives have been recorded as texts, a transition that creates a new set of conventions, contexts of usage, and modes of transmission. While depending on each other, textual and oral narratives are opposites, the

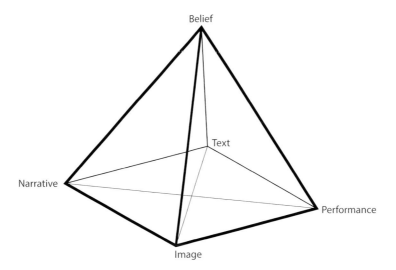

FIGURE 12

Schematization of the links of
mythical belief with narrative, text,
image, and performance.

former subverting the latter's possibilities of permanent reinvention and endless ingenuity. They may belong to different social segments in hierarchical relationships, with textual narratives sometimes controlled by dominant groups. Nevertheless, the status of oral narratives can be high even in literate societies, and they may be considered the domain of high-standing ritual performers or medical specialists.

Visual images add recognizable shapes to mythical narratives, and they may also reproduce the visage of characters and scenery from ritual performances. Yet they do not simply illustrate narratives and rituals, nor do they depend entirely on them. Artistic images may shape the ways in which mythical narratives are apprehended and influence the appearance and demeanor of ritual performers. As López Austin wrote: "A visual image . . . is not a servile description of a myth, but an appropriation of the myth; in art, mythic symbolism has its own set of values, independent of myth-narration. The image may be an explanation from which the clever believer can extract knowledge not accessible through analysis of the myth."[47]

While not entirely dependent on them, artistic representations reiterated the distinctions between heroic and nodal subjects of mythical narratives. Variations in the choice of characters, objects, locations, and other details reflected the fluidity of heroic subjects, echoing the details of particular versions of myths that were known to the artists through oral recitations, textual readings, or ritual performances. Ancient representations were not uniform and, instead, reflect the variability of heroic subjects in oral narratives. López Austin's approach to the analysis of textual and oral narratives can be applied to images, which can be compared in a search for synonymies. Reiterated visual themes likely correspond to the more resilient parts of myths, which may find correspondences with the nodal subjects of narratives. Unambiguous correspondences at the level

of heroic subjects can only be expected in the case of conjoined texts and images, where there are definite links between written or oral narratives and visual representations. Otherwise, significant correspondences between visual images and narratives should be sought at the level of the nodal subjects of myth.

INSTRUMENTS OF SEEING

How did Mesoamerican peoples understand the interplay between text and image? Glosses from sixteenth-century dictionaries show that the same word served for both writing and painting in Mesoamerican languages. According to the Calepino Maya de Motul, *dzib* meant "to write; it is also to paint and draw," while the Nahuatl verb *tlacuiloa* referred without distinction to the actions of painting and writing. In addition to "letter," "picture," and "writing," the glosses for *tz'ib* in the Tzotzil dictionary of Santo Domingo Zinacantán included the Spanish word *retablo*, defined in Sebastián de Covarrubias's seventeenth-century Tesoro de la Lengua Castellana o Española as "the table in which some history of devotion is painted."[48] The Dominican friar who compiled the dictionary understood that the range of meanings of the colonial Tzotzil word tz'ib ranged from alphabetical texts to depictions of episodes from religious stories. Adam Herring has shown that its meanings extended to a variety of patterned surfaces in the colonial Yucatec Maya language. Hieroglyphic evidence suggests that the term carried a similar range of meanings in Classic Maya writing.[49]

To describe their intent, the authors of the Popol Vuh used the verbal phrase *xchiqa-tz'ib'aj*, "we shall write," which might equally be translated as "we shall draw or paint." The Popol Vuh was "written," in the European sense of the word, using a modified Spanish alphabet to write the K'iche' language. The authors explained that they would write it because there was no longer an "original book [*nab'e wujil*]" where the account of their origins could be seen, yet they did not discriminate whether that book was written or painted in the European sense of the words. Moreover, they qualified the original book as an *ilb'al*, literally an "instrument or place of seeing."[50] This word could refer to drawings, as indicated by a gloss for "figure of drawings" in Domingo de Basseta's seventeenth-century Spanish-K'iche' vocabulary: *"figura de dibujos: r ilbalil, ilbal re."*[51]

Commenting on the use of this term in the Popol Vuh, Dennis Tedlock noted an important connotation. In modern K'iche' usage, the words *ilb'al* or *ilob'al* refer to eyeglasses, binoculars, and the crystals that diviners use to gaze at the unseen. Whether it was painted or written, the authors of the Popol Vuh conceived the original book as an instrument that allowed its users not just to see the images or read the stories, but also to gain knowledge and understanding beyond what was written or painted. Restating their motivations toward the end of their work, the authors asserted that the lords who possessed such an instrument were able to know whether there would be war, death, or famine.

The concept is not exclusive to the K'iche'. John Monaghan and Byron Hamann suggested that throughout Mesoamerica, books fall into the category of objects that are believed to enhance the vision of ritual practitioners. Modern ritualists sometimes own books or report that they gained knowledge from reading books in dreams.[52]

Basseta's gloss for "figure of drawings" raises the question of whether the rich imagery of ancient Maya vessels implied these objects were also conceived as instruments of seeing. The pictorial and textual contents of these objects—not radically distinct from each other—allowed their users to read and visualize episodes from mythical narratives. In a deeper sense, they may have served to enhance their vision, allowing them to gaze into the meaning of the myths, gain understanding from them, and perhaps even foresee the future.

njan en ellos tal orden para no se olvidasen.
conviene a saber: que se instruyan en las
antiguedades quanto lo tienen lo quien mas por
los q' esto de hystoriadores usavan refirie
de los todos los generos de cosas que perte
necian ala hystoria: y aquellas encomendavan
a ellos en la memoria y hazian solos reci
tar y si el uno de alguna cosa no se acordia
va los otros sela emendavan y añadian m.
pero por q' este modo era defectuoso: muchas
de sus antiguedades entendiendose tuvieron
falta: y otras de diversa manera se enturaron:
y avn algunas tienen alguna verisimilitud
y delas verdaderas algun rastro: empero
estan en muchas partes depravadas.

¶ de la criacion pues tenian esto o dimos:
dezian q' antes ella njavia cielo ni tierra
ni sol ni luna ni estrellas. ponjan que dos
un marido y una muger divinos q' ella
maron xchel xtamna: estos avian tenido
padre y madre los quales engendraron
treze hijos y q'el mayor con algunos
otros se enbervecieron y quiso hazer crea
turas contra voluntad del padre y madre: y
no pudieron por q' lo q' hizieron fueron unos
vasos viles de esquirro avn jarros y ollas
y semejantes. los hijos menores q'
el uno avia huncheuen y unahau: pidie
ron licencia a su padre y madre para hazer
criaturas un poco de la diziendoles que
saldrian criaturas por q' se avian humillado.
e asi lo primero hizieron los cielos y plane
tas y uegos agua y tierra. despues
en q' dela tierra formaron al hombre. y el

2 Pictorial and Textual Sources

The case is that they say that God existed, the Infant God. So let's begin the story;
as they told it to me, I stamped it in my mind and I keep it present.
—Don Lucio Méndez

So began Don Lucio Méndez—a resident of the Ch'orti' community of Los Vados, in eastern Guatemala—as he told a story, recorded in the 1990s by anthropologist Julián López García. The story is not about the early life of Christ, but about Kumix, a major character in modern Ch'orti' narratives.[1] The earliest known version of Kumix's story dates from the 1960s, but the basic plot echoes a wide assortment of narratives recorded across Mesoamerica from the sixteenth century to the present. Which of these narratives, if any, are relevant to understanding ancient Maya mythology? Did the ancient Maya know earlier variants of similar stories? Do modern Ch'orti' versions contain potential clues for the interpretation of ancient Maya artistic representations?

Don Lucio's offer to tell the story just as it was told to him offers a promising sense of permanence, but it cannot be tested due to the absence of earlier records. The study of ancient Maya myths involves comparisons between a corpus of images produced by ancient Maya artists and an array of textual sources of diverse origin and date that include hieroglyphic inscriptions, early colonial documents, and narratives compiled in modern communities. These sources do not necessarily reiterate the same stories, and even if they do, the variations are significant. This chapter explores the promises and queries posed by these widely disconnected sources for the interpretation of ancient Maya mythical imagery.

MYTHS IN ANCIENT MAYA ART AND WRITING

Manuscript page from Bartolomé de las Casas, Apologética Historia Sumaria, with a creation account from highland Guatemala. Written ca. 1555–59. Real Academia de la Historia, Madrid, España.

Mythical subjects permeated every aspect of ancient Maya art. The portraits of kings and queens evoked the appearance of mythical characters, while their actions reiterated the primeval deeds of the gods. Representations of historical events such as royal accession and war victories were often framed by motives that made them significant on the cosmic scale. Calendric annotations did not simply place events in time; they linked them to

creational events that transpired at the beginning of the Long Count calendar, and sometimes even earlier. The architectural shape of buildings and their sculptural and pictorial programs alluded to mythical places and beings. Mythical themes were not confined to particular spheres of religious art; they pervaded human existence, explained social institutions, and justified political order.

The links between myth and political power are apparent even in the earliest stages of development of Maya art. During the Preclassic period, mythical themes occupied major spaces in sculptures and mural paintings. Stuccoed façades boasted enormous masks portraying gods who appeared to dwell in the building platforms themselves—often conceived as mountains—and peeked out to oversee human performances of ritual duties. As interpreted by Karl Taube, the mural paintings on the west wall of Las Pinturas Sub-1 at San Bartolo—dated around 100 B.C.—showed the enthronement of a ruler, in symmetrical opposition to a badly preserved representation of the mythical enthronement of the Maize God. The god's investiture provided a paradigm for the ruler's, using conventions that would remain associated with royal accession through centuries.[2]

At San Bartolo, the ruler's enthronement occupied only a section of a much broader program that focused on the primeval deeds of the gods. Likewise, in the Preclassic stelae of Izapa and Tak'alik Ab'aj, rulers' portraits shared considerable space with representations of mythical episodes. Julia Guernsey suggested that probable rulers dressed with the attire of mythical avian beings performed episodes of mythical stories, which provided paradigms for their divinely sanctioned power.[3]

This early trend intensified during the Classic period, when the focus of monumental artworks concentrated to a much greater degree on royal personae and courtly ritual. The Early Classic mural paintings of Structure B-XIII at Uaxactun did not reiterate the mythological subjects portrayed at nearby San Bartolo, concentrating instead on royal and courtly pageant. During the Classic period, mythical episodes were rarely represented in large-scale works such as mural paintings and monumental sculptures. Yet the mythical foundations of political power were always present in Classic Maya monumental art, implied rather than explicit, evoked rather than expounded. Mythical subjects reappeared in the more intimate, small-scale media provided by the surface of Classic Maya ceramic vessels. They were frequently painted, molded, or etched on the surface of vessels that were used in daily life to serve and consume food and drink, and were also traded and exchanged as gifts or tribute items. These vessels also had ritual and religious functions, and eventually many were placed in cache deposits and burials, where they contained food and drink for the deceased. Altogether, they form a substantial corpus of information about Classic Maya gods and myths, as first noted by Michael D. Coe.[4]

While the style and dexterity of their work varied significantly, the creators of these vessels were generally accomplished artists and scribes, likely conversant with the content and meaning of mythical subjects. Some were members of the higher echelons of Classic Maya society, and their names sometimes contained titles that were reserved

for the nobility.[5] Yet there is no indication that all these artists shared unified views about the myths. In fact, there is considerable regional variation in the mythical subjects represented on pottery. For example, the extensive corpus of codex-style vessels from northern Petén and southern Campeche includes portraits of the Maize God surrounded by women, but there is no known representation of the god's canoe trip, while these episodes are closely associated with each other in vessels from other regions. Were the creators of codex-style pottery acquainted with variants of the myth that did not include the canoe trip, or was this the result of local aesthetic preferences and religious dictates?

The variation highlights the fragmentary nature of the pictorial record. For all their richness, there is no assurance that the scenes represented on pottery vessels form a representative sample of Classic Maya myths. The artists' choices were not necessarily determined by the relative importance or religious significance of the myths. Other considerations, including functional and aesthetic preferences that varied through time and geographic space, may have influenced their choices. Some mythical themes were favored at the expense of others, and there is a high probability that important mythical passages were never represented on pottery. Variations may have also resulted from the artists' acquaintance with particular versions of myths that were not identical throughout the Maya Lowlands.

While pictorial content is dominant in the ceramic corpus, the vessels also feature hieroglyphic annotations of variable length. These annotations provide glimpses of what was probably an extensive corpus of mythical texts. While the extant Maya codices do not include long narratives, Gabrielle Vail and Christine Hernández suggested that the augural texts in codical almanacs were excerpted from myths. From this perspective, the primeval deeds of the gods provided models for the prognostication of events that were believed to recur in cycles tied to calendric structures.[6] Books containing full written versions of mythical narratives may have circulated, allowing a degree of uniformity throughout the Classic Maya Lowlands. In any case, it is risky to assume such uniformity, which would imply unwarranted assumptions about fixed textual narratives that are not attested in the extant hieroglyphic corpus.

A notable example appears in the so-called "Regal Rabbit" Vase (fig. 13). Interpreters agree that it tells the amusing story of a rabbit—not necessarily regal—that took the garments of the powerful God L. In the painted scene, the humiliated god stands naked before the rabbit, who holds the stolen garments while shouting obscene remarks at him, according to Dmitri Beliaev and Albert Davletshin's reading of the captions. Another scene shows God L, still naked, complaining before the Sun God, while the mischievous animal peeks out from behind the latter's knee. Related representations in other vessels show further episodes involving additional characters and situations, but only this vase provides fairly extensive textual explanations and even quotations by the participants.

Explanations for the rabbit's story vary considerably. David Stuart noted that the myth was not present in the Popol Vuh, whereas both Dieter Dütting and Richard Johnson,

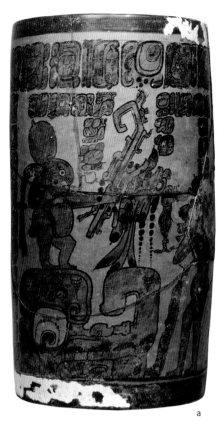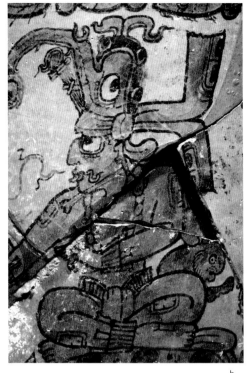

a

b

FIGURE 13

Details of the Regal Rabbit Vase
(Vase K1398) before restoration,
Late Classic, lowland Maya area.
Present location unknown: (a) The
rabbit holds God L's clothes, hat,
and scepter; (b) The rabbit hides
beneath the Sun God's knee.

and Mary Miller and Simon Martin, suggested links with the episodes of the K'iche' book describing the triumph of the Hero Twins over the lords of Xibalba. Beliaev and Davletshin preferred to link these vases with trickster tales involving a rabbit that deceived and outwitted more powerful characters, which are abundantly distributed in modern Maya communities.[7] Largely unexplored are the lunar connotations suggested by the presence of the Moon Goddess on several of these vases. The tale may have explained the rabbit's association with the moon, a frequent theme in Mesoamerican mythology.

While unmatched in extent or detail, the text on the Regal Rabbit Vase contains only a short section of what may have been a much longer and more elaborate story that was transmitted orally and perhaps written down in books, from which these passages were presumably excerpted. Mythical scenes on Maya pottery are often devoid of textual annotations or provide little more than name tags and brief captions. While valuable, these captions provide only isolated clues about characters and events. Clearly, ceramic vase paintings were not designed to convey extensive narratives. Instead, they illustrated passages from myths that were widely known to the users of these objects.

The rabbit story includes two Calendar Round dates. Such notations appear with some frequency in mythical scenes on pottery, but typically there is no clue about their position in the Long Count calendar. Therefore, it is not possible to fix them in time or relate them with dynastic events, which are normally dated through the Long

Count system. Unambiguous dating of these events seems to be irrelevant, although the dates were perhaps intended to mark associations with significant positions in the Calendar Round.[8]

According to the dedicatory phrase written around its rim, the vase belonged to K'ahk' Tiliw Chan Chahk, ruler of Naranjo, a major site in northeastern Petén.[9] Ownership statements were usual on Classic Maya ceramic vessels. Dorie Reents-Budet suggested that the vessels were displayed, used, and exchanged in the context of elaborate feasting and gift-giving activities. On these occasions, rulers publicized their patronage of these elaborate objects and the artists who created them. Moreover, ownership of these vessels marked the lords' connections with the mythical characters and themes depicted on them, highlighting the significance of myths for the construction of Classic Maya rulership.[10]

Besides statements of the vessels' ownership, mythical scenes on Maya ceramics are generally free of references to historical characters or dynastic events. While the separation was not radical, the mythical events commemorated on monumental sculptures overlapped little with the vivid episodes illustrated and sometimes recounted on ceramic vessels. It appears that ceramic vessels allowed artists to focus freely on mythical passages, without linking them in explicit ways to the rulers' dynastic concerns—the major foci of Classic Maya monumental inscriptions and art.

PRIMEVAL EVENTS IN THE HIEROGLYPHIC TEXTS

In addition to scattered passages written on ceramic vases, brief statements inscribed on Classic Maya stone monuments are the only other contemporary sources on ancient Maya mythology. While extremely valuable, their thematic focus is severely constrained. In fact, Classic Maya monumental art showed little concern with mythical episodes, except those that justified the rulers' political power, and for that reason were evoked in royal rituals. Quotations and picaresque remarks such as those of the rabbit story had no place in stone sculptures, which concentrated on a very special subset of mythical themes, rendered in the formal language of dynastic records. Mythical passages tend to appear at the beginning of the inscriptions, offering paradigms for kingly acts recounted in ensuing sections.

Rendered with finely incised glyphs, a small annotation on a stone panel from the site of Lacanjá describes the birth of Ajan K'awiil, or "Corncob K'awiil," as read by Alexandre Tokovinine (fig. 14).[11] The event took place at Ik' Way Nal, a location that is frequently associated with mythical events. The newborn is a manifestation of K'awiil, a major god in the Classic Maya pantheon who is strongly associated with agricultural bounty. The text opens with a Calendar Round date that is not fixed in the Long Count, as usual in mythical texts on pottery. Unlike those texts, this annotation is not associated with a mythical scene. Instead, it relates to the actions of the lord who holds a ceremonial bar

with K'awiil heads emerging from both ends. Presumably, his ritual performance reenacted the mythical event described in the inscription, tantamount to bringing Ajan K'awiil to life.

The Lacanjá panel's gloss is characteristic of Classic Maya inscriptions on stone monuments, where mythical events are normally confined to brief phrases, tied to kingly rituals and dynastic statements. The panel's main text commemorated the dedication of the sculpture and the enthronement of a *sajal*—a high-ranking courtier of the king of Lacanjá and Bonampak—while the description of the mythical event occupied only a secondary annotation. The protagonist of the scene may be the sajal or perhaps more likely the king himself, whose ritual performance was commemorated on the panel by his obliging courtier. Be that as it may, the lord's portrait occupied center stage on the panel, while the mythical event was not represented, but rather only implied by the protagonist's actions.

There was no room for chronological ambiguity in Quiriguá Stela C (figs. 15, 16). The first part of the text explained how the gods placed three stones at named mythical locations, on the Calendar Round date 4 Ajaw 8 Kumk'u. This was the first Period Ending commemoration, at the end of thirteen *baktuns*—a modern name used to designate a calendrical period of four hundred *tuns,* or 144,000 days. According to current estimates, the date fell in the year 3114 B.C. For practical purposes, it marked the beginning of the Long Count calendar, although it was inscribed within a higher order of time reckoning composed of vast units, which extended to mind-boggling lengths into the past and future.

The significance of the 4 Ajaw 8 Kumk'u Period Ending remains poorly understood. Ceramic vases refer to an alignment of gods that took place on that date (fig. 17), while the inscriptions from various sites associated it with a hieroglyphic phrase that, according to Stuart, refers to a "change of images."[12] While the meaning of this phrase is obscure,

FIGURE 14

Panel from Lacanjá, Chiapas, Mexico, Late Classic, lowland Maya area, AD 746: (a) Drawing of carved relief; (b) Detail of secondary text that narrates the birth of Ajan K'awiil. Dumbarton Oaks, Washington, D.C.

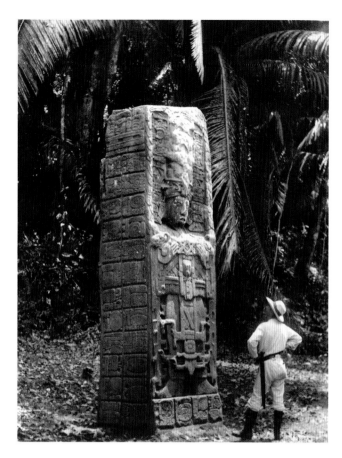

the date marked a turning point in the Maya calendar, with deep implications for Classic Maya royal rituals. On Quiriguá Stela C, the phrase referring to the change of images was followed by the setting of three stones by various gods, at specific locations. The phrasing was the same as that used to describe the dedication of stelae by Maya kings during Period Ending celebrations throughout the Classic period. In the rhetoric of the inscription, the three primeval stone settings provided a paradigm for the Quiriguá kings' performance of ceremonial duties on Period Ending dates in A.D. 455 and 775, recorded on the opposite side of the monument—the latter date marking the dedication of Stela C itself.

Less convincing is the supposition that the three stones mentioned on Quiriguá Stela C corresponded to the three stones of a primeval hearth, as initially suggested by David Freidel, Linda Schele, and Joy Parker.[13] The inscription does not allude to fire rituals, as would be expected in that case. Instead, it refers to the collocation of stones and the ceremonial binding of stones, using standard dedicatory phrases employed in Period Ending celebrations to commemorate the dedication of stelae. While momentous, the primeval events recorded on Quiriguá Stela C appear to be largely related to the divine institution of Period Ending rituals at the beginning of the Long Count calendar.

FIGURE 17

At Palenque, the inscriptions of the Group of the Cross feature the longest known mythical passages in the Maya hieroglyphic corpus. While dated around the initial date of the Long Count, the divine feats recounted in these texts correspond with those the local rulers enacted in historic times. Paralleling Quiriguá Stela C, the Palenque texts follow a consistent format that begins with the acts of the gods in mythical time, followed by those of early historic rulers, and culminating with the deeds of the current kings. The intent of the Palenque texts—further discussed in the next chapter—was neither to offer explanations of Maya cosmogony nor to commemorate the creation of the world or even the origin of the Maya gods in a broad sense. Instead, these texts focused on the patron gods of the local ruling house. They described events that were deemed relevant to explain the origins of the ruling dynasty and the performance of royal rituals, thus reaffirming the political rights and spiritual powers of the Palenque kings.

In a recent review of mythical texts in the Maya inscriptions, Stuart noted, "Creation was very local in flavor, with different kingdoms and cities claiming different supernatural origins, each a center of the cosmos in its own way."[14] The gods who participated in primeval events were different at Palenque, Quiriguá, and other sites, and the mythical events that were highlighted at each site also show a degree of variation. However, Stuart's reasoning should be understood only in reference to particular sources of information—hieroglyphic texts on major stone monuments that focused on the aggrandizement of the local ruling dynasties and their patron gods. Such texts were not intended to record extensive mythical narratives, and their local flavor is consistent with their dynastic nature.

Mythical passages in the hieroglyphic inscriptions are preciously brief. In Stuart's translation, the mythical episodes recounted in Palenque Temple XIX equal twenty-one English sentences.[15] There is little doubt that they were part of a much longer narrative that probably included a wealth of details, subsidiary stories, and rich variations, as myths usually do. Much of this was lost when scribes traced on stone the few sentences that were pertinent to their compositions, leaving no space for extraneous details. For all their importance, these passages do not match colonial or modern mythical narratives in terms of extent and detail.

Stuart also compared the mythical passages in Classic Maya hieroglyphic texts with sixteenth-century narratives from highland Guatemala and Mexico, finding few coincidences. The Popol Vuh, he noted, was cosmic in scope, but nevertheless a very local product of the highland K'iche' that had relatively little in common with ancient Maya mythology, as known from artistic representations and inscriptions. The cosmogonies of highland Mexican peoples were equally local, although especially notorious because of Tenochtitlan's rank as an imperial capital in Late Postclassic times: "Its cosmos was the world's cosmos."[16]

Indeed, Mesoamerican myths refer to the origins of local peoples, and especially their ruling dynasties. There is no overarching story about the creation of humanity. In

early colonial Guatemala, the members of different *parcialidades*—lineage-based, land-holding social units within larger communities—were conceived as descendants from separate forebears. Yet the apparent diversity of names and circumstances belies common basic arguments that were shared by the ancient Maya. Sixteenth-century highland Maya narratives reiterated the patterns observed in the Classic Maya inscriptions. Early colonial books such as the Popol Vuh and the Memorial de Sololá began recounting the mythical stories of the gods in primeval times, which anticipated and explained the origins of local dynasties, their ascent to power, and the deeds of successive lines of rulers. Their stories were local, but nevertheless structured along the patterns that prevailed long before in the Palenque and Quiriguá texts.

It would be a mistake to take the mythical accounts from the Palenque or Quiriguá inscriptions as paradigmatic of Maya mythology in general, just as it is a mistake to take the Popol Vuh as such. They exhibit commonalities that correspond to broadly established patterns of Mesoamerican dynastic narrative, and yet each should be understood within its proper historical setting. A revision of the historical origin of the Popol Vuh is relevant to assess its value for the study of ancient Maya myths.

CONTEXTUALIZING THE POPOL VUH

No single text matches the Popol Vuh in terms of its extent, literary qualities, and wealth of information on Maya myths. Its early composition, only decades after the Spanish conquest of Guatemala, makes it especially relevant for the study of indigenous religion and mythology. Available in modern scholarly translations into English, Spanish, and other languages, the Popol Vuh is widely read.[17] Yet its origins, purpose, and authorship remain the subject of considerable debate, posing important queries that are relevant to understanding its mythical content. The following paragraphs address critical questions that can only be partially answered: Why was the Popol Vuh written? Who wrote it? What reasons determined its structure and content?

Mythical narratives were infrequently written down during the colonial period in the Maya area. Spanish religious authors, including Bartolomé de las Casas, Diego de Landa, Bernardo de Lizana, and Diego López de Cogolludo, recorded valuable but rather brief mythical passages in their respective works.[18] The most substantial records were the work of indigenous writers who employed the Latin alphabet. In Yucatán, they wrote important passages in the prophetical texts known as the Books of Chilam Balam. In the Guatemalan Highlands, they produced texts that described the origins of the ruling houses, their migrations, and the establishment of their kingdoms and cities, aiming to legitimize their status and justify their control of community lands under the Spanish colonial system.[19]

While partial versions may have circulated earlier, there is some agreement that the Popol Vuh was composed sometime in the 1550s or 1560s in Santa Cruz del Quiché,

a colonial town built to resettle the people of Q'umarkaj, the former capital of a king-dom that dominated extensive territories in western Guatemala at the time of the Spanish conquest.[20] It was written in the K'iche' language, using a Latin script intro-duced by Dominican and Franciscan friars, who added special characters to the Spanish alphabet to write the Maya languages of highland Guatemala. The names of its authors remain unknown, as no signature appears in the extant manuscript. However, Dennis Tedlock noticed that the concluding section of the Popol Vuh highlighted the Nim Ch'okoj, holders of an important title in K'iche' political hierarchy, praising them as "mothers of the word, fathers of the word." He proposed that these were the authors of the Popol Vuh, who preferred to identify themselves only by the name of their office.[21]

Building on Tedlock's insight, Ruud van Akkeren compared references to the Nim Ch'okoj in the Popol Vuh with a contemporary K'iche' text, the Título de Totonicapán. This document contains an important version of K'iche' origins and history that parallels the Popol Vuh, while diverging in important respects. One of its authors, Diego Reynoso—who identified himself as a member of a K'iche' noble lin-eage—refuted the claims of the Nim Ch'okoj and other important officeholders who were recognized as such in the Popol Vuh. Van Akkeren concluded that the Popol Vuh was written in a context of political contestation among the K'iche' noble houses, who vied for recognition at a time when the imposition of the Spanish colonial system had considerably disrupted the previously existing hierarchies.[22]

From this perspective, the Popol Vuh was a political statement, not unlike the hieroglyphic statements carved in the Palenque tablets. Like them, it linked the origins of the K'iche' with the primeval deeds of the gods, which preluded the account of the rul-ing houses' rise to power. In ancient Mesoamerica, links with divine predecessors were key for political legitimacy, and it was customary to begin royal records with more or less detailed statements that traced the origin of ruling houses back to primordial times.[23] Contestation was commonplace, and knowledge of ancient narratives might have but-tressed the validity of a faction's claims. Nevertheless, political motivations do not account for the extent and degree of elaboration of mythical narratives in the Popol Vuh, nor do they explain the nearly complete avoidance of Christian content.

A comparison with the Título de Totonicapán highlights major points of divergence. The document began with a long excerpt from the Theologia Indorum, a treatise on the Christian doctrine in the K'iche' language, composed by the Dominican friar Domingo de Vico before his death in 1555.[24] This section substituted for the first part of the Popol Vuh and linked the origin of the K'iche' with biblical traditions from the Old Testament. In the early colonial context, acquiescence with a Spanish view of the origin of humanity appears to be a more effective strategy for legitimation. Although it only included brief mention of territorial boundaries, the Título de Totonicapán is generally closer to the genre of land titles crafted by the members of highland Guatemalan lineages, which they used to legitimate their claims to land and leadership in their communities before the Spanish

civil authorities.[25] The lack of reference to territorial boundaries sets the Popol Vuh apart from that genre.

In the first lines of their work, the authors of the Popol Vuh declared their intention: to write the "ancient word" (*ojer tzij*). Throughout the text, they reasserted their intent, insisting that these were the words of "ancient people," about things that happened "anciently." In his seventeenth-century thesaurus of the Kaqchikel language—closely related to K'iche'—Thomás de Coto glossed *ojer tzij* as "antiquities that are told or recounted."[26] At variance with the Título de Totonicapán, the authors of the Popol Vuh consciously set to write down their old traditions, presumably told by elder people, to the exclusion of Christian beliefs that were only known to them from recent experience.

There has been a protracted debate about the extent of Christian influence in the Popol Vuh. The authors' knowledge of the Latin script leaves no doubt that they were schooled by the Dominican friars, whose primary concern was to teach them Christianity. Intertextual analysis by Garry Sparks shows that they were acquainted with the Theologia Indorum and probably other Christian doctrinal texts. Yet the authors included no unambiguously Christian content in their work. While an absolute lack of influence is improbable, scholars generally agree that no part of the Popol Vuh is obviously derived from Christian doctrine.[27] This was likely the result of the authors' conscious decision to exclude all content that did not belong to the "ancient word."

The authors of the Popol Vuh made it clear at the outset that they wished to be regarded as Christians: "We shall write about this now, amid the preaching of God, in Christendom now." They wrote this sentence immediately after a declaration about the K'iche' gods, praising their words as truthful and enlightened. Both Tedlock and Allen J. Christenson read in these phrases a subtle comment against the Christian missionaries' condemnation of K'iche' religion. Sparks suggested they wrote in direct response to the Theologia Indorum, contrasting the "ancient word" of the K'iche' to the Christian message contained in Vico's treatise.[28] While those implications may be correct, the authors' reaffirmation of Christianity—reiterated toward the end of the document—may have served the purpose of leaving no doubt about this point in the eyes of the most likely readers of their work, the Dominican friars.

It is often supposed that the authors of the Popol Vuh concealed their work, in fear that their attachment to non-Christian beliefs would bring retaliation from the Spaniards. A more likely scenario is that they worked at the request of the Dominican friars, and possibly under their supervision. During the 1550s, the Dominicans engaged in active efforts to compile information about indigenous religion, which they conceived as being necessary to better understand and ultimately eradicate it.[29] In a challenging study of the Popol Vuh, René Acuña noted that the friars of the Dominican province of Chiapas and Guatemala endorsed this policy at a 1558 chapter, which ordered that every convent, parish, and church should have a book containing "the idols and their names and figures, and the peoples who adored them and had them, and how many they were; and this book

should be kept in the deposit."[30] Another chapter, held in 1578, once again stimulated the friars to learn about such matters, in order to better uproot them.

The Dominicans were indeed familiar with the names of the gods, places, and episodes mentioned in the Popol Vuh. In his Theologia Indorum, Vico directly addressed indigenous beliefs, pointing out what he saw as their flaws.[31] Another Dominican, Bartolomé de las Casas—who as bishop of Chiapas brought Vico and other friars to the country—described the religious practices of the K'iche' and the people of Verapaz in his Apologética Historia Sumaria, which included short but important passages from mythical narratives. Unpublished until the nineteenth century, Las Casas's work was extensively copied through the colonial period and influenced every discussion about the customs, history, and religion of highland Guatemalan peoples.[32]

While collaborating with the Dominican friars, the authors of the Popol Vuh also wrote for themselves and for other literate K'iche'. Robert Carmack and James Mondloch noted that important sections of roughly contemporary documents from Totonicapán were based on the Popol Vuh, and suggested that copies of the text, or parts of it, were available to K'iche' scribes in that region.[33] Whatever their role in the original composition of the Popol Vuh, there is definite evidence that the text was not hidden from the Dominican friars, but freely available to them. Acuña found no less than eight literal quotations from the Popol Vuh in the glosses of Domingo de Basseta's K'iche' dictionary, composed in the second half of the seventeenth century. Basseta attributed one of these quotes to friar Alonso Bayllo, who worked closely with Vico in the mid-sixteenth century and composed a book of sermons that is now lost.[34] The missing pieces make it difficult to reconstruct a history of the manuscript and its users, but there is evidence that the Popol Vuh was read and quoted by Dominican friars during the sixteenth and seventeenth centuries. The gestation of the Popol Vuh can be better understood in the context of collaboration—imposed or not—between the Dominican friars and the K'iche' authors of the Popol Vuh.

The only motivation voiced in the Popol Vuh—immediately after the author's reaffirmation of Christianity—was the loss of an original, ancient book, whose readers now hid their faces. They referred to this book as *popol vuh*, a title that has become attached to their work since the nineteenth century.[35] There has been much speculation about that book and the ways in which the authors of the Popol Vuh might have reproduced its content. The existence of pictorial manuscripts in highland Guatemala is attested by brief descriptions contained in colonial documents, but there are no extant examples of screenfold books or lienzos used by highland Guatemalan peoples, and no substantive information about whether they employed pictorial or glottographic scripts. Tedlock and Christenson suggested that the ancient book mentioned in the Popol Vuh contained texts in a glottographic script, either related or identical to lowland Maya writing. This would imply that they could record full narratives without relying on mnemonic methods that would be needed to read a pictorial book.[36] However, mural paintings from Q'umarkaj and

Iximche show that the K'iche' and Kaqchikel employed a variant of the international symbol set that prevailed throughout much of Postclassic Mesoamerica. The modes of writing associated with this symbol set were largely pictorial, although there is a possibility that, like the contemporary Nahua, highland Maya peoples added place names and personal names written in a glottographic script. The ancient book described in the Popol Vuh may have employed such combinations, although any inference will remain speculative in the absence of clear examples.[37]

Several copies of the Popol Vuh may have circulated in the sixteenth century, both among Dominican friars and K'iche' scribes. Yet only one copy has reached the present, thanks to the work of a Dominican friar, Francisco Ximénez. As we know it, the manuscript of the Popol Vuh is part of a doctrinal collection, compiled by Ximénez in the early eighteenth century. The volume includes two main treatises: (a) a grammatical treatise of the Kaqchikel, K'iche', and Tz'utujil languages, and (b) a manual for Catholic priests to administer the sacraments and confession. Appended to the second treatise is the section that we know as the Popol Vuh, written in double columns that, respectively, contain the original text in the K'iche' language and Ximénez's Spanish translation. This section is entitled "*Empiezan las historias del origen de los indios de esta provincia de Guatemala traduzido de la lengua quiche en la castellana para mas commodidad de los ministros de el santo Evangelio*" ("[Here] begin the stories of the origin of the Indians of this province of Guatemala, translated from the K'iche' language to Castilian [Spanish] for better ease of the ministers of the holy gospel"). It includes a prologue by Ximénez and a final, shorter section that contains his *scholia,* or explanatory paragraphs for the preceding stories.[38]

While separately titled and paginated, these sections appear to have been written and put together by Ximénez as a single volume, designed to instruct his fellow Dominicans. Néstor Quiroa called attention to the introduction to the second treatise, where Ximénez explained the collection's structure and aims. After describing how priests should fight against the devil just like military commanders against their enemies, he added: "This is the aim of the second treatise that contains a confessionary and a catechism. I also added another treatise that I translated from K'iche' into Castilian. Here can be seen the errors with which Satan attempts to wage war on these miserable Indians."[39] Thus, the appended "stories" were intended to make the Catholic priests aware of the many non-Christian beliefs that still prevailed in highland Guatemalan communities. In accordance with the sixteenth-century Dominican chapters, Ximénez believed that the friars should be familiar with indigenous religion, in order to extirpate it.

Nowhere in his work did Ximénez mention where he obtained the Popol Vuh manuscript, and his information about this point is contradictory. According to his prologue, he translated it to satisfy the curiosity of many, and to disavow the opinions of some, who could not understand the stories or knew them only from hearsay and thought that they conformed well to the Catholic faith.[40] Ximénez's justification suggests that the Popol Vuh, or some version of it, was known not only to Ximénez, but also to his

fellow Dominicans, and that it was a matter of discussion among them. However, in his later history of the Dominican order in Chiapas and Guatemala, he commented that the Indians had hidden the stories they had written at the time of the Spanish conquest, and there was no memory of them among Catholic priests. Acuña pointed out that this statement was false, judging from the quotes he found in Basseta's seventeenth-century dictionary. In the same paragraph, Ximénez recalled how, while serving as parish priest in the K'iche' town of Chichicastenango, he found that the Indians kept many such books and that they even memorized them. While this recollection may be accurate, Ximénez's wording does not necessarily imply that he obtained the manuscript of the Popol Vuh in Chichicastenango.[41] Arguably, his omission of the manuscript's source was not due to reticence or oversight, but simply to the fact that there was nothing to explain. The Popol Vuh was available on the shelves of the Dominican convents—the "deposits" called for in the 1558 chapter. It was read and quoted by some of the friars and discussed by others, with or without deep knowledge of the K'iche' language.[42]

The Popol Vuh was a product of a colonial situation, in which members of K'iche' society interacted with each other and with the Spanish Dominican friars. The Dominicans introduced literacy in the Latin-based script, and their missionary quest to learn about K'iche' religion may have stimulated indigenous scribes to compile the "ancient word" in a detailed and extensive fashion that produced not just a compilation of diverse beliefs, but a coherent narrative. The friars had access to the resulting document, but there is no indication that they actually intervened in its compilation or redaction. This was the work of K'iche' authors, who acknowledged their purpose of recovering knowledge that they perceived as disappearing. In the process, they also built an argument that favored the political claims of certain K'iche' lineages to preeminence, in contestation with rival factions.

In the opening sentences of their work, the authors of the Popol Vuh made it clear that they would write about a place called K'iche', and more specifically about their city and its people, "the fortress of K'iche'" and "the people of the K'iche' nation." In closing, they reiterated that "all is now completed concerning K'iche', called Santa Cruz."[43] The content of the Popol Vuh reflected the knowledge, the aspirations, and the biases of members of the colonial community of Santa Cruz del Quiché, who made no pretense of writing about anything other than their own town and their people. They belonged to a particular social group within that town and wrote accordingly, making conscious decisions about what to include or exclude from their text.

Important myths that circulate until the present across the Guatemalan Highlands were not included in the Popol Vuh, while others were written in ways that departed from other known versions. A comparison with the Título de Totonicapán is illustrative. According to that document, the sun was a young man called Hunahpu, while the moon was a young woman called Xbalanqueh.[44] While the names of the sun and moon heroes coincide, the Popol Vuh did not specify which one became either luminary, nor did it distinguish them by gender. Such details may have been irrelevant or obvious to

the authors of the Popol Vuh, although this was not the case in the Título de Totonicapán. They may also have had deeper, perhaps political reasons to omit them.[45] In any case, we cannot assume that the authors of either document had a better understanding of the myths. Either they knew different versions or made choices about adding or omitting details in their respective texts.

Such variation is not strange in mythical narratives, even though, as in this case, they come from closely related, contemporary communities of people who spoke the same language. This example highlights the fact that the version contained in the Popol Vuh is by no means representative of the mythical beliefs that prevailed among the sixteenth-century K'iche', much less among sixteenth-century Maya peoples in general. It also casts doubt on the supposition that the stories of the Popol Vuh corresponded closely with much earlier versions from the Maya Lowlands, as affirmed by, among others, Freidel, Schele, and Parker, who wrote: "The genesis stories in the Popol Vuh are a redaction of the central myths celebrated by lowland Classic Maya."[46] The tendency to search for connections with that region is also manifest in Christenson's puzzling comment that "the authors of the Popol Vuh made clear that they based their writings on an imported text from the Maya Lowlands."[47] There is simply no such affirmation in the Popol Vuh.

There is a contrary view, which regards much of the content of the Popol Vuh and other sixteenth-century texts from the Guatemalan Highlands as being derived from highland Mexican influence, or as "a mixture of Maya and Mexican elements," as recently characterized by Victoria and Harvey Bricker. Among other sections, they regarded the K'iche' account of previous creations as resulting from such influence, and suggested that it was pieced together, "combining themes from the K'iche' heritage with those received from elsewhere."[48] Indeed, highland Guatemalan peoples were influenced by the cultural and political preponderance of the Mexica during the Late Postclassic period. However, that interpretation reflects a short-ranging view of interregional interaction in Mesoamerica, and a view of the Maya as pristine peoples who had little interaction with other Mesoamerican communities before the Postclassic. The account of previous creations in the Popol Vuh is significantly different from contemporary Nahua versions, enough to discard the notion that one was adapted from the other. Yet the shared nodal subjects suggest that both derived from common, much older sources, together with related narratives found across Mesoamerica—including rich and elaborate myths about earlier eras, compiled in modern highland and lowland Maya communities.

Archaeological research shows evidence of sustained interaction among Mesoamerican peoples, which became especially evident during the Classic period. Far from a one-way flux, cultural exchange went in every direction, as reflected by the presence of Maya-style mural paintings, sculptures, and inscriptions at Early Classic Teotihuacan and Late Classic Cacaxtla and Xochicalco. Parallels between the Popol Vuh and highland Mexican myths did not derive from the relatively short-lived Mexica expansion during the Late Postclassic period. They derived from a shared set of beliefs that goes

far beyond the earliest inscriptional and iconographic pieces of evidence, reinforced by constant interaction throughout millennia.

The correspondences between the Popol Vuh and ancient Maya beliefs did not derive from the permanence of more or less fixed texts. The myths of the Popol Vuh are closely related to versions that are spread across Mesoamerica. Some are known from colonial compilations produced by indigenous or Spanish authors, while others were only written down within the last century. Their comparison highlights the nodal subjects of Mesoamerican myths, while it also highlights the striking peculiarities of the sixteenth-century K'iche' version contained in the Popol Vuh.

COLONIAL NAHUA MYTHS

Compared with the Maya area, there is a relative wealth of colonial documentation about Nahua myths from highland Mexico, in Nahuatl and Spanish texts written by indigenous and Spanish authors.[49] Some of the most important texts derive from the work of missionaries intent on learning about Nahua religion, who annotated and transcribed the content of pictorial books and collaborated with members of local communities to record information about deities and rituals, including narratives about the origin of the gods and their roles in the making of the world and humanity.

There is no good match in colonial Nahua literature for the Popol Vuh, in terms of its extent, internal coherence, and cosmologic breadth. Nevertheless, a brief comparison with an important text reveals significant points of concurrence and departure. The anonymous Legend of the Suns was written in Nahuatl between 1558 and 1561. There is disagreement about whether its author was from Mexico or Tlatelolco. While the text contains no explicit indication, John Bierhorst believed that it transcribed the content of a pictorial book. Perhaps following the chronological structure of a pictorial manuscript, the Legend includes dates, which are totally absent from the Popol Vuh and are also unimportant in other K'iche' documents.[50]

Like the Popol Vuh, the Legend of the Suns has no title, but the author stated his purpose in the first lines, which Bierhorst translated as: "Here are wisdom tales made long ago, of how the earth was established, how everything was established, how whatever is known started, how all the suns that there were began."[51] Surprisingly broad, this statement contrasts with the Popol Vuh's specific reference to a particular place and its people. Yet the text of the Legend focused on a specific people, the Mexica, and the reasons for their supremacy. The "wisdom tales" correspond to the Nahuatl word *tlamachilliztlatolçaçanilli*, which in Rafael Tena's Spanish translation is *la leyenda de la palabra sabia* ("the legend of the wise word"). Alfredo López Austin analyzed the term in some detail and proposed "the amusing narrations of wise words." He suggested that this term might have designated a genre of mythical narratives, although there was no Nahuatl term that clearly designated myths.[52] Unlike the K'iche' ojer tzij, it does not allude

to the narrative's antiquity. Nevertheless, the Legend fulfilled its promise of telling how everything began in a remote past.

The Popol Vuh and the Legend of the Suns share important themes, even though they do not appear in the same sequence. Both began with accounts of successive creations and their demise. The Legend described the advent of four suns, the people who lived in each of them, and their catastrophic demise. The Popol Vuh did not describe successive suns, but instead concentrated on three successive attempts to create people, and the final condemnation or destruction of the imperfect beings who came out. Both documents conceded special attention to the origin of the sun and the moon, which involved the self-sacrifice of two male gods in a pyre or pit oven. The Popol Vuh has no explicit parallel for the myth of the origin of warfare, explained in the Legend by the defeat of the four hundred Mimixcoa, who were killed to feed the sun. Yet these characters shared significant aspects with the four hundred boys who were killed by a primeval monster in the Popol Vuh.

The creation of people took different paths in each text, which nevertheless have much in common. In the Popol Vuh, the first four men were created from beverages made with ground maize grains, while in the Legend, Quetzalcoatl brought from the land of the dead the precious bones—presumably from the dead of a previous creation—to be ground and mixed with sacrificial blood. In Mesoamerica, bones are frequently equated with seeds and believed to be carriers of progeny, suggesting an analogy between the precious bones and the corn grains.[53] In both texts, the creation of people was closely related to the discovery of maize.

Both documents described the triumph of heroes over primeval monsters: the Hero Twins against Seven Macaw and his children in the Popol Vuh; Mixcoatl against Itzpapalotl and the women of Huitznahuac in the Legend of the Suns. Michel Graulich compared the saga of Mixcoatl and his son, Ce Acatl—the calendric name of Quetzalcoatl—with the story of the Hero Twins and their father in the Popol Vuh. Like them, Ce Acatl searched for his dead father and took revenge against his killers. There is no clear counterpart in the Popol Vuh for the fall of Tollan, which provided a moral justification for the rise of the Mexica. However, both documents conclude describing—very succinctly in the Legend of the Suns—their peoples' rise to power.[54]

Similar correspondences can be found with colonial sources from other regions of Mesoamerica, although the available texts are less abundant. Graulich highlighted one example from the sixteenth-century Purépecha of west Mexico, recorded in the Relación de Michoacán. This passage reiterates the story of two generations of heroes. The father was killed in a remote place after losing a ball game. His son grew up as an orphan, but later searched for the remains of his father, avenged his death, and tried to restore him to life.[55] The story is modeled on the same basic argument found in the Popol Vuh story of the Hero Twins, and in the account of Quetzalcoatl in the Legend of the Suns. Not limited to colonial sources, it reappears with much strength in narratives compiled across Mesoamerica in the twentieth and twenty-first centuries.

MODERN MYTHS

Colonial texts provide a highly skewed vision of Mesoamerican mythology that excluded entire regions and linguistic groups. No myths were compiled from the large majority of Mesoamerican communities until the twentieth century. Yet their inhabitants preserved rich troves of oral narratives, transmitted from mouth to mouth across generations. The corpus of Mesoamerican mythical narratives has grown steadily since the early twentieth century, through the work of ethnographers, linguists, missionaries, amateur scholars, writers, and, increasingly, members of indigenous communities who are making efforts to preserve their traditional knowledge. The records are uneven in terms of coverage and quality. Some communities and regions have received more attention than others. Some narratives have been carefully recorded in the storyteller's language, and scholarly translations are available in certain cases. Many others have appeared only in translations with various degrees of editorial input and, in some cases, with literary alterations. The names of the original storytellers have often been lost. Nevertheless, even when poorly recorded, the stories retain much value for comparative studies. Publications are widely scattered and sometimes hard to find, although several compilations offer useful comparisons of the available narratives.[56]

Comparisons between modern stories, colonial texts, and the inscriptional or iconographic records from archaeological sites reveal a high degree of continuity. López Austin related the extraordinary resilience of Mesoamerican myths to the persistence of family relations, subsistence and trade practices, and other social and economic patterns that favored the preservation of the core elements of worldview and religion. This does not imply that mythical beliefs and narratives remained unchanged. Shifting historical circumstances and external stimuli altered them to varying degrees, and yet, in López Austin's terminology, they affected primarily the outer layers of myths—the heroic subjects in narratives—without necessarily transforming their inner cores.[57]

Modern stories often contain Christian motives that were first incorporated since the sixteenth century. Certain characters have the names of Catholic saints, and biblical passages have merged with similar episodes in Mesoamerican myths. The question is not whether modern narratives have Christian influence or not, but to what extent such influence has altered the myths' inner core. López Austin distinguished multiple degrees of innovation that may affect different layers of myths.[58] The most superficial innovations include changes in the names of mythical characters, places, or other features, which affect only the heroic subjects. Extraneous motives or incidents may also be inserted into the narratives without altering their basic structure. A deeper level of innovation involves the insertion of important passages, which nevertheless may occur without transforming the myth's general sense and outcome. Finally, there are innovations that affect the inner core of myths and the underlying cosmic principles.

An interesting case involves the identification of the Catholic Holy Mary with Mesoamerican mother goddesses. Van Akkeren noted such identification in a modern marriage petition prayer from the Achi of Rabinal. According to his summary of the prayer, the protagonist, Qachu Kilaj Qapoj, "Our Mother Beloved Maiden," was locked in the paternal house, but became pregnant after eating an apple San Pedro gave her through a small window. She was condemned to die, but her executioners, San Miguel and San Vicente, let her go. To appease the father, the executioners faked her death cry and brought the father the red juice of the pitaya instead of her blood. During her flight, she endured various trials, overcoming them with the help of animals. She finally reached Jerusalem, where she married San José, the poorest of numerous suitors. Pursued by the angry rivals, they escaped and endured new trials. The prayer ends with the birth of "the son of god who is in heaven," set in Bethlehem, where angels announced the good news to the shepherds and a star guided the Three Wise Men.[59]

Although the names of the characters are Christian, Van Akkeren noted the prayer's parallels with the story of Xquic in the Popol Vuh, while several passages find broad parallels in other narratives. The first part of the prayer contains core elements of Mesoamerican myths that describe the prodigious impregnation of a tightly guarded maiden, against the will of her parents. The final section follows more or less closely the Christian story of the birth of Christ, and Van Akkeren reported that some priests in Rabinal stretch the prayer, telling the whole life of Christ during prolonged marriage petitioning ceremonies.

A rough measure of the permanence of Mesoamerican oral narratives can be assessed in some cases by comparing versions that were recorded in the early twentieth century with more recent ones. H. E. M. Braakhuis compared more than twenty versions of the Q'eqchi' sun and moon myth recorded between 1909 and 2004 in the Alta Verapaz, southern Petén, and Belize. They vary in many respects, from the names of the characters to the omission of entire episodes. Unusual details appear in some, and yet neither the myth's core themes nor the majority of episodes have changed significantly, despite multiple political, economic, and religious upheavals that have affected Q'eqchi' communities. The narrative structure remains essentially constant, and particular details reappear once and again in versions recorded many decades apart.[60]

Variations across geographic and linguistic boundaries are more significant. While certain passages are broadly distributed, distinct narratives tend to be shared only in closely linked communities. Narratives from Poqomchi', Ixil, Kaqchikel, and other highland Guatemalan peoples share passages with the Q'eqchi' sun and moon myth, but they differ, among other things, in their final outcome, which generally does not include the heroes' transformation as luminaries. Similar variations were likely present across the broad expanse of the Maya Lowlands in ancient times.

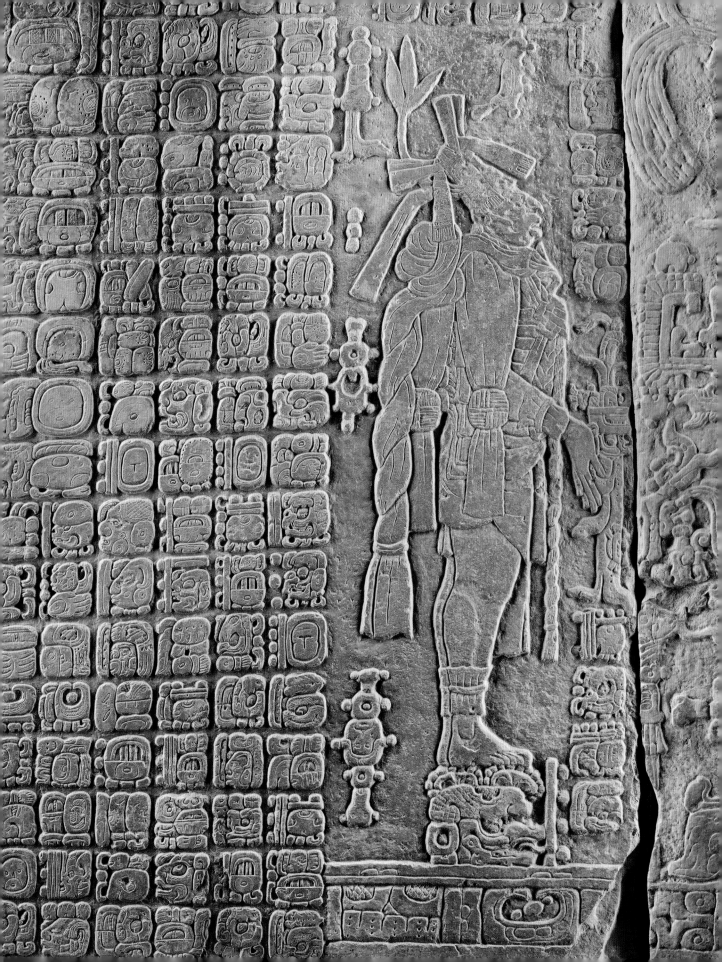

3 Mesoamerican Cosmogony

There is another story that men tell, when there was no sun that we see nowadays in the sky.

—Anonymous Ch'orti' narrator

The words of a Ch'orti' narrator from eastern Guatemala, recorded in the 1960s by linguist John Fought, speak about a time when the world was in darkness and describe what happened when the sun rose.[1] The story evoked a critical junction in Mesoamerican cosmogony, which transformed the world and created the conditions for human life on earth. Yet despite the importance of the sun rising, there are no descriptions of the first sunrise in the Maya hieroglyphic corpus, to the best of our current knowledge. Nor are there passages that describe the inhabitants of earlier eras and their fate, although brief references to floods may refer to their cataclysmic end.

Colonial texts and modern accounts suggest that the Maya shared with other peoples of Mesoamerica a core set of beliefs and narratives about the origin of the earth, the former eras and their inhabitants, the flood, and the creation of humanity. Some of these themes find correlates in ancient Maya art and writing, while others are not readily linked with hieroglyphic passages or pictorial representations. Yet the relative muteness of the extant records does not mean that the ancient Maya ignored these aspects of cosmogony, nor does it imply that they conceived them in ways that were radically different from other Mesoamerican peoples. A broad review of Mesoamerican myths is relevant to understanding ancient Maya concepts about the cosmic processes that led to the formation of the world, the creation of people, and the first sunrise.

CREATION

In Mesoamerican cosmogony, creation did not happen at once, nor did it result from the conscious acts of a god or group of gods. Instead, it was the consequence of multiple beginnings, trials, and demises. Different components of the cosmos originated at different times, through the actions of different gods, who sometimes acted in unison,

but frequently in opposition. Their confrontations and misdeeds are the substance of mythical narratives that explain how their actions triggered major creative processes.

An important debate among students of the Popol Vuh involves the meaning of the K'iche' word *winaqir* and its derivations. While most modern translators have glossed it as "to create," Dennis Tedlock commented that "the word 'creation' is too heavily laden with an implied ontological priority of the spiritual over the material."[2] In his translation, he preferred to use different terms according to the context, such as *generation, formation,* and *rise.* Allen J. Christenson used *creation,* while noting that a literal translation of *winaqirik* would be "to people" or "to populate." Reviewing the problem, Nathan Henne concurred that the term *creation* implied an *ex nihilo* process—out of no previously existing matter—that resonated with Christian concepts and misrepresented Mesoamerican cosmogony.[3] To some extent, the term's ambiguity relates to the Spanish word *criar.* In his seventeenth-century dictionary, Sebastián de Covarrubias made it clear that, in accordance with theological authorities, "criar" could only refer to God's ex nihilo creation. However, it was commonly used in the sense of "engender." Accordingly, colonial authors related it to the Christian God's creation of the world. In his dictionary, Thomás de Coto agreed that "criar" referred to animated beings, and his Kaqchikel glosses included terms for "to conceive" and "to engender."[4]

Indeed, creation in Mesoamerica did not occur ex nihilo. It generally involved transformations of previously existing beings, sometimes in unforeseen ways. At Chenalhó, Calixta Guiteras Holmes noted, people showed no interest in explaining the ultimate origin of things "and took for granted that there was a great deal to begin with." The K'iche' creator gods received the epithets *Tz'aqol, B'itol,* translated by Tedlock as "maker, modeler," and by Christenson as "framer, shaper." Both scholars noted that *Tz'aqol* referred to someone who makes things by adding different components, such as building materials, while *B'itol* was someone who models things by shaping a suitable material such as clay.[5] These terms do not imply an ex nihilo mode of creation. Moreover, it should be noted that in Mesoamerica, there is no such thing as creation from inert materials. All matter is considered animated and, therefore, its transformations involve the transmission of vital forces from one being to another.

There is no unified version of Mesoamerican cosmogony. Roughly contemporary versions recorded in the same region may contain important variations, as shown, for example, by the comparison of sixteenth-century Nahua texts that describe the previous suns. The number of suns and their sequence vary significantly in the available texts. While scholars have tried to explain the discrepancies and distill a definitive order, the available evidence shows that there was no master sequence and that different versions coexisted.[6] The variations bring to mind Robert Laughlin's remarks about modern Zinacantec origin stories: "In the beginning who really knows how it was? No Zinacantec can flash a photographic memory of the origins or the outlines of the cosmos. Scraps of knowledge are passed to the younger generations, but Zinacantecs are unconcerned about

the gaps, the conflicts, the inconsistencies. They know that the world and mankind have both survived multiple creations and destructions, but they do not agree on the number or sequence of these events."[7]

Laughlin's impressions from Zinacantán contrast with Gary Gossen's studies of oral narratives at the neighboring community of San Juan Chamula. Gossen described the Chamula as "obsessively conscious of their own history." He discerned a succession of four creations that provided a consistent historical framework for interpretations about the origin of the world and the progression from the failed beings who inhabited earlier creations to the modern people of Chamula.[8] While such contrasting statements may reflect the ethnographers' aims and methods, the comparison of Mesoamerican creation myths shows that broadly shared patterns are discernible, despite the prevailing disparities. Mesoamerican creation myths are generally concerned with the overlapping events that led to the origin of the earth, the sun and the moon, maize, and people. In addition, sixteenth-century narratives sometimes feature additional subjects such as the origin of the calendar and the origin of warfare. Michel Graulich showed the extent to which these topics are rendered in comparable terms in the Popol Vuh and in Nahua myths from highland Mexico.[9] Modern narratives from many regions reiterate similar themes, which can also be recognized in ancient Maya art and inscriptions.

THE CREATORS

According to a sixteenth-century highland Maya myth recorded by Bartolomé de las Casas, there was a primordial couple, named Xchel and Xtcamna, who had thirteen sons. In arrogance, the older sons tried to create living creatures, but all they obtained were vile pots and jars. The younger ones, Huncheven and Hunahau, humbly asked permission from their parents and were able to create the heavens, planets, air, water, and land. Finally, they created men and women from earth. The older ones were thrown to hell. Craftsmen venerated the younger brothers, asking them for dexterity and skill in their works.[10]

Largely overlooked, this is not a random mix-up of pieces from the Popol Vuh or other sources, but a mythical version of creation—in all likelihood, one among many versions that coexisted in northwestern Guatemala. This one happened to be summarily recorded by the bishop of Chiapas, and the reference to "hell" may reflect his Christian bias. Nevertheless, the opposition among siblings is not rare in Mesoamerican myths. Generally, the younger siblings prevail upon their elder brothers, who are punished in various ways. While the myth departs significantly from the Popol Vuh, both versions share important details with each other, and with other Mesoamerican narratives.

The Las Casas story featured two generations of gods. The primordial couple was largely idle, and the major creative acts were done by their offspring. There is a parallel

in sixteenth-century Nahua accounts of a primordial couple who did little else than give birth to their children, the gods who took charge of creation.[11] In one version, Citlalatonac and Citlalicue were the primordial, celestial couple. Their children were frightened when Citlalicue gave birth to a large flint knife, and they decided to throw it down from heaven. When it landed, sixteen hundred gods came out from it. Finding themselves expelled, they asked their mother to let them create people.[12] In his retelling of the myth, the Franciscan friar Jerónimo de Mendieta likened the expelled gods to the bad angels fallen from heaven and equated their expulsion to punishment. Yet it makes more sense to regard the older brothers who threw down the flint knife as akin to the arrogant older brothers of Las Casas's myth. The gods who were born from the knife in the Nahua myth—that is, the younger ones—humbly requested permission to create people, and their mother granted it. Thus, the young and despised brothers were the ones who engaged in successful creative acts. Another version, from the Historia de los Mexicanos por sus Pinturas, did not describe confrontations among siblings, but also attributed the creation of people to the younger pair in a group of four brothers who were born from a primordial couple.[13]

The characters acquired Christian names in a modern K'iche' myth from Chinique. The old couple, Padre Eterno and Virgen Trinitaria, lacked the strength to "make the creation," so they entrusted it to their trickster son, Pedro Arimal—named after Pedro Urdemales, a frequent character in Spanish and Latin American folktales. "But he was 'puro animal,' like a beast, and only went about molesting young women and stealing money. He was finally turned to stone." Then the old couple called together all their offspring and gave the task to Jesus and Mary, who succeeded only after defeating their enraged brothers, the bad saints.[14] Despite the characters' names, the basic plot is not different from sixteenth-century Nahua and highland Guatemalan myths that described a primordial couple, and how their younger offspring succeeded in their creative attempts, while the older ones were punished for their disrespect.

The version contained in the Popol Vuh also began by naming a primordial couple, Xpiyacoc and Xmucane, qualified by a series of reverential names that include Tepew, Q'ukumatz ("Sovereign, Quetzal Serpent"), and Alom, K'ajolom ("she who has borne children, he who has begotten sons").[15] While there is no explicit indication about their children, the text continues describing the creative acts of a triad of gods designated as "Heart of the Sky," individually called Kaqulja Huracán, Ch'i'pi Kaqulja, and Raxa Kaqulja. The names mean, respectively, "One Leg Thunderbolt," "Youngest Thunderbolt," and "Sudden Thunderbolt." Comparison with parallel versions suggests that this triad was the primordial couple's offspring. Like the younger gods of Las Casas, and the Nahua sixteen hundred gods, they conferred with the primordial couple and accorded to create people. However, the Popol Vuh makes no mention of conflict among them, nor does it mention older siblings with whom they competed.

This is one of many passages in which the Popol Vuh shows significant variance in comparison with parallel versions of Mesoamerican creation. Equally remarkable is the

internal coherence of the Popol Vuh creation account. At the outset, the gods spelled out their wishes and queries, which condensed the principal constituents of creation: "How should the sowing be, and the dawning? Who is to be the provider, nurturer? Let it be this way, think about it: this water should be removed, emptied out for the formation of the earth's own plate and platform, then should come the sowing, the dawning of the sky-earth. But there will be no high days and no bright praise for our work, for our design, until the rise of the human work, the human design, they said."[16]

Tedlock noted the significance of the sowing and the dawning, paired concepts that were frequently reiterated as a couplet in the Popol Vuh.[17] The sowing referred to the beginning of cultivation but, more specifically, to the discovery of maize. The dawning referred to the first sunrise, the critical transition that brought a moral order to the world and made it inhabitable for people. Rather than being distinct creational events, the sowing and the dawning complemented one another, perhaps expressing the earthly and heavenly facets of creation. In highland Guatemalan communities, sowing is metaphorically related to pregnancy, but also to the burial of the bones of the dead. Correspondingly, dawning relates to childbirth and to the destiny of human souls after death.[18]

The gods' initial questions provided a rationale for subsequent episodes in the Popol Vuh, which explained how the sun came to be, how maize was discovered, and how people were created. The gods were not initially cognizant of the means to achieve these aims, and much of the Popol Vuh deals with their pursuit, beginning with the narrative of their failed trials in previous eras. The story of the Hero Twins can be understood as an extended explanation about the origin of the sun, the moon, and maize—the sowing and the dawning—that brought about the onset of a new era and its inhabitants, moral people who responded to the gods' demands and provided for them.

THE EARTH

How to create the earth was not among the questions the gods initially posed in the Popol Vuh. While seemingly important, this major component of creation was faultlessly accomplished by the will of the gods, without further contradiction. They commanded the earth to emerge by spelling the word *Earth.* It arose suddenly: the mountains and valleys were separated from the water, and the rivers found their course. While admirable, such uncomplicated execution of the gods' will contrasts starkly with other creational events described in the K'iche' text, which required multiple trials and involved elaborate heroic episodes. Yet a comparison with modern narratives shows that this passage is indeed compatible with Mesoamerican notions about the formation of the earth. The gist was not the creation of the earth per se, but the formation of mountains and river valleys that allowed water to drain, and dry earth to emerge.

The separation of the earth from water easily overlaps with beliefs about primeval floods that ended former creations. According to Braulio Pérez, from the Mam

community of Palestina de Los Altos in western Guatemala, the world was flat, and the hills and ravines were formed when the waters of the flood that destroyed a former people subsided. In the Q'eqchi' sun and moon myth from San Antonio, Belize, a boy was selected to become the sun after the sun of the former era had plunged several times into the sea, causing the earth to flood. It was he who requested that hills, valleys, and rivers be created instead of the dull, flat surface that existed. A modern Chamula myth, recounted by Manuel López Calixto, describes how Our Father Sun in Heaven evaporated the seas of the east and west, while the earth lords collaborated by opening paths for the rivers that drained the land. In López Calixto's version, this happened after a flood that drowned "those who lived long ago," implying the inhabitants of a previous era. In nearby Chenalhó, it was the Sun God's father who opened sinkholes with his staff, to drain the waters of the flood. Ch'orti' myths also describe a flat and muddy earth that suffered from periodic floods before God created the mountains as barriers to contain the sea. In western Mesoamerica, Huichol myths describe the primeval earth as a flatland that was covered with water until an old bat opened the valleys, allowing the water to drain.[19]

The notion of the earth as an inert element shaped by the gods at will coexists with another version, in which the earth was created from a living creature that was violently subdued and torn apart. The sixteenth-century Nahua conceived earth as a voracious being, portrayed with crocodilian or humanlike attributes. Its gender could be ambiguous, but it was frequently portrayed as a female with disheveled hair, menacing teeth, and multiple mouths in her joints. Her portraits were often associated with spurts of blood, skulls, and crossed bones. According to the Historia de los Mexicanos por sus Pinturas, the earth was formed from the body of a primordial monster called Cipactli, identified as "a big fish . . . like a caiman."[20] Another version, from the Histoire du Mechique, describes how the gods Ehecatl and Tezcatlipoca split apart the monstrous Tlalteuctli, which had multiple mouths in the eyes and joints, and bit like a savage beast. They formed the earth from its back and raised the other half to heaven. Far from consensual, this creative act was an infringement that angered other gods. To compensate the shattered beast, they adorned it with vegetation, streams of water, mountains, and caves. Still, it cried at night, craving to eat men's hearts, and yielded no fruit unless watered with human blood. Feeding it with sacrificial victims was a major duty in Mexica ritual life.[21]

The concept of a crocodilian earth was not foreign to the ancient Maya. A passage in the colonial Yucatec Book of Chilam Balam of Mani described a creature named Itzam Cab Ain, or "Iguana Earth Crocodile," that threatened to cause a great cataclysm and a flood. The god Bolon Ti Ku did not allow it, and "he cut the throat of Itzam Cab Ain and with his body formed the surface of the Peten"—a name applied to the Yucatán peninsula in colonial Yucatec texts.[22] Iconographic evidence suggests that the ancient Maya also linked the earth with crocodilian creatures. One of them was a crocodile or caiman with crossbanded eyes, often represented with humanlike hands and elongated fingers. This

creature appears in the basal section of stelae at sites such as Yaxhá and Yaxchilán, and
on the façade of the Temple of the Cross at Palenque. It is often associated with water
lilies and fish, suggesting that it was conceived as a denizen of watery places. The stone
markings that sometimes appear on the body and legs reinforce its earthly connotations.
On Copán Altar T, it adopts the characteristic pose of earth gods in Mexica art—flattened,
with the legs extended and folded on both sides of the body. It also took the appearance of
a tree, with the head and front legs in the earth, and the tail projecting upward like a trunk
with leafy branches.

While sometimes subsumed together, this creature can be distinguished from the
Starry Deer Crocodile, a celestial creature that combined crocodilian features with deer
legs and ears.[23] Instead of crossed bands, the eyes of this creature have star signs, which
also tend to appear around its head and armpits. While it may have stone markings, this
creature had a celestial character. Its body was frequently represented as a sky band, and
at Copán Temple 22 as a series of cloud scrolls populated by celestial beings. While rarely
represented together, the two cosmic crocodilians stand side by side at the base of the
Quiriguá acropolis, represented on Zoomorphs O and P. Least understood because of
its advanced deterioration, Zoomorph P shows an elaborate portrait of the Starry Deer
Crocodile (figs. 18–20).

Ancient Maya representations of the earth crocodile appear less vicious than Mexica representations of Tlalteuctli, commonly represented in aggressive stances, threatening viewers with ominous teeth and claws. Nevertheless, the modern Maya share with other peoples of Mesoamerica the notion of a devouring earth and, specifically, the belief that human beings feed the earth with their own bodies at death, to pay back for a lifetime of reaping the earth's bounty. From testimonies provided by Manuel Arias Sojom, in the Tzotzil community of Chenalhó, Guiteras Holmes concluded that the earth "relentlessly swallows back, as a monster, the beings that she produces.... She grudgingly tolerates man's living on her surface, and allows him to prey on her creatures. She takes advantage of any opportunity to drag man's ch'ulel [soul] in to her recesses. When she is offended by the stench of human excrement, she will sicken man and prevent his recovery. She resents procreation."[24] The belief in a devouring earth is central to Mesoamerican concepts about humanity and the relationship of people with the earth and the gods, and will be further explored later in this chapter.

THE ERAS

There is a debate about whether the ancient Maya shared with other Mesoamerican peoples the belief in successive eras that ended catastrophically, before the present world began. Victoria and Harvey Bricker argued that such beliefs resulted from highland Mexican influence during the Postclassic period, a view that implies sharp distinctions in the cosmogonic beliefs of Mesoamerican peoples before the end of the Classic. Yet the dearth of explicit references to floods in the hieroglyphic texts more likely reflects their restricted range of subjects, rather than the absence of such beliefs among the Classic and Preclassic Maya. A flood episode described in the hieroglyphic tablet of Palenque Temple XIX suggests that beliefs in ancient, catastrophic destructions were indeed present in Classic Maya cosmology.[25] Modern myths from the Maya area and elsewhere abound in stories about floods that destroyed former peoples, although not all of them describe series of successive destructions.

Sixteenth-century texts from highland Guatemala, central Mexico, and Oaxaca contain accounts about the previous eras. The Mixtec codices refer to a former people who turned into stone when the sun first rose. Nahua sources described a succession of eras and provided details about the god who became the sun in each, their inhabitants, and their eventual demise.[26] There is no hint that the K'iche' account contained in the Popol Vuh derived from those versions. Unlike the Mixtec version, it did not describe direct confrontations between the people of former eras and the ancestors of the K'iche' kings. Unlike the Nahua versions, it paid no attention to the sun of each former era. Modern myths provide further comparisons, and, in fact, the most abundant and elaborate descriptions about former eras do not come from highland Mexico, but from modern Maya communities. Myths that describe sequences of three or four eras have been recorded among

the modern Yucatec, Lacandon, Tzotzil, Tz'utujil, and Mam.[27] Like the Popol Vuh, they do not reiterate sixteenth-century Nahua myths, casting doubt on their supposed derivation from Postclassic highland Mexican influence.

Modern myths often affirm that the inhabitants of previous eras lived in darkness, and highlight the rise of the present sun as the critical juncture that resulted in the establishment of a proper moral order. In a Tzeltal version from Chenalhó, the sun of a former era was Lusibel—adapted from a Christian name of the devil. He did not provide enough heat to dry the ground, and men could not burn their cleared fields in preparation for planting. A new sun took his place—the K'ox, a child hero who is often conflated with Jesus Christ. Throughout Mesoamerica, the sun is often identified with Jesus, whose ordeal and sacrifice, generally at great variance with biblical versions, explained the beginning of a new era and the demise of the immoral beings who had lived before.[28]

A Tz'utujil version, recorded by Nathaniel Tarn and Martin Prechtel from an officer in the religious hierarchy of Santiago Atitlán, described four eras and three suns. The first era had no sun, but only God the Father, "who was the world." He died and split into a male sun and a female moon. In the second creation, the first sun and the first moon had three sons and two daughters. At this point, the narrator commented, "You know the story of how the first two children kill their grandmother by shoving her in the sweat bath and then they become the sun and Venus." The comment hinted at a long mythical passage, summarized all too briefly in this version. The narrator added that the third brother became the lord of the hills. The sisters became the moon and the moon's star. Then the second sun conquered the first. With María, he fathered Jesus Christ—also known as Manuel—who is the sun of the present era. He is the one "who fights the enemies left over from the previous creation . . . who makes the world we live in out of the bones, which are rocks, of the previous sun . . . who brings us the corn . . . who makes the Fourth World which is this one of ours."[29]

The Tz'utujil account condensed significant episodes of Mesoamerican cosmogony. The grandmother's death during the second sun recalls widespread myths that opposed the young sun or maize hero against the old woman who raised him as an orphan. Versions of this confrontation appear in the Popol Vuh and in numerous narratives about the sun and moon heroes and the maize hero throughout Mesoamerica. The account of the third sun summarized a Mesoamerican version of the story of Jesus Christ, which culminated with his crucifixion (sometimes associated with the creation of useful plants from his body or blood), his ascent as the sun, and his concomitant victory over the evil beings who inhabited the previous creation.[30]

Unlike the Tz'utujil myth—which offers no details about those who lived under the previous suns—most Maya narratives pay special attention to former peoples, generally considered unfit and morally corrupt, and sometimes described as cannibals or sorcerers. They are seldom regarded as forebears of the present people. Some stories describe their

transformation into monkeys, and they are also identified with ghastly beings and spirits that still inhabit wild places.

According to Braulio Pérez's Mam narrative, the first people ate their own children. Displeased, the gods emptied the seawaters on them. The second people were the *chimanes* and the *ajka*—priests, diviners, and sorcerers—who instituted curative arts, religious rituals, and carved cult statues. But they were too powerful and began killing each other. God first curtailed their powers and finally killed them with burning turpentine. Knowing that their end was coming, they made large jars to hide themselves under the earth. After the turpentine, the world was flooded by rain for forty days and forty nights. Only two children were able to hide from the turpentine rain, and God saved them from the flood inside a box that floated. Chamula myths from highland Chiapas reiterate the former peoples' cannibalistic tastes and their destruction by ardent rains, which boiled them just as they used to boil and eat their children. Some hid in caves, but the caves collapsed upon them.[31]

Floods were the main cause of destruction in Tzotzil and Yucatec myths. In a Tzotzil account from San Andrés Larraínzar, successive floods—one of water, and the other of boiling water—killed the people of two former worlds, who displeased the gods because they would not die. In a Maya version from Izamal, it was the former sun who caused the flood. Tired of wearing his crown, he took a dip in the ocean; the water rose and caused a flood. The same argument appears in Eric Thompson's version of the Q'eqchi' sun and moon myth, which begins by explaining that the sun was tired of wearing his crown and took a plunge in the sea, causing a deluge that drowned many people and left the world dark and flooded. He resumed his duties, but would once again cause a deluge after seven years. They selected a substitute—a young orphan boy who lived with his grandmother—and the bulk of the story explains how he finally reached his destiny in heaven.[32]

In comparison with modern myths, the Popol Vuh seems dissimilar at first glance. There is no mention of previous suns, and the narrative concentrates on the creatures that were created in succession—animals, mud people, and wooden people—only to be destroyed because of their failure to recognize and praise the gods.[33] Nevertheless, the Popol Vuh and the modern Q'eqchi' and Tz'utujil myths share a similar structure. After rather brief accounts of the former eras, they delve extensively into the advent of the present era, explained in terms of the deeds of the heroes who overcame the beings who prevailed in former eras, and ultimately rose as the sun and the moon. The modern myths share with the Popol Vuh variants of the solar hero's confrontation with the old lady who raised him, as part of the explanation about his rise as luminary, although the Tz'utujil account added a final section—in fact, an additional sun—corresponding to Jesus Christ. More broadly, the sixteenth-century K'iche' version shares with modern accounts its attention to the faults of earlier peoples, who offended or slighted the gods in various ways, bringing about their own demise.

THE SURVIVORS OF THE FLOOD

In the Popol Vuh, the gods sent a flood to destroy the wooden people of the third creation, who were able to speak and reproduce, but were senseless and failed to recognize their creators. The text initially appears to imply a flood of water, but it soon describes resin that came down from the sky, recalling the destruction of an earlier creation by fire in sixteenth-century Nahua myths, the burning turpentine of the Mam myth (also combined with a flood of water), and the boiling rains of the Chamula myth. In addition, the wooden people of the Popol Vuh were attacked by their domestic animals, and their daily implements revolted against them—a cataclysmic episode that reappears in Mesoamerican and Andean myths, and is still present in modern Chamula origin stories.[34]

Not surprisingly, modern flood myths intertwine with biblical flood passages, although they are essentially at odds with them. Generally, the supreme gods did not instruct survivors about the incoming flood; it was someone else—another god, an animal, or an unidentified man—who warned them about the disaster. In most stories, the survivors did not generate humanity; as soon as the waters subsided, they offended the gods and were punished by suffering a hideous transformation.

According to a Ch'orti' story from eastern Guatemala, the sea rose every fifty or one hundred years, cleaning the world and killing all people. There was a man called Noén; another man told him, "Prepare your harp, but a large harp, which is [like] a large box, because rain will start, twenty days of rain and twenty to recede." The hero has a biblical name, the "harp" is a cognate of the biblical ark (the Spanish words *harpa* and *arca* are phonetically close), and the duration relates to the forty days of the biblical flood. However, the rest of the story departs significantly from Christian versions. When the harp finally rested on earth, Noén found lots of dead fish on the ground and told his wife to cook them. The smoke alerted God, who until then was unaware that someone had survived. In punishment for pretending to survive of his own will, God killed Noén. However, another Ch'orti' version describes how God took the survivors' entrails and stuffed them in their bottoms as tails. They became monkeys.[35]

Divine punishment for lighting fire and cooking fish—and sometimes other dead animals—is a deeply engrained motif in Mesoamerican flood stories, as shown in Fernando Horcasitas's detailed survey of Mesoamerican flood narratives. The earliest known testimony, from the Legend of the Suns, tells how Tezcatlipoca instructed a couple to save themselves in a hollowed giant cypress (*ahuehuetl*) and advised them to eat only one maize kernel each. When they finally came out, they drilled fire and cooked a fish. The celestial gods, Citlalinicue and Citlalatonac, asked who was smoking the skies. Angered, Tezcatlipoca cut off the survivors' heads and stuck them on their rumps, turning them into dogs.[36] Modern versions from the Purépecha, Teenek, Totonac, Tepehua, Mazahua, Popoluca, and Nahua of northern Veracruz reiterate this theme in similar ways. In the Maya area, they are documented in Ch'orti', Ch'ol, and Tzeltal communities.[37] Invariably, the survivors were punished and became dogs, monkeys, or other animals.

Horcasitas distinguished a group of flood myths that had a different outcome. The survivor took with him a female dog. After the flood, he started working in the fields, while the bitch remained home. Wondering who cooked for him every day, the man spied on her and realized that after he left, she took her skin off, turned into a woman, and prepared food. One day he stole her skin or rubbed salt on it, so that she could not wear it anymore. The dog retained her womanly shape and became his wife. Numerous versions of this story are spread from northern Mexico to the Gulf Coast and Oaxaca. In the Maya area, it has been attested in Ch'ol and Tzotzil communities of Chiapas. To illustrate the broad geographic expanse of this version of the myth, Horcasitas cited a sixteenth-century version from Quito, Ecuador, in which two macaw women took off their mantles and cooked for two brothers who were saved after the flood. One day, the younger brother managed to catch one of the macaws, who became his wife.[38]

THE FORMER PEOPLES

A preoccupation with the fate of the peoples of earlier eras is constant in Mesoamerican cosmology. Like inverse images, earlier peoples lacked the basic moral qualities that distinguish people from animals or other kinds of beings, and they subverted social and aesthetic norms. Essentially, they were unfit to live under the sun of the present era. Mythical narratives describe how former peoples were unable to stand sunlight and were destroyed or transformed by its radiance. They burned or turned to stone, as reported in such varied places as the Q'anjob'al and Mam towns of Santa Eulalia and San Miguel Acatán, Guatemala, and the Mazatec community of Jalapa de Díaz, Oaxaca. Their transformation into stone recalls the stone people of a former era in the sixteenth-century Mixtec codices. People of former eras are often thought to have survived beneath the earth or hidden in wild places, and they are commonly associated with archaeological sites. Widely distant accounts from Tzeltal and Totonac communities assert that they still suffer from the heat of the sun.[39]

A Ch'orti' myth—quoted at the beginning of this chapter—described what happened when the sun first rose. The people who lived at that time were scared and tried to bring the sun down with shotguns and cannon fire, but failed. They were unable to stand sunlight, which blinded and burned them. The intense heat blackened their feet. Many died, but some took refuge in rock crevices, tree roots, and caves. Their descendants lived in the wilderness. They were black people who came out at night to catch people along the roads, carry them inside their caves, and eat them. Equally repulsive are the *tiumi,* who lived before the sun was born, according to the Mixtec of Nuyoo. They lived in the wilds and hunted under the dim light of the moon. They mated freely, like dogs that "did not recognize their mothers or fathers." When the sun rose they died of fright, and some hid in caves. Yet some think that the survivors were the ancestors of modern people.[40]

Anath Ariel de Vidas documented the same belief in the Teenek community of Tantoyuca, in northern Veracruz. People described the *aatslaabtsik,* "venerated ancestors" who lived in complete darkness before the sun came out. They were short and did not eat or defecate, but consumed only the smell of food. Fearing that they would burn when the sun came out, they plunged into the earth, in an attempt to hide from the sunlight, and formed the mountains. However, not everyone hid. The Teenek descend from those who stayed and were baptized—an indication that the sunrise is equated with the advent of Christianity. The ones who hid themselves are the *baatsiik,* who still live under the earth. They used to steal things and even people until the patron saint defeated them, but they can still carry off the souls of people. They are spirits of the earth, and they resent the fact that people fill the earth with excrement. They can be appeased with liquor and prayers, letting them know that human life is ephemeral, and that people will die soon and stop bothering them. The Teenek identify the aatslaabtsik as the builders of the ancient pyramids found at archaeological sites.[41]

The people of a former era are also believed to have built the ruins that dot the Yucatec landscape. They are often identified as dwarves and sometimes as *aluxes*—small, mischievous beings that are still believed to inhabit the bushes and archaeological sites. According to a version gathered by Alfred M. Tozzer at the turn of the twentieth century, they lived in darkness and turned to stone when the sun came out. Their petrified images can still be seen in the ruins.[42] Traditionally, the modern Yucatec Maya do not regard themselves as these beings' descendants, as shown in a version by Virgilio Canul. He contrasted modern people—civilized, well-dressed, well-fed, and obedient, among other things—with the "first race," the Aluxes, who built the ruins in the first era and died in the flood, and with the "second race," the "Indians," bad people who lived in the woods and went around naked. The latter deserved no respect and were exterminated by the Spaniards. According to Manuel Gutiérrez Estévez, the modern Yucatec do not regard themselves as descendants of "the Maya," the former people who built the archaeological sites; powerful sorcerers, the Maya were finally destroyed by the flood. Rather, the current people consider themselves "Mayeros," essentially contrasting with the former "Maya." The distinction reflects the complexities of modern ethnicity in Yucatán, while echoing widespread Mesoamerican notions about the people of earlier eras.[43]

"Time past and distant space meet" in Mesoamerican thought, as Duncan M. Earle noted for the modern K'iche'.[44] Socially or geographically distant peoples—sometimes including foreigners—are often identified with the inhabitants of previous eras. After providing much detail about the behavior of the "people who ate people," the narrator of the Ch'orti' myth recalled that they still live in a mountain called Lacandon. Men and women have long hair; they go around naked, cannot resist strong noises, and abhor sunlight. From the perspective of highland Maya peoples, the Lacandon—the historical inhabitants of small communities in the jungle lowlands of Petén and northeastern Chiapas—embody the qualities of the people of a previous era, who rejected sunlight.

They are portrayed as such in traditional dances and carnivals in highland Chiapas and Guatemala, where they share the stage with monkeys, Jews, devils, and other characters that oppose the sun and Christ, and belong with the forces of darkness and chaos. They subvert the normal patterns of human social life and are feared as savage warriors and cannibals. Stories from Santa Eulalia reiterate their wild habits and appearance, as well as their practice of witchcraft and cannibalism. They lived in the jungle, "like animals," and stole children in order to eat them. They burned when the sun rose, although narrators also remember wars fought against them, perhaps reminiscences of colonial period *entradas* to their lowland territory.[45]

Some historical basis is also present in Q'eqchi' stories about the *ch'ol wiinq*, conceived in much the same way as the Lacandon—as wild inhabitants of the forests. Historically, the term, meaning "Ch'ol people," designated speakers of Ch'ol languages who lived in lowland regions of northern Verapaz and southern Petén. They dwindled to the verge of extinction in colonial times, while some were incorporated into Q'eqchi' communities.[46] This fact is not relevant to modern Q'eqchi' narratives, where they are portrayed as alien people, cannibals who walk around naked in the jungle. The ch'ol wiinq are the people of the past, identified with the builders of archaeological sites. They are believed to have transforming powers and to possess rich cacao orchards deep in their jungle villages or inside their caves. They are also associated with the gods of the earth, generally regarded as owners of great wealth. Importantly, they are not Christian, and are therefore antisocial beings that fall outside the traditional Q'eqchi' definition of personhood.[47] While the available narratives do not describe them as people of a former era, they belong together with the Lacandon as people who lived in darkness and rejected the rise of the sun.

The moral shortcomings of an earlier people may explain a cosmic debacle described in the colonial Yucatec Books of Chilam Balam. The people in question are called Ah Mucen Cab. According to parallel passages of the Books of Chilam Balam of Chumayel, Tizimin, and Mani, they were somehow involved in a confrontation between the gods Oxlahun Ti Ku and Bolon Ti Ku, during Katun 11 Ajaw. In the Maya calendar, the term *katun* designated a period of twenty *haab'*—"vague years" of 360 days—totaling 7,200 days, or about 19.7 solar years. In Timothy Knowlton's translation of the Book of Chilam Balam of Chumayel: "On the Peten / during the katun Eleven Ahau / when the Ah Mucen Cab emerged / Oxlahun Ti Ku blindfolds them / Neither his older sister nor his children knew his name any longer / They spoke to him / but his face was not revealed to them either / So when it finished dawning / they knew not that it would come to pass / that Oxlahun Ti Ku was caught by Bolon Ti Ku."[48]

While generally regarded as instigators and active participants in an episode of world destruction, this translation suggests a different role for the Ah Mucen Cab. Blinded by Oxlahun Ti Ku, the Ah Mucen Cab were seemingly unable to know the god's name or his face, nor were they able to realize that dawn was approaching. While the phrasing

is ambiguous, the failure to recognize older sisters or children hints at incestuous behavior. A later passage described Oxlahun Ti Ku as a sinful ruler, displaying ribald and insolent speech and unclean eating habits. In Ralph Roys's translation, "Forgotten is his father, forgotten is his mother, nor does his mother know her offspring.... He shall walk abroad giving the appearance of one drunk, without understanding.... He does not know in what manner his end is to come."[49]

These are the kinds of moral shortcomings that are generally attributed to the people of earlier eras in Mesoamerican myths, which explain their catastrophic demise. The Chilam Balam narratives continue, describing calamities that included rains of fire, ropes, stone, and wood, the stealing or hiding of maize and other edible seeds, and a flood. Presumably, these events brought about the demise of the Ah Mucen Cab. The narratives contain no explicit statement about their identity, but their name may contain a hint. The colonial spelling is potentially ambiguous, because the medial *c* may correspond to the *k* or *z* sounds. Roys related the name to modern bee gods called Ah Muzencab. However, Erik Velásquez transliterated it as *Ajmuken Kab'* ("He Who Is Buried under the Earth").[50] While Velásquez still regarded them as the ones who caused the deluge, his translation of the name supports the idea that they were its victims instead. They may have shared the fate of the hideous peoples of an earlier era in Mesoamerican myths, who went hiding under the earth when the sun first rose.

The Chumayel version of the Katun 11 Ajaw myth concluded by describing the coming of Jesus Christ. As Knowlton noted, the colonial scribes regarded this as the culmination of their account of the end of a former era. Modern narratives also identify the advent of Christianity with the sunrise of a new era, and non-Christians with the peoples of previous eras. However, notions about earlier creatures that rejected sunlight did not originate with Christianization in the sixteenth century. They derived from ancient Mesoamerican beliefs about the fate of former peoples.

The Popol Vuh described the sunrise as a portent that made both people and animals glad. No one tried to oppose it, much less to bring it down. However, the text mentioned that the heat could not be endured, and that a character named Zaqui Coxol went hiding under the trees, taking with him the puma, the jaguar, the rattlesnake, and the pit viper, all of which turned into stone: "Perhaps it wouldn't even be our day today, if the original animals hadn't been turned to stone by the sun when he came up."[51] The modern K'iche' regard Zaqui Coxol as a mischievous spirit who lives in the mountains, owns riches, and is also associated with ancient artifacts, which are believed to have petrified when the sun rose.

The same fate awaited the patron gods whom the K'iche' ancestors received at Tulan. Before the sun came out, they asked their bearers to hide them deep in the forests, where they could not be found. They turned to stone when the sun rose.[52] The myth marked a dichotomy between the sun and the displaced gods, who became distinctly associated with specific mountains in the Guatemalan Highlands and took a definite role

as earth gods. However, the assimilation of the gods with the creatures of darkness that inhabited previous eras, and that were unable to stand sunlight, is not easily explained.

There is an important parallel in sixteenth-century Nahua myths, which in a sense subverted Mesoamerican beliefs about the people of earlier eras. The gods did not hide from the radiance of the sun, but instead, it was the sun who required the blood and vigor of all the other gods and refused to move unless they died. They finally acquiesced and were sacrificed. In fact, they themselves preferred to die, rather than keep living among people, as hinted at by their remarks in the Florentine Codex. Realizing that the sun would not move unless they died, they asked, "How shall we live? The sun cannot move. Shall we perchance live among common folk?"[53] Their death definitely distanced them from the people who would live under the sun. According to the Legend of the Suns, Tlahuizcalpanteuctli—a Venus god—shot his arrows at the sun to make it move. While the purpose was different, his actions were akin to those of the former people who tried to bring the sun down with gunfire in Ch'orti' myths. The Legend adds that "this Tlahuizcalpanteuctli is the frost," an appropriate ascription for an opponent of the sun.[54]

The Nahua myth is broadly understood as a model for human sacrifices that were justified by the need to provide sustenance for the sun. The Popol Vuh offered no such reasons for the gods' petrification, although later sections explained that human sacrifices began in order to provide food for the gods who were hidden in the mountains. However, the K'iche' and Nahua myths coincide in portraying the gods as akin to the inhabitants of an earlier era, who abhorred and, according to some accounts, opposed sunlight. A key to the significance of this paradox comes from Gossen's observations about modern Chamula deities.[55] From a Chamula perspective, Ladinos—people of Hispanic culture and language who live outside indigenous communities—belong to the fringes of society. In the Chamula carnival, they appear together with the Lacandon, the monkeys, the Mexicans, and the Guatemalans, all conceived as sinful peoples who lived in an earlier era, before the sun established the Chamula moral order. Yet Christ and Mary—identified with the sun and the moon—together with the saints who live in the church are represented by white-skinned images and are acknowledged as Ladinos. Likewise, the earth lord is conceived as a wealthy and authoritarian Ladino landowner, living in a cave full of riches, always disposed to capture and enslave people's souls. The Chamula gods are thus equated with the people of an earlier era, akin to the K'iche' and Mexica gods who died or turned to stone when the sun came out.

For students of ancient Maya religion, the question is whether the gods—or some of them—were similarly equated with the inhabitants of a former era who died or turned to stone when the sun rose. Intriguingly, there is evidence that ancient Maya temples were often equated with mountains. The iconography of temples' façades frequently contains mountain imagery, and the inner rooms were equated with caves, with the doorways sometimes representing the open mouths of fantastic earthly beings. Caves are associated with Maya temples and ritual compounds, to the point that their location was sometimes

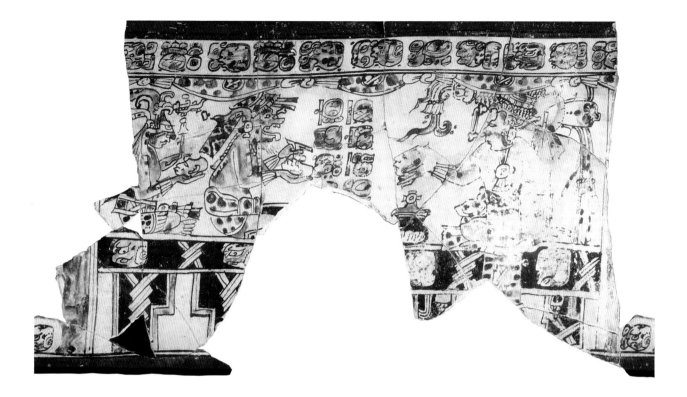

FIGURE 21
Rollout photograph of Vase K8457,
Late Classic, lowland Maya area.
Present location unknown. The
hieroglyphic text refers to the
shaping of the first people.

determined by the presence of caves, and, in some cases, artificial caves were dug when natural ones were not available.[56] The ancient Maya gods were believed to inhabit the inner spaces of these mountains, whether natural or symbolic, and in that sense, they come close to the K'iche' gods, who were hidden in mountainous recesses and turned to stone when the sun rose.

THE PROVIDERS

In sixteenth-century myths from highland Guatemala, the first men and women were created from ground maize—mixed with the blood of a tapir-serpent brought from the ocean, according to the Memorial de Sololá.[57] While compelling, this explanation is not attested elsewhere in Maya narratives. According to a seventeenth-century version from Yucatán, the bones and flesh of the first man were made of mud and the hair of grass. Dmitri Beliaev and Albert Davletshin compared this version with passages from modern Tzotzil, Q'eqchi', and Lacandon myths, which recount how the first people were modeled from clay. They suggested links with representations in a group of Classic Maya vases that show gods using delicate instruments to shape or paint human heads or masks that they hold in their hands (fig. 21). The texts describe their activity with variations of the transitive verbal root *pak'*, whose range of meanings includes the actions of constructing, shaping by hand, painting, and planting. The object of the verb is *wak yax winik*, "first six men / people." Beliaev and Davletshin suggested that these vases

portray a Classic Maya version of the creation of the first men, who were modeled by the gods from clay.[58]

In the Popol Vuh, the creation of the first people was the answer to the question posed by the creator gods at the beginning: "Who is to be the provider (*tzuqul*), nurturer (*q'o'l*)?" Christenson explained the sense of their words as follows: "Tzuqul is a provider of any kind, although generally in the sense of food." He further added: "Q'o'l is one who provides sustenance, primarily in the form of nourishment, but also nurtures in any other way, such as a mother caring for an infant."[59] The role of human beings was thus established at the outset; their task would be to provide nourishment for the gods.

In Mesoamerican religion, the gods require sustenance, which human beings provide through properly conducted prayers, offerings, and sacrifices. Michel Graulich and Guilhem Olivier distinguished various forms of divine nourishment that include prayer, song, music, and other forms of veneration—hence the gods' endeavors in the Popol Vuh to create creatures that would provide them with praise and worship. The gods also consume normal food, although they are believed to take only its essence, represented by the vapors and smells of freshly prepared food, the aroma of flowers, and the smoke of resins. An especially important form of nourishment is copal incense. In an early eighteenth-century report about K'iche' religion from the coastal region of Suchitepéquez, the Franciscan Antonio Margil de Jesús complained that the Indians had a pact to provide food for the devil, who appeared and communicated with them, "receiving the smoke of copal with a thousand gestures of mouth, nose, and other body parts."[60]

A further source of divine nourishment consisted of the blood and the bodies of humans and animals. People shed their own blood in painful rituals of self-sacrifice. The royal performance of bloodletting rituals is an important theme in ancient Maya art. Severed phalanges found in archaeological deposits suggest that on occasion, people also presented the gods with solid body parts, although it is hard to tell whether they represent the remains of self-sacrifice or not.[61]

According to the Popol Vuh, the blood from self-sacrifice was the first kind of offering the gods required from the first four men, the ancestors of the K'iche': "It remains for you to give thanks, since you have yet to take care of bleeding your ears, yet to take stitches in your elbows. You must worship. This is your way of giving thanks before your god."[62] Tedlock noted a word play in this passage, involving the terms *xikin* ("ears") and *ch'uk* ("elbows"), which pun on the words for "birds" and "breechcloths" and allude to genital bloodletting. Exemplary in their performance of self-sacrifice, the K'iche' progenitors received the epithets *aj k'ixb', aj k'ajb'* ("penitents, sacrificers") in the Popol Vuh.[63] At a later stage, the gods begged for animal sacrifices: "Give the creatures of the grasses and grains to us, such as the female deer and female birds. Please come give us a little of their blood, take pity on us." When the gods drank the blood that the K'iche' progenitors poured into their mouths, they spoke and their appearance changed. Rather than stones, they looked like boys who rejoiced over the blood. Finally, the gods demanded human victims.[64]

Graulich and Olivier noted that the Mexica gods were sometimes likened to children who needed to be nurtured by their mothers. In the Popol Vuh, this metaphor became evident in the episodes where the gods requested human victims. At the beginning of their migrations, the members of the *amaq'* ("the nations")—rivals of the K'iche' in their contest for supremacy in highland Guatemala—agreed to "embrace" the K'iche' gods and to let them "suckle" in exchange for fire. Tedlock and Christenson noted the double entendre implied by the term *tu'nik* ("to give breast," "to suckle," "to nurture"), which implied that the people of the amaq' would nurture the gods like babies from their mothers' breasts. The authors of the Popol Vuh explained what the gods meant: "that all the tribes [amaq'] be cut open before him, and that their hearts be removed 'through their sides, under their arms.'"[65] In the rhetoric of the Popol Vuh, the amaq' entered into a primordial obligation toward the gods, which they could only pay by offering themselves in sacrifice.

Similar concepts reappear throughout Mesoamerica. The sixteenth-century Nahua used the word *nextlahualtin* in reference to blood sacrifice and sacrificial victims. In Alonso de Molina's sixteenth-century Nahuatl dictionary, the term is glossed as "blood sacrifice that they offered to the idols, cutting themselves or piercing a part of the body." Alfredo López Austin translated it as "the payments" and noted that it designated a class of sacrificial victims. He explained, "Man, dependent on divine gifts, must restore vigor to his benefactors by surrendering energy from the different components of his own organism."[66] In a thorough revision, Ulrich Köhler questioned whether modern scholars—perhaps misled by the Christian concept of original sin—misinterpreted the term to imply that men were permanently indebted to the gods. Despite his critique, there are many indications that Mesoamerican peoples traced the origins of sacrifice to primeval covenants with the gods.[67]

The ethnography of modern Mesoamerican communities reveals the widespread belief that human beings have an obligation to provide food for the earth, ultimately with their own bodies. This was the result of a primordial contract, according to a K'iche' narrative from Cubulco. The earth was hurt when the ancestors first cultivated it. The weeds and the trees cried when people tried to pull them out. They asked God to intervene and finally reached a settlement. The earth agreed to endure cultivation and provide food for humans, only after God promised that men would feed the earth in turn: "When a child of mine dies, it's your meat." The narrator added, "We place our fines because we aren't the only ones that eat, says the holy earth. The holy earth is waiting for his food, too—chocolate, wine, liquor, beer are what he asks for."[68]

Variant versions have been documented among the Ch'orti' and Chuj of Guatemala, the Nahua of northern Puebla, and the Mixtec of Oaxaca. In a Ch'orti' myth, the earth took the appearance of an old woman who came at night to raise the trees that Adam—the first man—had felled during the day to plant a cornfield. When he protested, the old woman asked who had given him permission to tear down her clothes—that is, the trees. Adam finally agreed to give her his body upon death. Meanwhile, the earth must be

ritually "paid" with offerings during people's lifetimes. Otherwise, she produces little.[69] Traditionally, the Ch'orti' make "payments to the holy earth" before planting. The blood and bodies of sacrificed turkeys and chickens, *chilate* (a beverage prepared with ground roasted maize and cacao), cigarettes, and copal incense are deposited in a cavity dug in the cornfield. According to Rafael Girard, similar rituals were carried out in community temples that were conceived as akin to cornfields. Payments are also made to water-bringing gods, to ensure the much-needed rains.[70]

These myths have profound implications related to concepts about the human condition and the relationship of people with the earth, which involves constant exchanges of food. During their lifetime, men and women sustain themselves from the earth's bounty, acquiring the obligation to feed the earth in turn. From his ethnographic observations in the K'iche' town of Chinique, Earle concluded that rather than "original sin," people were born with "original debt."[71]

John Monaghan regarded the myth as a guiding principle in the religious and social life of the modern Mixtec community of Nuyoo. People conceive themselves as forming part of a single household with the earth, which provides sustenance for them just as parents do with their children. In return, they feed the earth their own bodies upon death. Rather than a form of reciprocity, Monaghan characterized the relation as based on covenants that involved "a bestowal of grace or a great promise," in addition to mutual obligations.[72] Acknowledgement of the covenants is an essential feature that distinguishes moral people, both from outsiders—who do not acknowledge their indebtedness to the earth—and from the wicked, less-than-human beings who lived in former eras.

If not provided with adequate food, the gods may react viciously. When they build a house, the Zinacantec offer sacrificed chickens to the lord of the earth, who allowed them the space and the materials for the new building. Otherwise, he might capture the soul of the residents or cause the house to tremble. The fowls substitute for the residents, and their blood and remains are ritually buried in a "tomb" dug in the center of the house. Likewise, the Mixtec of Nuyoo consider sacrificial items—pulque, incense, flowers, candles—as food for the gods and as proxies for their own bodies.[73]

THE ORIGIN OF WARFARE

In ancient Mesoamerican myths, the creation of human beings was inextricably linked to the origin of warfare, which provided the essential way to obtain the victims who would nourish the gods. In other words, it was through warfare that human beings were able to fulfill their essential role as providers. According to the Popol Vuh and the Título de Totonicapán, the K'iche' progenitors abducted the people of the amaq' along roads, making it appear as if they had been eaten by jaguars. They did this to acquire the sacrificial victims demanded by the gods. This was the beginning of the wars that eventually

led them to triumph against their more numerous and well-established foes. Graulich regarded this passage as analogous to central Mexican myths that explained the origin of warfare as a means to provide sustenance for the sun.[74]

The Memorial de Solalá makes an especially strong assertion about the nature and purpose of people: "Then the Obsidian Stone (*Chay Ab'äj*) is birthed by Raxa Xib'alb'ay [and] Q'ana Xib'alb'ay. Then people were created by the Maker, the Modeler, [they were] the sustenance providers for the Obsidian Stone."[75] The Kaqchikel term *chay* and its cognates in other Maya languages refer to obsidian or flint. Strictly, in the sense conveyed in this passage, it refers to a sacrificial knife, as suggested by a gloss for *chay* in Domingo de Basseta's colonial K'iche' dictionary: "flint blade with which they killed men before their idols."[76] The creation of sacrificial knives played counterpoint to the creation of people, acting as complementary aspects of each other. In the rhetoric of the Memorial, men were understood from the beginning as the providers of sustenance for the sacrificial knife. In a succeeding passage, the Kaqchikel ancestors were characterized as "warriors" (*aj lab'al*), who were given arrows and shields and put in charge of the Ch'ay Ab'äj, the sacrificial knife: "This is your burden; this you must nourish, you must sustain. It is called the Obsidian Stone."[77]

The Memorial de Solalá referred specifically to the Kaqchikel ancestors, the writers' forebears, who were portrayed in the document as chosen people who duly fulfilled the gods' desires. However, it also echoed the broader notion that people were created to provide sustenance for the gods, in the form of sacrificial victims. By implication, they were created for warfare, which provided a way to ensure the supply of victims. The connection was plainly stated in the Historia de los Mexicanos por sus Pinturas: "[The gods] said that because the earth had no clarity and was dark . . . they should make a sun to illuminate the earth, and let him eat hearts and drink blood, and for that they should make warfare, in which could be obtained hearts and blood."[78]

Nahua texts provide a mythical precedent for human warfare in the story of the four hundred Mimixcoa, or four hundred Chichimecs. As explained in the Legend of the Suns, the sun himself admonished them in terms that recall the instructions given to the Kaqchikel ancestors in the Memorial de Solalá: "And then the sun commands the four hundred Mixcoa, he gives them darts and says to them: 'Here is how you will give me a drink, how you will serve me'—also a shield. . . . And the one who is your mother is Tlalteuctli." They were thus instructed to wage war to feed the sun and the earth, but unlike the Kaqchikel progenitors, the Mimixcoa disobeyed. They played, hunted birds, and failed to provide for the gods. They slept with women and got drunk. The sun then commanded five more Mimixcoa to destroy them: "And then they conquered, destroyed them, and served the sun and gave it a drink."[79]

The Popol Vuh contains a close parallel to the Mexica myth, in the story of the four hundred boys who were killed by Zipacna, an ungracious character who was strong

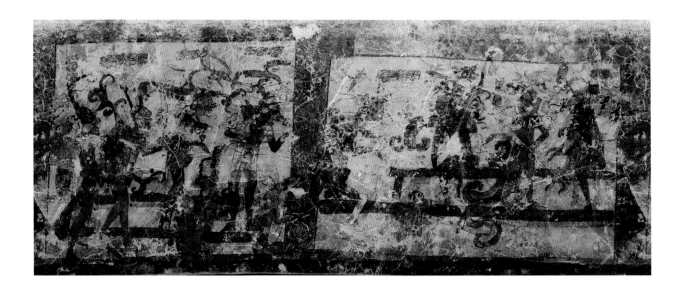

enough to move the mountains on his back. After Zipacna carried by himself a large post
they were hauling for their house, the boys were scared and plotted to kill him. Realizing
their deceit, Zipacna faked his death, while the four hundred boys prepared pulque to
celebrate their victory. Zipacna then killed the drunken boys, bringing the house down
on them. He was eventually defeated by the Hero Twins, who enticed him to grab a fake
crab at the bottom of a canyon, and then threw a mountain down on him.[80] When the
heroes rose to the sky as the sun and the moon, the four hundred boys joined them as
the stars.

The story of Zipacna merged two themes that were differentiated in Nahua myths:
the origin of the earth, and the origin of warfare. The character's name was related
to Cipactli, a Nahua name of the earth monster. His final destiny, buried under a moun-
tain, suggests an earthly identity, even though the Popol Vuh did not imply that the earth
was formed from his body. His confrontation with the four hundred boys paralleled
Nahua myths about the primeval war against the four hundred Mimixcoa. In addition to
their large numbers, the four hundred boys shared the Mimixcoa's drunkenness, which
led to their condemnation and defeat. Eduard Seler noted that the Mimixcoa were repre-
sented in sixteenth-century codices as stars, recalling the final destiny of the four hundred
boys in the Popol Vuh, although the K'iche' document made no direct reference to their
role as the first war victims who provided sustenance for the sun.[81]

Despite the variations, these passages reveal points of congruence between six-
teenth-century K'iche' and Nahua beliefs about the origin of warfare. Iconographic evi-
dence suggests that related beliefs also circulated in the ancient Maya Lowlands. Stars and
stellar beings are associated with warfare in Classic Maya art, notably in the Bonampak
mural paintings, where the constellations preside over the presentation of war captives
before a triumphant lord. Key evidence is provided by the Vase of the Stars, a Late Classic
painted vase that portrays a host of stellar beings, some of which are presented as captives

before three enthroned gods (fig. 22). Apparently leading a group of victorious stellar warriors is the Jaguar War God (also known as the Jaguar God of the Underworld), the Classic Maya patron of warfare. As I have suggested in previous publications, the vase was probably related to an ancient version of a Mesoamerican myth that explained the origin of warfare in terms of a primeval confrontation among the stars.[82]

CREATION MYTHS AT PALENQUE

The origin of warfare was also commemorated on the Palenque sculptures, which contain the most detailed extant records of Classic Maya cosmogony. Many students have analyzed the multiple layers of religious and dynastic meaning of these carvings.[83] This brief overview highlights the iconographic themes related to the origin of the sun, the origin of warfare, and the origin of maize, represented in the Group of the Cross tablets (figs. 23–27). The rhetoric of the tablets links these events with the origins of the Palenque ruling dynasty and its patrons, a trinity of gods whom Heinrich Berlin dubbed as "the Palenque Triad." The hieroglyphic texts commemorated the birth of the Triad Gods, which occurred in primeval times, near the beginning of the Long Count calendar.[84]

According to David Stuart and George Stuart's recent analysis, each of the tablets in the inner sanctuaries of the temples of the Cross, the Sun, and the Foliated Cross centered on an overarching theme, expressed through the iconography and the hieroglyphic texts. Briefly, the Temple of the Cross tablet's principal theme was "solar rebirth in the heavens."[85] The celestial band that runs across the base of the tablet marked a heavenly location, while the jeweled tree that grows in the center was associated with the eastern sky. The tree grows from a skeletal censer plate marked with a *k'in* "sun" sign, which both David Stuart and Karl Taube identified as a symbolic womb, associated with solar rebirth.[86] The Tablet of the Cross's hieroglyphic text commemorated the birth of GI, one of the three patron gods of the Palenque dynasty, who combined solar and aquatic connotations.

The dominant theme in the Tablet of the Sun was "sacred warfare on earth."[87] The location is indicated by the earth signs on the basal band, while the central icon features crossed spears and a war shield with the frontal face of the Jaguar War God. The combination of spears and shield is a well-known war metaphor in Mesoamerican art and literature. The hieroglyphic text commemorated the birth of GIII, a god who bears a distinct—if not completely understood—association with the Jaguar War God. The tablet makes no explicit reference to stars, although the portrait of the Jaguar War God on the shield may have evoked them, considering the god's prominent role as a stellar warrior in the myth of primeval warfare that was depicted on the Vase of the Stars. The Jaguar War God was also marked as a stellar being in major sculptures at Copán, Yaxchilán, and Naranjo.[88]

The Tablet of the Foliated Cross centered on "the power of agricultural growth and procreation from precious water."[89] It shows maize plants growing from three sources,

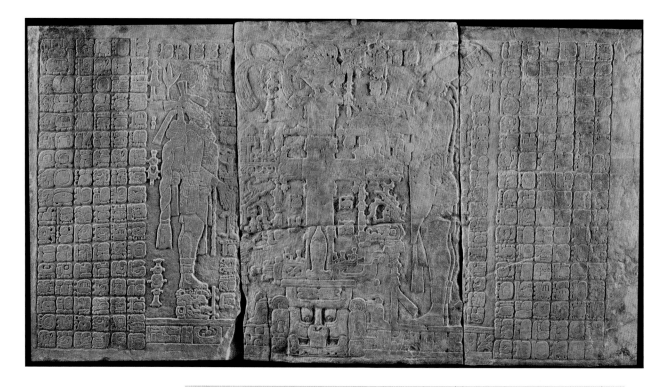

FIGURE 23
Tablet of the Cross, Palenque, Late Classic, lowland Maya area, AD 692. Museo Nacional de Antropología, Mexico.

FIGURE 24
Drawing of the middle section of the Tablet of the Cross, Palenque (see fig. 23).

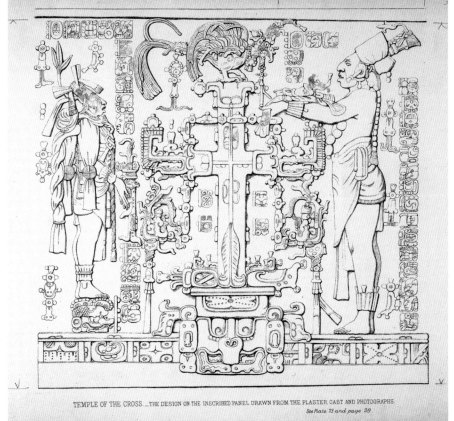

TEMPLE OF THE CROSS.—THE DESIGN ON THE INSCRIBED PANEL DRAWN FROM THE PLASTER CAST AND PHOTOGRAPHS.
See Plate 73 and page 29.

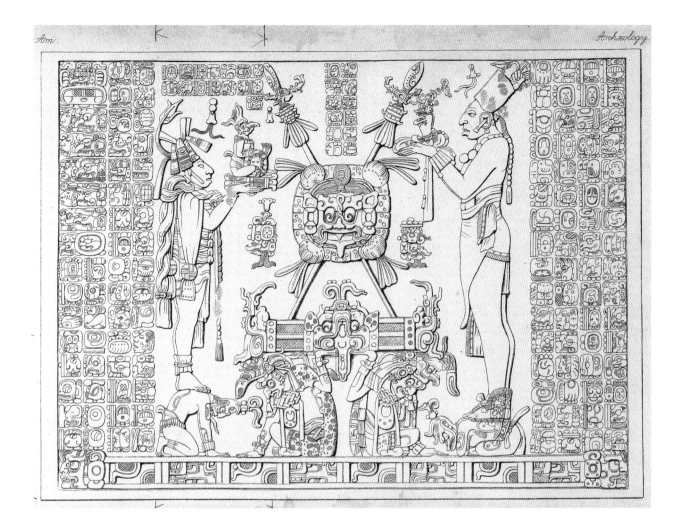

FIGURE 25

Drawing of the Tablet of the Sun,
Palenque, Late Classic, lowland
Maya area, AD 692.

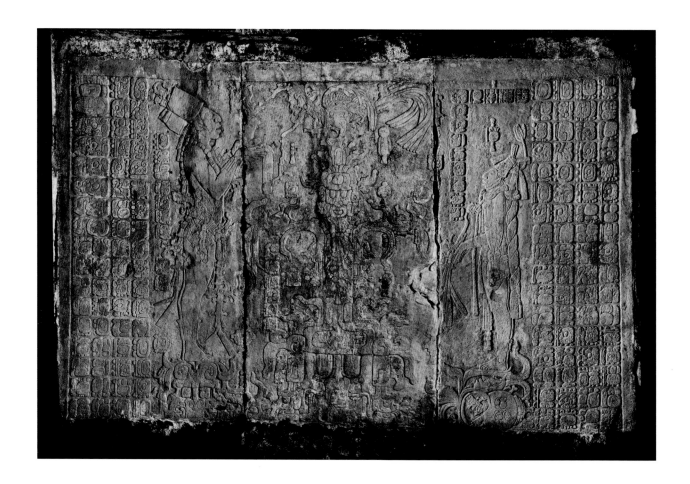

FIGURE 26

Tablet of the Foliated Cross, Palenque, Late Classic, lowland Maya area, AD 692. Palenque, Chiapas, Mexico.

FIGURE 27

Drawing of the Tablet of the Foliated Cross, Palenque (see fig. 26).

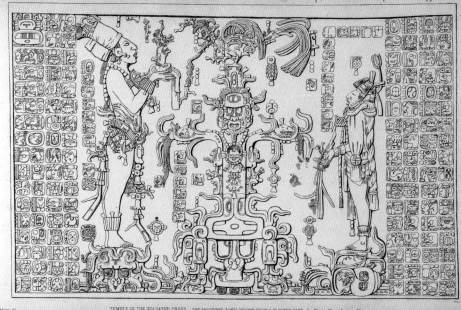

TEMPLE OF THE FOLIATED CROSS.__THE INSCRIBED PANEL DRAWN FROM A PLASTER CAST. *See Plate 80 and page 30.*

all of which rest on an underlying aquatic band. In the center, maize grows from an over-sized mask that, according to Stuart and Stuart, corresponds to the hieroglyphic colloca-tion *K'an Nahb*, or "precious sea." To the observer's left, maize grows from a hill labeled *Yaxhal Witznal*, perhaps meaning "Place of Green / Fresh / Fertile Hill." To the right, it grows from a conch shell whose hieroglyphic label includes the place name Matwil. Strongly linked to the Palenque ruling dynasty, this mythical location was the place where the Triad Gods were born. The tablet emphasized the aquatic origin of maize, a subject that finds clear correlates in Mesoamerican maize hero myths. The text commemorated the birth of GII, the youngest of the Triad Gods, whose name reads as *Unen K'awiil*, or "baby K'awiil." A complex deity, K'awiil was, among other things, a god of lightning, a phenomenon that is often associated with the fertilization of the earth in Mesoamerica. He shared important attributes with the Maize God and was strongly associated with agri-cultural bounty.[90]

The Group of the Cross tablets did not portray mythical events, per se. In accor-dance with the prevailing themes of Classic Maya monumental sculptures, the tablets focused on royal rituals that nevertheless evoked mythical events. The three themes out-lined by Stuart and Stuart corresponded to major creative processes in Mesoamerican cos-mogony: the first sunrise in the eastern sky, the origin of warfare on earth, and the origin of maize in water. They find correlates in the questions of the K'iche' gods in the Popol Vuh: "How should the sowing be, and the dawning? Who is to be the provider, nur-turer?" The advent of the sun corresponds to the first dawn, while the discovery of maize corresponds with the first sowing. The creation of people was strongly correlated with the creation of warfare—the means by which men would be able to fulfill their role as the providers for the gods.

Another mythical passage in the Palenque inscriptions involved a flood event, briefly recorded in the Temple XIX tablet. Analyzing this passage, Velásquez suggested correlations with the myth of Itzam Cab Ain, the crocodilian who threatened to cause a flood and was slayed by Bolon Ti Ku, according to the Katun 11 Ajaw myth in the Books of Chilam Balam. The hieroglyphic text is succinct and contains only a hint of what was surely an elaborate narrative. David Stuart showed that the episode of world destruction and restoration after the flood was closely linked to the accession of GI as ruler—a prec-edent for the accession of the Palenque ruler who dedicated the tablet, recorded later in the text. Expectedly, the text linked the ritual acts of the current Palenque ruler with the primeval deeds of the dynasty's patron gods.[91]

The Palenque flood episode hints about beliefs in the denouement of succes-sive eras, which are not attested elsewhere in the Classic Maya hieroglyphic corpus. Yet they were mentioned in the Postclassic codices, as first noted more than a century ago by Ernst Förstemann (fig. 28).[92] In comparison with colonial and modern myths, ancient Maya texts and images related to floods are conspicuously devoid of allusions to the inhabitants of earlier eras and their fate. Instead, they appear to focus on the slaying of a

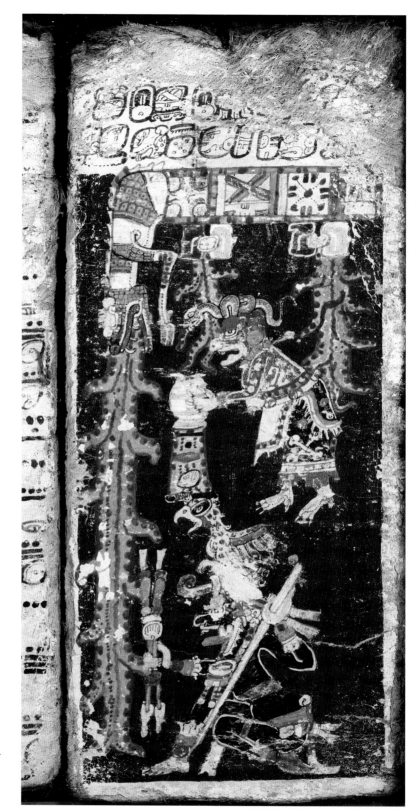

FIGURE 28

Dresden Codex, p. 74, Postclassic, lowland Maya area. Sächsische Landesbibliothek – Staats- und Universitätsbibliothek Dresden (SLUB), Germany. This page probably represents a primordial flood myth involving Chak Chel and God L.

monstrous crocodilian, and on the role of the gods who intervened in the events. Perhaps the absence can be explained in terms of the context of the extant fragments—dynastic texts in monumental sculptures and augural passages in the codices. Nevertheless, the inhabitants of former eras were likely as relevant for the ancient Maya as they are for modern Mesoamerican peoples. While not identified explicitly as such, a variety of fantastic and often frightening creatures that populate ancient Maya art—perhaps including the gods themselves—were likely conceived as inhabitants of previous eras that survived their catastrophic ends, or died but still remained powerful and influential in people's lives.

The formality of the ritual evocation of primeval events on the Palenque tablets contrasts starkly with the vivid representations of mythical passages on Classic Maya ceramic vessels. Rather than referring to the patrons of particular dynasties, ceramic vessels refer to the gods whose exploits—ranging from childbirth to death, from amorous encounters to quarrels and contests—brought about the present world and its inhabitants. The following chapters delve into mythical depictions on Maya ceramic vessels, and their probable correspondences with the nodal subjects of Mesoamerican myths.

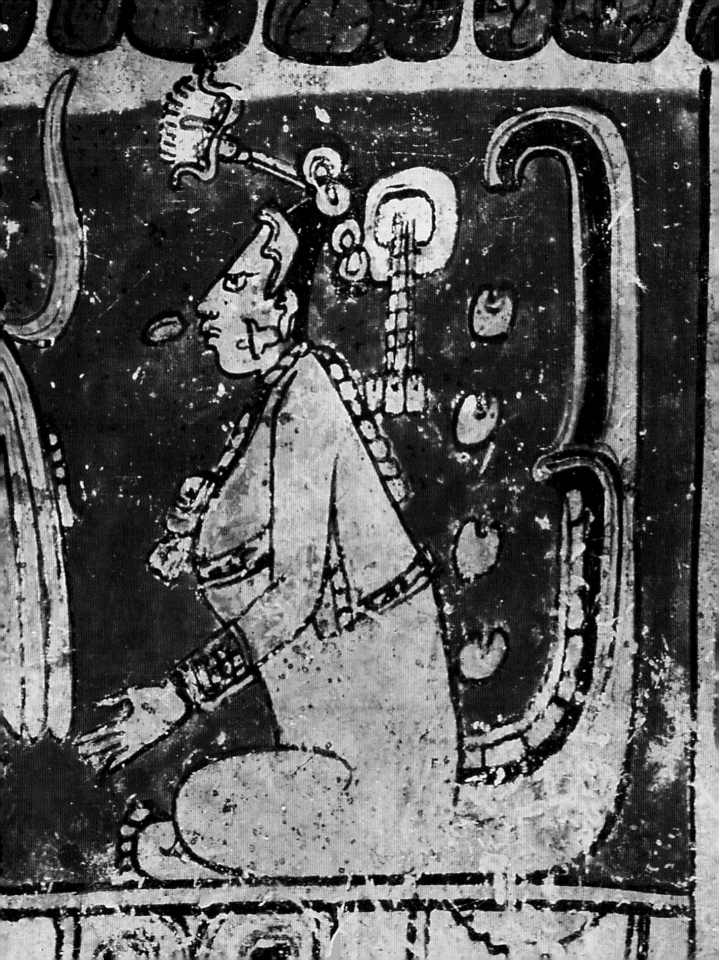

4 The Maiden

In olden days, when not a single man was yet born on earth, here in the center of a large mountain, inside a good cave, there lived our grandfather, lord Tzultaq'a. Only his daughter was his companion. Po is her name.

—Juan Caal

Juan Caal's narrative, recorded in 1909, is the earliest known version of the Q'eqchi' sun and moon myth. It opens with a placid description of the household of Tzultaq'a, the god of the earth, who lived with his daughter Po ("moon"), a dedicated weaver.[1] The harmonious scene was soon disrupted by B'alamq'e, the sun, who magically transformed in order to approach the girl, against her father's will. Their unlawful union met with the father's punishment, but it proved to be a major cosmogonic junction that resulted in the advent of the sun and the moon, the origin of sexuality and reproduction, and the beginning of sickness and curing.

Numerous narratives throughout Mesoamerica reiterate the nodal subject of the Q'eqchi' myth—the seduction of a tightly guarded maiden by a magically disguised hero, against the will of her father or mother, and sometimes against her own will, resulting in her abduction or impregnation. In many versions, the maiden's predicament was a point of departure for the heroic exploits of the gods who created the conditions for human life. Sixteenth-century texts from Guatemala and Mexico feature variants of this mythical encounter, and recent studies provide evidence about its representation in ancient Maya art.[2]

XOCHIQUETZAL AND XQUIC

In his comments on the Popol Vuh, friar Francisco Ximénez recalled an anecdote from the early days of Christianization in highland Guatemala. Rumor spread that "Hunahpu was God, the one they were preached about, and Hun Hunahpu was *filius Dei* [son of God], and Xuchin Quetzali, who is the one who in this language is called Xquic was Holy Mary, and that Vahxaquicat was Saint John the Baptist, and that Hun Tihax was Saint Paul."[3] The friar saw these as grave mistakes, inspired by the devil. He may have confused the names

DETAIL OF FIGURE 29

of Hun Hunahpu and Hunahpu, who appear in the Popol Vuh, respectively, as father and son, although this annotation raises the possibility that some versions of the myth reversed their names.

Most interesting was the match of the Nahua goddess Xochiquetzal with the K'iche' Xquic. Whether Ximénez made this connection himself or took it from an earlier testimony, it highlighted noticeable parallels between the Popol Vuh and contemporary Nahua myths. The correspondence is not straightforward, and the two goddesses cannot be considered as exact counterparts to each other. Yet the single extant version of Xquic's story is indeed reminiscent of the brief and sometimes confusing references to Xochiquetzal's mythical deeds, contained in Spanish and indigenous documents from highland Mexico.[4] They were both young goddesses who trespassed prohibitions involving marvelous trees, and their transgressions had implicit sexual overtones. They both mothered important gods, and their plight gave way to major creational events.

In colonial sources, Xochiquetzal was not commonly correlated with Mary, but rather with Eve. So implied the Dominican friar Pedro de los Ríos in his annotation to her portrait in the Codex Telleriano-Remensis: "The sin of the first woman."[5] In the codex, she confronted Tezcatlipoca in animal disguise, which—Ríos added—was like the devil tempting Eve to sin. The friar's imposition of Christian meaning was obviously misleading, and yet understandable. Xochiquetzal was generally regarded as a young goddess, associated with carnal love and childbirth and with the feminine arts of weaving and spinning. She was sometimes equated with the primordial mother goddess Tonacacihuatl, and overlapped with Tlazolteotl-Ixcuina, Ixnextli, and Itzpapalotl, goddesses who were broadly associated with sexuality and motherhood.[6]

While the extant accounts are not entirely in agreement, several sources linked Xochiquetzal with Tamoanchan, a primordial place of abundance and solace where a flowering tree grew. According to a Tlaxcalan narrative recorded by the late sixteenth-century chronicler Diego Muñoz Camargo, Xochiquetzal was a goddess of unmatched beauty who lived in Tamoanchan, amid beautiful groves and fountains, secluded in a well-guarded place so that no men could see her. She was the wife of Tlaloc, until Tezcatlipoca abducted her. Her impregnation was not mentioned, but the Histoire du Mechique described how she laid inside a cave with the god Piltzinteuctli—perhaps a manifestation of Tezcatlipoca—and gave birth to Centeotl, the Maize God, who originated all sorts of useful plants.[7]

The annotations of the Codex Telleriano-Remensis and the closely related Codex Vaticanus 3738 explain that the gods originally lived in Tamoanchan, until Xochiquetzal— or the related goddesses, Ixnextli and Itzpapalotl—cut the flowers and branches or ate the flowers, causing the tree to break. As a result, the gods were expelled from that idyllic place. Michel Graulich interpreted the gods' transgression in Tamoanchan as a metaphor for copulation, sparking an important debate about the bearing of the Christian concepts of sin and sexual transgression in colonial accounts of Nahua religion.[8]

Mesoamerican myths have numerous points of convergence with biblical passages, which were duly highlighted—sometimes exaggerated and even invented—by the Spanish friars and the new converts. Xochiquetzal's approach to the Tamoanchan tree was compared to the biblical story of Eve and the tree of good and evil. Yet there is no clear indication that the Mesoamerican myth derived from Genesis, nor do the parallels imply revisions that modified the nodal subject of the Tamoanchan myth.

Throughout Mesoamerica, modern ethnographic studies coincide with early colonial sources in describing negative views about sexuality, in ways that bear no relation to the Christian concept of sin.[9] Alfredo López Austin largely concurred with Graulich and linked the Tamoanchan myth with the origin of sexuality. The god's transgression at Tamoanchan was not conceived as a manifestation of evil, but as a powerful creative force that, nevertheless, threatened to break established mores and hierarchical relations. Both scholars regarded this as a turning point in Mesoamerican cosmology, a rupture that resulted in major creational events.[10]

Without referring to Ximénez's early equation of Xochiquetzal with Xquic, Graulich highlighted the parallels in the goddesses' stories. According to the Popol Vuh, Xquic was the daughter of Cuchumaquic, one of the lords of Xibalba, the underground realm of death. With trickery, the lords had killed the brothers One Hunahpu and Seven Hunahpu, and hung the former's skull from the fork of a tree. At once, the tree bore round calabash fruits that were indistinguishable from One Hunahpu's skull. Having heard about the portent, Xquic longed to see the tree and craved its fruit, which she heard was truly sweet.[11]

Ethnographic comparisons reveal the thinly veiled sexual connotations of Xquic's craving for the fruit. In Mesoamerica, fruits are classified in a category of edibles that provide no nourishment for the human body and are eaten in excess, simply for enjoyment. They are fundamentally different from maize, the "real" food that provides sustenance and strength. In Maya languages, the verbs employed for eating fruit are generally different from those used for eating maize.[12] Nathaniel Tarn and Martin Prechtel highlighted the sexual connotations of ritual offerings of fruit to Mam, a major deity in the traditional religion of Santiago Atitlán. While lying surrounded by ripe fruit, specially harvested for the purpose by a group of young men during a ritual pilgrimage to the Pacific coast, Mam is said to be "eating the fruit"—that is, having sex. In the same vein, Robert Laughlin examined a modern narrative from Zinacantán, in which a group of men obtained wives from a man who also owned a rich plantation of bananas. The men harvested the fruits and also got the man's daughters, which were essentially analogous to each other.[13]

Xquic's intercourse with One Hunahpu's skull was not the casual result of her curiosity; the rhetoric of the Popol Vuh implied a distinctly erotic motivation in the girl's quest for the fruit of the forbidden tree. While expressed in a metaphorical way, her infringement of the lords' dictates, her appetite for the fruit, and her impregnation alluded to sexual transgression, paralleling Xochiquetzal's myths.[14] Xquic's father accused her of

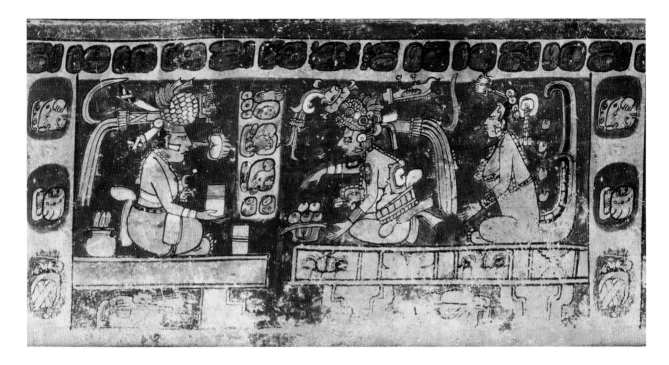

FIGURE 29

Rollout photograph of the Three Gods Enthroned Vase (Vase K504), Late Classic, lowland Maya area. Virginia Museum of Fine Arts, Richmond. A young man with a hummingbird nosepiece approaches Itzamnaaj and the Moon Goddess.

fornication and condemned her to death, but she managed to escape and eventually gave birth to the Hero Twins, Hunahpu and Xbalanque.

The transcendental scene of Xquic's impregnation by the dead hero's skull evoked profound concepts related to procreation, generational succession, and, specifically, to the Mesoamerican notion of bones as carriers of progeny.[15] Yet it finds no close parallel in modern narratives, which generally concede an active role to a living suitor, who cunningly seduces a tightly guarded maiden. Modern stories accord in general with Muñoz Camargo's version of Xochiquetzal's myth, except for his assertion that the goddess was Tlaloc's wife. In modern narratives, the struggle was always against the maiden's father or mother (rarely both), who kept their daughter away from potential suitors, inducing them to adopt magical transformations to pursue their goal.

THE HUMMINGBIRD

In modern Maya narratives, the suitors invariably took the shape of hummingbirds—creatures that are commonly associated with the male qualities of warlike belligerence and sexual prowess throughout the New World.[16] Parleys between the disguised suitor and the young maiden's old father were likely portrayed on the finely painted "Three Gods Enthroned" Vase (Coe's designation) (fig. 29). An old god and a young goddess sit on a celestial throne, marked as such by a sky band along the edge. Their position, to the observer's right, is usually reserved for the higher-ranking characters of courtly scenes in Maya vase painting. A large moon sign on her behind marks the young lady as a Moon Goddess. The identity of the old god is uncertain, although he has some attributes

FIGURE 30

Detail of a ceramic vase from Tikal Burial 196, Late Classic, lowland Maya area. Museo Sylvanus G. Morley, Tikal, Guatemala. The hieroglyphic caption identifies the human-bodied bird as *tz'unun* ("hummingbird").

of the paramount god Itzamnaaj. A young man occupies a lower, unmarked bench while holding up a vase, perhaps presenting it to the old god. A clue about his identity and role in the scene is the long, curved beak that projects in front of his face, pricking through a flower. In Maya art, this kind of beak is a distinctive attribute of hummingbirds, as confirmed in several instances by associated hieroglyphic tags that convey the word *tz'unun,* or "hummingbird" (figs. 30, 31). In this case, it probably stands for a mask worn by the young man.

The characters of the Three Gods Enthroned Vase relate to each other in a way that suggests parallels with modern hummingbird myths. The young man with a hummingbird mask can be plausibly identified as a disguised suitor, presenting respects to the young Moon Goddess's father, his potential father-in-law.[17] One point of departure from modern versions involves the old god's celestial throne, as, in modern stories, the maiden is usually the daughter of an earth god. In Q'eqchi', Ixil, and Kaqchikel stories, the maiden's father is repeatedly named Mataqtani, or variations thereof. According to glosses in colonial dictionaries, the name refers to a whale, swordfish, or other large fish, meanings that

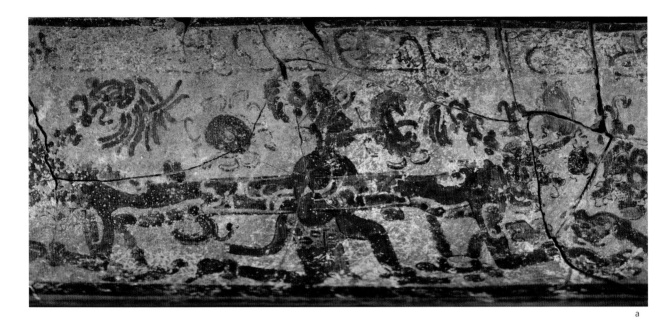

a

b

FIGURE 31

Bowl from the Naranjo area, Petén, Guatemala, Late Classic, lowland Maya area. Museo Vigua de Arte Precolombino y Vidrio Moderno, Antigua Guatemala: (a) Detail of a rollout photograph, showing a young man wearing a humming-bird beak with a pierced flower; (b) Detail showing the face and beak.

reinforce the father's links with Mesoamerican earth monsters.[18] Nevertheless, the interaction between the suitor and the old god on this vase accords with Ixil myths, in which the young man initially asked for the lord's daughter in marriage, but was rejected. The Three Gods Enthroned Vase may represent a corresponding episode based on a Classic Maya version of the myth.

Examining traditional marriage practices in modern Maya communities, H. E. M. Braakhuis noted that confrontations among potential in-laws are usual and, in fact, can be part of the expected protocol. Marriage petitioning involves multiple visits by the suitor's family or intermediaries, who present themselves humbly while bringing presents, and are initially met with rejection—to the extent that they may resort to magical procedures to appease the bride's father. According to Jane Collier, at Zinacantán suitors could only present their request after forcing their way into the bride's house and then asking for the father's forgiveness.[19]

Such practices may explain why the story of the girl's seduction, and of the couple's confrontation with the enraged father, were recited during traditional marriage ceremonies documented by Aquiles Palomino at the Ixil town of Chajul. The Chajul prayer consisted of a series of poetical dialogs, whose meaning can be partly understood by comparing them with parallel narratives from Chajul and the neighboring Ixil community of Nebaj. The prayer involved an initial supplication by the suitor, who was refused by the father. He then transformed himself into a hummingbird that flew over the flowers, attracting the girl's attention. Some versions explain that she wanted the bird as a model for her weaving patterns. The old man acquiesced with his daughter's plea and knocked the bird down with his blowgun. According to the Nebaj versions, she put the bird inside her clothes, "next to her belly."[20] Once inside her room, the bird retook his human shape, and the lovers spent the night together.

Suspicious, the father sent insects to check on his daughter. In the Chajul prayer, he sent a group of fleas; in a Nebaj narrative, he first sent a louse and then a flea.[21] Both gorged themselves with the lovers' blood and never returned. The father finally caught them with the help of a firefly that shed light on them. The unwilling father agreed to the union, but imposed Herculean tasks, such as building a house with twelve doors and planting a large field within a short period. The hero accomplished them, assisted by his wife's magic. Still enraged, the father attempted to suffocate the couple inside a sweat bath or, according to a Nebaj variant, tried to trap the hero in a burning field. When the couple finally escaped, the old man shot them with lightning, killing his daughter. The hero collected her bones inside a jar or box and left them in the care of a lady. Hearing noises, the curious woman opened the jar, which released many kinds of quadrupeds and birds—rabbits, deer, pigeons, and others. With the help of a woodpecker, the hero finally found his wife, forever transformed into a honeybee.

The Ixil story may explain the suitor's appearance before the old god on the Three Gods Enthroned Vase, but it does not account for the young woman's lunar qualities. In this respect, the Classic Maya myth that inspired the scene seems closer to modern Q'eqchi' narratives, in which the heroes finally became the sun and the moon, although Q'eqchi' narratives featured no bridal service, nor any other form of interaction between the suitor and the girl's father. Clearly, no modern narrative accords entirely with the Classic Maya version portrayed on this vase, which nevertheless shared not only nodal subjects, but also some heroic incidents with modern Ixil and Q'eqchi' myths.

In the Q'eqchi' stories, the girl picked up the unconscious bird, brought down by her father's blowgun shot. To revive it, she put it inside her blouse and took it with her to sleep. At night the hero recovered his appearance, and the couple escaped before the girl's father realized the deceit. After several incidents, lightning hit the maiden and spilled her blood in the sea or another body of water. With the help of dragonflies, the hero recovered the girl's blood and her spoils and put them in thirteen jars. When he opened them, he found many kinds of serpents, scorpions, wasps, and other biting, poisonous creatures inside them. She was finally reborn from the last jar.[22]

In his detailed studies, Braakhuis explored multiple meanings of hummingbird myths, relating to the origins of sickness and curing, and pregnancy and childbirth. In all versions, the incubation of the collected remains inside jars or boxes stands as a symbolic pregnancy, which did not result in human offspring. In Ixil and Kaqchikel myths, the incubated bones generated game animals and honeybees; in Q'eqchi' versions, the blood produced poisonous, biting creatures. Braakhuis noted that each kind of progeny responded to the concerns of a different occupational group. The game animals and honeybees of Ixil and Kaqchikel myths are significant for hunters and beekeepers, while the poisonous creatures of Q'eqchi' versions relate to the arts of curers and sorcerers, whose work involves knowledge of poisons and the creatures that produce them.[23]

Only the Poqomchi' narratives describe a normal human pregnancy. The heroes ran away and managed to escape from lightning, protected inside a turtle shell while they crossed a stretch of water. Pregnant, the girl stayed inside a cave and became maize—the trade of farmers.[24] Braakhuis concluded that the myths explain man's quest for the products of the earth, signified by the reproductive capacities of the earth lord's daughter, which he kept zealously guarded from intruders. The heroes forced their way into his domain only through cunning and magic. This is, however, a transgression that meets punishment, unless the earth receives appropriate appeasement. Braakhuis concluded: "The relationship of man to the earth and its bounty can apparently be viewed as an affinal relationship, or rather, as a permanent state of being a suitor."[25]

In addition to being a nodal subject of hummingbird myths, this metaphor of human behavior can be overlapped and contrasted with the concept of original debt, in which men reap the fruits of the earth according to the terms of primeval covenants, paying back by ritually feeding the earth with offerings and eventually giving their own bodies. In the permanent suitor metaphor, men solicit the earth's bounty in the same way they pursue potential wives. Like a father-in-law, the earth lord is unwilling to grant his daughters unless properly appeased by the suitor. Yet there is a possibility that men will take the earth's products without following the socially sanctioned rules, incurring the owner's rage. In a harmonious way, the Three Gods Enthroned Vase condensed the tensions between potential in-laws that were implicit in this metaphor.

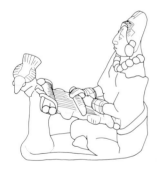

FIGURE 32

Ceramic figurine from Jaina Island, Late Classic, lowland Maya area. This represents a young weaver with a bird perching on a stump that holds the loom.

THE WEAVER

Jaina-style ceramic figurines representing weavers are among the most charming artworks of the ancient Maya (fig. 32). Donald and Dorothy Cordry and Hilda Delgado related them with modern Mixe stories from Oaxaca that reiterate the episode in which a suitor transformed into a bird to approach a tightly guarded maiden.[26] The best-documented example, excavated by Delgado on Jaina Island, has a bird perched on the stump that holds the loom. In unprovenanced figurines, the bird walks on the floor or comes even closer to the maiden.

Echoing the highland Guatemalan versions, the maiden of Mixe narratives was a dedicated weaver. As such, she embodied the qualities of a well-raised young woman and a potential wife. Spinning thread and weaving finely made clothes were not just feminine chores, but highly valued aspects of womanhood in Mesoamerica. Moreover, the materials and instruments employed for spinning and weaving—the spindles, the loom and its components, together with raw cotton and thread—were often considered as feminine magical charms. The goddesses were often represented wearing unspun cotton and spindles full of thread in their headdresses, and wielding battens like weapons.[27]

In the rhetoric of Q'eqchi' hummingbird myths, the loom was a magical instrument that protected the maiden against the suitor's advances. To succeed, he had to find ways

to turn her away from the loom. An intriguing sentence in Eric Thompson's account from San Antonio, Belize, highlights the break in her labor. Distracted by the beautiful creature, the girl suspended weaving to pick the hummingbird that fell to the ground, stunned by her father's shot. At this point, the narrator added an intriguing detail: "As she stooped down, the strap which passed round her waist and held the loom taut slipped, and the loom fell to the ground."[28] Seemingly inconsequential, this sentence marked the moment in which the bird overcame her resistance; her defeat resulted from losing the magical protection of the loom.

In a Q'eqchi' version from Senahú, the maiden developed a strong toothache after the hero threw fifteen red corn grains over her house. The nature of her pain is revealing, since toothache is consistently associated with sexual transgressions in Mesoamerican myths. According to an ethnomedical survey of the etiology of toothache among the Q'eqchi', young men suffering from toothache were suspected of sexual liaisons or perhaps having made a woman pregnant.[29] In the Senahú story, the maiden's toothache was propitious for the suitor's aim, because it kept her away from weaving. While she cried, he borrowed the hummingbird's outfit and flew over a tobacco plant, sucking nectar from the flowers. The very sight of the bird calmed the maiden's pain, and she resumed weaving after placing the stunned bird first in the gourd where she kept her yarns—a likely allusion to her womb—and then inside her blouse. By conquering her weaving, the suitor entered the ultimate domain of her womanhood, and she started making only bird patterns.

The loom was the focus of contention in parallel passages from Mixe myths. Initially rejected by the maiden, the hero transformed into a little bird that perched and, according to some versions, defecated on her loom. Furious, she hit the obnoxious bird with a weaving stick, but then picked up the inert creature and sheltered it inside her blouse. The bird revived, bit her breasts, and flew away. The girl became pregnant, but died after being expelled from her parents' house. Her children, the sun and the moon, were born when a vulture opened her dead body's womb.[30] Mixe myths are unique in their description of the maiden's death and her postmortem delivery. Yet there are many stories in which the young mother died or largely disappeared from the scene after giving birth. This happened to Xquic, who did not die but was barely mentioned in the Popol Vuh after the birth of her children.

While modern Maya myths do not mention the bird biting the maiden's breasts when she sheltered it in her blouse, iconographic evidence suggests that such a passage was indeed present in Terminal Classic and Early Postclassic versions of the myth, from the Pacific Coast and northern Yucatán. While working in the Soconusco region of coastal Chiapas, Carlos Navarrete recorded a parallel story, told by Jesús Pérez.[31] God asked a beautiful girl to marry him, but was rejected. He took the shape of a bird and visited her while she washed clothes. To get rid of him, she hit the bird with a stick. Compassionate, she revived the bird by placing it in her bosom. The bird bit her nipples and flew away,

FIGURE 33

Tohil Plumbate ceramic figurine,
Early Postclassic, probably from
the Pacific Coast of Guatemala.
Museo Miraflores, Guatemala City,
on loan from Colección Santa
Clara. A bird bites the breast of a
woman, probably implying her
magical impregnation.

making her pregnant. She died in childbirth, but her twin children became the sun and the moon.

Navarrete raised the issue of ancient and modern population movements across the Soconusco, which brought beliefs and traditions from many regions to the local repertoire. Yet there is evidence that this mythical episode had great antiquity in the Soconusco, going back at least to the Early Postclassic period. A candid representation appears in a Tohil Plumbate effigy that shows a bird biting the girl's breast as she struggles to get rid of the painful aggressor (fig. 33). Hector Neff's analysis of clay sources has shown that Tohil Plumbate pastes originated from the coastal plain of Soconusco, around the Cahuacan River.[32] The potter who made this figurine in the Early Postclassic period lived and worked within a day's walk from the places where Jesús Pérez lived and worked in the twentieth century.

This Tohil Plumbate effigy exemplifies the problems confronted in the attempt to correlate mythical events with ancient imagery. The bird's gender is not evident in the figurine, and there is a possibility that it is breast-feeding, although the woman's stance is not obviously maternal. While cogent, these possibilities find no correlates in the region's narrative repertoire. Therefore, there is a better probability that the figurine represented the encounter between the maiden and the disguised suitor, present in a local version of the sun and the moon story.

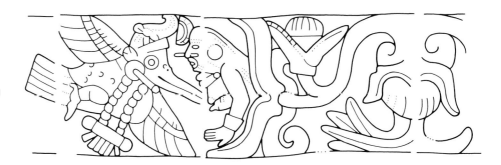

FIGURE 34

Detail of a carved frieze in the
Lower Temple of the Jaguars,
Chichen Itza, Late Classic, lowland
Maya area. A hummingbird bites
the breast of a woman who
emerges from a flower.

A similar explanation applies to a relief from the Lower Temple of the Jaguars at Chichen Itza, which, arguably, presents a version of the myth in which the maiden became identified as a flower—an appropriate object of the hummingbird's desire (fig. 34). With much caution, Eduard Seler identified the bird: "The bird with the long, pointed bill that, here, apparently, is plunging into the opened breast of a human flower, could—perhaps—also be intended for this bird . . . the hummingbird."[33] While his reserve was justified, Seler's interpretation was most likely correct, as the scene finds parallel in the Katun 11 Ajaw myths from the Books of Chilam Balam. The most explicit version appears in the Codex Pérez: "Ppizlimtec transformed himself into a hummingbird and came down to pick the flowers. He sucked the honey from the flower with nine petals, and the flower took him as a husband."[34]

Thompson compared these passages with the Guatemalan hummingbird myths, and linked the suitor's name with the Nahuatl Piltzinteuctli, the god who lay down with Xochiquetzal and fathered Centeotl, according to highland Mexican texts. In his seventeenth-century history of Yucatán, Diego López de Cogolludo cited Pizlimtec as the name of a god of poetry, singing, and music, also called Ah Kin Xooc or Xocbitum.[35] However, the god's Nahuatl name does not imply that the Maya had learned a Nahua myth shortly before the Spanish conquest. Rather, it suggests that the heroic subjects of Maya and Nahuatl versions were easily merged with one another in the context of intense interaction through the Postclassic period.

THE MOSQUITO

Representations in Classic Maya ceramic vessels suggest that the suitor could also take the shape of a biting insect, most likely a mosquito. This is apparent in a polychrome plate that shows a long-muzzled insect biting the breast of a young lady (fig. 35). The unpleasant creature can be recognized as a mosquito by the muzzle, skinny legs, skeletal head decked with eyeballs, and wings marked with ak'ab signs that denote its nocturnal habits. The young woman raises her hand as if ready to slap it dead, yet her outward distress may conceal an ambivalent attitude toward the insect's harassment. This appears to be a variant of the mythical episode in which a bird bit the breasts of a young maiden, presumably impregnating her.

Why was a mosquito portrayed in a role that modern narratives accord to hum-
mingbirds? Karl Taube noticed that mosquitoes shared a distinctive attribute of hum-
mingbirds, namely a flower pierced by their muzzle, and suggested that mosquitos were
regarded as insect counterparts of hummingbirds. The overlap was not complete, since
hummingbirds were normally represented as fleshed, feathered birds, while mosquitoes
were normally fleshless and skeletal in Maya art. Yet their respective habits of sucking nec-
tar or blood with their long muzzles may have brought them together in Mesoamerican
animal classifications. In a modern Nahua narrative from Tzinacapan, Puebla, a humming-
bird behaved like a bloodsucking mosquito. Unable to speak with a girl, it bit her, took
a little bit of her blood, mixed it with its own, and placed it near a water spring. A plant
grew that produced a strange fruit with blood inside. People threw it in the water and later
found the baby Sentiopil, the Maize God, in the spring.[36]

FIGURE 36

Drawing of Vase K7433, Late
Classic, lowland Maya area. The
incised scene depicts intercourse
between oversized insects and
women.

The suitor can take many forms in Nahua, Otomí, Totonac, and Teenek stories from
Puebla and the Huastec region of Veracruz, Hidalgo, and San Luis Potosí. In some ver-
sions, the girl simply found a shiny stone, an egg, or another object, swallowed it, and
became pregnant. Other stories describe a hummingbird, a grackle, or an unidentified
bird that may or may not be explicitly identified as a disguised suitor. The encoun-
ter normally happened while the girl was bathing or washing clothes in a spring or a
small stream. She turned to look at the bird, which dropped a maize grain in the water
or directly in her mouth, making her pregnant. In Teenek versions, she swallowed the
droppings of an impolite grackle, which were likened to semen.[37] This is suggested by
Hilario Hernández Francisco's Nahua version from Hidalgo, in which the rejected suitor
instructed a bird to drop "that white thing" in the girl's mouth, while she washed her nix-
tamal in a stream.[38]

The suitor may also take the shape of a biting insect, usually a flea, to climb the girl's
dress or to enter a wooden box—sometimes described as a trunk or coffin—where she was
confined.[39] A Nahua story from Chicontepec, Veracruz, involved several insects. After
rejecting a suitor, the girl's parents locked her inside a coffinlike box. The suitor asked a
mouse and then a blowfly to open a hole through the box, but they proved unable to do so.
Then he asked a *quijote* (a wood-boring insect), which finally accomplished the job. A flea
entered the hole and started tickling and biting the girl, who became pregnant. The story
recalls Ixil myths in which the girl's father sent various insects to check on his daughter. In
Domingo Sánchez Brito's Ixil version from Nebaj, it was the suitor who sent three insects
as messengers—arguably in the role of matchmakers. The tick filled its belly and came back
with no answer. The flea just went to sleep. Finally, the firefly was able to find the girl and
her father, and threw light on the blanket where they were hiding. Still, the suitor was unable
to approach her until he took the shape of a hummingbird and caught her attention.[40]

Ancient Maya representations seem to focus on mosquitos, although the insects'
anatomical features are not always distinctive. The finely incised Vase K7433 shows two
scenes in which a woman interacts with an unpleasant creature that has a broad head and
long muzzle (fig. 36). The eyeballs around the head are distinctive of mosquitos and other

FIGURE 37

Rollout photograph of the Mosquito Vase, Late Classic, lowland Maya area. Museo Vigua de Arte Precolombino y Vidrio Moderno, Antigua Guatemala. God S watches a mosquito biting the breast of a young woman, while other insects present a crocodilian tree to the old god Itzamnaaj.

insects in Maya art. Far from rejecting it, the naked woman in the first scene seems to offer her breast to the insect's bite. In the second scene, the creature kisses a fully dressed, standing woman. It is difficult to determine whether these are sequential episodes of a continuous story, or whether the vase shows two versions of the story. If the latter was the case, it must be assumed that the artist recognized parallel passages from related narratives. In the first, the insect bit the maiden's breast, an episode that corresponds best with the bird's actions in contemporary tales from Oaxaca and Soconusco. In the second, the insect deposited its seed in the lady's mouth, just like the birds of modern myths from the Huastec region.

Several insects appear to be involved in an elaborate representation of the myth painted on the codex-style "Mosquito" Vase (fig. 37). In a palatial setting, Itzamnaaj gestures over a plate that contains a crocodilian tree. An attendant dwarf watches behind the lord, while a human-bodied insect with a skeletal head and dark wings enters the dwelling. The insect may be presenting the crocodilian tree to the old god, who seems unaware of the portent that unfolds in his own backyard. On the opposite side of the vase, a flying mosquito bites the breast of a barely dressed woman, while a jaguar-eared young man with a spot on his cheek turns his head to watch her. Considering the usual interplay among the three main characters of Maya hummingbird myths—the young maiden, her suitor, and her father—it is likely that the young woman receiving the insect bite was the old god's daughter. The handsome aspect of the jaguar-eared man makes him a good candidate for the suitor's role. However, his relationship with the insects is unclear. Was he the instigator of the mosquito's attack—that is, the rejected suitor, using a magical transformation to impregnate the lady? Was he conspiring with the insects to distract her father? Was he taking the shape of an insect to present the crocodile tree to his potential father-in-law? Was this a gift, perhaps one of the impossible tasks imposed by the old god, in parallel with modern Ixil and Kaqchikel versions?

Because of the spot on his cheek, this young man appears to be God S.[41] The jaguar ear was not a common attribute of this god, but it did appear occasionally—for example, on Vases K1222 and K5608. A role for God S in this version of the myth is also suggested by his presence on Vase K1607, where he presents a crocodilian tree on a plate to Itzamnaaj.

Very likely, this is the same plant that appears between the lovers on Vase K7433, with three flowering branches growing from a monstrous head. In previous work, I suggested that this might correspond with the tobacco plant that often played a role in Maya versions of the myth.[42] Its presence also recalls the prodigious tree of the Tamoanchan myths and the gourd tree of the Popol Vuh, whose fruit was the object of Xquic's craving. Be that as it may, a tree or plant played an important role in the mythical sequence of events that presumably led to the maiden's impregnation by an insect.

PIERCING THE CONCH

Alan Sandstrom compiled a Nahua story from Amatlán, Veracruz, in which the girl was named Tonantsij, "our sacred mother." Hearing talk and laughter inside the *chachapali* (a large clay vessel) where she kept Tonantsij, her mother peeked inside and found her in animated conversation with a flea. Needless to say, the girl became pregnant. Sandstrom noted that the vessel signified a womb, "where fertility, personified by Tonantsij, is safeguarded from potential suitors."[43] Indeed, that is the role of the enclosures described in parallel stories, which range from wooden boxes or trunks to clay jars and even entire rooms. In an Otomí version from Veracruz, narrated by Raymundo Hernández Juárez, the hero turned into a small ant to enter a windowless room, in which a woman had locked her daughter to keep her away from him. Impregnated, the girl gave birth to the maize hero, who was promptly killed and eaten by his grandmother. After several incidents, the girl's mother put the corn that repeatedly grew from the child's remains inside the same room where she had kept her daughter. Like a womb, the enclosure nurtured the corn; when the old woman opened the door a month later, there was a child.[44]

The enclosure was a whole palace in a quasi-historical version. According to the Historia Mexicayotl, the early Mexica king Huitzilihuitl—whose name, not coincidently, meant "hummingbird feather"—coveted Miyahuaxihuitl, a princess from Cuauhnahuac (modern Cuernavaca), a rich land that was noted for its abundant cotton. The princess's father, Ozomatzin Teuctli, was a great sorcerer who mustered all kinds of poisonous, biting creatures to guard his daughter: "He summoned all manners of spiders, centipedes, snakes, bats, and scorpions; he commanded them all to guard his daughter, Miyahuaxihuitl, for she was most admirable, so that no one would intrude, no wicked one would dishonor her where she was confined. The daughter was heavily guarded: everywhere at the palace entrances all manner of fierce beasts guarded her."[45]

The proud lord rejected Huitzilihuitl, ruler of a poor people who, according to the text, clothed themselves with breechclouts made from marsh plants. Following the advice of the god Yohualli—a manifestation of Tezcatlipoca—Huitzilihuitl shot a beautifully decorated dart that landed in Miyahuaxihuitl's courtyard, loaded with a precious greenstone. Thinking that it came from the sky, the princess found the greenstone and swallowed it. She became pregnant and gave birth to the great Mexica king

Moteuczoma Ilhuicamina. The king's prodigious conception had important implications for Mexica dynastic history, casting him as akin to the gods who resulted from their father's magical penetration of a secluded, feminine space in mythical narratives.[46]

Doris Heyden pointed out the phallic symbolism of arrows, which are repeatedly shot by male heroes at the women they pursue in Mesoamerican myths. Huitzilihuitl's arrow finds a remarkable parallel in the Senahú version of the Q'eqchi' sun and moon myth. The sun hero first found the moon when he shot an arrow that hit the ground near the place where the unsuspecting girl was weaving, startling her.[47] While not described as a weaver, Miyahuaxihuitl embodied the wealth of her father's realm and, especially, its rich cotton production. Huitzilihuitl's conquest of the secluded princess amounted to a conquest of the coveted fiber, symbolic of her femininity. It paralleled the trickery of the Q'eqchi' sun hero who aimed his magic at the moon's weaving, and the impertinence of the bird that defecated on the girl's loom in Mixe myths.

Miyahuaxihuitl's unapproachable palace was akin to the windowless room of the Otomí myth, and the boxes or jars where the maiden's parents kept her in other versions. Acting as the suitor's agent, Huitzilihuitil's dart substituted for the ant that entered the room or the insects or rodents that were able to pierce through the walls of the enclosures in modern stories. The phallic connotations of these magical agents are tangible, and their success in entering the maiden's seclusion is an obvious metaphor for sexual intercourse. The suitors' penetration of these spaces was tantamount to entering the maidens themselves, and the result was their impregnation.

The metaphorical representation of a woman's womb as a vessel is widespread in Mesoamerica. Among the Otomí, Jacques Galinier noted, "Ceramic objects are associated with parturition, with the pots symbolizing women, the neck representing the mouth or the vulva opening into the uterine cavity, the 'belly,' or the 'body.'"[48] The modern Mixtec also compare the womb to a cooking pot and conceive pregnancy as a cooking process. According to John Monaghan, "Any process that involves the transformation of something through baking it in an oven, firing it in a kiln, or boiling it in a jar resembles what goes on in a woman's womb when she is pregnant."[49]

In Guatemalan hummingbird myths, the remains of the maiden who was struck by a lightning bolt were "cooked" inside closed jars or boxes. Braakhuis noted a version in which the girl's spilled blood originated menstruation, and highlighted the containers' womblike functions and the suitor's absence during the gestation. In some versions the containers were prematurely opened before his return, and the incomplete gestation yielded imperfect creatures—game animals in Ixil versions, and poisonous creatures in Q'eqchi' narratives. The jars' womblike nature becomes apparent by comparison with a Mopan story, in which poisonous creatures were born from the moon's own belly. After deserting the sun, the moon went to live with the devil and became pregnant. When the sun finally got her back, he kicked the moon's belly, and she gave birth to snakes, toads, lizards, and scorpions.[50] The jar metaphor of woman's sexuality also relates to

beliefs about courtship, and to actual courtship practices in the Lake Atitlán area. In 1933, Samuel K. Lothrop noted that young men from Santiago Atitlán proposed marriage by breaking the girl's jar as she walked down to the lake to fetch water. Whether such reckless practice was commonplace or not, it reappeared in a narrative gathered by Tarn and Prechtel in 1979, about the sexual exploits of the Atiteco god Mam. Encouraging a young man in love to chase a disdainful girl, Mam urged him, "Go smash her water jug now!" Lois and Benjamin Paul quoted Lothrop's observation while describing how afternoon walks to fetch water provided opportunities for young women from San Pedro la Laguna to meet with potential suitors, who "station themselves to wait for the girls to ascend from the lake with full water jars on their heads."[51] Such practices may be less evident in places that are farther away from water. Nevertheless, sources of water such as springs, streams, lakes, and seas are consistently related to seduction, sexual encounters, and pregnancies in Mesoamerican narratives.

The suitors' magical entries into the enclosures guarding the maidens in mythical narratives find intriguing parallels in ancient Maya representations of male characters puncturing conch shells. It appears that conchs correspond with the jars and boxes of modern stories, metaphorically representing the sexuality of women and, specifically, their womb. In sixteenth-century Nahua religion, conchs were associated with the Moon God Tecciztecatl. An annotation to his portrait in the Codex Telleriano-Remensis explains: "He is called Tecciztecatl because as a snail comes out of the snail shell, so a man comes forth from the womb of his mother."[52] While the gloss does not explain fully the Moon God's association with snail shells, it provides a basis from which to associate conchs with childbirth. Among other authors, David Kelley cited it in support of his argument that the Cross Group tablets referred to the birth of the gods of the Palenque Triad. He linked the emergence of maize from a conch, represented on the Tablet of the Foliated Cross, with the birth of GII, recounted in the tablet's hieroglyphic text (fig. 38; see figs. 26, 27). In recent work on the Palenque inscriptions, David Stuart showed that the conch was repeatedly associated with Matwil, the mythical birthplace of the Triad Gods.[53]

A finely incised alabaster bowl from Bonampak Building 10 shows a lady pulling the arms of a youthful character, bringing him out of a conch, while another young man drills the mollusk's wall with a fine rod (fig. 39). The composition—a man-woman couple flanking a central character—evokes representations of rulers flanked by their father and mother in the Palenque sculptures. While not named, the characters on either side of the conch of the Bonampak bowl are probably man and wife, while the emerging youth is their child. By analogy with mythical passages in which the suitor punctured a secluded container, the scene may allude to the couple's sexual union, merged with their child's birth. The woman may also be doubling as a midwife, although her young age is not compatible with that role. A water lily sprouting below the conch denotes an aquatic setting, perhaps related to the conch's natural source while also compatible with the scene's portrayal of sexuality and childbirth.[54]

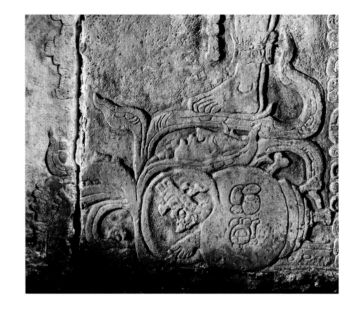

FIGURE 38

Detail of the Tablet of the Foliated
Cross, Palenque (see fig. 26). Maize
grows from a conch shell. The
hieroglyphic label includes the
place name Matwil, the mythical
location of the birth of the
Palenque Triad gods.

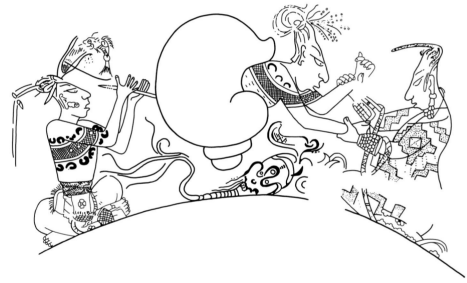

FIGURE 39

Incised scene on an alabaster bowl
from Bonampak Building 10, Late
Classic, lowland Maya area. Sexual
intercourse and childbirth are sug-
gested by the young man drilling a
conch shell, and the woman pull-
ing another young man from the
conch.

OPPOSITE **FIGURE 40**
The Bleeding Conch Vase, Late
Classic, lowland Maya area.
Present location unknown.

The conch as a metaphor for feminine sexuality reappeared behind the hips
of the naked young woman who confronts an eerie character on the Bleeding Conch
Vase (figs. 40–42). His ugly appearance—long, bulbous nose, wrinkled forehead, almond-
shaped eye, and wide-open mouth with forlorn teeth—is a far cry from Maya ideals of
male beauty, but the woman doesn't seem to care. She caresses the freak's chin in a wel-
coming manner, while he eagerly fondles her breast. In an exploration of ritual humor in
Maya art, Taube noted the sexual overtones of this encounter, and the contrast between
the girl's youthful, feminine beauty and the unseemliness of her suitor.[55] However, their
encounter was part of a larger scene that involved a young man standing behind her.
His noble profile would appear to make him a more desirable partner, were it not for

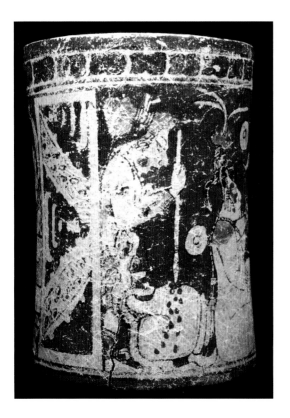 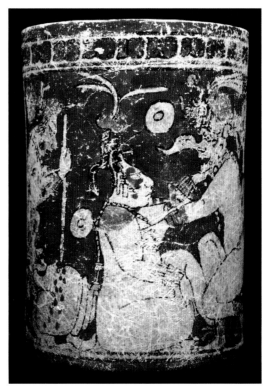

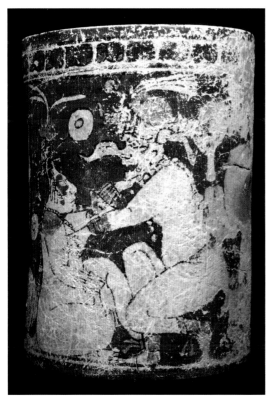 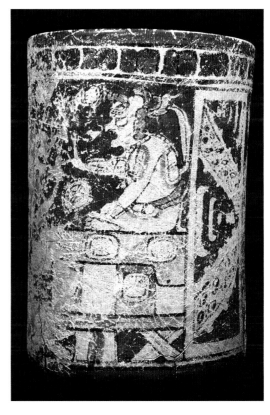

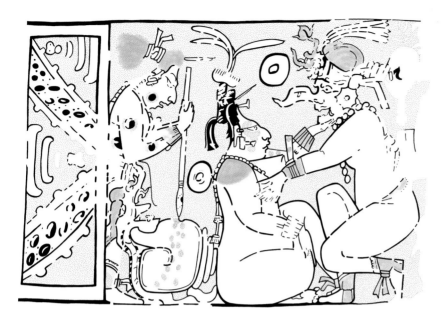

FIGURE 41

Drawing of the Bleeding Conch
Vase (see fig. 40). God S pierces a
conch behind the hips of a naked
woman, who embraces a long-
nosed partner. Note the serpent
coiling around the conch.

FIGURE 42

Detail of the Bleeding Conch Vase
(see fig. 40).

the swelling abscesses that blemish his face and arm. These are the distinguishing marks of God S, who stabs the conch with a spear, creating an open wound that bleeds copiously.

The position of the conch, attached to the woman's hips, underscores its genital connotations. It recalls portraits of Xochiquetzal with a turtle shell behind her hips in sixteenth-century Nahua codices, a trait that presumably related to her encased sexuality (fig. 43). The thick, red drops that flow down from the wound on the Maya vase may be the result of her defloration or may represent her menstrual bleeding. God S's spear seems analogous to Huitzilihuitl's dart, which entered Miyahuaxihuitl's deeply guarded palace. More literally, it appears to represent the spotted god's penetration of her genital organs.

The scene has much in common with the version represented in the Mosquito Vase (see fig. 37). The enthroned, old god Itzamnaaj—presumably the young woman's father—is present in both, and there was probably another character before his throne, in an eroded section of the Bleeding Conch Vase. On both vases, an unseemly character approaches a naked young woman in ways that suggest sexual contact, and the spotted God S is somehow involved. It appears that on both vases, the girl received the attentions of a suitor in disguise, or an agent sent by the suitor as his substitute. The long-nosed character in the Bleeding Conch Vase may be a human-bodied insect, although his appearance is not easily characterized. Taube related him to the big-nosed character who personifies the syllable pa in Maya writing, although he lacks the distinctive black color. He also compared him with the old men who embrace and caress beautiful young women in Maya figurines and painted vessels.[56] While this character's identification is uncertain, all participants

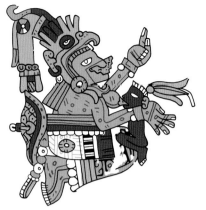

seem to be related to mythical passages that involved magical seduction and sexual encounters.

While the Mosquito Vase portrayed God S as a spectator, the Bleeding Conch Vase made him an active participant. There was a definite correspondence between the woman's encounter with her unbecoming suitor and her defilement by God S, although it is not easy to determine whether these were two separate affairs or two facets of the same. In both vases, God S seems to approximate the role of the suitor who used a disguise to approach the maiden. His attributes will be further discussed in Chapter 7, but it is relevant to point out that God S corresponds in many ways with solar heroes in Mesoamerican myths. This may be significant, considering that in modern Q'eqchi' and Mopan myths, the suitor was destined to become the sun.

The bleeding conch evokes menstruation or defloration, presumably leading to the woman's impregnation. However, she is not defenseless against the god's onslaught. There is a serpent that coils below the conch and reaches up toward God S. There are several possible explanations for this animal. In Mesoamerica, snakes, centipedes, and other biting and poisonous creatures are often associated with the filth that results from sexual activity.[57] They are also related to menstrual blood, a substance that is broadly regarded as noxious and threatening, especially for men. As such, the serpent may stand as a threat to God S, like the snakes, centipedes, spiders, and other biting, poisonous creatures that Ozomatzin Teuctli summoned to guard the doors of his daughter's palace. It may explain why God S did not approach her directly, but instead employed a spear to pierce the enclosure that represented her sexuality—the conch shell.

There is another, overlapping possibility: The serpent may embody the woman's toothed vagina, of serpentine shape, turned against God S's onslaught. Further discussed in the following chapters, this fearful attribute is accorded to mythical females who entice suitors only to harm or kill those who fall in their deadly embrace. In a sense, the poisonous creatures that guarded Miyahuaxihuitl's palace can be understood as embodiments of her toothed vagina. Only the heroes' magical powers enabled them to go through those frightful portals, into the women's coveted bodies.[58]

The toothed vagina is an attribute of both young and old goddesses. The former wielded it against potential suitors, while the latter directed their aggression toward the infant gods who were placed in their charge—sometimes their own grandchildren. As will be discussed in the next chapter, the old goddesses' antagonism toward the child heroes, as well as their final fate, are key components of Mesoamerican creation myths.

5　The Grandmother

The sweat bath is called tuj, but it is our grandmother.

　　　　—Antonia Soben

In the words of Antonia Soben, a modern K'iche' midwife from Santa Clara La Laguna—a town in the Lake Atitlán region of western Guatemala—the traditional sweat bath is more than a hygienic and curing facility. The sweat bath *is* Saint Anne, the mother of Mary, the mythical grandmother who helps healers treat disease and allows midwives to see unborn children inside their mother's womb and fix them if misplaced. The white-haired Saint Anne, "our grandmother sweat bath," has been there to help midwives since the beginning of time.[1]

　　Midwives still use the sweat bath in postpartum and perinatal care in highland Guatemala, although modern medical practitioners sometimes question it. In a study of modern opposition to traditional midwives in the Lake Atitlán region, Elena Hurtado and Eugenia Sáenz de Tejada reported that some people feared women and newborn babies were sometimes burned in the sweat bath, even though no such accidents actually occurred.[2] The concern seems to evoke the fate of the mythical grandmother, the model midwife. Her role in childbirth makes the grandmother appear beneficent, but the myths generally portray her as a nasty character who was evil toward the child heroes, often contriving to kill them. In the majority of Mesoamerican narratives, the heroes finally vanquished her and, according to many versions, they suffocated or burned her inside a sweat bath. Attested in narratives from several towns around Lake Atitlán, this outcome is closely linked to a related episode, in which the heroes turned their brother into a monkey.

　　The heroes' antagonism toward their siblings, their grandmother, and sometimes their own mother are major themes in Mesoamerican mythology. Yet despite their importance, the myths of the grandmother were not among the favorite subjects of ancient Maya artists. The significance of the old goddesses is indicated by their prominent presence in the Postclassic codices, while scattered representations in ceramic vessels and figurines provide clues about their roles and appearance in Classic Maya art.

Detail of Dresden Codex, p. 39. See fig. 44.

a

FIGURE 44

Details of the Dresden Codex, Postclassic, lowland Maya area. Sächsische Landesbibliothek – Staats- und Universitätsbibliothek Dresden (SLUB), Germany: (a) p. 39b; (b) p. 67a. The old goddess Chak Chel pours water from a jar. Note the jaguar eye and claws.

OLD AND YOUNG GODDESSES

Saint Anne was paired with Mesoamerican grandmother goddesses since the sixteenth century. In his Apologética Historia Sumaria, Bartolomé de las Casas quoted a letter from the cleric Francisco Hernández that described supposed correspondences between the Maya gods and the Christian sacred family, based on information provided by a "principal lord" from Yucatán. Despite the obvious misinterpretations, the letter contained hints of a divine genealogy that broadly agreed with those described elsewhere in Mesoamerica: "The Father was called Izona, who had created men and all things; the Son had the name Bacab, who was born from a maiden who always remained a virgin, called Chibirias." Further down, Hernández mentioned "the mother of Chibirias, called Hischen, who we say to have been Saint Anne."[3]

The names are clearly misspelled. Eduard Seler identified Izona as the celestial god Itzamna—probably spelled *Itzamnaaj* in the Classic inscriptions. The names Chibirias and Hischen, respectively, corresponded to Ix Chebel Yax and Ix Chel, two goddesses who, according to Diego de Landa, were worshipped in a stone temple at Isla Mujeres, on the east coast of Yucatán. Hernández provided no more details about the myth, which was not attested in other texts. Nevertheless, we can presume that this version was not radically different from others. If that is the case, Chibirias corresponded to the mythical maiden who was magically impregnated and gave birth to Bacab. From Hernández's text, Izona appears to be the father of Bacab, although this may reflect the cleric's Christian bias, as the usually aged appearance and lordly status of Itzamnaaj suggest that he might correspond instead to Chibirias's father. Hischen's role as Bacab's maternal grandmother fits well with Landa's identification of Ix Chel as a goddess of medicine. Landa reported that midwives put an idol of Ix Chel, "who they said was the goddess of making children," under the bed of parturient women.[4] The coupling of Hischen and Izona, as probable parents of Chibirias, finds a correlate in the highland Guatemalan creation myth gathered by Las Casas, which identified the primordial creators as a husband and wife, called Xchel and Xtcamna. As Michel D. Coe and Karl Taube noted, the names are cognates of the Yucatec Ix Chel and Itzamna.[5]

Ixchel and Ix Chebel Yax, the mother and daughter who were worshipped in Isla Mujeres, embodied a basic age distinction between old and young goddesses, reiterated in myths throughout Mesoamerica. In general, there are no middle-aged goddesses. In the myths, the role of the young goddesses normally ended after they were magically impregnated and gave birth to the heroes. At this point, they generally died or otherwise forsook their children; in some cases, they simply passed into oblivion. Invariably they took second stage while the grandmother—maternal or paternal—gained prominence. When present, the hero's mother tends to overlap with the grandmother, and they sometimes acted in unison. Both may suffer the hero's sexual assault, although there are many variations. In some, the mother reappeared at a later stage as an old woman in a less negative role.

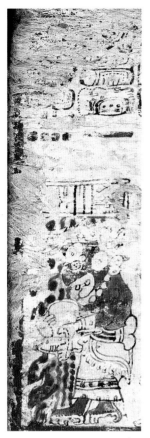

b

The generational distinction corresponds well with the contrasting ages of the goddesses in the Maya codices. The early colonial Ix Chel has a clear counterpart in the aged Goddess O of the codices, whose hieroglyphic name was Chak Chel (fig. 44). She wears a knotted serpent as a headdress—also occasionally used by Goddess I—and a black skirt with crossed bones. She has an aggressive, jaguar aspect indicated by jaguar ears and, less frequently, jaguar eyes and claws. Both Goddesses I and O appear as weavers in the Codex Madrid, although only Chak Chel normally wears spindles on her head. She often holds an inverted jar that yields abundant water. Extant narratives offer no clear parallel for Chak Chel's participation in cataclysmic flood events in the Dresden and Madrid codices, which were likely related to the demise of previous eras.[6] Nevertheless, her frightful appearance seems compatible with the grandmother's role in mythical narratives.

In recent work, Timothy Knowlton showed that Ix Chebel Yax was related to painting, writing, and textile decoration in colonial Yucatán. As the younger goddess in Hernández's letter, Ix Chebel Yax's codical counterpart may be Goddess I—whose hieroglyphic name remains undeciphered. In the codices, Goddess I often appears as the wife of various gods or animals, who sometimes engage in sexual intercourse with her (fig. 45). She also carries infant gods in her hands or in shawls tied to her back. Goddess I belongs among the young goddesses who engaged in amorous encounters and produced portentous offspring in Mesoamerican mythical narratives. While she was generally young, Taube noted that she occasionally appears as an aged woman in Codex Madrid, suggesting an overlap with the old Goddess O.[7]

DEATH IN THE SWEAT BATH

In the Popol Vuh, the Hero Twins contended with their grandmother, Xmucane, and their half-brothers, Hun Batz and Hun Chouen. In the first pages of the K'iche' account, Xmucane and Xpiyacoc appeared as a primordial creator couple, called "midwife" and "patriarch," among other epithets. Later on, they reappeared as the parents of One Hunahpu and Seven Hunahpu and, by implication, the paternal grandparents of the Hero Twins, Hunahpu and Xbalanque. However, the grandmother took a leading role, while Xpiyacoc was conspicuously absent from the passages that described the heroes' birth and early life.

As the story goes, Xmucane rejected Xquic, the maiden from Xibalba, who approached her carrying the yet-unborn children of her dead son, One Hunahpu. She only acknowledged them as her grandchildren after Xquic displayed their magical power, generating abundant corn from a single maize ear. Still, Xmucane scorned them. The authors of the Popol Vuh made special note that the heroes were born outside the house, in the mountains, and that the grandmother was not there—thus neglecting her expected role as midwife. When the babies came to the house, she could not stand their screams and ordered their older brothers to throw them out. Hun Batz and Hun Chouen placed them

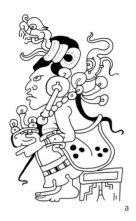

a

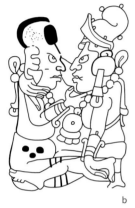

b

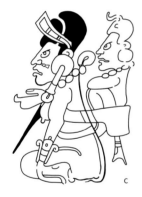

c

FIGURE 45

Details of the young Goddess I in the Dresden Codex, Postclassic, lowland Maya area. Sächsische Landesbibliothek – Staats- und Universitätsbibliothek Dresden (SLUB), Germany: (a) Goddess I sits on a bench (p. 18a); (b) Goddess I embraces a young god (p. 19b); (c) Goddess I carries the Maize God as a baby (p. 20c).

on an anthill, and later on brambles, where they slept placidly and did not die. They grew up in the mountains, as hunters, but Xmucane denied them food and gave all the birds that they brought to their older brothers.[8]

The Hero Twins finally punished their brothers, transforming them into monkeys, but spared their grandmother, who later became affectionate and even cried when she thought they had died. In these passages, as in many others, the Popol Vuh departs markedly from the majority of myths documented in the Maya area and elsewhere in Mesoamerica. Consider a highly abridged Nahua story from San Miguel Acuexcomac, Puebla. There was a girl whose parents didn't want her to marry. While she was bathing, a falling star made her pregnant. Her parents detested her child; they first tried to kill him in an anthill, then in a sweat bath, and then they threw him to the swine, but he did not die. Finally, they tossed him in a river. A barren couple found the baby and took charge of him. After eight years, he asked for a horse and a machete and rose to the sky as Santiaguito. Before leaving, he transformed his grandmother into a sweat bath and his grandfather into a fireplace.[9]

The surrogate mother—normally an old lady, with or without a husband—reappears in many narratives, largely overlapping with the grandmother. The adoptive parents were benevolent in the Acuexcomac story, but in most variants they were evil, effectively substituting for the children's own grandparents. The accounts can be contradictory; in modern Yucatec myths, the old woman who found and raised the hero was benevolent to him, yet a version compiled by John L. Stephens in the mid-nineteenth century warned about her threatening aspect. She could still be seen sitting in a cave by the edge of a stream near the town of Maní, offering water to passersby in exchange for children to feed the serpent that accompanied her.[10] The old woman's hatred of children is patent in a modern Cora myth. An evil old woman came to the house of a pregnant woman and offered to treat her—as midwives do—but instead opened her womb with her fingernail and stole the child, planning to eat it. In a Tepehua version, the old woman offered to take care of a baby while the mother went down to wash the diapers, but instead killed the child and made tamales with him. People finally grabbed her and burned her inside a sweat bath.[11]

Numerous stories about the Mixtec and Chatino sun and moon heroes, the Totonac sun hero, and the maize hero of the Nahua and Otomí describe the old woman's punishment. The children prepared the sweat bath for her, sealed it, and added heat until she burned. A frequent episode describes how the maize hero sent a toad—sometimes a different character—to throw her ashes into the sea. The curious envoy opened the bag and let out all sorts of wasps, flies, and other insects that bit him badly, leaving his skin full of sores. The pests have remained in the world since then. The incident appears to link the origin of the sweat bath and its healing properties with the origin of disease-bearers, embodied by the biting insects.[12]

The grandmother also burned in a sweat bath in Kaqchikel and Tz'utujil narratives from the Lake Atitlán region.[13] Maya stories from other regions generally do not mention the sweat bath, but they still describe how the heroes killed their grandmother or their

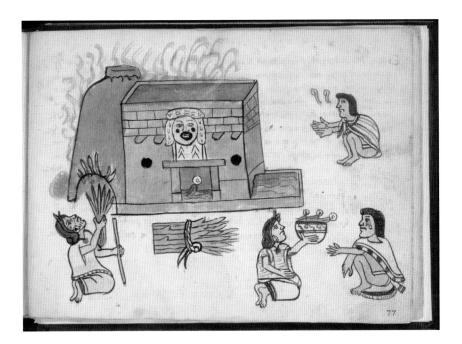

FIGURE 46

Codex Magliabechiano, p. 77r,
Valley of Mexico, 16th century.
Biblioteca Nazionale Centrale di
Firenze, Italy. An old woman lights
the fireplace of a sweat bath that
has the face of Tlazolteotl above
the doorway.

old adoptive mother. In Q'eqchi' sun and moon myths, they did it with arrows, stones, a knife, or by making her crash down and break her head.[14] In Ch'orti' and Popoluca narratives, she was burned in the middle of the field that the hero prepared for planting. In another Ch'orti' version, the hero burned the old woman inside her house—perhaps an indirect reference to the sweat bath. Widely scattered versions from the Pipil of El Salvador, the Chinantec of Oaxaca, and the Teenek of San Luis Potosí reiterate the death of the old woman in her burning house.[15]

With few exceptions, death by burning is a constant theme in the old woman myths, and it overlaps with the mythical origin of fire. The overlap is evident in Nahua myths from southern Puebla, in which the hero turned his grandmother into a sweat bath and his grandfather into a fireplace. According to Popoluca stories, the field where the old woman burned was set on fire by an opossum, the animal that brought fire to the world, according to myths from various Mesoamerican regions. In a Trique version from Oaxaca, the opossum stole fire from the old woman herself, although the story does not describe her final burning.[16]

There is no account of the grandmother's death in sixteenth-century Nahua texts, but she finds a clear manifestation in Temazcalteci, the "Grandmother of the Sweat Bath"; she was revered by physicians and midwives, who placed her image in front of sweat houses. According to Bernardino de Sahagún's informants, the goddess was equated with Teteoinnan, the mother of the gods, also named Tlalli Iyollo ("heart of the earth") and Toci ("our grandmother"). She overlapped considerably with other female goddesses, old and young, including Cihuacoatl-Quilaztli, Coatlicue, Tlazolteotl, Itzpapalotl, and Xochiquetzal. The head of Tlazolteotl stands above the door of a sweat bath depicted in the Codex Magliabechiano (fig. 46). Henry B. Nicholson categorized this group of

goddesses within the Teteoinnan complex, "the late pre-Hispanic central Mexican version of the widespread earth-mother concept." Associated with maternal and terrestrial fertility, these goddesses also embodied the earth's devouring aspect, "the great womb and tomb of all life."[17] Nahua goddesses were often portrayed with skeletal attributes and gaping mouths full of teeth, ready to bite.

The old goddess's death was ritually reenacted every year during Ochpaniztli, an important feast in the Nahua ritual calendar. Midwives attended her impersonator, a mature woman who wore the attributes of Toci and was sacrificed and flayed during the feast. In another manifestation, as Ilamateuctli ("old lady"), she was also celebrated during the feast of Tititl, when a symbolic effigy of the goddess was burned.[18]

A paramount member of this group of goddesses was Cihuacoatl. Sahagún's informants described her as "a savage beast and an evil omen," who walked at night weeping and wailing—a behavior that linked her with Tlalteuctli, the primeval creature that was torn apart to create the earth, and according to the Histoire du Mechique, wailed at night craving for human hearts and blood.[19] H. E. M. Braakhuis noted the parallels between the Mexica earth goddesses and the evil grandmother of Q'eqchi' myths. Indeed, Cihuacoatl played the role of the adoptive mother who raised the orphan Ce Acatl Quetzalcoatl after his mother died in childbirth, according to the Legend of the Suns.[20]

Modern Chatino myths are explicit about the meaning of the grandmother's death. After burning her, the sun and moon heroes declared that she would stay in the sweat bath and would get very good food whenever children were born. According to a version from Tepenixtlahuaca, Oaxaca, they said: "You will remain here, holy mother, and you will eat from what the children who will be born in the future give you. If they don't feed you, the children will die, everyone will come to you to have strength."[21] They instituted the practice of bathing newborns and bringing food and offerings to the sweat bath. Intended to propitiate childbirth, these offerings also appeased the old woman, who might otherwise harm the newborns. Reflecting the high rates of perinatal and infant mortality that prevailed in ancient Mesoamerica, the grandmother was likely believed to keep many children for herself.[22]

RAPING THE GRANDMOTHER

In the Popol Vuh, a turning point in the Hero Twins' story was the moment when a rat revealed that they were not destined to be farmers, and that their fathers—the brothers Hun Hunapu and Vucub Hunahpu, both named as "fathers" of the heroes—had left their ball-playing gear hanging from the roof of the house. To get it, they tricked their grandmother, asking her to mash chili peppers for them to eat. Thirsty, they emptied the water jar and asked for more. When Xmucane went down to fetch water from the river, they sent forth a mosquito that pierced her jar. Water gushed out, and the old woman was unable to stop it. Meanwhile, the rat cut loose the ropes that held

the ball-playing gear to the roof. Having recovered it, they went down to look for their grandmother, while still complaining of thirst, and stopped her leaking jar.[23]

Commenting on this episode, Mary Preuss suggested that the mosquito piercing the jar and letting the water out implied sexual intercourse.[24] She stopped short of noting that, as the Hero Twins' agent, the mosquito substituted for them. Therefore, the insect's mischief amounted to the heroes' sexual assault on their grandmother. Shocking as it may appear, the fact is that the entire episode is loaded with sexual innuendo. There is more than veiled lewdness in the heroes' request for mashed chili peppers—*q'utum ik*, spelled *cutum ic* in Francisco Ximénez's manuscript. According to Domingo de Basseta, the word *ik* ("chili pepper") was also employed in the sense of "moon," "the month," and perhaps by extension "when the menses come to women."[25] The heroes' request for mashed chili peppers easily overlaps with a demand for women's menses. This was no normal, socially sanctioned intercourse, but rather a terrible wrongdoing, compounded by the heroes' drinking the grandmother's bowl of chili sauce, akin to her menses. As previously mentioned, Mesoamerica peoples regard menstrual blood as a noxious substance that brings disease and death. According to a Q'eqchi' testimony, menstruation is "very hot," and a woman can "steal" her husband if they have sex while she is menstruating—meaning that she can steal his soul, causing illness. In San Pedro la Laguna, Lois Paul reported that menstruating women were sometimes likened to witches, who used their bloody rags to harm men: "Many men have eaten their beans with the blood of their wives and didn't know it." Having sex with menstruating women was especially dangerous, because "a long thing like a rope inside the woman descends and beats him when he enters her."[26]

Sexual transgression has consequences, and the Popol Vuh did not omit them. The heroes' unquenchable thirst evokes the punishment met by adulterers in modern narratives from the K'iche', Ch'orti', Tzeltal, and Tzotzil. The stories are about a deceived husband who managed to castrate his wife's lover and then tricked her to eat the penis. The woman became insatiably thirsty and drank water until she died from swelling or vomiting, or simply burst dead. A Tzotzil version tells how the husband asked his wife for food while giving her her lover's penis to eat. In marked agreement with the Hero Twins in the Popol Vuh, he requested mashed chili peppers. The woman became insatiably thirsty and drank many gourds of water until she finally burst.[27]

A parallel passage appears in Q'eqchi' myths. The sun punished the moon's unfaithfulness by making her and her lover eat a tamale prepared with turkey gall and ground chili. They choked and became very thirsty and drank all the water in the house, until the moon had to go down to the river with her jar to fetch more. There, a vulture convinced her to fly away to live with his king, identified in variant stories as an evil man, the devil, and, in the Senahú version, the lord of a place called |X|balba.[28] Her flight was tantamount to a transit to death, evoking the subsequent fate of the Hero Twins, whose transgression paved the way for their descent to Xibalba.

In this passage, as in many others, the authors of the Popol Vuh employed subtle, metaphorical language to convey deep religious concepts. Other narratives are much rougher, plainly describing sexual assault against the old woman. In the Kaqchikel town of San Antonio Palopó, Robert Redfield compiled a story about three brothers who lived with their grandparents. The older brothers went every day to the fields. Through prayer, they put their hoes to work by themselves, while they played in the shade—just like the Hero Twins in the Popol Vuh. Their younger brother found out and told the grandmother. Angered by their laziness, the old woman went to the field and scolded the hoes, which stopped working. Since then, men have had to toil the fields with much effort. In revenge, the older brothers asked the younger to climb a tree, where he turned into a monkey. Then they invited their grandparents to take a sweat bath. Once inside, they seized them and put ears of corn in their anuses: "In the anus of the grandmother they put a cane, and they cut off her vulva. They blew at the grandmother and she was swept away across the mountain. They planted her vulva and up came the güisquil, which has this form."[29] The grandfather turned into a tapir. The older brothers became the sun and the moon.

Tz'utujil myths from the opposite rim of Lake Atitlán offer variations. In a story from San Pedro la Laguna, it was the mother of the sun and moon heroes who died at their hands, in the sweat bath.[30] The overlap between the two women echoes the corresponding passage of the Popol Vuh, which described the mother and grandmother acting together. This is intriguing because Xquic, the Hero Twins' mother, largely vanished from the narrative after giving birth. There was no mention of her during the heroes' upbringing, yet she reappeared precisely at the moment when the heroes came to the house asking for food and drink, "just fooling their grandmother and mother." They sent her down to the river to check on their grandmother and later found both women trying to seal the jar by the river.[31] Throughout this passage, the mother appears to be largely assimilated with the grandmother, and both appear to be targets of the heroes' sexual assault.

A modern Yucatec narrative reiterated the passage in which an old woman's adoptive grandson perforated her water jar to distract her while he searched for the musical instruments she kept hidden.[32] While the story did not elaborate on the topic of sexual assault, the grandmother's deceit marked a turning point in the hero's plight, leading to his confrontation and eventual triumph over powerful foes. Otomí, Totonac, and Tepehua narratives contain subtle allusions to the maize hero's assault on his own mother. When the child returned home after enduring many trials, he threw arrows at the jars (chachapali) his mother had made, which were drying on the patio. In the Tepehua story, she kept plugging the holes every time. In a Totonac version, she started to make new vessels without knowing who was breaking them. While the sexual connotations are not explicit, perforating the jars is likely a sexual metaphor. Equally suggestive are Nahua myths from Veracruz, in which the hero found his mother weaving under a nance tree. He climbed the tree and threw fruits at her—another metaphor for sexual assault,

underscored by the woman's exclamation, in a Nahua story from Veracruz, "Oh, how delicious is this nance, and so big!"[33]

In a Popoluca version, the hero's mother was walking to fetch water by the river when her lost son found her. She did not initially recognize him and thought that her husband had returned from the world of the dead. The potentially incestuous relationship between mother and son is never fully voiced in the narratives, and it is outright disallowed by the hero in Eric Thompson's version of the Q'eqchi' sun and moon myth. Not knowing who he was, the mother invited her son to stay and be her husband, but he rejected her in anger.[34]

THE GRANDMOTHER'S LOVER

Her old age notwithstanding, the grandmother is commonly described as a sexually active woman who denied the children food and gave it to her lover instead. A version from Santiago Atitlán reiterated the adventures of three brothers who lived with their grandmother. The two older ones magically toiled their field, while the younger stayed home. Curious to learn where they all went, one day the boy followed his grandmother when she left the house. Instead of bringing food for the brothers in the field, the old woman went into a ravine to meet her lover, a monstrous animal with spotted skin. The Tz'utujil story omitted an important sequel, in which the heroes killed the monster and, according to many narratives, tricked the old woman to eat her lover's meat—often his penis, testicles, heart, or liver. In the Santiago Atitlán story, it was the younger brother who met punishment for telling the grandmother how the older ones made their instruments work by themselves. The brothers castrated him, turned him into a monkey, and fed the boy's penis to their grandmother. The old woman became ill; they prepared the sweat bath for her and heated it until she exploded. A güisquil grew from her ashes. The transformation of the old woman's genitals into a güisquil is a recurrent theme, also present in the story of Homshuk, the Popoluca maize hero from southern Veracruz.[35]

In Ch'orti', Q'eqchi', and Mochó myths, the grandmother's lover takes the shape of a tapir, although some versions describe another animal, a giant, or an unidentified monster. The heroes hunted birds in the forest and brought them home, but the old woman gave all the food to her lover. While the heroes were asleep, she spread grease on their lips and fingers, to make them believe that they had eaten. They finally found out, either by their own wits or by being alerted by a bird or animal. They killed the monster and, according to some versions, deceived the old woman and made her eat her lover's penis or testicles. This kind of punishment for sexual excess is widespread in New World myths, including Amazonian narratives in which a cuckolded husband fed his wife the penis of her lover, sometimes identified as a tapir. The myth's broad distribution attests to its probable antiquity.[36] The punishment was ritually enacted in the Guatemalan Highlands, as attested in Thomás de Coto's seventeenth-century Kaqchikel thesaurus: "After the ancient

people sacrificed a man, tearing him apart, if he was of the ones they took in war, they kept the genital member and testicles of the one sacrificed, and gave them to an old woman whom they held as prophet, for her to eat them."[37]

In numerous variants, the murder of her lover sparked the old woman's hatred for the children, and she decided to kill them. In an episode that recalls Xmucane's errand in the Popol Vuh, Q'eqchi' stories describe how the old woman went down to a stream. In Thompson's version, she took her jar and told the children that she was going to fetch water. Aware of her real intentions, they sent a lizard to watch her. The lizard found her sharpening her nails to kill the children and ran between her feet. Annoyed, she threw a sherd that stuck to the lizard's head, explaining the origin of the animal's crest. Warned by the injured envoy, the children put logs in their hammocks, with gourds for heads, and covered them with blankets. In some versions, the decoy was a bunch of bananas, in which the savage woman dug her nails, thinking they were the children.[38]

A version from Senahú makes evident the passage's sexual connotations; while the woman kneeled down in the water, the lizard ran between her legs, grazing her clitoris. The animal's phallic connotations are evident, and they echo sixteenth-century Nahua concepts that associated lizards with genital organs and sexual license.[39] Although markedly different, the lizard of the Q'eqchi' myths parallels the mosquito in the Popol Vuh; both were agents of the heroes' sexual assault on the old woman, down by the stream.

THE TOOTHED VAGINA

The old woman's sojourn to the river acquired further meaning in Don Lucio Méndez's detailed version of the Ch'orti' myth of Kumix. Having hunted all the birds in the forest, Kumix could no longer bring them to the Ciguanaba who had raised him. Alarmed because she was taking a long time to return from the river, the child realized that she planned to eat him and sent a small bird to spy on her. When the envoy reached the stream, "the woman was naked, spread inside the water, and she had a long stone and was sharpening her teeth . . . it was a thing to eat the child."[40] The bird flew back, but not without getting a bump on the head from a pebble that the old woman threw at it, complaining how rude it was to have passed beneath her—obviously between her legs, like the lizard of Q'eqchi' myths. The animals in these passages have definite phallic connotations, and the old woman's curious posture suggests that she was sharpening the teeth between her legs.

In Don Lucio's story, Kumix took the pestle from the Ciguanaba's grinding stone, wrapped it in a blanket, and placed it in his bed. Thinking that it was the sleeping child, she bit it hard and broke her teeth. Kumix came out and found her complaining of a toothache. Not by coincidence, the Q'eqchi' and Ch'orti' stories agree that the decoys were hard, cylindrical, and phallic-shaped objects—logs or stone pestles—or, alternatively, bunches of bananas, whose shape is quite suggestive. The sexual overtones of the old woman's bite

were made evident by her complaints in another Ch'orti' version, where she repeatedly bit the pestle: "Oh, my child . . . your bone is so hard."[41] While the narratives are not explicit, they insinuate that the woman possessed a toothed vagina.

Kumix's confrontations with his adoptive mother were completely omitted in Rafael Girard's abridged version, which reduced the entire passage to a single sentence, in which the hero ordered his mother to grind *chilate* for him.[42] This passage recalls, in a highly condensed form, the episode in which the Hero Twins fooled their grandmother and mother, asking them to mash chili peppers for them. While the drink is different, it probably contained a subtle allusion to Kumix's sexual aggression against the old woman.

Parallel episodes in a Tzeltal story from Chenalhó, Chiapas, are no less graphic. The hero, Ojoroxtotil, spent a night at the house of K'uxbakme'el, an old woman who ate people. She let him stay in the sweat bath, where they lit a fire. At midnight, K'uxbakme'el began sharpening her teeth. Instead of placing a decoy, Ojoroxtotil himself became like a big, hard stone—a transformation that carries obvious phallic connotations. One version specifies that he turned himself into a stone of the kind used to make grinding stones. Expectedly, the old woman bit him and broke her teeth. The next morning, she complained, "Ah, all my teeth are aching."[43] The hero went to find curing herbs for her. Healing and reproductive acts are suggested by the episode's setting inside a heated sweat bath—an unlikely place to spend the night. Both meanings overlap in previously cited Q'eqchi' myths that explain the origin of toothache, while relating it with sexual transgression.

The old woman breaking her teeth against hard, phallic objects finds further explanation in mythical beliefs about terrible females who possessed a toothed vagina. The myths are extremely widespread in the New World.[44] In general, they describe primeval females who castrated and sometimes killed men with their toothed vaginas. While some narratives make explicit mention of the fearful organs, others are less explicit and contain only veiled allusions to the women's aggressive sexuality. The oral and vaginal dentitions are sometimes transposed, as in Don Lucio's version of the Ch'orti' myth. The heroes normally succeeded in removing the vaginal teeth using a hard instrument made of stone, bone, antler, hardwood, or even metal—akin to the logs or pestles that the monstrous woman bit in the Q'eqchi' and Ch'orti' myths. Having lost their teeth, the women died or became available for sexual relations and reproduction.

Terrifying females who lure men with their apparent beauty, only to destroy those who fall in their traps, appear insistently in Mesoamerican narratives. The majority of accounts make no explicit mention of their toothed vaginas, which, nevertheless, are plainly described in Otomí, Mazahua, Mixtec, Huave, and Zoque narratives.[45] In the Mixtec town of Nuyoo, Oaxaca, John Monaghan recorded myths that described women's genital organs as serpent mouths: "A man falls madly in love with a beautiful woman. After having sex with her, he finds that her vagina is really the gaping mouth of a snake. Soon after, he dies." He related the belief to concepts about female genitals as sources

of pollution. Like the grandmother who rendered the heroes' magical tools useless in highland Guatemalan myths, the women of Nuyoo are believed to break machetes—the main masculine tools—just by coming in contact with them. Women are also believed to be friendly with snakes, creatures that are generally regarded with fear and whose very sight can cause illness, even if small and harmless.[46]

Félix Báez-Jorge found a similar belief about the Nawayomo ("evil water woman"), a female who, according to the Zoque of western Chiapas, possessed serpentine genitals: "There is a snake in the streams, it is big like a *mazacoate.* It is the snake that becomes *Nawayomo* . . . she is a woman but her thing [genital organ] is the mouth of a snake; the young men do not know it and they follow her. Then they die of hemorrhage, because it bites them when they use her [copulate]; it comes out at night."[47]

Detailed narratives about women with toothed vaginas are prevalent in Huichol myths. The trickster hero Kauyumari put teeth in women's vaginas to prevent people from multiplying. Lascivious, he forgot what he had done and was castrated, but he later placed a sacred deer antler in his penis—which had grown back—and broke the women's vaginal teeth, opening them for reproduction. Other Huichol myths describe the Sun God copulating with an underworld serpent at the beginning of the rainy season. Devoured by her toothed vagina, he transforms into a nocturnal sun.[48]

In Mixtec myths from eastern Guerrero, the heroes who would become the sun and the moon confronted a powerful woman who had teeth in her vagina. The narratives highlighted her craving for the fruits—zapotes or chirimoyas—that the lunar hero was eating, a clear indication of her sexual incontinence.[49] He finally shared them, and the fruits induced her to fall asleep. By itself, the shared fruit suggests sexual intimacy, but the narratives are much more explicit. Before ascending to the sky, the lunar hero opened the woman's legs and hit her with a stone pestle until he broke all her vaginal teeth. Another version described him removing the teeth with metal pincers. The procedure caused much bleeding, and the hero finally had sex with her.[50]

When the old woman woke up and realized what had happened, she threw her sandal to the hero, forming a group of stars—likely the Pleiades. Parallel episodes appear in Tlapanec, Trique, and Chatino narratives from eastern Guerrero and Oaxaca, and their analogy is reinforced by reiterated references to the formation of the Pleiades. The published versions rarely assert that the old woman had a toothed vagina, but they contain suggestive hints. In a Tlapanec version from Malinaltepec, Guerrero, the lunar hero employed two stones to shave the pubic hair of an old woman who pretended to be the sun or the moon. The pubic hair obviously substituted for her vaginal teeth, and like them, it had to be removed with stones. When she woke up, the woman threw the shaved hairs to the ascending hero, forming the Pleiades.[51]

The adoptive grandmother suffered the same fate in Trique myths. The heroes used a stone penis to rape her while asleep. She threw her sandals at them, forming

the Pleiades, as well as her weaving sticks, which formed the constellation of Taurus. A Tlapanec narrator made it clear that the abused old woman was different from the heroes' adoptive grandmother; nevertheless, in another version from the same community, she met the grandmother's usual retribution: "You will remain inside the sweat bath, so that they give you offerings there."[52]

In a Chatino story, the sun and moon heroes found a sleeping girl and raped her. The younger brother caused her to bleed and commented, "With this there will be children later."[53] The connotations are clear. The rape of the woman and the removal of her vaginal teeth explain the origin of menstruation, sexual intercourse, and reproduction. Echoes of this passage are repeatedly found across Mesoamerica, with or without reference to the removal of women's vaginal teeth. The Totonac of northern Puebla, the Nahua of Hidalgo, and the Purépecha of Michoacán explain menstruation as the result of visits from the moon, who comes to have intercourse with women every month. Similar notions are widely distributed across South America.[54]

Ethnographic accounts of the Huave of the Isthmus of Tehuantepec report the tradition—often told in jesting manner—that in the past, older men deflowered newly married women and removed their vaginal teeth before their young and inexperienced husbands could have intercourse with them. Guilhem Olivier noted a related tradition, described in a late sixteenth-century account from Yucatán, that implied the belief that women had toothed vaginas. Virgin women were brought to the Ahk'in priests, who deflowered them with a flint or deer antler, "so that their husbands could have dealings with them."[55] These practices—real or fictitious—seem to evoke ritual procedures in which priests emulated primeval myths explaining the origin of sexuality and reproduction.

In Jacques Galinier's view, "The toothed vagina is a key image to unravel the Mesoamerican cosmological puzzle of yesterday and today." Báez-Jorge and Eduardo Matos Moctezuma linked it with beliefs about the devouring earth and the return of the deceased to the earth's primeval womb, devoured by a toothed vagina. Matos Moctezuma suggested correspondences with representations of the earth as an aggressive female being with ravenous dentition in Mexica art.[56] His interpretation is strengthened by comparison with modern myths that transpose buccal and genital functions. However, as happens in the narratives, the toothed vagina was rarely, if ever, represented in an explicit way. Artists preferred to make more or less subtle allusions to the fearful organ. Other than buccal dentition, the toothed vagina sometimes took the shape of a gaping serpent, as in the case of the Bleeding Conch Vase. In addition, serpents also played the role of birth canals, effectively substituting for feminine genital organs. Further explored in the following sections, such representations are consistent with Zoque and Mixtec narratives that describe females with serpentine genitals.

FIGURE 47

Codex Magliabechiano, p. 76r,
Valley of Mexico, 16th century.
Biblioteca Nazionale Centrale di
Firenze, Italy. A Tzitzimitl is shown
with a serpent between her legs.

CHILDBIRTH

Sixteenth-century Nahua pictorial manuscripts show serpents crawling between the legs
of the *tzitzimime* (plural of *tzitzimitl*), dreadful females who threatened to come down
from the sky to devour people at critical calendric junctures (fig. 47). Serpents also crawl
under the skirts of the monumental Coatlicue and Yolotlicue statues from the Templo
Mayor precinct in Mexico. Following an original insight by Mary Miller, Michel Graulich
explained the snakes as menstrual blood. However, there is a possibility that these reptiles
embody the goddesses' threatening genitals. The actively polluting and detrimental quali-
ties generally attributed to menstrual blood easily overlap with beliefs in mythical charac-
ters with toothed vaginas.[57]

Serpentine genitals posed clear threats to potential suitors. Yet they also embodied
the blissful qualities of reproduction and childbirth. In fact, emerging from serpentine
maws was a common convention for childbirth in Mesoamerican art. Clear exam-
ples appear in the Birth Vase, a Classic Maya ceramic vase of quadrangular shape that
carries unique depictions of a mythical passage involving childbirth (figs. 48, 49). In a
detailed study, Taube analyzed the vase in light of Mesoamerican birthing practices. A
group of old goddesses with jaguar attributes play the role of midwives, attending a young
woman who stands on a large, personified mountain. One of the midwives embraces

FIGURE 48

The Birth Vase (Vase K5113), sides
1–3. Late Classic, lowland Maya
area. Los Angeles County Museum
of Art.

SIDE 1

SIDE 2

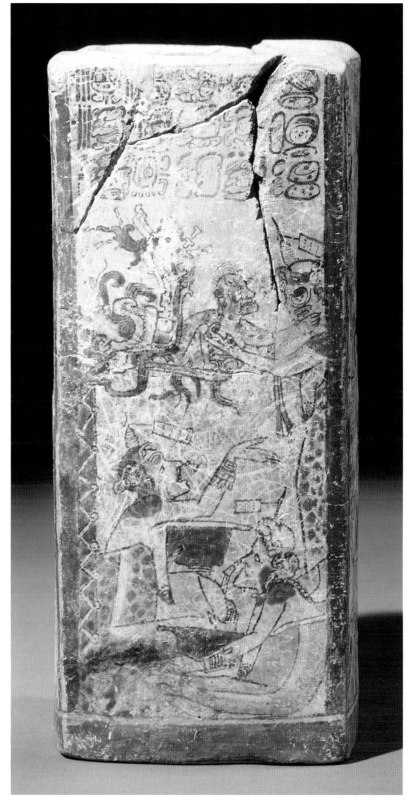

SIDE 3

FIGURE 49

Detail of the Birth Vase, sides 1–3
(see fig. 48). Old jaguar goddesses
play the role of midwives in a
mythical childbirth scene.

the parturient from behind, while she holds twisted, serpentine ropes that descend from above. Taube noted that the cords evoked umbilical cords, while also corresponding to actual ropes that are hung from the roof of houses during childbirth.[58]

No less than seven midwives attend the labor. Their wrinkled faces and hanging breasts denote their old age. They have jaguar ears, and one of them also has jaguar eyes and claws. They wear entwined serpentine headbands around their bald heads, together with spindles, thick with thread. Cotton, spindles, and weaving sticks—common attributes of Mesoamerican goddesses—are especially associated with midwifery. At Santiago Atitlán, Robert Carlsen and Martin Prechtel reported that the process of making cloth is likened to a birthing process, while the weaving sticks are regarded as aspects of important female deities. Midwives use them as magical tools to aid difficult deliveries.[59]

The young woman is clearly in labor, but the offspring are not born from her body, but rather from the open maws of two serpents that glide through the mouth of the personified mountain and turn upward on both sides of the vase. There, the midwives stand ready to receive the children. Arguably, the young woman's body bears a correspondence with the mountain itself—both capable of procreation—while the serpents function as birth canals. They embody feminine genitals, which in this case pose no threat to sexual partners, but instead open their maws to deliver the infants. The portentous delivery

produced curious babies with elderly-looking faces and jaguar attributes, perhaps related to the baby jaguars represented on codex-style vases (see fig. 11).

Taube highlighted the barely visible curved fangs that emerge from the baseline on either side of the personified mountain. The childbearing serpents pass through this maw, which therefore stands as a birth portal of sorts. These are the mandibles of a centipede, a creature that was strongly associated with childbirth in Maya art.[60] A striking example is the massive skeletal centipede maw that engulfs K'inich Janaab' Pakal on the Palenque sarcophagus lid. In recent work, David Stuart and George Stuart questioned the traditional interpretation of these maws as a portal to the underworld that swallowed the king's deceased body. Following an initial lead by Clemency Coggins, they noted that skeletal maws in Maya art served as places of cosmic emergence, and not of entrance. They concluded that the sarcophagus lid portrayed Pakal's rebirth from a centipede maw. Underscoring the metaphor, the king was portrayed in the bodily posture of a baby.[61] From this perspective, it appears that the skeletal centipede maw substituted for feminine genitals, serving as the king's birth canal.

A similar connotation applies to the serpentine creatures portrayed on Yaxchilán Lintels 13 and 14, which serve as birth conduits for members of the site's royalty. The inscription on Lintel 13 commemorates the birth of king Itzamnaaj Bahlam IV, whose parents, known as Bird Jaguar IV and Lady Chahk Skull, are shown standing and holding bloodletting implements (figs. 50, 51). Stephen Houston and David Stuart suggested that the future king himself is the character who emerges as a newborn from the maw of a serpentine being that winds around his mother's waist. They asked whether the scene could be interpreted as "an elaborate visual metaphor of birth."[62] Rather than a serpent, the creature can be recognized as a centipede, as indicated by its segmented body with multiple appendages, and by the shape of its frontal teeth, one curving markedly and the other projecting forward.

The companion, Lintel 14, shows an almost identical scene, although the standing male is not the king himself, but instead the brother of Lady Chahk Skull—suggesting the mother's brother could play the role of the father, at least in some contexts in ancient Maya royalty (figs. 52, 53).[63] While the inscription contains no mention of birth, the scene reiterates the iconographic conventions of Lintel 13, presumably referring to the birth of a royal woman identified in the associated hieroglyphic caption, likely a daughter of Lady Chahk Skull. On both lintels, the protagonists hold bloodletting implements, implying that their ritual performance involved self-sacrifice. Related scenes on other sculptures at Yaxchilán show royal women pulling cords through their tongues, in the context of painful sacrificial rituals. While sometimes involving men, the bloodletting rituals portrayed on these carvings were most often performed by royal women at Yaxchilán and elsewhere, and there are indications that they were related to the propitiation of royal childbirth.[64] While frequently identified as "visions," the serpents and centipedes portrayed on Yaxchilán Lintels 13 and 14 appear to embody the royal ladies' procreative powers and,

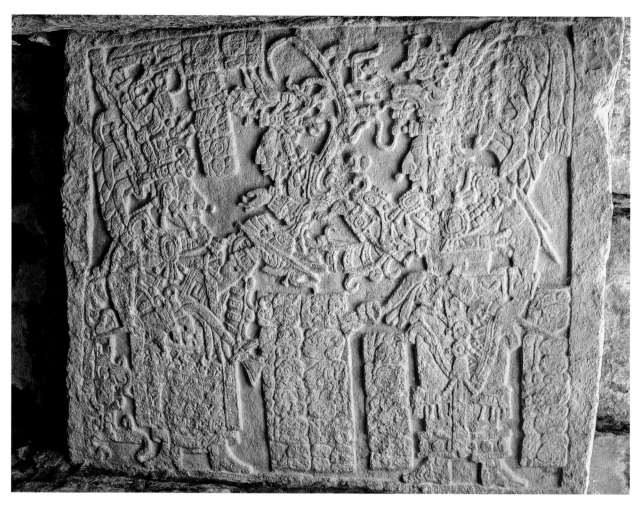

FIGURE 50
Yaxchilán Lintel 13, Late Classic,
lowland Maya area, AD 741.
Yaxchilán, Chiapas, Mexico.

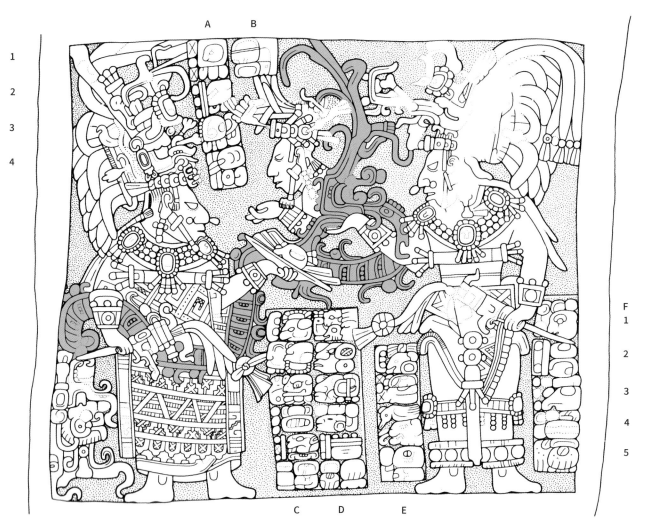

FIGURE 51

Drawing of Yaxchilán Lintel 13
(see fig. 50). The hieroglyphic text
commemorates the birth of a
royal heir, who emerges from the
open maw of a centipede.

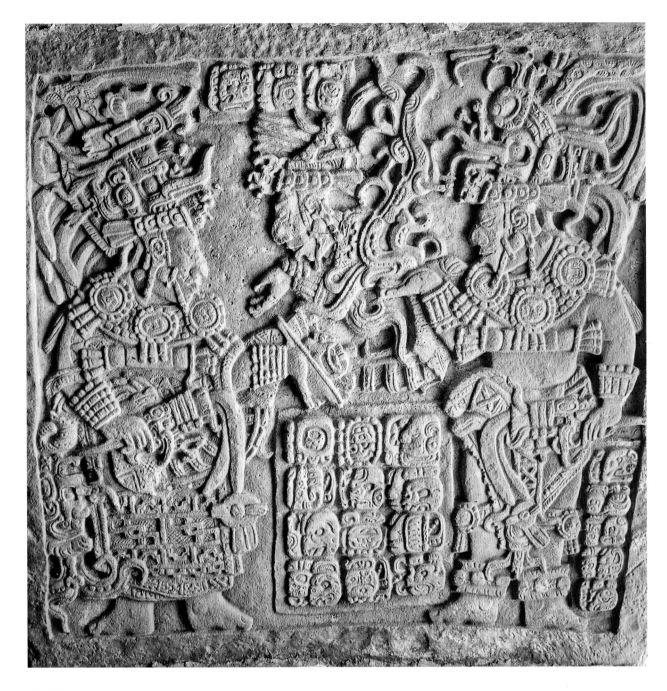

FIGURE 52
Yaxchilán Lintel 14, Late Classic,
lowland Maya area, AD 752.
Yaxchilán, Chiapas, Mexico.

FIGURE 53

Drawing of Yaxchilán Lintel 14 (see fig. 52). Note the serpent shedding its skin to reveal the segmented body of a centipede.

FIGURE 54

Nahua goddesses associated with centipedes and serpents: (a) Detail of Codex Borbonicus, p. 19, Valley of Mexico, 16th century. Xochiquetzal with a centipede under her seat and a serpent crawling under her feet; (b) Detail of Codex Fejérváry-Mayer, p. 27, Central Mexico, 16th century. Probable portrait of Chalchiuhtlicue, with a serpent in her jar and a centipede in water.

more precisely, their genitals, represented in the very act of producing offspring. Commenting on bloodletting rituals, Stuart pointed out, "Royal bloodletting was seen as a procreative act, metaphorically 'giving birth' to ancestors and other deities."[65] It appears that at Yaxchilán, the act of giving birth was not just alluded to in a metaphorical way, but also represented as a portent, in which royal mothers procreated children through the open maws of centipedes and serpents.

The ability of the royal ladies to interact with centipedes and serpents amounts to a veritable portent, especially considering the noxious connotations of these creatures. In Mesoamerican beliefs, centipedes and serpents belong with a host of poisonous, biting creatures that are generally regarded as carriers of disease. Yet it is not rare to find them in close association with women. In highland Mexican pictorial manuscripts, they are frequently associated with goddesses related to sexuality and childbirth (fig. 54; see fig. 43). This association may find explanation in Mesoamerican notions about sexuality. In early colonial Nahua literature, sexual activity was characterized as earthly and filthy, epithets that also applied to centipedes, serpents, and other lowly creatures that crawl in the earth. Modern Maya myths explain that poisonous creatures actually originated from feminine genitalia or from menstrual blood. As noted, Q'eqchi' sun and moon myths described the origin of poisonous creatures from the blood of the moon—sometimes plainly characterized as menstrual blood—while a Mopan version described the birth of noxious creatures from the moon's womb itself.[66]

In Izamal, Yucatán, María Montoliú Villar recorded a myth that described the origin of plagues and diseases as a result of a young man's intimacy with a girl whom he found on the beach. They fished together, shared fruits, and slept together under a flowering tree. After that, they heard noise inside a rocky hole in the beach. When they removed the stones that covered it, all sorts of biting and poisonous creatures came out. Less subtle, a Cora myth from west Mexico described how Sautari, the evening star, fell in the embrace of a woman who tempted him to have sex. She then let go all sorts of pests, "scorpions, centipedes, spiders and tarantulas that will remain. They would not exist if our older brother Sautari had not got lost."[67] In every case, poisonous creatures result from the pollution associated with sexual activity and are especially associated with menses and feminine genital organs.

Midwives are absent from the portentous childbirth scenes of the Yaxchilán lintels. While sometimes portrayed on ceramic figurines, old women were not favored subjects of ancient Maya artists. Despite their important role in myths, old goddesses were also uncommon. The Birth Vase's midwives stand out among a reduced number of portraits of old goddesses in Classic Maya art. However, Taube noted that they correspond in every detail with the portraits of the goddess Chak Chel in the Postclassic codices (see fig. 43).[68]

One of the most intriguing characters in Mesoamerican mythology, the grandmother is at once a primary creator goddess and an aggressive antagonist of the young heroes who created the conditions for human life—her grandchildren, by birth

or adoption. Her personality ranges from a nourishing maternal figure to a pathetically lewd old hag and a rancorous child-eater. While not always explicitly identified with the earth, her behavior is consonant with the notion of the earth as a voracious mother who yields her fruits reluctantly and ultimately consumes her own children. Overpowered by the heroes, the grandmother acquired an equally duplicitous role as the model midwife—the sweat bath—who delivers children on condition of being properly fed and appeased, but who may also retain them at will.

The old goddess was not the only foe whom the sun and moon heroes confronted. Reiterated episodes in Mesoamerican narratives describe monstrous beings that prevailed in former eras and opposed their rise as luminaries. The heroes finally defeated them, allowing the institution of proper moral order. Yet the sun's opponents remained powerful, were revered as gods, and were represented in major artworks by the ancient Maya and other Mesoamerican peoples.

6 The Sun's Opponents

It came down to burn the sacrifice at noon, like a macaw coming down, flying
with its feathers of many colors.

—Bernardo de Lizana

Writing in the early seventeenth century, the Franciscan friar Bernardo de Lizana re-
called K'inich K'ak' Mo', "an idol with the figure of the sun" that received cult in a major
temple at Izamal, Yucatán. People flocked there at times of plague and death by sickness
or hunger. They brought offerings and witnessed how K'inich K'ak' Mo' came flying down
at noon, like a macaw with colorful feathers, and burned the offerings with bolts of fire.[1]

The appearance of K'inich K'ak' Mo' to gather offerings at noon recalls modern
myths about monstrous birds that appeared at dawn or at noon, obscuring the sunrays
with their wings. According to some versions, they snatched people along the roads
or required human victims for food. Related stories describe monstrous birds—some-
times serpents—that pretended to shine like the sun, but shed only a dim light over people.
Invariably, they perished in encounters with the heroes who would become the sun and
the moon. With some frequency, the celestial monsters were joined by earthly partners,
described as aggressive females who also confronted the heroes, opposing their rise
as luminaries. The defeat of these primeval monsters was a crucial step that created
the conditions for the rise of the luminaries and the advent of people. Yet the defeated
monsters remained significant and powerful and were accorded proper cult, just
like K'inich K'ak' Mo' at Izamal.

THE BIRD WITH THE TOOTHED VAGINA

Izapa Stela 25 is one of the most famous carvings in Mesoamerican archaeology, repeat-
edly reproduced and discussed in scholarly works, textbooks, and popular literature
(figs. 55, 56). The stela originally stood in the Group A plaza of Izapa, built during the
Late Preclassic period. The carved surface is almost complete, and it preserves consider-
able detail, although it may have suffered damage at the hands of looters who robbed the

OPPOSITE **FIGURE 55**

Izapa Stela 25, Late Preclassic, Pacific Coast of Chiapas, Mexico. Museo Arqueológico del Soconusco, Tapachula, Mexico.

FIGURE 56

Carved relief on Izapa Stela 25 (see fig. 55). Note the serpentine maw biting a severed arm in the abdomen of the great bird, and the mutilated arm of the character who stands below.

stela in 1960 and thinned it for transportation.[2] Despite its importance, the sculpture's published records are poor and confusing. There are few available photographs, and the published drawings vary considerably in important details.

The stela shows a crocodilian tree, with the head and front legs in the ground and the hind legs and tail rising up, transformed into leafy branches. A small bird is perched on top. A male character stands in front, holding a staff with his right hand. He pulls the lower end inside a jar, while turning his face up to watch a huge bird that perches on crossbars atop the staff. His left hand is conspicuously missing, substituted by three undulating gushes that presumably represent blood flowing from the stump.

Beginning with Gareth W. Lowe, many scholars have linked Stela 25 with the mythical story of Seven Macaw.[3] According to the Popol Vuh, Seven Macaw was a proud being that pretended to shine like the sun and the moon over the wooden people of the previous era. He boasted of his bright eyes and teeth that glittered in the dark like precious stones, silver, and gold. Yet the text makes it clear that this happened when there was no sun, and the earth was dimly brightened. The Hero Twins saw evil in Seven Macaw's pride and decided to shoot him down. They stalked him as he perched every day on a nance tree to eat from its fruit. Hunahpu hit the bird's jaw with a blowgun shot, bringing him down to the ground, but when he ran to grab him, Seven Macaw tore off the hero's arm from his shoulder.[4]

The great bird of Stela 25 is a formidable being. It is very large in comparison with the human character—conceivably a boy, although there is no certainty about his age. The bird's chest has a large, skeletal face, with a snake coming down from the mouth and coiling around the staff and the crocodilian tree, to reach the jar at the base. The bird's wide-open beak reveals a partly eroded human head inside. Its own peculiarly shaped, undulating head is crowned by a stub that Karl Taube identified as a maize symbol.[5] A cartouche on the widely open left wing contains an *ak'ab* sign that denotes the night or darkness. By comparison with related birds in Preclassic Maya art, the right wing probably had a *k'in* sign, denoting the sun or the day. An especially important detail that has remained largely unrecognized is the series of bird heads—no less than two, and perhaps originally three—that peek out from the wing. Equally intriguing is the serpentine maw that appears in the bird's abdomen, biting a severed arm. This is likely the hero's torn arm, with the hand hanging loosely behind the bird's own leg.

Similar attributes reappeared several centuries later, in the Early Classic modeled stucco macaws from the first building stage of the Copán ball court, which was uncovered by William and Barbara Fash (fig. 57). Portrayed frontally, these powerful, red-painted birds have distinctive macaw features. They share with the Izapa bird the manifold small heads peeking out from the upper part of the spread wings, and the serpent head that juts out bluntly from the abdomen, biting a severed arm. Fash and Fash noted an incised oval dot on the arm and suggested that it belonged to the young spotted god, labeled God S by Taube. This is the character whom Michael D. Coe identified as a

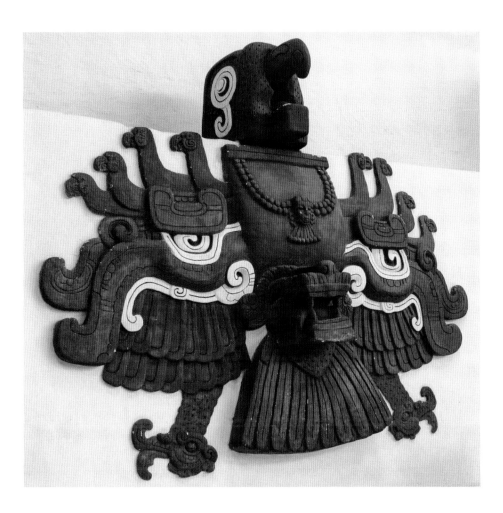

FIGURE 57

Replica of stucco macaw from the first constructional stage of the Copán ball court. Museo de Escultura de Copán, Honduras. The serpent in the bird's groins is biting God S's severed arm.

counterpart of Hunahpu, the hero of the Popol Vuh, who lost an arm in the struggle with Seven Macaw.[6]

The parallels with the Popol Vuh story are tangible, but it appears that the sculptors of Izapa and Copán based their work on an ancient version of the myth, in which the great bird did not tear the hero's arm off with its beak, but rather with its forbidding abdominal mouth. In previous work, I suggested that this was the bird's toothed vagina, represented as a serpentine maw.[7] This interpretation reinforces, rather than disavows, the links between these images and the account of Seven Macaw in the Popol Vuh. A close examination of the Popol Vuh passage shows that it is rich in sexual innuendo.

SEXUALITY AND SICKNESS IN THE SEVEN MACAW MYTH

Every day, Seven Macaw perched on a nance tree to eat from its fruits. While this habit may seem appropriate for a macaw, there could be deeper reasons why it was described with some detail in the Popol Vuh. As noted in previous chapters, eating fruit is a metaphor for sexual intercourse in Mesoamerica. This habit was likely an allusion to

Seven Macaw's sexual appetites, which contributed to his defeat. By no coincidence, the Hero Twins shot Seven Macaw while he was engrossed in eating nances. Multiple narratives describe characters who were vanquished as a consequence of their engagement in sexual activity, which is generally considered debilitating, especially for men.[8]

Hunahpu's mutilation is equally suggestive, since the loss of a limb has repeatedly served as a metaphor for castration. Victoria Bricker described its use by jesting performers in the modern carnivals of highland Chiapas, which involve role reversal and a break in established social mores. At Chamula, the performers risk "breaking a leg"—that is, losing the penis—by stumbling over the stones on which women sat to watch the festivities. According to Bricker, the performers equate the stones with women's vaginas. Sexual transgression is frequently associated with the loss of a leg, to the extent that "breaking a leg" or "burning a leg" is a euphemism for marital infidelity, in common usage among Maya and non-Maya Guatemalans. However, the leg may substitute with another member. According to Jacques Galinier's ethnographic studies, the modern Otomí conceive a correspondence between the loss of a foot, an arm, and even the head, all of which are structurally related to castration.[9]

At Santiago Atitlán, Mam—the god who "eats the fruit" during traditional Easter rituals—is sometimes described as lame. Stories describe how he lost a leg, an arm, or a finger in his fight against Itzil Winiq, an evil monster who lived in the Atitlán volcano. Which member he lost seems to be irrelevant, but the mutilation is essential. Disorderly sexuality and sexual ambiguity are salient characteristics in Mam's myths, to the point that the Atiteco forebears had to dismember him to stop him from seducing all the women in town.[10]

Hunahpu's blowgun shot in the Popol Vuh may allude to sexual assault, although it seems to relate more strictly to the magical inducement of sickness. The shot broke Seven Macaw's mouth, triggering a strong toothache. Disguised as the companions of curers—their grandparents in animal shapes—the Hero Twins approached Seven Macaw's home while he yelled in pain. Their solution to the monster's demand for help was to extract his teeth and replace them with "ground bone," which in fact was only white corn. Deprived of his shining teeth, Seven Macaw lost his lordly splendor. The heroes completed their task by plucking out Seven Macaw's bright eyes. With this, his greatness faded out, and he finally died.

The sun hero of modern Q'eqchi' myths used a similar ploy to overcome the evil lord—the devil, the king of vultures, or an evil man—who had abducted his wife, the moon. He threw red maize kernels over the roof of his house, which had the same effect as Hunahpu's blowgun shot. They induced an unbearable toothache for the lord or, according to some versions, for the unfaithful moon. Like the Hero Twins, the Q'eqchi' sun hero disguised himself as a curer and musician, but did not treat the lord's pain. According to different stories, he induced the ailing lord to sleep, or simply killed him and fled with his wife.[11]

In their respective studies, María Montoliú Villar and H. E. M. Braakhuis discussed Yucatec, Mopan, and Q'eqchi' narratives that explain the origin of disease agents—stinging, biting, and poisonous creatures such as snakes, scorpions, centipedes, toads, wasps, and ants—as a consequence of sexual transgression. The colonial Yucatec incantations contained in the Ritual of the Bacabs also associated sickness with such agents, and explained them as the result of lewd sexual encounters. As previously discussed, toothache is especially associated with sexual desire and transgression in Q'eqchi' mythical narratives, and the modern Q'eqchi' associate toothache with sexual transgression.[12]

Ultimately, the links between toothache and sexuality relate to mythical beliefs about the toothed vagina. As previously noted, the ogresses who possessed a toothed vagina in mythical narratives were usually defeated when the heroes broke their terrible dentition. The Tzotzil old woman, K'uxbakme'el, who broke her teeth biting a stone pestle—or biting the hero himself, turned hard like a stone—complained of a strong toothache the next morning. Her name translates as "Mother Bone Cruncher," but according to Calixta Guiteras Holmes, she was "the mother of toothache."[13] The hero himself brought herbal remedies for her, thus instituting both the sickness and its cure.

Seven Macaw's habit of eating fruit, his rejoinder to Hunahpu's attack (a metaphorical castration), and his toothache cast him as sexually incontinent and sexually aggressive. He fits well in the category of immoral beings who dominated the world before the sun came out. From this perspective, this character of the Popol Vuh comes quite close to the great birds represented many centuries earlier at Izapa and Copán, holding the heroes' torn arms in their vaginal maws. The remedy that the heroes applied—extracting the monstrous dentition—replicated the punishment exerted on the primeval monstrous females with toothed vaginas.

PONDERING CHIMALMAT

The authors of the Popol Vuh did not describe Seven Macaw as possessing a toothed vagina. He was a male, as implied by the fact that he had a wife, called by the Nahua name Chimalmat. Mentioned only in passing, she died together with her husband, but there is no explanation of why or how. While a separate individual, Chimalmat appears to be Seven Macaw's feminine aspect, who was unable to endure by herself after he died. There is no way to reconstruct the details about Chimalmat that the authors of the Popol Vuh left unmentioned. Yet her name recalls other aggressive females in Mesoamerican mythology, and her presence is consistent with the allusions to the toothed vagina myths contained in the Seven Macaw story.

Chimalmat's name is closely related to Chimalman, the name of an aggressive female in sixteenth-century Nahua myths. Recounted in the Legend of the Suns, her story begins with the hunters, Xiuhnel and Mimich, pursuing a pair of two-headed deer that

came down from the sky. The deer took the shape of women, who lured the hunters with food and drink. Xiuhnel acceded and lay down with the woman, who turned over him and broke his chest open. Mimich resisted, making fire and entering in it to escape while being pursued by the woman, who was named Itzpapalotl. She finally got stuck in a ball cactus, where Mimich shot her repeatedly. Under the name of Mixcoatl, he became a conquering hero. As noted by Pat Carr and Willard Gingerich, the episode is reminiscent of myths about terrible women with toothed vaginas who made prey of the unsuspecting men who fell into the trap of their embrace.[14]

Mixcoatl was tempted for a second time by Chimalman, who appeared naked and open-legged, exposing her crotch before him. At once alluring and threatening, her stance signified an outright aggression to the hero. Women exposing their genitals are repeatedly mentioned in contexts related to warfare in Mesoamerica. The modern Chamula describe how their women fought with their genitals during the War of Castes of 1867–70, raising their skirts and showing their buttocks to cool down the opponents' firearms. In a famous episode of Mexica history, the women of Tlatelolco came to defend their city naked, beating their genitals and showing their buttocks, wielding brooms and weaving implements like weapons, and throwing their milk and excrement at the advancing warriors. Whether it happened or not, the descriptions of their charge in sixteenth-century accounts cast the conquest of the city as akin to the triumph of the sun—personified by the Mexica king Axayacatl—over the monstrous beings that prevailed in primeval times.[15]

Mixcoatl was only able to subdue Chimalman after he twice shot four arrows at her. Both times, one arrow passed above her, the second passed by her side, she caught the third with her hand, and the fourth passed between her legs. While the text is not explicit, the sequence suggests that the fourth arrow, directed against her genital area, was the one that allowed the hero to overcome her aggressive sexuality; he finally lay down with her and made her pregnant. Their son, Ce Acatl, was born after four days of painful labor for his mother, who then died. The prolonged labor and final death of Chimalman cast her as a model for the *mocihuaquetzque*, the heroic women who died in labor, regarded as akin to the warriors who died on the battlefield or on the sacrificial stone. It also recalls the death of the Mixe maiden whose children came out from her dead body.[16]

As Seven Macaw's wife, Chimalmat probably shared more than just the name with her Nahua namesake. At the very least, she belonged in the category of the monstrous beings who opposed the rise of the sun. Chimalmat's role in the narrative hints at the possibility that Seven Macaw had a feminine aspect, separate but strongly merged with him. They behaved as dually gendered beings, "entities who simultaneously incorporate within themselves both a wholly male and a wholly female aspect," as defined by Cecelia Klein.[17]

The pairing of Seven Macaw and Chimalmat is consonant with the dual forces that Mesoamerican solar and lunar heroes confronted, in myths that pitted them against celestial and terrestrial, male and female foes. Both had to be vanquished before the sun could rise and moral order could be established.

Jesper Nielsen and Christophe Helmke noted that the Seven Macaw myth belonged to a widespread genre of "monster-slayer" myths that are broadly distributed throughout the New World. In many stories, the hero or heroes—sometimes twins—confronted avian monsters that posed a threat to the world and often possessed objects or knowledge that the heroes pursued. Modern narratives contain numerous examples.[18] Yet scholars are generally unaware that Mesoamerican myths feature a complementary pair of opponents, male and female, who confronted the heroes in succession or, in some cases, at once. This is especially apparent in modern narratives about the sun and moon heroes from Oaxaca, Guerrero, and Veracruz. The male and female foes whom the heroes confronted in those stories offer parallels for the dually gendered couple formed by Seven Macaw and Chimalmat in the Popol Vuh.

A widespread myth describes a primeval time in which there were giant birds—eagles or hawks—that carried people away to eat them or feed them to their chicks. People covered their heads with baskets or cages to hide from them. Some stories feature an episode in which a man was finally able to kill the chicks and the bird itself. Such stories have been widely attested among the modern Maya, in Lacandon, Ch'ol, Chontal, Ch'orti', Mam, Poqomam, Jakaltek, and Ixil communities.[19] Modern Maya myths do not link the story with the origin of the sun and the moon. However, such a link is clear in myths from Oaxaca and Guerrero, which frequently attribute the monsters' defeat to the heroes who would become the sun and the moon.

Chinantec and Cuicatec myths describe an eagle that snatched people and, according to some versions, had multiple heads. In Chinantec versions, the heroes were two orphan children—a boy and a girl—who were raised by an old woman. They killed the old woman's husband, a deer, and some stories affirm that they fed her the heart. They finally turned the old woman into a tepescuintle. In a version from Usila, Oaxaca, they later found an evil woman who killed and ate people. While she was a different woman, she suffered the fate commonly reserved for the grandmother in myths from other regions—the heroes burned her in her house. In due course, they encountered a multiheaded eagle—with two or seven heads, according to different versions—that perched on top of a tall mountain and came down to snatch people. The children protected themselves under a cage and were carried within the cage by the monster. Reaching the mountaintop, they found other victims, who told them that the eagle slept every day at noon. At that hour, the children strangled the monster until its bright eyes popped out. Some versions describe how the eagle stumbled downhill until it hit the ground, where its eyes fell out.[20]

The predator was not always a bird. The monster was a giant serpent in Trique, Mixtec, and Chatino myths, while Tlapanec and Chatino versions describe a lagoon-dwelling snake or dragon. The Tlapanec heroes killed it with arrows, while their Trique, Mixtec, and Chatino counterparts threw heated stones in the monster's mouths—all seven of them,

according to a Mixtec version from Guerrero. Invariably, the heroes extracted the beast's bright eyes.[21]

Mixe stories from the region of San Lucas Camotlán, Oaxaca, recorded by Walter Miller, marked a distinction between the two opponents whom the heroes confronted. First, the heroes killed a giant serpent, throwing a burning stone in its mouth; second, they shot with arrows a large animal of unidentified species—according to one version, larger than a tapir—that snatched people and took them to a lofty mountain or a tall tree. Like the great birds of Chinantec stories, it crashed down to the foot of the mountain when the heroes shot it. The Mixe myths do not mention the monster's bright eyes, which are critically important in other versions.[22]

While not present in every story, the monster's fall from a tall tree or a high mountain and the final extraction of its bright eyes are common themes that the Oaxacan narratives share with the story of Seven Macaw. Echoing the Popol Vuh, some myths also describe the dim light that the monster shed before the true sun came out. In a Chatino version from San Juan Quiahije, Oaxaca, a woman told the heroes that the bright-eyed snake was the one that illuminated them, in exchange for human victims. As she prepared to give her own daughter for sacrifice, the woman remarked that everything would be dark if they killed the snake.[23]

Retelling a Nahua myth from the Sierra de Zongolica, Veracruz, Lorenzo Tahuactle Tehuintle described an "immense luminous snake that barely illuminated that endless darkness," and required young maidens as food.[24] In this version, the death of the monster was distinctly tied to the punishment of the heroes' adoptive grandmother. The heroes gathered abundant firewood and used part of it to heat the sweat bath in which they suffocated the old woman. With the rest of the wood, they burned a field that they had slashed for cultivation and heated the stones they threw in the monster's mouth. Finally, they threw themselves in the fire and emerged as the sun and the moon. The Zongolica myth made it clear that the serpent and the old woman died at the same time, just like Seven Macaw and Chimalmat in the Popol Vuh.

In most narratives, the heroes' fight against the bright-eyed monster took place after they had dealt with the evil old woman who raised them. However, the children's opponents merged in Trique myths, where the old woman herself was the one who shed a dim light before the sun came out, walking in the sky with a pine torch. A Zapotec myth explains that the bright-eyed monster was the old woman's brother. As the story goes, the heroes killed the old woman's husband and gave her the heart to eat. Vexed, she called her brother, asking him to pursue the children in their escape. Although he appears to be a man, the old woman's brother is akin to the monstrous serpents of related stories. The heroes killed him by throwing heated stones in his mouth and then plucked off the bright eyes from his cadaver.[25]

Another variation appears in a Mixtec narrative from eastern Guerrero, which omitted mention of the heroes' adoptive mother. Instead, it concentrated on their fight

against a seven-headed serpent that required young maidens as food. They killed it with heated stones and extracted its bright eyes. Then they confronted the owner of the serpent, a woman who had a toothed vagina. As previously noted, they induced her to sleep with chirimoyas, and then the lunar hero broke her vaginal teeth and raped her.[26]

The dual nature of the primeval monsters confronted by the sun and moon heroes is a nodal subject in Mesoamerican mythology. Broadly speaking, the myths describe two contrasting antagonists who had celestial and terrestrial, male and female qualities. The male, celestial foes were generally bright-eyed birds or serpents that shone with a dim light; their female, terrestrial counterparts were old women, sometimes possessing a toothed vagina. These women overlap considerably with the heroes' grandmothers, although most narratives distinguish them. Expectedly, this pattern is not evident in every version. Individual stories tend to highlight one or the other, and, in some cases, both antagonists merged into a single individual.

Seven Macaw merged both aspects. His avian nature, glowing eyes, and dim light pertained to his male, celestial aspect. His sexuality may relate to both, while the final extraction of his teeth betrayed his feminine side, as a counterpart of the monstrous females with toothed vaginas who opposed the rise of the sun. This aspect seems to be personified by Chimalmat, his feminine counterpart in the Popol Vuh. The couple embodied the male and female, celestial and terrestrial forces that opposed the rise of the sun and the moon.

BIRDS OF A FEATHER

Narratives that describe the heroes' confrontation with a great bird pay recurrent attention to the hour of the monster's death. When noted, it occurred at critical points of the solar cycle—at noon or, less frequently, at dawn. It was at noon when the sun and moon heroes strangled the double-headed eagle in the Chatino version from Usila. In Popoloca myths from southern Puebla, it happened early in the morning. The hero shot an arrow at a great eagle that perched before the sun, casting its shadow over the earth. The eagle fell down, allowing sunlight to shine.[27]

A Teenek myth evoked an ancient time when an enormous man-eating hawk appeared at noon, blocking sunlight with its enormous wings. It was Dhipaak, the maize hero, who confronted the monster. He instructed people to prepare a large jar of atole, put a stirring rod over it, and placed himself as a decoy on the stirring rod. At noon, it got dark as the hawk approached. It came down on Dhipaak, who jumped and removed the stirring rod. The bird fell in the hot atole, where people beat him to death. They marveled at the little hawks that were born from every feather they pulled out.[28]

Despite the geographic and temporal distance, Dhipaak's ploy to kill the great hawk may help to explain the pole held by the maimed protagonist of Izapa Stela 25. The great bird is perched on top of the pole, while the lower end of the pole is inserted in a jar. The

question is whether this pole might be analogous to the stirring rod of the Teenek myth. In the absence of synonymous passages from other narratives, the ploy used by the maize hero in the Teenek myth cannot be considered as a nodal subject of the myth, and the possibility that the Preclassic stela represented a similar ploy remains speculative. However, the links are reinforced by the multiple heads on the great bird's wing on the Izapa stela, which are probable counterparts of the little hawks born from the monster's feathers in the Teenek narrative.

The stirring rod is an important motive, with possible sexual connotations. The modern Teenek of Chontla, Veracruz, liken the rod used to stir nixcomel (maize cooked with lime) to a penis, and the cooking jar to a womb. From this perspective, the hawk's death in the Teenek myth may involve a metaphor of sexual incontinence and sexual aggression—in consonance with the pervasive sexual connotations of great bird myths throughout Mesoamerica. In a similar vein, Betty Bernice Faust reported that Yucatec Maya women from Campeche make sexual jokes while stirring chocolate with a special stick that is sometimes referred to as a "penis," likening the movements to sexual intercourse.[29] While these testimonies are quite removed from the Late Preclassic version of the myth that was known at Izapa, they suggest possible meanings for the rod and jar of Stela 25. These motives may allude to the bird's immoderate sexuality, which led to its defeat.

The fate of the great hawk in the Teenek myth also recalls the death of Itzpapalotl, which also happened at noon. According to the Legend of the Suns, Itzpapalotl fell on a *teocomitl* that came down from the sky, and Mixcoatl repeatedly shot her with arrows. In Alonso de Molina's dictionary, the word *teocomitl* refers to a large cactus, although its literal meaning is "sacred bowl."[30] Several authors have noted the word's double sense, alluding both to a ball cactus and to an actual recipient, perhaps akin to the atole jar of the Teenek myth. Thus, Itzpapalotl's fall in the teocomitl parallels the fall of the great hawk in the atole jar. If indeed Mixcoatl's arrows had phallic connotations, as Doris Heyden suggested, then thrusting them at the teocomitl—a sacred bowl and a symbolic womb— was likely a metaphor for sexual aggression, a common punishment for the primeval female monsters.[31]

The great bird of Izapa Stela 25 is the earliest known example of an iconographic theme that would reappear in Early Classic Teotihuacan art. Fash and Fash pointed out that the ventral maw of the Copán ball court macaws—their toothed vagina—was a feathered serpent, closely resembling models from Teotihuacan. While feathered serpents were present in the Maya area since the Preclassic, the use of Teotihuacan iconographic conventions by the Copán sculptors suggests that they somehow related these birds to the highland Mexican city.[32] Indeed, the Teotihuacan mural paintings contain depictions of large birds that shared iconographic features with the earlier representation at Izapa, and were likely related to the primeval defeat of the sun's opponents.

At the base of the sun pyramid at Teotihuacan, the rooms of a palatial compound known as "Conjunto del Sol" contain representations of humanized birds—with a human

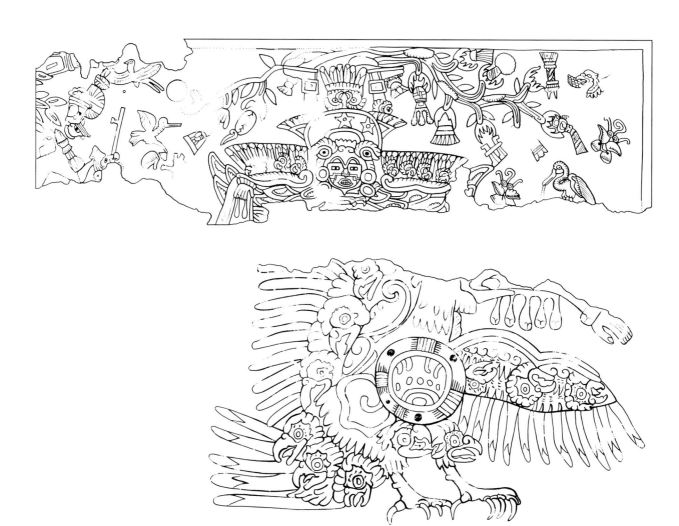

FIGURE 58

Detail of a mural painting from the Conjunto del Sol, Teotihuacan, Early Classic, Valley of Mexico. A great bird flies down amidst flowering vegetation. At left, a blowgun hunter shoots at birds.

FIGURE 59

Detail of a mural painting from Atetelco, Teotihuacan, Early Classic, Valley of Mexico. Multiple heads stick out from the wings, legs, and body of a great bird that bites a severed human arm.

face inside the open beak, human legs, and hands—that descend amidst a flowering landscape of lush vegetation (fig. 58). Multiple small bird heads peek out from their wings, legs, and tail. Taube saw in these birds the combined features of quetzals and macaws and tentatively suggested that they portrayed a Teotihuacan solar god. He quoted a modern Huichol myth, originally recorded by Robert Zingg, that explained the origin of macaws and parrots. When he emerged from the underworld, the Sun God had no clothes. He spit in the sea—a probable metaphor for fecundation, perhaps involving sexual transgression. Several birds came out, the macaw among them. When the macaw shook its wings, many small parrots flew in every direction. Their feathers were used to craft the sun's ritual arrows.[33]

Nielsen and Helmke noted that the Conjunto del Sol murals also featured blowgun hunters shooting small birds. Moreover, they described further examples from the mural paintings of Atetelco, Teotihuacan (fig. 59). The fragmentary paintings include remains of two standing birds that had multiple heads in their outstretched wings, legs, and tail. One

of them preserves part of the beak, which bites a human arm that hangs laxly, dripping abundant blood. Nielsen and Helmke related the torn arm in the beak of the Atetelco birds to Hunahpu's mutilation by Seven Macaw in the Popol Vuh and, more broadly, they related these representations to widespread myths about the defeat of a great birdlike creature by twin brothers in New World myths.[34]

Teotihuacan-style ceramics from the Pacific Coast of Guatemala feature further examples. Figurines representing avian characters with multiple bird heads in the arms and legs may correspond to humanized versions of the great bird (fig. 60). Most impressive are the so-called "theater" censer lids that represent temples (figs. 61–63). These unprovenanced objects likely originated from sites in the coastal plain of Escuintla, a region that experienced a strong cultural influx from Teotihuacan during the Early Classic period.[35] Perched on the roof of the temples, there are large, descending birds, with or without a human head inside their beaks, and with multiple macaw heads on their wings. Their large, round eyes and broad beaks suggest macaws, strengthening their connection with the nearly contemporary representations at Copán. The connection with the great birds at Izapa, Copán, and Teotihuacan is underscored by the rows of severed human arms that hang down from the temple cornices, together with small birds. Thick drops, surely of blood, flow down from the freshly cut arm in the middle of the cornice.

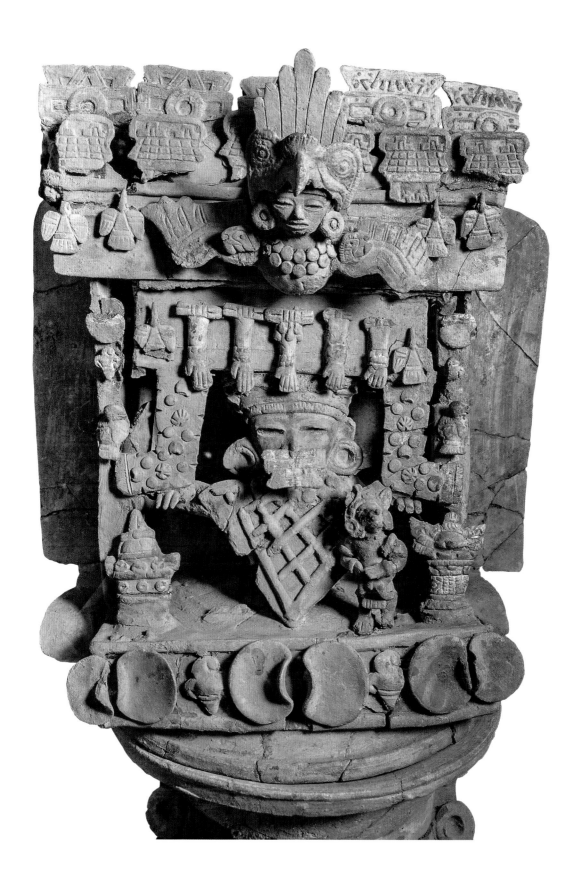

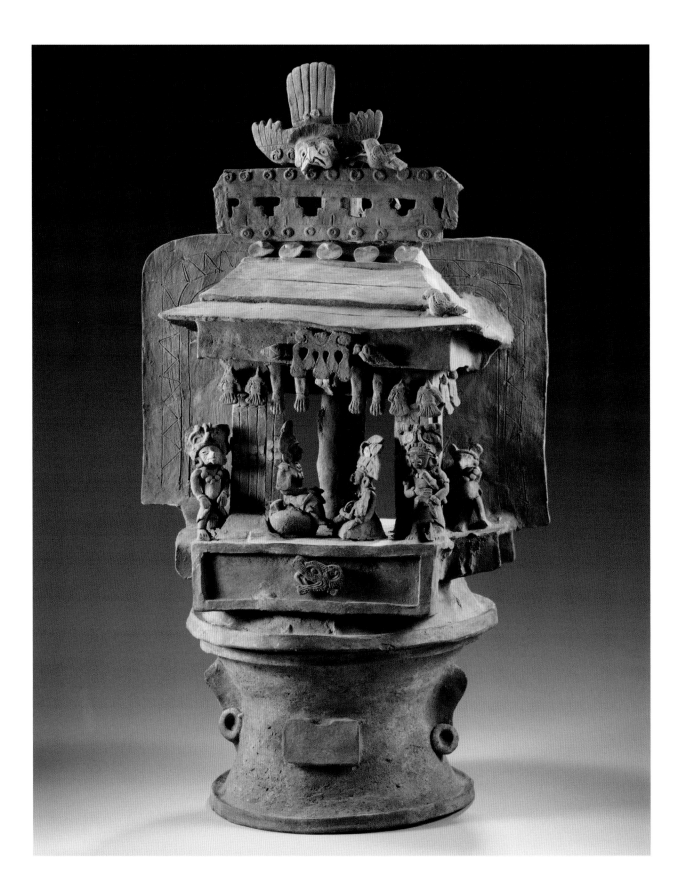

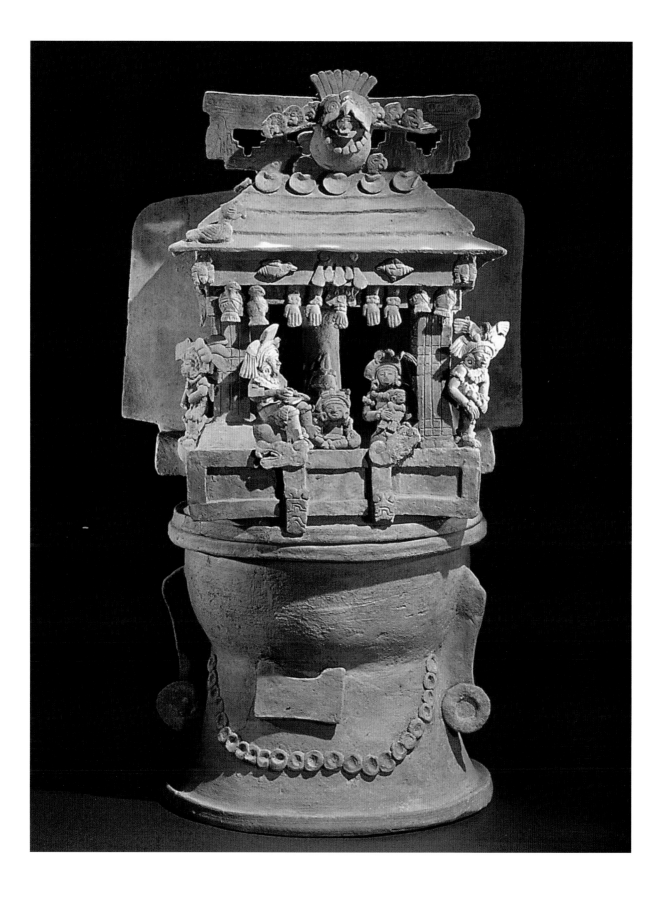

The Popol Vuh account about a hero who lost an arm in his fight with a primeval monster is uncommon in Mesoamerican narratives. As such, the incident might be considered a heroic subject in the sixteenth-century K'iche' version. Nevertheless, iconographic evidence attests to its sustained presence in pre-Columbian art, in contexts that link it with the defeat of the primeval monsters that opposed the rise of the sun. A millennium separates the Early Classic Escuintla censer lids from the version of the episode that was written down in the Popol Vuh. Yet the arms hanging from the temple cornices find an intriguing correspondence in the K'iche' text. When Seven Macaw came home bringing Hunahpu's severed arm, he explained to Chimalmat: "This I have brought to hang over the fire. It will dangle over the fire until they come to take it back again."[36] Plausibly, the Escuintla censer lids were models of actual temples in which the arms of sacrificed victims were ritually hung from the cornices as offerings to the great bird. The myths that inspired such offerings were plausibly related to Early Classic coastal variations of the passage described centuries later in the Popol Vuh.

The myth's diffusion reached beyond Teotihuacan. Artistic representations include Late Classic carved reliefs at El Tajín and Veracruz, and Early Postclassic mural paintings at Jaltepetongo, Oaxaca.[37] Representations of the hero's confrontation with a bird also reappeared in Late Classic Maya art. At the minor site of Las Pacayas, in southwestern Petén, Héctor Escobedo and his collaborators recovered the fragments of a painted plate that was deposited as a burial offering in a small residential compound (figs. 64, 65). The plate shows a dramatic rendering of the confrontation of God S with a bird, likely a macaw, as identified by the excavators.[38] A lone spot on the cheek marks God S, who sports a jaguar ear—an attribute that appears with some frequency in his portraits. The blowgun that rests behind him may evoke the bird's shooting, in the manner of the Popol Vuh. The plate shows the very moment when the bird mutilated God S. Blood spurts in thick droplets from his left wrist, while the bird bites his severed hand.

The candid representation from Las Pacayas contrasts with the esoteric meanings encoded in the stucco façade from the fifth terrace of the Toniná acropolis (fig. 66). Lying on his back, God S bends his legs upward, supporting the bird's weight. This is not the rather naturalistic macaw of the Las Pacayas plate, but a godlike bird with serpent wings, a large round eye, a long, upturned lip, and a beard. A missing section of the stucco relief may have contained the severed hand, dangling below the bird's mouth. The mutilation is evident on God S's left arm, which is neatly sliced at the wrist. Especially intriguing is the associated hieroglyphic caption, "*Bahlam Chahkaj U Kab' Chan Mo' Winikil(?)*" ("Jaguar His Hand Is Chopped Four Macaw. . ."). This seems to be a name caption that designates the mutilated god as "Jaguar" and incorporates a record of the event in which his hand was chopped by "Chan Mo' Winikil(?)," which presumably is the name of the bird. While the bird has no obvious macaw features, Marc Zender pointed out that the same name reappeared in page 40b of the Dresden Codex, where it designated a human-bodied macaw that wields two fiery torches in the sky (fig. 67). Eric Thompson regarded the latter as a representation of K'inich K'ak' Mo'.[39]

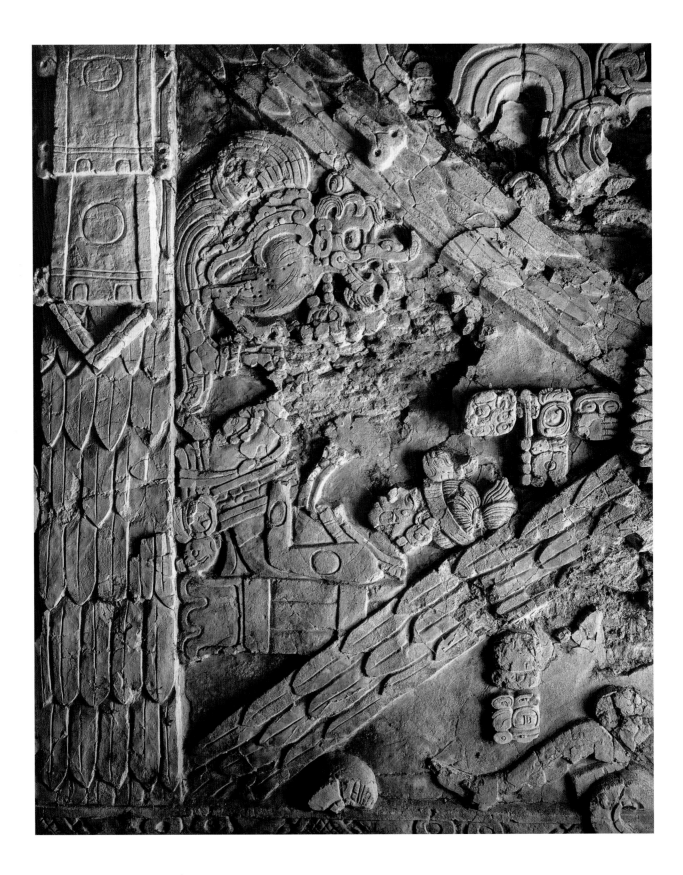

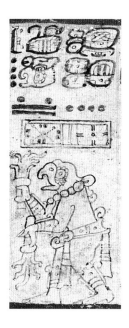

THE BIRD OF DAY AND NIGHT

Like its counterpart at Toniná, the great bird of Izapa Stela 25 has no obvious macaw features. Instead, it shares key iconographic traits with a broad category of avian creatures that are commonly dubbed as representations of the "Principal Bird Deity." The iconography of this mythical being, its temporal and geographic variations, and its bearing on ancient Maya concepts of kingship have received much attention, as aptly summarized by Julia Guernsey.[40] The following paragraphs highlight temporal shifts that are apparent in the Principal Bird Deity's iconography and explore its links with the great birds of mythical narratives, and with the birds with toothed vaginas represented at Izapa and Copán.

The "Principal Bird Deity" label subsumes a variety of avian characters, whose connections with each other, and with the characters of mythical narratives, are not always clear. In Preclassic Maya art, these birds have a broad, down-turned beak, usually surmounted by a prominent nostril. The mouth has rounded, down-turned corners, and the eyes take angular shape. The head is elongated, often undulating, and crowned with a simplified corncob.[41] In Classic examples, the maize symbol is often substituted by a jewel shaped as a *yax* sign, meaning "green" or "ripe." Another important ornament is a diadem with a frontal medallion inscribed with an ak'ab sign, with hanging tassels attached. The outstretched wings are serpentine, with feathers growing down from a flattened reptilian maw.

In certain cases the bird's chest is marked with a personified form of the "mirror" sign, tentatively read by David Stuart as *lem,* or "shine, flash" (fig. 68).[42] Of special significance are the cartouches on the wings, frequently inscribed with k'in and ak'ab signs, which respectively refer to day and night. Generally, the k'in sign appears on the bird's right wing, with ak'ab on the left one. However, other motives may appear

in the same position. At San Bartolo, several examples show lem signs on the wings, perhaps denoting brightness in a general sense, rather than alluding specifically to day and night. Another variation, of uncertain meaning, shows crossed bars instead of k'in and ak'ab cartouches on the great bird's wings.

The great bird portrayed on Stela 25 shows the characteristic head and the ak'ab sign on the left wing. In other respects, it departs from portraits of the Principal Bird Deity at Izapa and elsewhere, which are missing the serpentine vagina and do not sprout multiple bird heads on the wings. As noted, both features reappeared in Early Classic portraits of mythical birds with macaw attributes from Copán and Escuintla. The question is whether these attributes distinguished the Stela 25 bird from other Late Preclassic representations, as a different aspect of the Principal Bird Deity or as an altogether different being.

It is worth considering another example in which the Principal Bird Deity appears to be associated with a severed arm, on Kaminaljuyú Sculpture 100 (fig. 69).[43] This fragmentary relief shows the head of the Principal Bird Deity with a human arm under the head. This may be a humanized representation of the Principal Bird Deity, comparable to Tak'alik Ab'aj Altar 30 (figs. 70, 71). However, in this and other humanized representations of the bird, the outstretched human arms have feathers or other wing elements

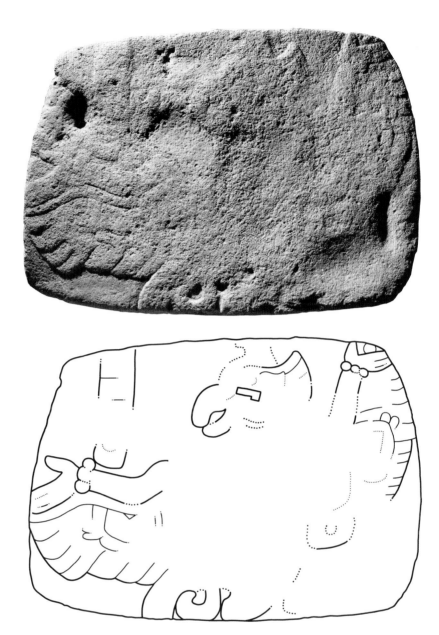

attached. The arm in Kaminaljuyú Sculpture 100 is devoid of feathers and its position seems anatomically awkward, as if dangling loose under the bird's head. No definite conclusions can be reached due to the carving's fragmentary state, but there is a distinct possibility that the Kaminaljuyú carving shows a severed arm in association with a Preclassic portrait of the Principal Bird Deity.

There has been a protracted discussion about the Principal Bird Deity's ornithological identification, and its relationship with the mythical character of Seven Macaw in the Popol Vuh. The bird's features are highly stylized, leaving little room for zoological analysis. Noting that it commonly holds a twisted snake in its beak, Nicholas Hellmuth and Karen Bassie-Sweet suggested that it was a raptorial bird, casting doubt on its

OPPOSITE **FIGURE 72**

Tak'alik Ab'aj Altar 13, Late Preclassic, Pacific Coast of Guatemala. Tak'alik Ab'aj, Guatemala.

FIGURE 73

Drawing of Tak'alik Ab'aj Altar 13 (see fig. 72). The Principal Bird Deity (shaded) falls down from a cleft in the sky.

identification as a counterpart of Seven Macaw. Guernsey questioned the emphasis on accurate ornithological identification, suggesting that natural models might have varied considerably, while the bird's mythical attributes remained consistent.[44] Indeed, the question should be restated more broadly. Rather than asking whether the Principal Bird Deity was related to Seven Macaw in the Popol Vuh, we should ask about the ways in which it related to the great birds—sometimes macaws, but often eagles or hawks—that opposed the sun and moon heroes in Mesoamerican myths.

Sculptures at Izapa and Tak'alik Ab'aj show the Principal Bird Deity falling headfirst from the sky. On Izapa Stela 2, it falls over a fruit-laden tree, flanked by two small, gesticulating characters who may correspond to the triumphant heroes in an ancient version of the myth. A related composition appears on the fragmentary Tak'alik Ab'aj Altar 13, which shows the bird falling down from an opening in the sky (figs. 72, 73). Oddly, the ak'ab

FIGURE 74

Detail of mural painting from the west wall of Las Pinturas Sub-1, San Bartolo, Guatemala, Late Preclassic, lowland Maya area, ca. 100 BC. The Principal Bird Deity descends from a cleft in the sky (right), and perches on a tree (center), while God S performs self-sacrifice (left).

medallion appears on the bird's right wing, while the one on the left wing is unreadable. One of the characters who stood below is a blindfolded Maize God, recognizable by his distinctive netted skirt and jeweled ponytail. Another character confronted him in the carving, but is almost completely lost. The Izapa and Tak'alik Ab'aj sculptures hint at Late Preclassic versions of the myth in which the Principal Bird Deity plunged down from the sky.

Less dramatic, the west wall of Las Pinturas Sub-1 at San Bartolo shows the bird flying down from a cleft sky band (fig. 74). Unlike its coastal counterparts, the bird is not plunging headfirst, but appears to be flying toward the trees below. There are four portraits of the great bird perched on trees that Taube identified as marking the four world directions. God S performs self-sacrifice in front of each tree, piercing his genitals with large leafy spines while presenting sacrificial offerings. There is no obvious confrontation between God S and the great bird on this wall, although a fragment from another section of the mural paintings shows God S with the great bird tied to his back. Observing its limp aspect and loosely hanging legs, Taube suggested that this fragment represented the dead bird, carried by the triumphant God S.[45]

Hellmuth noted that the Principal Bird Deity shared important features with Itzamnaaj, including the elongated, tonsured head, often crowned with a yax sign, and the ak'ab

medallion on the forehead. In several examples, the bird is actually named Itzamnaaj. Stephen Houston, Taube, and Stuart read further examples of its hieroglyphic name in Late Classic texts as Muut Itzamnaaj ("Itzamnaaj Bird").[46] In these contexts, it appears that the Principal Bird Deity acted as an avian messenger of the celestial god, Itzamnaaj, bringing a message to God S. Discussed further in the following chapter, this episode overlapped with the shooting of the great bird that opposed the rise of the sun, and the artists did not provide explicit clues to solve the ambiguity. While Itzamnaaj had no discernible solar connotations, his links with the Principal Bird Deity raise questions about whether this major god was regarded in certain contexts as the sun of a former era.

The available evidence suggests temporal shifts in the mythical role of the Principal Bird Deity, also shown in recent work by Guernsey.[47] In Preclassic representations at Izapa Stela 25, and possibly Kaminaljuyú Sculpture 100, the bird participated in the severed arm episode. Stelae at Izapa and Tak'alik Ab'aj depicted its downfall and likely defeat. The representations can be plausibly related to mythical beliefs in monstrous birds that opposed the rise of the sun. However, by the Classic period, the Principal Bird Deity no longer partook in the severed arm episode, which became associated with avian creatures that had distinctive macaw attributes, such as the great birds represented on the Copán stuccoes, the Escuintla censers, the Teotihuacan mural paintings, and the Las Pacayas plate. While its physical appearance is unrecognizable, the bird of the Toniná stucco frieze sported a macaw name. All of these examples depart significantly from contemporary representations of the Itzamnaaj Bird.

Equally significant was the disappearance of the k'in-ak'ab signs that marked the Principal Bird Deity's wings. Discussing examples from San Bartolo, Taube noted that this contrasting couplet (k'in-ak'ab) alluded to the sun's diurnal and nocturnal aspects and suggested, "During the Late Preclassic period, the Principal Bird Deity was a strongly solar being, perhaps even a particular aspect of the sun."[48] It seems that in later periods, the bird's connotations shifted in other directions. Ubiquitous in Late Preclassic representations, the k'in-ak'ab wing cartouches were sometimes omitted during the Early Classic, and were completely absent by the Late Classic. Perhaps the Principal Bird Deity's solar associations faded, while its manifestation as an aspect of Itzamnaaj gained prominence.

In Mesoamerican narratives, the encounters of a hero with a monstrous bird were commonly attributed to the children who eventually rose to the sky as the sun and the moon. In ancient Maya art, such encounters generally involved God S. Therefore, ancient Maya representations hint at the solar identity of God S. Further explored in the following chapters, this line of inquiry throws light on the ancient Maya solar and lunar heroes and their correspondences with the characters of Mesoamerican myths.

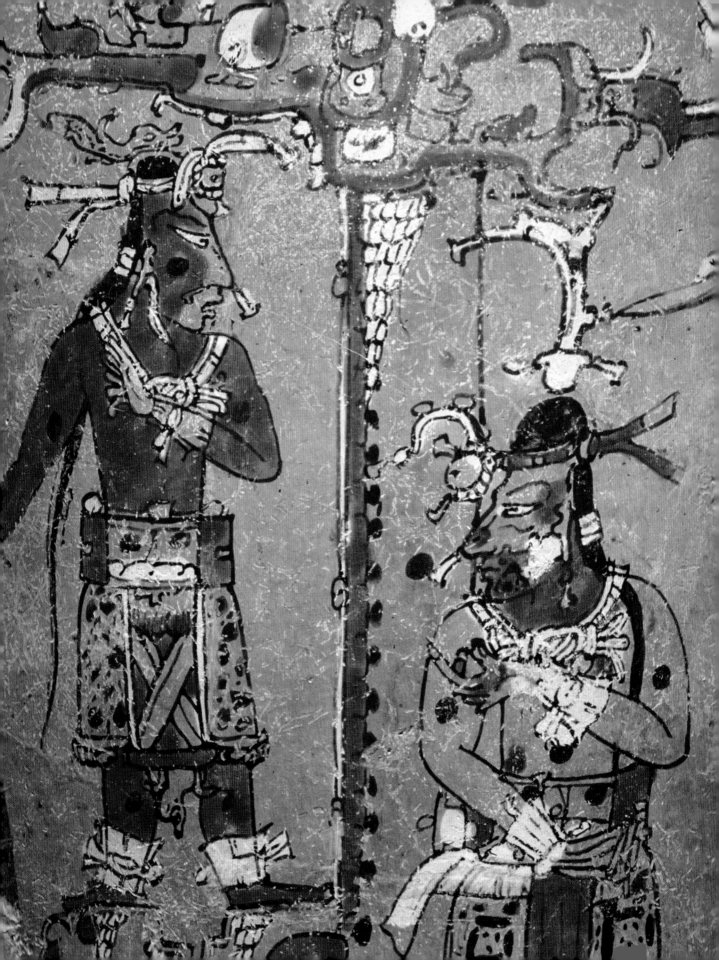

7 The Sun

—I will jump, said the little boy.

—You will not resist.

He jumped into the fire and came out like lightning. He came out shedding light
like the sun. The old men were very happy.

—Miguelito de la Torre Chatoch

In 1960, ethnographer Marcelo Díaz de Salas compiled an account of the origin of the
sun in the Tzotzil town of Venustiano Carranza, Chiapas (formerly San Bartolomé de
los Llanos). The story was about a little boy who lived with his mother. The world was dark
and the elders were sitting around the fire, but were not brave enough to throw themselves
into it. The boy told his mother that he would go; she tried to prevent it, but he went any-
way. The elders thought he wouldn't dare jump into the pyre. The boy did it, and he came
out as the sun. His mother went after him, looking for her child, and became the moon.

In his field notes, Díaz de Salas commented, "It is the 'legend of the fifth sun,' told
by a boy of about eleven years who has not been in school, and told me that he 'heard it
from old people.'"[1] The ethnographer was obviously surprised to find a version of a story
that was familiar to him from sixteenth-century Nahua texts, describing how the sun
originated from the self-sacrifice of a god in a blazing pyre. His remark that Miguelito,
his young informant, had not attended school reflected a suspicion that modern school-
teachers might have introduced the Nahua version to the village. However, Miguelito's
terse account did not parallel the Nahua versions. In most details, it coincided with other
stories about the origin of the sun and the moon, documented among the Maya peoples
of Chiapas. Díaz de Salas rightly reported this as a Tzotzil myth.[2]

The origin of the sun and the moon is a major topic in Mesoamerican myths. The
narratives are generally about young heroes who were unlikely candidates and had to
overcome powerful foes to reach their destiny. Their fire sacrifice is not always featured,
and yet it appears repeatedly in colonial texts and modern stories from distant regions.
Fiery death was the fate of the Hero Twins of the Popol Vuh, whose deeds shared much
with those of modern Mesoamerican solar and lunar heroes.

The Headband Gods in a cave
setting. One of them combines
the spotted skin with the jaguar
pelt patch around the mouth.
Late Classic, lowland Maya area.
Present location unknown.

In pathbreaking work, Michael D. Coe identified the Headband Gods as the Hero Twins' ancient Maya counterparts.[3] As such, they should be expected to share the nodal qualities of Mesoamerican solar and lunar heroes. Indeed, both this pair and their frequent companion, the Maize God, share important features with the protagonists of Mesoamerican myths that explain the origin of the sun and the moon.

BROTHERS, OLDER AND YOUNGER

The travails of the Hero Twins in the Popol Vuh began at birth. Rejected by their grandmother and their older brothers, they grew up in the mountains and became hunters. Their prowess with blowguns was one of the reasons that led Coe to link them with the Headband Gods of Classic Maya art. However, major episodes in the Hero Twins' early life find no correspondence in ancient Maya art. There are no known representations of the heroes' conflicts with their grandmother, one of the major foes whom they confronted in the Popol Vuh. Equally intriguing is the apparent lack of representations of the heroes' conflicts with their older brothers. This important episode reappears in multiple versions in modern Maya communities, suggesting that it was equally widespread in ancient times.

Díaz de Salas and Arthur Rubel compiled versions of the San Bartolomé de los Llanos myth that contain details about the sun's infancy. The boy's older brother tried to kill him in various ways, only to find him alive and well after he returned home. He finally tricked his brother, throwing cottonseeds that created a honeycomb on top of a tall tree. The older brother climbed the tree to get the honey, ate it all, and shared only crumbs of wax with the boy, who waited below. Angered, the boy brought a gopher—or made it from wax, according to versions recorded in other communities—to cut the roots of the tree, which fell down, killing the older brother. From his remains, the boy created all kinds of animals. Rubel's version reiterated the outcome of Miguelito's story: the twelve apostles made a bonfire and tried to enter it, but were unable to stand the flames. The boy jumped into the fire and became the sun.[4]

Solar myths from Maya peoples across Chiapas generally share a similar plot, although the episode of the sun's fiery sacrifice has only been recorded at San Bartolomé de los Llanos. The solar hero was always a young boy who lived with his mother and his older brother—in some versions, two brothers. He killed them by felling the tree they had climbed and then created animals from their remains. When his mother asked about his older brothers, he brought the animals for her.

The more detailed narratives feature a passage in which the boy began to prepare a cornfield, to provide for his mother. He was able to make the tools work by themselves, but his work was thwarted by animals that came every night to raise the trees he had cut down. In some versions, he punished the animals in ways that explained their anatomical features, such as short tails or long ears; in others he pulled out their tails while trying to catch them. Finally, he realized this was not his destiny, climbed to heaven (in some

versions equated to the roof of the house he built), and became the sun. In many accounts, his mother followed him to the sky and became the moon. Variations of the plot are known from Tzeltal, Tzotzil, Mochó, and Ch'ol communities. In related versions from the Q'anjob'al town of Santa Eulalia, Guatemala, Christ's older brothers despised him until he made them climb a tall tree and turned them to monkeys, buzzards, or hawks.[5]

In Chiapas, the boy who became the sun is generally called K'ox, Xut, or Xutil. Both roots mean "the last," because the boy was the youngest in a group of brothers. In colonial Tzotzil and Tzeltal, Xut or Xutul also meant "crumble" or "shabby thing," terms that appear to be consistent with the boy's condition as the last and most humble among his brothers. There is a closely related term, *xu*, glossed in the colonial Tzotzil and Tzeltal dictionaries as "buboes," while the Tzeltal *xuil uinic* was the Spanish *buboso*, meaning "buboed, afflicted with buboes."[6] Mesoamerican solar heroes are frequently described as enduring sickness, and skin afflictions are especially common. A Tzeltal version from Cancuc describes the boy's misery and infirmity: "Xut had many jiggers in the feet, he couldn't walk, he walked handicapped, he had no father, he was a fatherless child."[7]

The opposition between older and younger siblings is a common theme in Maya myths that resonates in modern family life. In San Pedro la Laguna, Benjamin Paul reported the belief that older children could harm their newborn siblings by "eating" their soul. To protect them, ritual specialists beat a chicken until dead against the body of the older child. The chicken was then prepared and fed only to that child, as a substitute for the newborn. The ritual ensured that the older child would pose no harm to the newborn.[8]

The siblings' relative age is inverted in modern narratives from the Guatemalan Highlands. The older brothers were the ones who possessed the magical power to make their tools work by themselves, and they finally turned their younger brother into a monkey. In Kaqchikel and Tz'utujil myths from the Lake Atitlán region, they did it to punish him for telling the secret of their magical tools to their grandmother, who neutralized their magic. The episode reappeared in Eric Thompson's version of the Q'eqchi' sun and moon myth from San Antonio, Belize, where the older brothers turned the youngest into a monkey because he did not approve of killing the grandmother. In every case, the older brothers asked the youngest to climb a tree and wrap a cloth around his waist; he could not climb down and became a monkey. In this respect, modern narratives from highland Guatemala depart from the usual pattern in Mesoamerican myths, in which it was the youngest child who overcame his older siblings and succeeded in the endeavors at which his elders had previously failed.[9]

The Popol Vuh followed the usual pattern. Becoming monkeys was the fate of Hun Batz and Hun Chouen, the Hero Twins' older brothers, who were jealous of the newborns and tried to kill them by placing them first in an anthill and then in brambles. They did not allow the children inside the house and denied them food. The Hero Twins grew up in the mountains and became able hunters, using their blowguns to bring down birds. They

brought the birds home, but their grandmother gave all the food to their older brothers. The heroes finally tricked their brothers in the usual way: they persuaded them to climb a tree that grew prodigiously, and the brothers were unable to come down. Their younger brothers told them to tie their loincloths, leaving a long stretch like a tail in the back, and they became monkeys.[10]

No modern story identifies the brothers who became monkeys as sages, artists, or artists' patrons. The Popol Vuh is the only source that describes them as such. However, in Bartolomé de las Casas's succinct creation account from highland Guatemala, Huncheven and Hunahau, the younger brothers who humbly asked and obtained license from their parents to create everything, were the ones who received veneration by all the artists and artisans.[11] The names of the heroes are intriguing: the name Huncheven corresponds to Hun Chouen, one of the older siblings in the Popol Vuh, while Hunahau was likely related to Hunahpu, one of the younger siblings in the Popol Vuh. The Las Casas account suggests that the mythical identity of the artists' patrons could be quite fluid, and that the names of the heroes shifted easily in related narratives.

Monkey gods were prominent patrons of the arts for the Classic Maya. Coe identified their representations as artists, scribes, and sages reading or writing in open books. In good correspondence with the myth reported by Las Casas, monkey scribes were featured among the gods who shaped the first people on several Late Classic vases. On Vase K8457, a monkey scribe is paired in that role with the Maize God (see fig. 21).[12] However, the extant representations provide no hint about their mythical origin. They rarely interact with Gods S and CH—the characters whom Coe identified as counterparts to the Hero Twins of the Popol Vuh. One important exception is Vase K2994, which shows God S and a monkey scribe, both holding large conch-shell inkpots. In short, there are good correspondences between the Classic Maya monkey scribes and the sixteenth-century highland Guatemalan patrons of artists and craftsmen, but there is insufficient evidence to determine whether Classic Maya myths pictured the monkey scribes as the brothers—younger or older—of the solar and lunar heroes, or whether they were believed to have become animals as punishment for mistreating their siblings.

THE MESSAGE

The delivery of a message or revelation is a turning point in Maya solar myths, one that plausibly merited the attention of ancient artists. The emissary was often a bird that spoke when the hero was intent on shooting it. In some versions, it was another kind of animal or a man. Upon receipt of the message, the hero or heroes realized that they were not destined to be farmers. In narratives from modern Maya communities in Chiapas, this happened after the animals thwarted the K'ox's effort to prepare a cornfield. In Manuel Arias Sojom's version from Chenalhó, it was the rabbit—the first among the animals that came every night to summon the trees to rise back up—who told him, "I have spoiled

your work because this is no place for you, this is the place of sin; you belong on high, not here."[13]

In the Popol Vuh, the revelation took place at the same juncture. Having turned their older brothers into monkeys, the Hero Twins offered to take their place and started preparing a cornfield to provide for their grandmother. Every night, animals came and raised the trees they had cut down during the day. They finally waited upon them, but were only able to catch the rat, which delivered the critical truth, in a rather cryptic way: "Your task is not to be maize farmers. But there is something that is yours."[14] The rodent then helped the heroes to get their father's ball-playing gear, which he had left hanging from the roof of the house. By doing so, they took the path that led to their ultimate destiny of becoming the sun and the moon. In addition, the K'iche' text featured a second message with the summons of the Hero Twins to Xibalba, which was delivered by a falcon. The two messages complemented each other, ultimately leading to the heroes' descent to Xibalba.

Like the Hero Twins of the Popol Vuh, the heroes of Q'eqchi' myths hunted birds with blowguns and brought them to their grandmother, but she denied them the food. Narrators from San Antonio and Crique Sarco, Belize, described how one day, the heroes tried to hunt a trogon bird that spoke and told them that the old woman was giving all the food to her lover, a tapir. The revelation set in motion their conflicts with the old woman and their subsequent ventures. In the Crique Sarco version, the boys were identified as Thunder and Morning Star; at San Antonio, one became the sun and the other the Morning Star, also identified as lord of the animals.[15]

A parallel passage appeared in the Ch'orti' myth of Kumix. Like the Hero Twins, he had no father and was rejected by his older brothers, who threw him in a stream to kill him, but he survived or, according to some versions, was reborn from the water froth mixed with his blood. A Ciguanaba found the baby by the stream and raised him. The boy became a hunter. In Don Lucio Méndez's version, the Ciguanaba first gave him a sling, but he could only kill small birds with it; he asked the Ciguanaba for a bow and arrow, with which he could shoot larger birds, until he killed them all. The old woman gave him a shotgun, which enabled him to hunt large animals, and he also decimated them. Desperate to bring more food for the Ciguanaba, he tried to shoot a bird that always escaped. The bird finally spoke and told him that the old woman was not his mother, but rather a Ciguanaba who wanted to eat him, and that his real mother was poor and destitute in a mountain or, according to other versions, in heaven. In the ensuing episodes, Kumix vanquished the Ciguanaba and began searching for his lost parents.[16]

Beyond the Maya area, the episode reappeared in a Mazatec narrative from Oaxaca. The sun and moon heroes were born from two eggs that an old woman found by the river. Initially, the children hunted with blowguns. They kept asking the old woman to get rifles for them. Annoyed, she finally gave them rifles, but warned them not to shoot their father, who was in the hills. While hunting, the children found a bird that spoke and told them

that the old woman was not their mother, and that their supposed father was really her lover, a deer. As expected, they shot the animal, fed the old woman his testicles, and filled the skin with wasps that stung the old woman when she went looking for her lover. Thus the bird's revelation unleashed the heroes' mischief and the old woman's wrath against them.[17]

The bird's message was likely represented in Classic Maya pottery painting. The theme easily overlapped with the shooting of the great bird that opposed the heroes. A key example, on Vase K1226, shows God S shooting the Principal Bird Deity, which seems to fall amidst the foliage of a tree (fig. 75). Interpreters generally relate this scene with the episode of the Popol Vuh in which Hunahpu shot Seven Macaw with his blowgun.[18] However, Marc Zender read the verbal phrase in the associated hieroglyphic caption as *ehmi chan* ("he descends [from] the sky"). He showed that the verb *ehm* was commonly employed in contexts that referred to the descent of messengers from the gods, usually of avian shape, and concurred with Karen Bassie-Sweet in interpreting the scene as unrelated to the Seven Macaw myth. Instead, it may correspond to a different episode, in which the solar hero shot a bird that brought him the crucial revelation that changed his path.[19]

BECOMING THE SUN AND THE MOON

A crucial problem in Mesoamerican solar myths is the contrast between the sun and the moon. Mythical narratives devote considerable attention to explaining the reasons why one of the heroes eventually became the sun, and the other, the moon, and the related question of why the light of the moon is weaker. Further questions include the origin of the moon's sullied face and the explanation of why there is a rabbit on the moon. The narratives privilege some of these issues over others, and not all of them are addressed in every story. The distinction is clear in stories that describe the sun and moon heroes, respectively, as male and female, although the gender contrast is not always present, and there are numerous myths in which both the sun and the moon are male.

The moon was the sun's mother in the Chiapas Maya myths. Rather uncommon elsewhere, this explanation reappeared in a Huichol myth compiled by Carl Lumholtz at the turn of the twentieth century. In the beginning, there was only the moon, but her light was not enough. Reluctantly, she gave her son to the principal men who came asking for him—a boy who was lame and blind in one eye. The principals adorned him and threw him in an oven, where he burned. Five days later, he appeared as the sun. Other Huichol versions do not always describe the boy as the moon's son, but they consistently reiterate that he suffered from eye or skin disease and was covered with pimples.[20]

Some narratives in Chiapas explain the moon's dim light: the mother cried so much for her son that her light faded. According to other versions, one of her eyes somehow got hurt, and she carries a rabbit because her son caught the animal that came at night to raise the trees and gave it to her as a companion. The moon was also feminine in Q'eqchi'

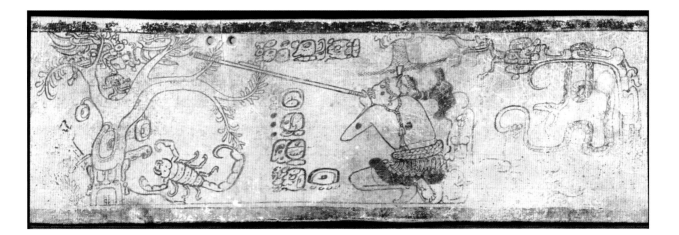

FIGURE 75
Rollout photograph of Vase K1226, Late Classic, lowland Maya area. Museum of Fine Arts, Boston. God S shoots at an avian messenger, identified as Itzamnaaj in the hieroglyphic caption.

narratives. She was the wife of the sun and rose with him to the sky. In Thompson's version, she was initially as bright as the sun. There was no darkness during the night, and people could not sleep until the sun dimmed her light, plucking out one of her eyes.[21]

Narratives that describe the sun and the moon as siblings, male and female, are rather uncommon but not entirely absent in the Maya area. A myth from Izamal explains that the children were born together from eggs and were then found and raised by iguanas. The boy slept on top of a tree, and the girl in a cenote. They finally rose to the sky, but the moon sometimes goes back to sleep in the cenote.[22] Whether portrayed as a male or female, the moon's attraction to water is a constant in Mesoamerican myths.

The heroes were also siblings, a boy and a girl, in Mixe, Chinantec, and Zapotec narratives from Oaxaca. While the girl's gender would seemingly mark her as destined to become the moon, the narratives describe contestations with her brother over who would become each luminary. In many versions, after killing the bright-eyed eagle or serpent that opposed them, they quarreled over who would get the brightest eye. The girl kept it at first, but became thirsty as they went along. Her brother found water for her and demanded the brightest eye in exchange. Details vary; a Zapotec myth omitted the exchange of the bright eyes and described how the moon plucked out one of her eyes in sacrifice to obtain water from a dry well. In another Zapotec version, the sun gave his sister a rabbit in exchange for the water. In Chinantec stories, the boy found water, but warned his sister not to drink it until he had brought a priest to bless it. The girl could not wait and drank. Angry, the sun took the priest—who was a rabbit—and smashed it in the moon's face. Mixe narratives made no mention of the monster's bright eyes, while some included a passage in which the sun smashed a sandal in the moon's face.[23]

The contestation over the monster's bright eyes reappeared in Chatino, Mixtec, Trique, and Tlapanec myths in which the heroes were both male. They quarreled over the monster's eyes, and the lunar hero initially took the brightest eye, but then gave it to his brother, usually in exchange for water. In some Trique and Tlapanec versions, he swallowed a rabbit. However, the lunar hero's main distinguishing characteristic was his sexual proclivity. Before rising as luminaries, the brothers raped the old woman who

opposed them—their adoptive grandmother in Trique myths.²⁴ It was the woman's blood that stained the lunar hero in a Chatino version, which added, "He became addicted to those things." When they rose to the sky, the lunar hero wanted to bring a woman, but the sun did not allow it: "They don't work together. That is because the moon was delayed searching for the woman, and the sun hurried up."²⁵

Male lunar heroes exhibit similar features in mythical narratives across Mesoamerica. Generally weaker than solar heroes, they commonly suffered from thirst and pursued water. They engaged in sexual encounters and enjoyed the company of women. The heroes were not always brothers. In many stories, the lunar hero was wealthy and had many relatives, while the solar hero was poor, frequently an orphan without relatives. In stories that involved the heroes' fire sacrifice, the lunar hero came late, went the wrong way, and was not brave enough to throw himself in the pyre.

A modern Nahua myth from Cuetzalan, Puebla, explained how the one who was initially destined to become the sun lost his place. He agreed to enter the pyre, but first had to bid farewell to all his relatives. The fire was ready, almost beginning to dwindle, and he had not yet returned. There was an orphan, who had no one to say goodbye to. He entered the pyre and took all the heat. When the first one finally came, the fire was almost extinguished. They still let him take part and shine by night. He entered the lukewarm ashes and became the moon.²⁶

In an Otomí narrative, there were two children, one of them a poor boy who was covered with pimples and had no father, only his mother. At first he didn't want to go and tried to run away, but he finally agreed. The boys went to wash themselves by the river, but the other boy did not hurry and played with women in the water. The fatherless boy finished soon, was given bright clothes and shoes, and threw himself in the blazing oven. The other boy threw himself in the ashes and obtained only the cool glow of the moon. The moon tried to follow the sun, but was deceived because the sun had turned his feet backward, to lead him in the wrong direction.²⁷

The moon's womanizing is most evident in Totonac myths from northern Puebla and Veracruz. According to a version compiled by Alain Ichon, the moon was originally a boastful man and a womanizer. "The lover of all women," he spied women in the springs where they washed clothes and carried them to the forest. He got angry when he learned that a boy would become the sun, and told all the women that he would be the one instead. The women threw on his face a calabash full of the water with which they had washed the corn, and that was how the moon's face got stained. Meanwhile, the boy who would become the sun had already started on his way with a dog and a walking stick. At a crossroads, he turned right, but left the dog and instructed it to tell the person following him that he had gone to the left. Misled by the dog, the moon went the wrong way. By the time he realized the deceit, it was too late; the sun was rising gloriously in the east.²⁸

In another Totonac version, the heroes were brothers, but one of them was a partygoer, good dancer, and musician. He had many lovers in town and had told them that he

would be the sun. His brother asked the animals to make a bonfire, threw himself into it, and flew to the east, taking the best of the heat. The partygoer was at the house of one of his lovers. When they told him about his brother, he came running and rolled in the hot ashes, while people made fun of him. The animals led him the wrong way, to the west. Yet another Totonac variant presented the moon as the sun's grandfather, a partygoer who visited women and bragged that he would be the sun. The boy threw himself in the burning field he had prepared for planting and then rose as the sun. His grandfather followed him in the embers and appeared when the sun was setting in the west.[29]

The burning field reappeared in a Teenek version, in which the sun and the moon were children, a boy and a girl. The moon tried to pass through the field, but changed her mind and went to swim in a lagoon to cool down. The sun crossed the field and came out blazing. He was poor and a very hard worker, setting a very good example for men. The moon was lazy and came from a rich family: "That is why it is now said that the rich do not go out in the sun, they prefer the cool air, while the poor walk all the time in the sun. It is also said that women are colder than men."[30]

Despite their multiple variants, modern narratives echo the underlying themes of the sixteenth-century Nahua myths that Díaz de Salas had in mind when he heard Miguelito's story in San Bartolomé de los Llanos. The most elaborate version comes from Bernardino de Sahagún's informants, who framed the whole story as "a fable in which it is told how a little rabbit lay across the face of the moon." They located the portent at Teotihuacan, where the gods assembled to determine who would be the sun. When they asked who would carry that burden, Tecciztecatl volunteered. The gods asked for someone else and chose Nanahuatl. Both fasted and performed sacrifice, but Tecciztecatl used only costly things as instruments of penance: quetzal feathers as fir branches, golden grass balls, greenstone and coral maguey spines, and incense. Intimating that he feigned penance, the narrators noted: "The reddened, bloodied spines were of coral." In contrast, Nanahuatl used lowly instruments, such as green water rushes for fir branches, grass balls made of reeds, and true maguey spines, "and the blood with which they were covered was his own blood. And for his incense, he used only the scabs from his sores."[31]

Nanahuatl was sick and miserable, while Tecciztecatl was rich and healthy. In the early seventeenth century, Hernando Ruiz de Alarcón described Nanahuatl as "afflicted with pustules and having sores." In colonial Nahuatl, the word *nanahuatl* was glossed as "buboes." While often associated with syphilis, paleopathological studies have not yielded conclusive evidence of the presence of venereal syphilis in the New World before the Spanish conquest. Therefore, the word is better interpreted in broad reference to treponemal diseases (caused by bacteria of the genus *Treponema*) that cause sores and rashes of various kinds.[32]

When Nanahuatl and Tecciztecatl finished fasting, the gods adorned them. Nanahuatl only received a paper headdress and a breechcloth, while Tecciztecatl got a

fancy heron feather headdress and a sleeveless jacket. The gods had prepared a furnace that burned for four days. Tecciztecatl tried to jump in the flames four times, but recanted each time. When his turn came, Nanahuatl cast himself at once and burned. Seeing this, Tecciztecatl followed him. Sahagún's informants omitted mention of Tecciztecatl's association with women, which was nevertheless present in sixteenth-century Nahua sources. In the Legend of the Suns, the lunar hero received the calendric name 4 Flint. He bathed and did penance together with Nanahuatl, but his needles were plumes and his spines and incense were jade. After four days, Nanahuatl went into the fire, while 4 Flint was singing among the women. He finally jumped, but only in the ashes.[33]

According to Sahagún's informants, both Nanahuatl and Tecciztecatl shone equally when they rose in the east, one after the other. The gods reproved it; one of them ran and hit Tecciztecatl's face with a rabbit. In the Legend of the Suns, it was Papáztac who broke his face with a "rabbit pot." Papáztac was one of the gods of pulque, known as the "four hundred rabbits," and the rabbit pot was a kind of vessel used for pulque. For the sixteenth-century Nahua, the moon's rabbit implied an association with pulque and inebriation, perhaps compatible with the lunar hero's gaiety in modern myths.[34]

THE SUN AND THE MOON IN THE POPOL VUH

While sometimes regarded as a Nahua myth—perhaps because of the early date, relative abundance, and dramatic detail of sixteenth-century highland Mexican versions—the fire sacrifice of the solar and lunar heroes is widespread in Mesoamerica. Modern versions from other regions are numerous, and there are no substantive reasons to regard them as derived from a paradigmatic Nahua model. Nor is the sixteenth-century version of the Popol Vuh based on such a model. The sixteenth-century Nahua and K'iche' versions, and modern versions recorded from West Mexico to the Maya area, likely derive from deeply rooted beliefs of great antiquity in Mesoamerica.

In the Popol Vuh, Hunahpu and Xbalanque met their death when they threw themselves voluntarily into a pit oven at Xibalba. Unlike the majority of versions, which state the purpose of the sacrifice at the outset, the Popol Vuh only explained the heroes' destiny later. The lords of Xibalba did not heat the oven with the purpose of choosing who would become the sun, and the heroes did not immediately emerge as luminaries; an intervening passage explained their rebirth from their ground ashes, their defeat of the lords of death, and their failed attempt to bring their father back to life. Only after that did they ascend to the sky as the sun and the moon.

More importantly, the Popol Vuh departed from other versions because it did not remark upon the heroes' contrasting character, nor did it explain why one became the sun and the other the moon. Throughout their travails, Hunahpu and Xbalanque acted largely in unison and were distinguished by their actions only occasionally. The most significant contrast between them involved the mutilations suffered by Hunahpu. First, he lost an

arm to Seven Macaw; second, he lost his head in the house of bats at Xibalba. In that episode, Xbalanque managed to craft a substitute head for him from a squash. The lords used Hunahpu's head as a playing ball, but were deceived by the squash head and by a rabbit that ran into the middle of the game, following Xbalanque's instructions. Thinking that it was the ball, the lords ran after the rabbit, allowing Xbalanque to put Hunahpu's head back in place.[35]

A comparable situation occurred in Mazatec myths that described the solar and lunar heroes' encounters with the old woman who had raised them. Parallel with other myths, the heroes killed the old woman's lover and fed her the testicles. They stole a ball of light that the old woman had hid and quarreled over it until the solar hero finally got it. However, the old woman caught the lunar hero and ate him. The solar hero reassembled his brother's bones and a dog helped him recover the head, but he was still missing the heart. He finally put a rabbit in place of his heart, and the lunar hero revived.[36]

The Mazatec lunar hero's initial death, and the substitution of his heart with a rabbit, recalls Hunahpu's beheading by a bat and the substitution of his head—the playing ball—with a rabbit. The parallel suggests an association with the moon, raising the suspicion that Hunahpu was regarded as the K'iche' lunar hero. However, the Popol Vuh did not emphasize the distinction. The ambiguity has resulted in protracted scholarly debates about which one of the Hero Twins became the sun and which one became the moon.[37] Despite indirect hints such as those contained in this episode, the fact is that the authors of the Popol Vuh did not provide clear indications about this important issue—the gist of Mesoamerican solar myths. On the contrary, it appears that they deliberately emphasized the heroes' parity. This was especially evident in the account of their sacrifice. The lords of death had prepared the oven with heated stones and hot coals and tried to trick the heroes into jumping over it, but the heroes already knew about their impending death and declared that they would not be deceived: "Then they turned to face one another, spread out their arms and together they went into the pit oven. Thus both of them died there."[38]

The heroes' parity in the Popol Vuh is a peculiarity, making this version different from every other. It contrasted strongly with a contemporary K'iche' belief recorded in the Título de Totonicapán: "And they called the sun and the moon 'a young woman' and 'a young man'; they called the sun Hunahpu, the moon was called Xbalanquej by them." Robert Carmack and James Mondloch took this sentence as confirmation that Xbalanque was female in the Popol Vuh.[39] Instead, it shows that the sixteenth-century K'iche' knew variable versions of the sun and moon myths. In the Popol Vuh, they were both male and largely undifferentiated; in the Título de Totonicapán, their different gender marked a clear distinction, and explained why one became the sun and the other the moon. Importantly, the contrasting versions contained in each document found echo in their respective accounts about the origins of K'iche' royalty. A comparison of the relevant passages suggests that the peculiar parity of the Popol Vuh heroes was politically motivated.

Ruud van Akkeren noted the variant versions of a legendary journey undertaken by the sons of the K'iche' forebears. According to the Popol Vuh, the sons of Balam Quitze, Balam Acab, and Mahucutah traveled to the east, to the court of the paramount lord Nacxit—a name that was commonly associated with the legendary king Quetzalcoatl of Tula. They came back invested with the symbols of rulership, including the titles of Ajpop and Ajpop K'amja, which designated them as the paired rulers of the K'iche' kingdom.[40]

The journey acquired a different character in a version contained in the Título de Totonicapan, in which K'okaib' and K'oqawib', the two sons of Balam Quitze, were the ones who traveled to meet the lord Nacxit. However, they went in opposite directions: K'okaib' went to the east, and K'oqawib' to the west. The directions that they took are strongly reminiscent of myths that described the lunar hero taking the wrong direction, to the west. Expectedly, K'oqawib' did not succeed in his task and returned by the edge of the sea—a possible allusion to the moon's aquatic associations—without having reached Nacxit. True to his lunar identity, he was attracted to women: "Then [K'oqawib'] showed his weakness, and fornicated with his sister-in-law, the wife of K'okaib'."[41] When K'okaib' returned, bringing the symbols of lordship conferred by Nacxit, his wife had given birth to his brother's son. He acknowledged the illegitimate child but was filled with despair, and he instituted for the child and his descendants the second-ranking office of Ajpop K'amja.

According to Van Akkeren, the K'iche' texts were written in the context of political contestation among the members of royal K'iche' lineages who sought legitimation in the newly established colonial system. The authors of the Título de Totonicapán insisted on the preeminence of the Ajpop and on the lesser character of the Ajpop K'amja, a rank that they regarded as the outcome of K'oqawib's wrongdoing. By contrast, the authors of the Popol Vuh stressed the parity of the ranks of Ajpop and Ajpop K'amja.[42] The contrasting mythical versions of the sun and moon story in each of these texts seem consistent with their authors' political agendas. The authors of the Título de Totonicapán acknowledged the disparity of the solar and lunar heroes—in agreement with every other version known throughout Mesoamerica. The authors of the Popol Vuh downplayed the contrast and cast the Hero Twins' deeds and their unison sacrifice at Xibalba as a paradigm for the parity of the K'iche' kings.

THE HEADBAND GODS

Coe initially suggested that the Classic counterparts of Hunahpu and Xbalanque were the youthful, lavishly dressed characters whom he labeled as "Young Lords"—usually in the plural, although some of the objects that he described showed a single Young Lord (fig. 76). He also noticed correspondences with a pair of youthful characters who often wore headbands, whom he labeled "Headband Gods" (figs. 77, 78). Coe's early work

FIGURE 76
Detail of Vase K7268, Late Classic, lowland Maya area. Present location unknown. Coe's "Young Lord" appears in an aquatic setting, with fish and water bands on either side.

a

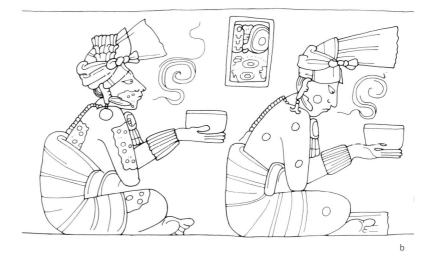

b

FIGURE 77

The Headband Gods. (a) Drawing 87 from Naj Tunich cave, Guatemala, Late Classic, lowland Maya area. The Headband Gods sit in front of each other: God S (left) and God CH (right). (b) Detail from vase K732, Late Classic, lowland Maya area, present location unknown. The Headband Gods carry drinking bowls.

reflected some perplexity, but also an awareness of the possibility of complex correspondences between the sixteenth-century K'iche' heroes and the characters represented on Classic Maya vessels:

> Identification of the Headband Gods is a puzzle. On some vases . . . they appear as twins, both with black spots. On others, one has black spots while the other has jaguar-skin patches covering his lower face and god-markings. Of course, one of the distinguishing features of the Hero Twins in the Popol Vuh is that they are great blow-gunners, and one of their feats is to polish off the bird-monster called 7 Macaw. My own feeling is that the Headband Gods are the same as the Young Lords (i.e., the Hero Twins), but in another role and thus with different characteristics.[43]

In later work, Coe adopted a more stringent view, arguing that it was possible to establish one-to-one correspondences. He concluded that the Headband Gods corresponded to Hunahpu and Xbalanque. His conclusion partly derived from research by Karl Taube, who identified Coe's Young Lords as representations of the Classic Maya Maize God, and espoused the idea—previously entertained by Coe himself—that the Maize God was a counterpart of One Hunahpu, the father of the Hero Twins in the Popol Vuh.[44] Further elaborated by other authors, this interpretation became paradigmatic and provided a widely accepted framework for the interpretation of ancient Maya mythology. As succinctly stated by Mary Miller and Simon Martin: "The father of the Hero Twins, One Hunahpu, is without question the Maize God. . . . The Hero Twins are readily identifiable, too: Hunahpu can usually be recognized by the spot on his cheek; Xbalanque by a patch of jaguar pelt around his mouth."[45]

Despite such reassurance, the prevailing view is far from conclusive and has been seriously questioned.[46] In principle, the search for one-to-one correspondences between ancient Maya gods and the Popol Vuh's dramatis personae is dubious, because it assumes unbroken continuities at the level of heroic subjects—the myths' labile, outer layers, in

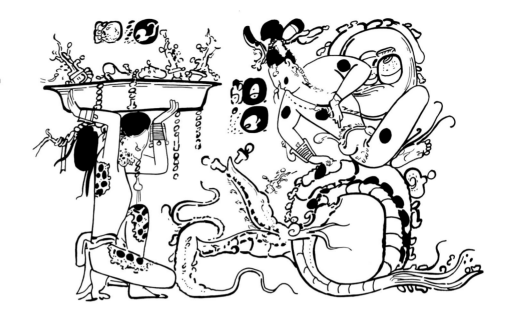

FIGURE 78

Detail of Vase K1004, Late Classic, lowland Maya area. God S rests on an aquatic serpent, while God CH holds up a plate containing the baby Maize God.

Alfredo López Austin's terminology. As argued in this book, significant correspondences should be sought instead at the level of the myths' nodal subjects. In fact, Taube proposed two possible correlates for the K'iche' Hunahpu, who corresponds to Gods R and S in ancient Maya art.[47] While related, the two gods bear different body markings and appear in separate contexts in the Postclassic codices and on Classic period pottery paintings. God R remains poorly understood and will not be discussed further. Nevertheless, it seems advisable to return to Coe's initial stance, allowing for the possibility of multiple correspondences between the Classic Maya gods and the heroes of the Popol Vuh.

Coe and other authors have sometimes labeled Gods S and CH as "Headband Twins." While it may be warranted to make the assumption they were regarded as brothers, the supposition that they were twins is only pertinent in rare cases that show two nearly identical portraits of God S or, even more rarely, two nearly identical portraits of God CH. The fact is that there is no definite indication in the Maya artistic or hieroglyphic corpus about their relationship to each other. Therefore, Coe's original label, "Headband Gods," is preferable.

The headband has long been recognized as a symbol of Classic Maya royalty. In recent work, David Stuart discussed its relation with the logogram AJAW ("king, lord," in Maya writing), and pointed out its cognates in Olmec, Zapotec, and Nahua writing. He noted that rather than being a symbol of affluence and pride, the headband related to the ordinary activities of common people.[48] Indeed, a salient feature of the Headband Gods is their humble, unassuming appearance as ordinary young men, often associated with animals and with the forest wilds. These attributes are consistent with the mythical descriptions of Mesoamerican solar heroes, including but not limited to Hunahpu and Xbalanque in the Popol Vuh.

As noted above, the supposed correspondence of the Headband Gods with the Hero Twins of the Popol Vuh implies that the former shared the qualities of the solar and

Name tags associated with portraits of God S. Notice the absence of the headband in all examples: (a) Detail of Vase K1004, spelled with the logogram of the day name Ajaw; (b) Detail of the Dresden Codex, p. 2a; (c) Detail of Vase K7821; (d) Detail of Vase K1183; (e) Detail of Vase K1202; (f) Detail of Vase K1222, with affixed **te** and **wa** syllables.

Examples of the Ajaw royal title. Note the headband in all examples: (a) Detail of a plate from Tikal Burial 195; (b) Detail of Arroyo de Piedra Stela 1; (c) Detail of Piedras Negras Panel 2; (d) Detail of Yaxchilan Hieroglyphic Stairway 3, Step 5; (e) Detail of La Corona Element 56; (f) Detail of Palenque Tablet of the 96 Glyphs; (g) Detail of the Cosmic Plate.

FIGURE 81
Examples of the Ajaw day name, Late Classic, lowland Maya area. Note the headbands in all examples: (a) 4 Ajaw, Detail of Piedras Negras Altar 2, Support 3; (b) 5 Ajaw, Detail of Dos Pilas Stela 15; (c) 8 Ajaw, Detail of Palenque, Hieroglyphic Stairway.

lunar heroes of Mesoamerican mythology. In the Popol Vuh, the rise of the Hero Twins as luminaries was the culmination of their deeds and the answer to one of the creator gods' primary questions: How shall it dawn? Surprisingly, discussions of the Headband Gods have largely shunned this critical aspect. Nevertheless, one member of the pair, God S, conforms significantly with the usual attributes of Mesoamerican solar heroes.

THE BLEMISHED GOD

In his comprehensive survey of ancient Maya gods, Taube coined the label "God S" to designate the young god with spots on his face and body whom Coe regarded as a counterpart to Hunahpu in the Popol Vuh. His hieroglyphic name was probably read Juun Ajaw, although some doubts remain.[49] On Vase K1004, the name is spelled with a finger variant of the logogram JUUN ("one"), combined with the sign of the twentieth day name, AJAW (see fig. 78). However, the majority of examples do not employ the Ajaw day-name sign. Instead, God S's hieroglyphic name is usually spelled with the numeral one prefixed to a logogram representing a youthful profile with a spot on the cheek and a crosshatched cartouche ringed with black circular tabs on the back of the head (fig. 79). This sign overlaps graphically, but does not substitute with the logogram XIB' ("man"), a profile head with a spot on the cheek, which lacks the crosshatched cartouche on the back of the head.

While often considered as cognate with each other, it is pertinent to distinguish variants of the glyph with and without a headband. The sign is consistently employed without a headband in name tags associated with portraits of God S (see fig. 79). The second variant, with a headband, appears to be obligatory in contexts where the logogram demonstrably conveys the reading AJAW, including the Ajaw royal title and the Ajaw day name (figs. 80, 81). The first variant, without a headband, is not part of the AJAW royal title

substitution set except in rare cases, nor does it substitute for the twentieth day name, casting doubt on the reading of God S's name as Juun Ajaw. The **wa** suffix in one example of God S's name tag (see fig. 79f) lends a degree of support to the AJAW reading, which nevertheless remains tentative.

An implication of the name's putative reading is a correspondence with the names of Hunahpu or his father, One Hunahpu, in the Popol Vuh. Hunahpu is the name of the twentieth day in the K'iche' calendar, corresponding to Ajaw and its variants in other Maya calendars. Strictly speaking, this would imply that the Classic god Juun Ajaw corresponded with One Hunahpu, the father of the Hero Twins in the Popol Vuh. However, the correspondence is generally traced to the latter's son, Hunahpu. To explain this incongruity, David Stuart contended that the K'iche' day name may have fused the numeral Hun ("one") with *Ahpu,* a variant of the twentieth day name, attested in the Poqomchi' calendar of highland Guatemala, and then became recombined with the numeral one in the name of One Hunahpu.[50]

While plausible, attempts to trace the evolution of the Classic Maya god's name to early colonial K'iche' counterparts are not necessarily conclusive. López Austin has shown that names belong in the realm of heroic subjects and are especially labile. They shift easily when the myths are transmitted and are easily affected by changing social and historical conditions or by extraneous influences that prompt innovation and adaptation.[51] A deeper level of analysis involves mythical events, which are less prone to change and tend to remain stable even when the names are altered. Therefore, rather than the names, the more relevant comparisons involve the events portrayed in ancient Maya art, and those of early colonial and modern narratives—the Popol Vuh among them.

Coe made fruitful comparisons between the deeds of the Headband Gods in Classic Maya art and those of the Hero Twins in the Popol Vuh.[52] Some were discussed in previous sections, but they are worth recapitulating. As a blowgun hunter, God S was often shown in wild, forested places, wearing a simple straw hat and engaged in shooting birds or other animals with his blowgun. This activity brings him close to the Hero Twins of the Popol Vuh, especially in scenes that show two nearly identical versions of God S shooting blowguns—as represented on the Blom Plate (fig. 82). Other hunters with no distinctive skin markings sometimes accompany God S, but it should be stressed that he was never paired with God CH in hunting scenes. As noted below, God CH was not involved in the defeat of the great bird in the known corpus of Maya art.

Like most Mesoamerican solar and lunar heroes, the Headband Gods of ancient Maya art were monster slayers, defeating powerful foes who opposed their rise as luminaries or pretended to be the luminaries themselves. In the Popol Vuh, the key passages involved the defeat of Seven Macaw and his children. Representations of God S confronting a monstrous bird—and sometimes losing an arm in the encounter—correspond to his role as a monster slayer and are distinctly related to the defeat of Seven Macaw in the Popol Vuh. As previously mentioned, overlapping representations show God S shooting

FIGURE 82

Detail of the Blom Plate, Late
Classic, lowland Maya area. Museo
Maya de Cancún, Quintana Roo,
Mexico. Nearly identical spotted
gods shoot their blowguns at the
Principal Bird Deity.

FIGURE 83

Drawing 21 from Naj Tunich cave,
Guatemala, Late Classic, lowland
Maya area. This shows a probable
portrait of God S as a ball player.

a bird that seems to play the role of a messenger, which correspond best in mythical epi-
sodes in which the hero shot an avian messenger (see fig. 75).

Ball playing was a conspicuous activity of the Hero Twins in the Popol Vuh, and
it may have been equally important in ancient Maya solar myths. While not abundant,
there are some representations of God S playing ball. As happens with hunting, ball-play-
ing scenes concede no part to God CH. Coe identified two representations of God S
as a ball player, although in both God S is missing the spots that generally characterize
his portraits. The straw hat provides a credible indication of his identity in a painting
at the Naj Tunich cave (fig. 83). In the central marker of Ball Court A-IIb at Copán, the
inscription identifies the Copán king Waxaklahuun Ubah K'awiil as an impersonator of
God S, in probable allusion to his mythical role as ball player (fig. 84).[53] Another example,
in the La Esperanza ball-court marker, shows a player ready to strike a ball inscribed with
God S's hieroglyphic name—without the usual coefficient one. Jeff Kowalski compared the
scene with the Popol Vuh episode in which the lords of Xibalba used Hunahpu's head as
a ball.[54] Expectedly, ball-game encounters are uncommon in modern myths, which pre-
serve little memory of a practice that fell in disuse soon after the Spanish conquest in most
regions of Mesoamerica.

Coe found no references to bloodletting by the Hero Twins in the Popol Vuh.
However, he noted representations on ceramic vessels in which God S employed a per-
forator to draw blood from his genitals (fig. 85). At Copán, a character with a jaguar tail
and paws adopts an acrobatic pose in front of an oversized stingray spine—an instrument
of self-sacrifice (fig. 86). Rather than jaguar-skin markings, the concentric circles on his
body recall God S's spots, which are sometimes encircled by a red halo in painted depic-
tions. Jaguar attributes are not inconsistent with God S, who sometimes sports a jaguar ear.

The west wall of Las Pinturas Sub-1 at San Bartolo contains vivid portraits of God
S piercing his penis with long, pointed tree branches, while presenting sacrificed ani-
mal offerings in front of world trees (see fig. 74). While unmentioned in the Popol Vuh,

FIGURE 84

Central marker of the Copán Ball Court A-IIb, Late Classic, western Honduras. Museo Copán Ruinas, Instituto Hondureño de Antropología e Historia, Copán, Honduras. The Copán ruler impersonates God S as a ball player.

FIGURE 85

Detail of a ceramic plate, Late Classic, lowland Maya area. God S holds a perforator, an instrument of self-sacrifice.

FIGURE 86

Sculpture from Copán, Late Classic, western Honduras. Instituto Hondureño de Antropología e Historia warehouse, Copán Ruinas, Honduras. This sculpture is in the shape of a stingray spine, with a probable portrait of God S in an acrobatic pose.

penitence is fully compatible with the qualities of Mesoamerican solar heroes, who are spiritually strong, pious, stark, and disciplined. Sixteenth-century Nahua myths emphasized penitence and self-sacrifice as the qualities that distinguished Nanahuatl and made him worthy of becoming the sun. He was closely associated with Quetzalcoatl, the legendary king of Tollan who was also noted for his exemplary acts of penitence. In the Legend of the Suns, they were plainly identified with each other: "It's the same as the sun of Topiltzin, Quetzalcoatl of Tollan. And before it was the sun, its name was Nanahuatl."[55]

The solar heroes' penitential acts are consistent with their physical ailments. They commonly endured various maladies, especially cutaneous conditions described as buboes, sores, pustules, or pimples. Like the pimple-ridden Otomí and Huichol boys and the jigger-infested Xut in the modern Tzeltal myth from Cancuc, the Nahua god who became the sun was infirm with pustules or sores. Absent in the Popol Vuh, this attribute is nevertheless evident in the Classic Maya God S. Coe described the god's most salient attributes as "large black death spots on the body," in reference to similar spots that are common in representations of death gods. Taube interpreted the spots as signs of putrefaction and noted that God S was strongly identified with death and sacrifice. Indeed, the spots of God S have the appearance of pustules or buboes, and the red haloes that appear in some examples likely denote swelling. His blemished skin is a distinctive attribute that casts him together with Mesoamerican solar heroes, whose endurance of pain and sacrifice gave them the fortitude they needed to become the sun.[56]

There is, however, an important piece of evidence that seems to contradict God S's identification as a solar hero. On the Vase of the Stars, God S is recognizable by the broad-brimmed hat, blowgun, and spots on his arms and legs (fig. 87). Like other characters on that vase, he bears the sign *ek'* ("star") on his shoulder. This suggests that rather than the sun, he was identified as a star, at least in some of the mythical versions that circulated in the Late Classic Maya Lowlands. Despite this apparent contradiction, God S is the best candidate for a solar hero in ancient Maya art, considering his appearance and demeanor in numerous examples.

The identification of God S as a solar hero begs the question of who was the lunar hero—his counterpart, and probable opposite, in ancient Maya religion and art. Did the ancient Maya conceive the solar and lunar heroes as basically identical to each other, as the authors of the Popol Vuh apparently did? Or did they conceive them as opposites, as they are in the majority of Mesoamerican myths, colonial and modern?

THE OWNER OF THE ANIMALS

In his earliest comments on the subject, Coe applied the label "Headband Gods" to paired depictions of God S, both marked with black spots (see fig. 82).[57] In subsequent work, he broadened it to include representations of the paired Gods S and CH, acting together in various contexts. Thereafter, the label has often been applied loosely to include representations of God S accompanied by other characters who do not have God CH's distinctive

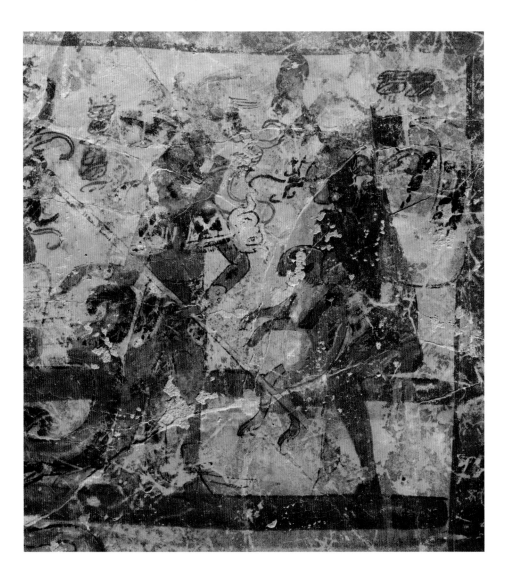

FIGURE 87

Detail of the Vase of the Stars (see fig. 22). God S holds a blowgun, and the Lunar Maize God holds a rabbit.

jaguar pelt patches on their face and body. Such laxity has obscured recognition of the spheres of action of each god, which are not identical.

God CH's hieroglyphic name consists of the logogram YAX ("green/blue"), prefixed to the god's profile head (fig. 88). In numerical contexts, this profile head is a logogram with the reading B'OLON ("nine"). According to Linda Schele and David Freidel, it also functions as a rare substitute for the b'a syllable. Noting the substitution, and the spelling *b'alun* for the number nine in highland Maya languages from western Guatemala and Chiapas, Miller and Martin proposed the reading YAX B'ALUN for God CH's name.[58] While generally accepted, the bases for this reading are tenuous. Maya head-variant numerals are polyvalent signs that tend to have thoroughly different logographic or syllabic values when employed in non-numerical contexts. In recent work, Zender discussed the head variant of numbers one and eight. The first is read JUUN ("one") in numerical contexts; elsewhere, it conveys the logographic value IXIIM ("grain corn"), and it also has the

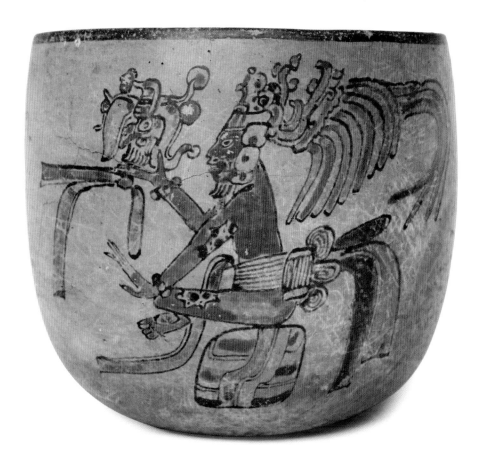

syllabic reading **na**. The head variant of numeral eight is logographic **WAXAK** ("eight") in numerical contexts, and **AJAN** ("fresh ear of corn") elsewhere.[59] By the same logic, the logo-graphic value of the number nine head variant—**B'OLON** ("nine")—is likely unrelated to its reading in the name of God CH, which remains undeciphered.

The Headband Gods were both associated with wild places and both sometimes sported jaguar ears, but God CH had an especially close relationship with the ani-mal domain, and his jaguar attributes were patent (fig. 89). In the Postclassic codices, Taube noted God CH's overlap with Uuc Zip, a god of the hunt in colonial Yucatán.[60] However, God CH does not appear to act as a hunter himself. He never partakes in God S's shooting of birds or other animals and, in fact, he is rarely shown holding a blowgun. A significant exception is Vase K3413, which features a rare representation of paired versions of God CH as identical twins, both distinguished by jaguar pelt patches on their face and arms (fig. 90). Both are holding blowguns, but they are not aiming them at the avian Itzamnaaj

FIGURE 90A

FIGURE 90B

that hovers above them. Nor are the paired Gods CH shooting the wild animals that approach them on a stepped platform, bringing plates and vases with food and drink, like human courtiers to their kings. The stepped platform suggests a palatial setting, while a tree growing in the foreground evokes the forest wilds. In a similar vein, Vase K5001 shows the enthroned God CH conversing with an animal, in the presence of God S and the avian Itzamnaaj. Taube interpreted these scenes as denoting God CH's dominion over forest animals, like a king over his human subjects. He suggested that God CH was conceived as a ruler of the forest and wild animals, while God S played a similar role as the model king of human realms.[61] While Taube related God CH's sway over the animals to the triumph of the Hero Twins over Seven Macaw in the Popol Vuh, these vases show no hint of confrontation. In the extant corpus of Classic Maya vase painting, the shooting of the Principal Bird Deity was not associated with God CH.

Taube also noted a parallel with the sun's brother, called Lord Xulab in Thompson's version of the Q'eqchi' sun and moon myth. Lord Xulab became the morning star, and he was also the owner of all the animals. He kept them in pens, where everyone could access them for meat. He had a big beard, which Taube compared to the patch of jaguar skin around God CH's mouth, sometimes hanging like a beard (see fig. 89). The ugliness of her husband was unknown to Lord Xulab's wife, who only saw him at night, in the dark. Instigated by a suitor, she lit pine sticks to see her husband's face and then laughed at his beard. As Lord Xulab jumped up, all the animals broke their pens and ran into the forest. He tried to catch them but was only able to break the tails of some. Since then, people have had to chase animals in the forest, and hunters must perform appropriate rituals to beg for a successful catch. Lord Xulab also prescribed the same prayers for planting corn.[62]

While there is no clear parallel for Lord Xulab's story in other narratives, some incidents reappear in sun and moon myths. Marianna Slocum published a Tzeltal myth from Bachajón, Chiapas, in which the animals appeared when the Xut toppled a tall tree, killing his older brother. Small animals came from the smaller pieces of the brother's shattered body, while the larger pieces generated large animals. The Xut brought them to his mother, but warned her not to laugh at them. She held the ones she liked better by their tails, but started laughing when they jumped around. The animals ran, and the deer, rabbit, boar, and tepescuintle dropped off their tails. The rabbit was the only animal she could catch, and she is still holding it as the moon. In another Tzeltal version, the solar hero tried to catch the animals that came at night to lift back the trees that he had felled to prepare a cornfield. Indeed, the same episode occurred in the Popol Vuh, where Hunahpu and Xbalanque tried to grab the animals that came at night to raise the trees back up.[63] Thus it appears that both the Hero Twins of the Popol Vuh and the modern solar hero from Chiapas performed actions that were consistent with Lord Xulab's role as owner of the animals in the Q'eqchi' myth.

As one of the Headband Gods, God CH is often identified as a counterpart of Xbalanque in the Popol Vuh, partly because of his jaguar attributes. Xbalanque's name

is not easily translated, but Christenson reached a plausible interpretation as "Young / Hidden Jaguar Sun."[64] There are indications that Xbalanque was a solar god in colonial Guatemala. The god Exbalanquen, without a brother, was the sole protagonist of the sixteenth-century myth recorded by Las Casas, in which he went down to hell, waged war against its inhabitants, and captured their king—just as the Hero Twins did at Xibalba, according to the Popol Vuh. There is no reason to think that Las Casas failed to mention Hunahpu, or that his consultants somehow forgot him. Rather than an inaccurate version of the Popol Vuh, this is a different version of the myth, in which Xbalanque did not share his role as vanquisher of the lords of death with a brother. Las Casas's succinct account makes no allusion to a parallel role as lord of the animals. Neither does Juan Caal's early twentieth-century version of the Q'eqchi' sun and moon myth, in which the solar hero was called B'alamq'e.[65]

A final question is whether God CH might be a lunar hero. In her comprehensive survey of Maya stellar gods, Susan Milbrath included God CH among lunar deities, but her arguments are not independent of the generally assumed correlation with Xbalanque in the Popol Vuh.[66] While the iconography of God S is fully consistent with the attributes of Mesoamerican solar heroes, God CH has no specific lunar connotations. He is not associated with lunar icons such as the moon sign, the lunar rabbit, or the Moon Goddess. In this respect, he departs from the lunar destiny of one of the Hero Twins in the Popol Vuh, and the feminine Xbalanque in the Título de Totonicapán.

Gods S and CH find no simple, one-to-one correlates in the Popol Vuh, nor do they correspond entirely with other groups of siblings in colonial and modern Maya myths. Nevertheless, Coe's identification of this pair with the Hero Twins is not entirely inaccurate. In the Popol Vuh, the Hero Twins were the solar and lunar heroes. In ancient Maya art, God S is compatible with the role of a solar hero, although he also had stellar connotations in some contexts. As owner of the animals, God CH finds better correlates in characters such as Lord Xulab—the sun's brother in modern Q'eqchi' myths. However, the Q'eqchi' heroes also overlap with the Hero Twins of the Popol Vuh, and with the Tzeltal solar hero, who appears to assume the role of owner of the animals in some narratives.

Gods S and CH are not entirely similar, but their relationship does not appear to involve radical disparities. They are both denizens of wild places, and they act in similar ways when shown together. The distinctions between them bear no relation to the contrast between the solar and lunar heroes in the majority of Mesoamerican myths, and moreover, none of them has clear lunar attributes. However, they frequently appear together with the Maize God, whose deportment and personality are markedly dissimilar, and whose lunar identity is sometimes indicated unambiguously by a moon sign. Together, they were the subjects of a rich array of mythical representations in Preclassic and Classic Maya art.

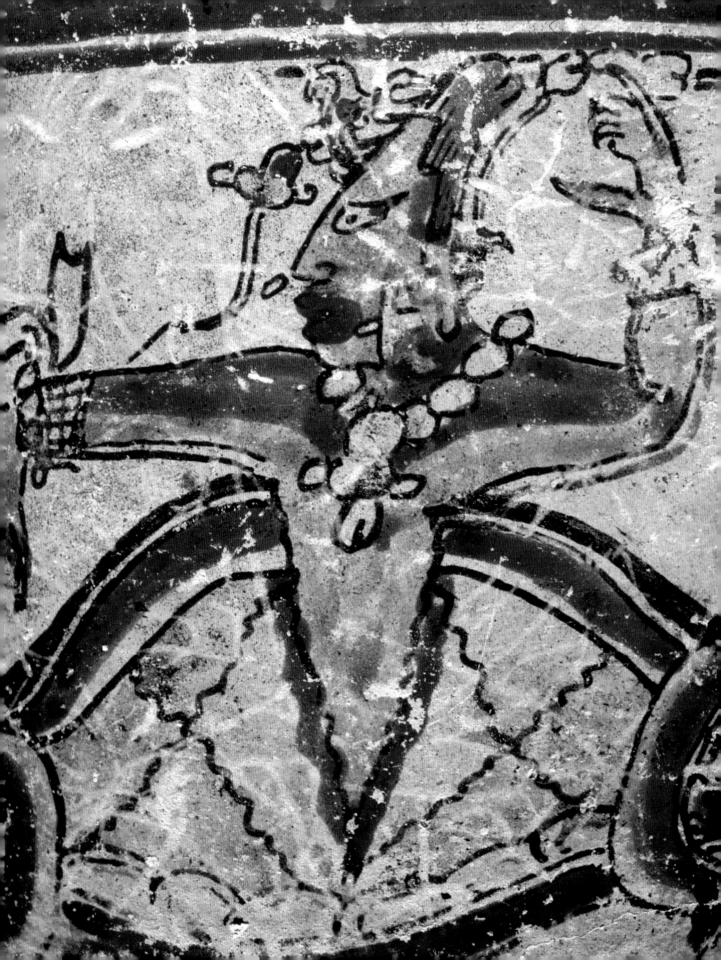

8 The Perfect Youth

God bled to make the world happy; he spilled the blood down the cross, as grain
 for us all. . . .
It was not blood, it was maize, it was maize grain; beans too, maize and cash too.
 —Don Nito

Rather than salvation in the afterlife, Jesus's sacrifice brought about human sustenance on earth, as understood by Don Nito, a ritual specialist (*zajorín*) from the Ch'orti' hamlet of Tunucó Abajo.[1] Not just maize, but also beans and even money—Jesus's sacrifice generated the basic human foodstuffs and all kinds of wealth. As described in a parallel K'iche' version from Chichicastenango: "While nailed to the cross, Jesus miraculously turned around completely, exposing his back, and from his back came maize—white, yellow, and black—and beans and potatoes and all the other food plants." In the corresponding passage of a Tepehua myth, Jesus freed himself from the cross and rose up as the sun. Its heat and brightness were too strong, and people asked the stars to cut off Jesus's middle fingers; all kinds of plants grew from the spilled blood. The outcome of Jesus's sacrifice is reminiscent of the crops that grew from the buried body of Centeotl, the Maize God— several kinds of maize, chia, sweet potato, cotton, and other useful plants—according to the sixteenth-century text of the *Histoire du Mechique*.[2]

Indigenous narrators embedded the passion of Christ in a Mesoamerican myth about the origin of the basic conditions for human life and the defeat of the evil beings that prevailed in a former era. In many ways, Jesus's sacrifice responded to the same questions that the gods asked in the Popol Vuh: "How should the sowing be, and the dawning?"[3] In the K'iche' text, the story of the Hero Twins provided answers for these questions. Ancient Maya views can be gleaned to a certain extent from artistic renderings of the mythical deeds of the Headband Gods and the Maize God.

Detail of ceramic vase. Late Classic, lowland Maya area. Present location unknown. The Maize God emerges from a cleft turtle.

THE YOUNG HEROES

With noticeable joy, Don Nito described the transformation of Jesus's blood into maize grains, as it flowed down the cross and fell into the hands of Mary Magdalene.

According to testimonies gathered decades ago by Rafael Girard, Mary Magdalene is the modern Ch'orti' name of the mother earth. When Our Lord's blood fell into her hands, it formed a milpa. His blood was also the first rainfall, the miracle that allowed the earth to yield its fruits. One narrator blamed Jesus's death on the Jicaques—a term that designates the Tolupan people of Honduras, who in this context stand for the savage inhabitants of a former era. They cut Our Lord's head and buried it together with his quartered body, but he revived as a child, who was maize: "When he spilled his blood at the foot of the tree of the cross, then came the miracle (rains, maize). It did not rain before, he gave the rainy season. They (the evil men) buried him after they killed him. The Lord revived with his power. The Child (little maize) was born from there. This is the one who reigns in the next stage. When he revived he brought up a crop.... The son of the Lord killed all the evil men, and they went to hell."[4]

The Ch'orti' narrative hints at two generations of gods and the transition between two eras. The death of the father, killed on the cross by the Jicaques, marked the end of the earlier era. In the subsequent era, his son avenged him and punished his killers. Both father and son seemed to have been identified with maize, and yet they were distinct. The father died, and it was the son who eventually triumphed. Girard noted the overlap between the Ch'orti' version of Jesus's passion and the myth of the child hero, Kumix, an orphan who prevailed over the evil beings who opposed him, provided for his mother, and avenged the death of his father. He characterized Kumix as "the young deity of maize and the solar god" and also compared him with the Hero Twins of the Popol Vuh.[5]

The childhood of maize heroes overlaps with the stories of sun and moon heroes from the Maya area and elsewhere. In Mesoamerica, maize is frequently conceived as a delicate child who needs much care and may easily die if unattended. Mesoamerican maize heroes are generally young, orphaned children whose father died in a remote place, and who were sometimes rejected by their mother. A distinctive episode that is absent in sun and moon stories is their death in a body of water, thrown by their own mother, grandmother, or older brothers. The heroes' watery deaths recall the destiny of the drowned in sixteenth-century Mexica beliefs: they were favored by the earth and rain god Tlaloc and destined to reside in a lush place of abundant vegetation and water. Not by coincidence, maize gods frequently possessed rainmaking abilities, and the myths sometimes described how they instructed other gods to produce rains.[6]

As a child, the maize hero is often described as a prodigious hunter, and as a musician who played different kinds of instruments. Common episodes include his struggle against the old woman, or against the old couple who raised him but eventually contrived to kill and devour him. After telling of the hero's defeat of the old woman, some narratives include an episode in which he searched for his real mother. More commonly, he undertook a difficult journey to the place where his father was killed. He defeated the murderers and, in some versions, turned them into rainmakers. In a final episode, he tried to resuscitate his dead father, but failed. The following paragraphs highlight

the common subjects and the variability present in modern Ch'orti', Nahua, and Popoluca myths.

Passages from Don Lucio Méndez's version of Kumix's story were reviewed in previous chapters. Briefly, he was an orphan, the youngest in a group of brothers—hence his name, which means "smallest," "youngest," or "the last in a series." His brothers rejected him and finally threw the baby in a river, pounding the water to kill him. Some versions describe how the baby was newly formed from the blood mixed with the water froth. The baby was found further downstream by the K'echuj or Ciguanaba, an insidious old woman in Ch'orti' tales. Kumix became an able hunter who brought all the animals in the forest for the old woman. Don Lucio omitted mention of the Ciguanaba giving the food to her lover. However, other versions describe her encounters with a tapir, a devil, or simply a monster. The usual passages ensue: The boy killed the lover, after a bird told him the truth about his origin. Angered, the Ciguanaba tried to murder Kumix and broke her teeth when she bit the stone pestle that he put in his bed as a decoy. In several stories, Kumix finally killed the Ciguanaba by burning her in the field he had prepared for planting.[7]

Kumix went in search of his mother, who was poor and destitute in heaven. He asked different birds to take him, but only the hummingbird proved able to lift him up. Initially, his mother mistook Kumix for her husband, insinuating a potential incest that was quickly ruled out when Kumix revealed his identity. Through magic and prayer, he produced clothing and abundant food for her. She told him that his father had been killed and his uncles had taken his inheritance. According to Don Lucio, the thieves were the spider monkey (*mico*), who took the whip; the monkey (*mono*), who took the drum; and the armadillo, who took his father's clothes, which were the clouds. Other versions feature different animals or named characters, and the objects also vary. In a version recorded by Brent Metz, Kumix's inheritance consisted of a drum, a machete, and a gourd. After tricking the thieves to give them back, he used them to generate, respectively, thunder, lightning, and rain. Kumix went on to defeat his father's killer. In Don Lucio's version, he summoned ants to bite the monster and then killed it with a stroke of lightning.[8]

A frequent episode—absent in Don Lucio's account—described how Kumix summoned lightning to destroy a tower that his brothers were building to reach the sky. The tower allowed monstrous eagles to descend and snatch people, who covered their heads with wooden cages to protect themselves—evoking the great birds featured in stories from other regions. According to versions recorded by Kerry Hull, Kumix instructed his brothers to hide their heads in the ground, while raising their legs up, a stance that recalls depictions of personified trees in ancient Maya art.[9] The good brothers obeyed, while the evil ones raised their heads and were blinded by lightning. The Ch'orti' identify Kumix's brothers as rain-bringing gods. Don Lucio's version concluded with Kumix's attempt to resuscitate his father by praying over his remains, which finally proved unsuccessful.

Kumix's myths find close parallels in a broad group of maize hero narratives compiled in Popoluca, Nahua, Totonac, Tepehua, and Teenek communities of the Gulf Coast

and adjacent regions. The names of the maize heroes vary: Homshuk among the Popoluca; Tamakastsiin among the Nahua of southern Veracruz; Sintiopiltsin or Chicomexochitl among the Nahua of the Huastec region; and Dhipaak among the Teenek. According to a beautifully crafted Nahua story told by Don Gregorio in Xochiatipan, Hidalgo, Chicomexochitl was born from a maiden whose parents kept her secluded inside a box.[10] As expected, the box was no deterrent for a suitor, who managed to magically impregnate her. Irate, the grandmother killed the child, only to find a maize stalk growing at the place where she buried him. She harvested the cobs, ground them three times, and threw the dough into the water. The fish and shrimp tried to eat him, but the child induced them to vomit, thus acquiring their bulging eyes and spiny back. A turtle found the child sitting by the shore and took him to the other side. Along the way, Chicomexochitl tickled the turtle while crafting a beautiful dress for her—hence the patterns in the turtle's carapace. The child went on to find his lost mother and punish his evil grandmother, who died in a sweat bath.

The father of Homshuk, the Popoluca maize hero, died in a distant place—in war, according to a version from Soteapan, Veracruz—and his mother ground the baby, tired of his ceaseless crying.[11] Homshuk somehow survived, and according to some versions took the shape of an egg, which was found by an old cannibal woman. Her husband wanted to eat the egg, but she decided to raise him. The child made her angry when he killed the birds, fish, or iguanas that made fun of him, which turned out to be his uncles. Determined to eat him, the old woman sharpened her teeth in the river. With the help of a bat, Homshuk beheaded the old man, sometimes described as a large serpent. The old woman drank her husband's blood, thinking it was the child's. She pursued the fleeing boy and met death in a field that the opossum set on fire, at Homshuk's request. The old woman's ashes originated biting insects that were set free by the toad that was supposed to throw them in the water.

The second part of Homshuk's story involved a difficult trip to find his parents. After several incidents, he reached the seashore. A turtle took him across water to the land of the Thunders, "where Hurricane was," in Leandro Pérez's version (retold by George M. Foster).[12] Once he reached that place, Homshuk made music with a drum, a turtle carapace, a flute, or other instruments. The noise annoyed the Thunders, who summoned him to their presence. After several contests, he defeated them, but let them live on the condition that they would sprinkle his head when thirsty. Some narratives include details about Homshuk's encounter with his mother, who initially mistook him for her dead husband. In most versions, Homshuk's story ends with his unsuccessful attempt to bring his father back to life.

The Popoluca narratives share not only broad outlines, but also specific details with their Ch'orti' counterparts. Hull reported an episode in which fish gathered around Kumix to feed on the blood that flowed from a cut on his shin. The incident reappeared in Fermín Gutiérrez's version of the Popoluca story, in which the lizards hit a sore

on Homshuk's leg with their tails, and the fish did the same when he entered the water.[13] In both cases, the incident occurred during the boy's early childhood. Producing maize was one of Kumix's feats, although the modern Ch'orti' myths do not identify him specifically as a maize god. Instead, they highlight his rainmaking abilities. Nevertheless, Girard and Hull identified him as a maize god, while Julián López García and H. E. M. Braakhuis and Hull emphasized his attributions as a rainmaker.[14]

Rainmaking was also an ability of the Nahua, Totonac, and Tepehua maize heroes. Several narratives explain how the hero cut off the tongue of a crocodile or caiman and used it to produce lightning and to bring rains. In Nahua stories, he finally entrusted it to other characters—sometimes identified as the Thunders or the owners of water—who would produce rain for him.[15]

The conflation of multiple attributions in the same character is not unusual for Mesoamerican gods. Maize heroes are frequently rainmakers, although they may share that ability with other gods. The Ch'orti' hero, Kumix, also became the sun, according to Girard's abridged version of a narrative told by Anastasio de León more than fifty years ago.[16] This conclusion is unknown in other versions, yet it is not implausible, since the myths of maize and solar heroes overlap in many ways. The characters are conflated in Totonac myths, which identify the heroes as "maize twins," even though they largely follow the argument of sun and moon stories, and credit the solar hero with the origin of maize cultivation.[17] A similar conflation was embodied in the Hero Twins of the Popol Vuh.

MAIZE IN THE POPOL VUH

The Hero Twins merged the attributes of Mesoamerican solar and lunar heroes with those of maize heroes. Their early contests with their grandmother and older brothers, their victory over the monstrous beings that opposed their rise as luminaries, and their voluntary death in a blazing oven, fit well with their ultimate destiny as the sun and the moon. They also shared correspondences with Gulf Coast maize heroes and with Kumix, the Ch'orti' hero—as noted by Foster, Girard, and Alain Ichon—including the initial death of their father, their early life with a malevolent old woman, their summons by their father's killer, their journey and passage through a body of water, their contestation and eventual victory against their father's killers, and their unsuccessful attempt to revive their dead father.[18]

Several passages underline the analogy of the sixteenth-century K'iche' and modern Ch'orti' myths. The Popol Vuh paid special attention to the objects that were left by the Hero Twins' father and his brother, which were analogous to the objects of Kumix's inheritance that were stolen by his uncles: "What Xibalba desired was the gaming equipment of One Hunahpu and Seven Hunahpu: their kilts, their yokes, their arm guards, their panaches and headbands, the costumes of One Hunahpu and Seven Hunahpu."[19]

The lords sent messengers asking them to come and bring their ball-game gear. Defying their demand, One Hunapu and Seven Hunahpu left their rubber ball tied under the roof of the house. The Hero Twins' recovery of their father's ball was a turning point in their story, which foreshadowed their encounter with the lords of death. Likewise, Kumix recovered his father's whip, drum, and clothes, and only then was he able to confront his father's killer. The passage reappeared in a Tepehua myth from Pisaflores, Veracruz, in which the boy recovered the drum that his father—a musician, killed by men who despised his music—had left in the loft.[20] When the men heard the music again, they went after the boy, setting in motion the confrontations that would lead to their defeat.

The evil men of the Tepehua myth had killed the hero's father in a ball game, throwing iron balls against him. They tried to do the same with his child, but he was able to catch the balls and throw them back, killing all but a few, who pleaded mercy. In the Popol Vuh, the lords of Xibalba fled in panic after the Hero Twins killed One Death and Seven Death, the foremost among them. They crowded at the bottom of a ravine, where ants swarmed upon them, until they finally gave themselves up to the triumphant heroes, pleading mercy. The biting ants also mediated the defeat of the Bronze King, the killer of Kumix's father in Ch'orti' versions. The hero magically generated swarms of ants that bit the powerful king, forcing him to take off his bronze armor, and allowing Kumix to finish him with a stroke of lightning.[21]

The Hero Twins' travails in Xibalba find equally strong correspondences in modern accounts of the Gulf Coast maize heroes. When he finally acquiesced to Hurricane's summons, Homshuk was thrown into a series of jails. According to Leandro Pérez's version, there was one jail with hungry jaguars, another with famished serpents, and a third one with flying arrows. In a variant recorded by Guido Münch Galindo, Homshuk's opponent was the god of death. Annoyed by the boy's singing, he threw Homshuk into the house of rays, where swords, arrows, and axes had life, and then into a house of serpents. In Nahua versions from Veracruz, the maize hero went in search of his father, who had been killed in Youajlaam, the "place of darkness," or Tagatawatsaloyan, "where men are dried." Reaching that place, the hero was thrown into a jail with live machetes, another with live axes, and a third with snakes. He survived in each case, assigning the jaguars and serpents their place to live, and instructing the arrows or other utensils to serve for men's defense and hunting. Hurricane's jails, Foster observed, corresponded with the houses of Xibalba, where the Hero Twins where subjected to a series of trials. Like the Gulf Coast heroes, they survived the house of knives by assigning the blades their future functions, and the house of jaguars by assigning the animals their food. By magic and ingenuity, they also survived the houses of darkness, cold, bats, and fire.[22]

Absent from the Popol Vuh is the heroes' death in water in early childhood—a critical episode in maize hero myths from the Gulf Coast, and in the Ch'orti' myth of Kumix. In the Popol Vuh, this key episode seems to be transposed to a later stage in the story. Before dying by their own will in the fiery oven at Xibalba, the Hero Twins

left instructions about what should be done with their bones: "It would be good if their bones were ground upon the face of a stone like finely ground maize flour. Each one of them should be ground separately. Then these should be scattered there in the course of the river. They should be sprinkled on the river that winds among the small and great mountains."[23] Robert Carlsen and Martin Prechtel realized the significance of this passage, which reveals the Hero Twins' identification with maize. Another indication was the signal that they left to their grandmother—maize stalks planted in the center of the house, which would dry up if the heroes died and sprout again if they were alive.[24]

The heroes came back to life from their scattered ashes, first as fish-men and then as poor orphans. Likewise, Homshuk and other Gulf Coast maize heroes were rescued or reborn in various ways from the water, as orphan children. The maize hero's piscine aspect was remarked in a Totonac version, in which he was born from a fish that became pregnant from eating an old woman's *nixtamal*—maize cooked with lime. The Ch'orti' hero, Kumix, turned into a fish when thrown into water by his brothers and was later reborn as an orphan, according to Anastasio de León's version. In an important essay, Braakhuis highlighted the significance of the Hero Twins' passage through water at Xibalba, and its parallels with the watery death and rebirth of Kumix and the Gulf Coast maize heroes. He noted, "The aquatic rebirth episodes of the Popol Vuh and the [Gulf Coast] Maize Hero are not just parallel: the shared symbolism of maize actually assimilates them to each other."[25]

The Hero Twins shared the qualities of Mesoamerican maize gods. However, they were not the only gods of the Popol Vuh who related to maize. Their mother, Xquic, was able to generate enough maize to fill a net by pulling the silk from the lone ear of maize that she found in the field, after invoking a group of female "guardians of the food."[26] Female maize deities are not uncommon in Mesoamerican communities. A counterpart for Xquic appears in modern Tzotzil accounts. In Manuel Arias Sojom's version, she was X'ob, "the mother of maize," daughter of a rain god and lord of the hills. She filled nets with maize from only four ears that stood in the corners of the field. Angered by her powers, her husband hit her, and the blood dripping from her nose stained corn grains, originating red corn. She returned with her father, but left little clay jars from which her children gathered abundant food, until the angry husband broke them.[27] More distant echoes come from Cora and Huichol myths. A very poor man went in search of food and came back to his mother's house, bringing a wife. Her father had warned him that she should not do any work. At once, there was abundant food in the house. The man's mother complained about the laziness of her daughter-in-law, who did not help her with the house chores, and ordered her to grind corn. The girl complied, but her hands bled when she started grinding—as if she was grinding herself. The girl left, or was taken back by her father, and the food went away with her.[28]

In the Popol Vuh, there is an explicit relation between the mother, who could magically multiply maize, and her sons, Hunahpu and Xbalanque, who were assimilated

with maize but were also the solar and lunar heroes. Mesoamerican myths often hint at a close relationship between the origin of the sun and the moon and the origin of maize. In Eric Thompson's version of the Q'eqchi' myth, the rise of the sun and moon was immediately followed by the explanation of how maize was found hidden inside a mountain. It was first found by the ants and other animals, and then by people who asked for help from the gods to split the mountain open to obtain the precious staple food. Poqomchi' narratives make the connection clear: after eloping, the sun left his wife inside a cave—pregnant in some versions. She stayed there and became maize. The animals found the grains that were hidden in the mountain, and the gods split the mountain open, allowing people to obtain food.[29]

The Popol Vuh contains no explanation of how maize came to be hidden in a mountain. Yet the triumph of the Hero Twins and their ascent as luminaries was immediately followed by the explanation of how maize was found at a place called Paxil, Cayala. Finding maize was thus an immediate outcome of the heroes' victory.[30] The name Paxil ("split" or "cleft") alluded to the mythical mountain that, according to widespread narratives, was split open to yield maize, sometimes together with other useful seeds. According to the sixteenth-century Nahua version of the Legend of the Suns, it was Nanahuatl—the buboed god who would become the sun—who opened Tonacatepetl, the mountain of sustenance, yielding maize of every color, plus beans, chia, amaranth, and other staples. Modern versions of this episode are found throughout Mesoamerica.[31]

Modern editors of the Popol Vuh have sometimes placed the finding of maize in Paxil, Cayala, at the beginning of a separate section, artificially distancing it from the deeds of the Hero Twins—a distinction that is not present in Francisco Ximénez's manuscript. The finding of maize was a consequence of the Hero Twins' pursuits, inextricably linked to their ascent as the sun and the moon.

THE ANCIENT MAYA MAIZE GOD

Paul Schellhas first identified the Maya Maize God in the Postclassic codices. He recognized the god's characteristic head shape—"prolonged upward and turned backward in a peculiar manner ... evolved out of the conventional drawing of the ear of maize." In a subsequent study, Herbert Spinden emphasized the god's youthful and handsome human appearance and noted his representation as a newborn, attached to an umbilical cord in the Paris Codex. While questioning Schellhas's interpretation of the god's visage as modeled after a maize ear, Spinden identified the god's portraits in Classic Maya sculptures by the copious foliation with bunches of circular seeds on his head.[32]

Long regarded as a minor deity, the Maize God leaped to the fore of ancient Maya religious studies thanks to sustained work by Karl Taube, who identified the god's iconographic attributes in Classic Maya art, analyzed its multiple connotations, and traced it back to Preclassic Olmec religion and art. Related work by Virginia Fields and Tomás

a b c

FIGURE 91

Representations of the Maize God:
(a) Detail of a mural painting from
the north wall of Las Pinturas Sub-
1, San Bartolo, Guatemala, Late
Preclassic, lowland Maya area; (b)
Detail of a stone disk, Early Classic,
lowland Maya area; (c) Detail of a
sculpture from Quiriguá Structure
1B-1, Late Classic, lowland Maya
area.

Pérez Suárez stressed the links between Maya and Olmec maize iconography, while the
discovery of Late Preclassic portraits at San Bartolo gave considerable support to the
interpretation of the lowland Maya Maize God as derived from Olmec models. A key con-
tribution was Taube's identification of Michael D. Coe's Young Lords as representations
of the Maize God. He noted that many examples in Classic Maya art lacked the maize foli-
ation that allowed Schellhas and Spinden to recognize the god's portraits. Yet they shared
his youthfulness and peculiarly elongated head, often curved backward and inscribed with
a spiral or U-shaped curl, which Taube identified as a corn grain. The god is characteris-
tically bald, except for a narrow brow fringe and an unkempt tuft of hair on the crown of
his head, corresponding to the corn silk.[33]

Schellhas noted the Maize God's resemblance to characters portrayed on the
Palenque reliefs, now known to be rulers' portraits. Indeed, the god's profile served as
a paradigm for Classic Maya male beauty, and some types of cranial modification may
have reflected a desire to resemble the god's elongated visage.[34] However, Taube showed
that the god's markedly human appearance only developed during the Classic period. In
Late Preclassic Maya art, the Maize God had a frontally projecting upper lip, buckteeth,
prominent cheeks, receding mandible, markedly slanting eyes, and undulating head. Early
Classic portraits retain the pronounced upper lip and receding mandible, often with a
long lock of hair falling backward or in front of his face, tied at regular segments with
round jewels. The occasional beard suggests that he was not always conceived as juvenile.
By the Late Classic period, his facial features are decidedly those of a handsome young
man (fig. 91).[35]

Both in the codices and the Classic period texts, the name of the Maize God was
spelled with a logogram that portrays his profile head. David Stuart proposed a tentative
reading of the logogram as *ixim* ("maize"), based on patterns of phonetic complementa-
tion.[36] In Classic period texts, the logogram is often prefixed by the numeral one, yielding
Juun Ixim ("One Maize").

Abundant jewelry enhanced the Maize God's handsome appearance. In Late
Classic representations, a frequent ornament consisted of an earspool-shaped device on
his forehead, with a serpentine head projecting forward (fig. 92). Assorted jewels, flowers,
and feathers completed his head ornamentation. With some frequency, the Maize God

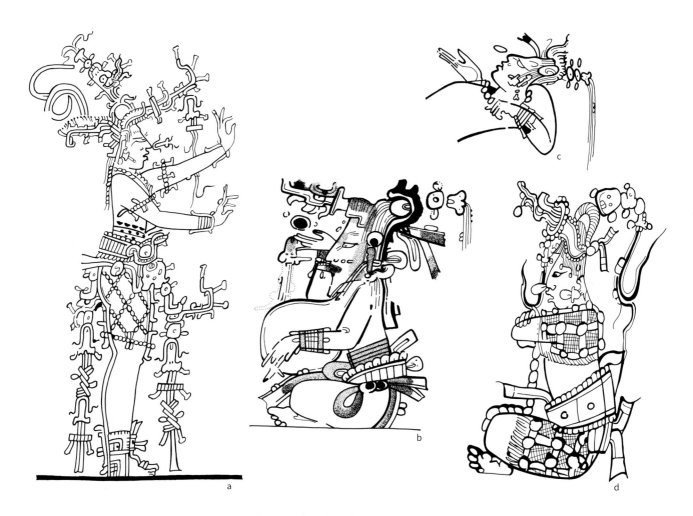

wore a net skirt, combined with an assemblage that featured a large bivalve shell form-
ing the mouth of a piscine creature, with hanging attachments (see fig. 92a). Often worn
by royal women in stately portraits, this combination has been interpreted as a femi-
nine attribute, related to the god's gender duality. The net skirt is sometimes interpreted
as composed of tubular and spherical jade beads. However, it was more likely made of
fibers, in the manner of the *mecaayatl* or *chalcaayatl,* a net mantle that was worn by Mexica
youngsters in the *telpochcalli* (young men's houses).[37]

Taube highlighted the Maize God's relation with jade, the most valuable gemstone
used by the ancient Maya. He also noted the assimilation of maize foliation with quet-
zal plumes, particularly in the rich dance costumes of the Maize God. Simon Martin
explored the Maize God's representations as a god of cacao, sometimes embodying
the tree, with abundant pods sprouting from his body. Jade, cacao, and quetzal feathers
were among the major items of wealth in ancient Mesoamerica. While personifying maize
and agricultural bounty, the Maize God was broadly related to prosperity, abundance,
and wealth in every sense. Wealth is also consistent with the Maize God's lunar aspect,
since lunar heroes are commonly described as wealthy, in stark contrast with their
solar counterparts.[38]

DANCE, SEDUCTION, AND DEATH

In ancient Maya art, the Maize God was commonly depicted as a dancer in elegant, dynamic poses.[39] Dancing and music making were typical abilities of Gulf Coast maize heroes, who played a variety of instruments—drums and turtle shells, guitars and violins, and sometimes flutes. Music and dance were not highlighted in Ch'orti' narratives, which nevertheless delved into Kumix's recovery of his father's drum, the instrument that allowed him to produce thunder. The meaning of the maize hero's music is clear in a Tepehua myth. Finding his father's drum in the house loft, the boy started playing music that sounded like a guitar and a violin playing together: "That is when music was born, not just any music, but the music of *costumbre.*"[40] In modern Mesoamerica, the word *costumbre* is often used in reference to traditional religious rituals and beliefs. One of the legacies of maize heroes was the music that still allows people to celebrate and invoke them. However, it brought persecution and death to the mythical heroes. The music produced by the Tepehua maize hero led to his confrontation with the "men who did not want to hear the music." They were the ones who had killed his father and now wanted to kill the child.

In the Popol Vuh the ball game clearly took the role that music-making has in modern myths from the Gulf Coast. The substitution is not strange. Representations of ball-game encounters in Classic Maya art normally include musicians playing long trumpets, conch shells, and other instruments. The ball game was a noisy affair, and it was the noise produced by the heroes' shouting and stomping that annoyed the lords of Xibalba, just as the noise of the Tepehua hero annoyed the men who reviled music in the Tepehua myth.[41]

The dancing Maize God appeared in a variety of contexts in ancient Maya art. In Late Classic clay figurines from the Alta Verapaz, he dances while bringing ears of maize, and sometimes also cacao pods (figs. 93, 94). Vases from the same region show the Maize God dancing together with God N—perhaps an episode from an unidentified myth that brought the two gods together (fig. 95). Agricultural bounty is less important in Late Classic painted plates from northeastern Petén that show the "Tikal dancer," a conventionalized portrait of the Maize God in choreographic poses, often underscored by the outstretched lengths of his loincloth and waving feather ornaments. Dynastic allusions gained importance in the finely painted "Holmul dancer" vessels, which show the Maize God dancing with elaborate back-racks that represent animals sitting on mountain masks, surmounted by sky bands with large birds on top. The mountains appear to designate specific sites or dynastic seats. The Maize God performs in these vases as a veritable mover of mountains, dancing with the hills on his back.[42]

Somewhat frequently, the Maize God adopts a contorted pose, with his face and feet turned in opposite directions (fig. 96). In Mesoamerican art, this stance was conventionally employed to represent the act of dancing, likely denoting the performer's twisting motions. The conventional twisting dance pose recurs through millennia across Mesoamerica, from the Preclassic sculptures of Kaminaljuyú to early colonial pictorial manuscripts from highland Mexico (fig. 97).

FIGURE 93

FIGURE 93
Ceramic figurine, Late Classic, Alta Verapaz, Guatemala. Museo Nacional de Arqueología y Etnología, Guatemala City. The Maize God dances while holding corncobs.

FIGURE 94
Ceramic figurine, Late Classic, Alta Verapaz, Guatemala. Museo Nacional de Arqueología y Etnología, Guatemala City. A cacao pod hangs from the belt of the dancing Maize God.

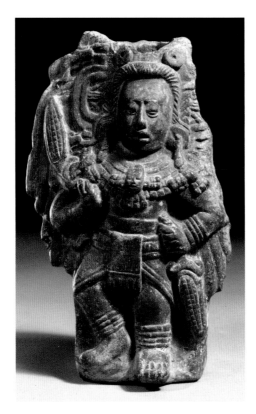
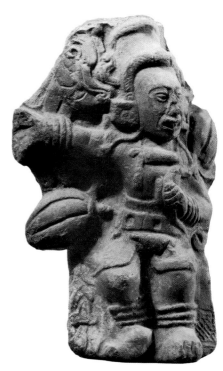

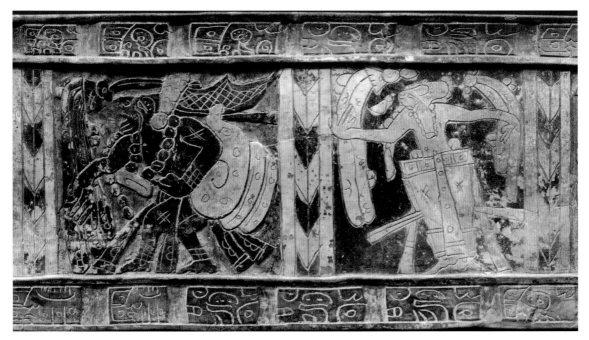

FIGURE 95
Rollout photograph of a ceramic vase, Late Classic, Alta Verapaz, Guatemala. Museo Popol Vuh, Universidad Francisco Marroquín, Guatemala City. The Maize God dances with God N.

FIGURE 96

Detail of Vase K6997, Late Classic, lowland Maya area. Hudson Museum, the University of Maine, Orono. The Maize God adopts a twisted dancing pose, with columns of day names on either side.

FIGURE 97

Dancers in twisted poses: (a) Detail of Kaminaljuyú Sculpture 9, Late Preclassic, Guatemala valley; (b) Detail of Bilbao Monument 21, Late Classic, Pacific coast of Guatemala; (c) Detail of Codex Vaticanus 3773, p. 52, 16th century, valley of Mexico.

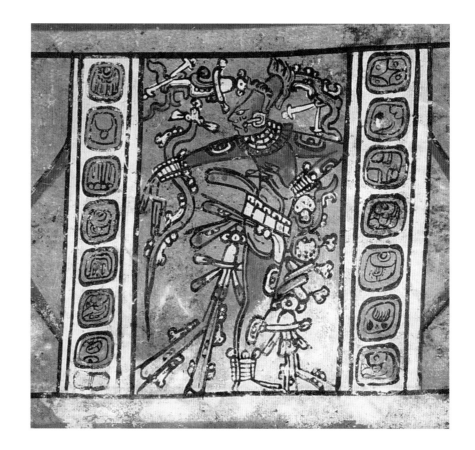

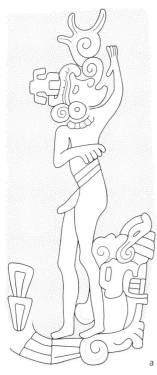
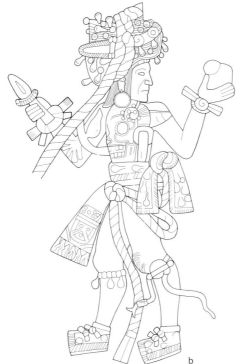
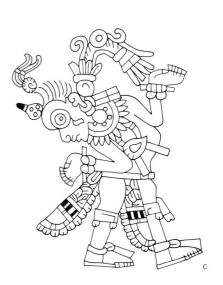

a

b

c

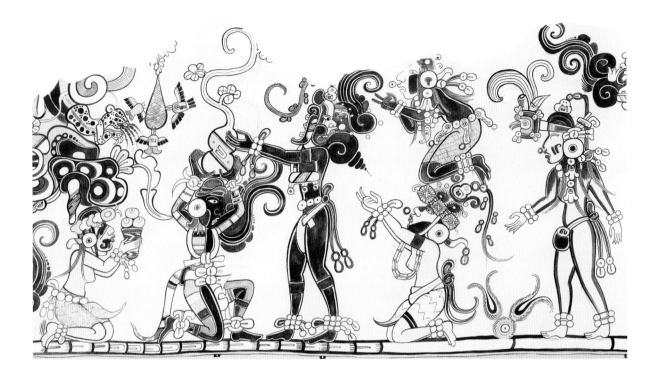

FIGURE 98

FIGURE 98

Detail of a mural painting from the north wall of Las Pinturas Sub-1, San Bartolo, Guatemala, Late Preclassic, lowland Maya area, ca. 100 BC. The dancing Maize God takes a gourd from a black-faced character, while attended by four young women.

An early portrait on the north wall of Las Pinturas Sub-1 at San Bartolo shows the Maize God standing in a twisted dancing pose (fig. 98). He is also singing, as indicated by the large red spiral in his mouth, whose shape resembles that of a conch shell trumpet. A similarly shaped sound scroll comes out of the mouth of a dancer, depicted in a similar stance on the roughly contemporary Kaminaljuyú Sculpture 9 (see fig. 97a). At San Bartolo, his attendants include four lightly clad women. This is the earliest known representation of an encounter that recurred frequently in Late Classic painted vessels. Taube noted the correspondence and suggested that one of the women might be the god's wife.[43] Indeed, the women's attitude toward the Maize God seems to involve erotic enticement, but the comparison with Mesoamerican myths suggests that rather than a legitimate union, this episode represents the Maize God's fall into sexual temptation. Active sexuality is a defining quality of the Maize God, in marked contrast with God S. The contrast is evident at San Bartolo. On the west wall of Las Pinturas Sub-1, God S performs penitence, repeatedly shedding abundant blood from his pierced genitals (see fig. 74); on the north wall, the Maize God sings and dances, surrounded by women.

The Maize God's sexuality found overt expression—perhaps more effectively than in formal artistic works—in a Preclassic graffito from Tikal Structure 5D-Sub3A, which shows an ithyphallic portrait of the dancing god (fig. 99). While sexuality provides a fertile impulse, necessary for the perpetuation of life, it is morally reprehensible in Mesoamerican myths and is normally conducive to death. Colonial and modern narratives offer multiple analogues in which amorous seduction led to the defeat and demise of mythical heroes. In the Legend of the Suns, Xiuhnel lay down with a woman and drank the blood that she offered

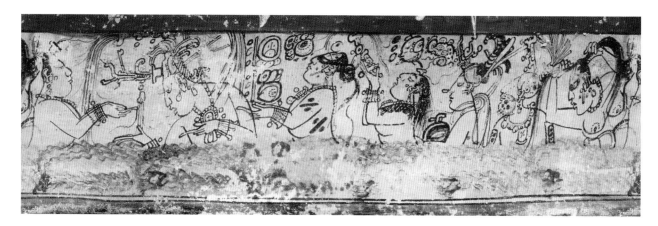

to him. After that, she turned on him, broke open his chest, and killed him. Mimich resisted and finally killed the horrendous woman. In modern Cora myths, the brothers Hatsikan and Sautari—the morning and evening stars—undertook a race. Hatsikan went counterclockwise through the four cardinal directions and resisted the call of a woman who invited him to "cut the flowers" in the west—the domain of the goddess of the earth and the moon. His older brother, Sautari, took the opposite way and slept with the woman, who "took all his flowers" and thus defeated him.[44]

Michel Graulich noted a similar encounter in legendary K'iche' history. According to the Popol Vuh, the Título de Totonicapán, and other sixteenth-century documents, the K'iche' progenitors captured the people of the *amaq'* ("the nations"), to offer them as sacrificial victims for their gods. In an attempt to defeat them, the lords of the amaq' sent their own daughters to tempt the K'iche' gods, who used to bathe in a river and take on the appearance of adolescent boys. The lords ordered the maidens to wash clothes by the river and told them that, if they saw the boys, they should undress, offer themselves to them, and bring proof that they had acquiesced. The gods would thus be defeated. As the story goes, the K'iche' gods resisted the temptation and were able to deceive the lords and defeat them instead.[45] Unlike them, the Classic Maya Maize God seemingly enjoyed the women's company and accepted their entreaties. This is apparent in a number of painted vessels that show one to six young women around the Maize God, dressing or bathing him, presenting him with finery or holding mirrors that allow him to contemplate his handsome appearance. Usually naked or lightly dressed, they hint of sexual availability.

The maidens who tempted the K'iche' gods in the Popol Vuh were named Xtaj and Xpuch—respectively, "Lust Woman" and "Wailing Woman."[46] Seduction and death also went hand in hand for the nubile women who surrounded the Maize God on Classic Maya vessels. Rarely named, their individual identities seem to have little relevance in most cases. However, some of them bear death markings—"percentage" signs and dark areas around the eyes—that reveal their mortuary aspect. Perhaps conveying the treacherous nature of their approaches, Vase K6979 shows two women with death markings and two without them (fig. 100). The blackened region around the eye and the death markings suggest that the former belong to the *Akan* group of deities, associated with inebriation,

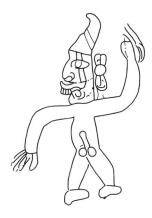

FIGURE 99

Graffito from Structure 5D-Sub3A, Tikal, Guatemala, Late Preclassic. Sexuality is overtly conveyed by this ithyphallic representation of the dancing Maize God.

TOP **FIGURE 100**

Rollout photograph of Vase K6979, Late Classic, lowland Maya area. Present location unknown. The Maize God is attended by four women—two of them with mortuary attributes—in the presence of the Headband Gods.

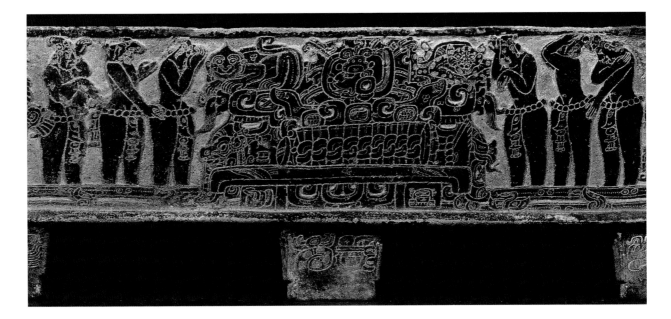

TOP **FIGURE 101**
Rollout photograph of Bowl K1202,
Late Classic, lowland Maya area.
Present location unknown. The
Maize God is attended by naked
women, while God S carries a
bundle.

BOTTOM **FIGURE 102**
Detail of the Death Vase (Vase
K6547), Early Classic, lowland
Maya area. Ethnologisches
Museum, Staatliche Museen zu
Berlin, Preussischer Kulturbesitz,
Germany. Six young women stand
in water, crying for a deceased lord
who was portrayed with the
appearance of the Maize God.

sickness, and death. One of them pulls her hair, seemingly in anguish. The associated text leaves no doubt about the outcome: the verbal phrase *och ha'* ("[he] enters the water"), followed by the Maize God's name, denotes his impending death. On Vessel K1202, the phrase is *och b'ih* ("[he] enters the road"), which conveys the same general meaning (fig. 101).[47]

In these representations, the women played a double role: they were the immediate cause of the Maize God's death and also his mourners. On the Early Classic Death Vase, six nearly naked women weep in sorrow, lamenting the death of a lord, whose body rests on a bench (fig. 102). While the deceased lord is identified as a historical character, Taube pointed out that he was portrayed with the physical features of the Maize God, and his funeral was equated with the god's mythical transit to death.[48] Accordingly, he lay surrounded by nubile women who corresponded with the Maize God's attendants. In accordance with mythical scenes of the Maize God's seduction and death, the women stand with their feet submerged in water, while weeping plaintively.

Aquatic settings with water lilies, fish, and other aquatic creatures are common in Classic representations of the Maize God's affairs with women. While alluding to the god's transit to death, aquatic locations also provide suitable settings for amorous encounters.[49] The sexual connotations of water are evident in Bernardino de Sahagún's portraits of the *ahuianime* ("pleasure women" of the sixteenth-century Nahua), who stand on water and carry water in their hands (fig. 103). Not by coincidence, the K'iche' gods were tempted when they came to bathe by the river. The Maize God's affinity with water is also consistent with his lunar aspect, and with the mythical episodes that describe lunar heroes thirsting for water and enjoying long baths in the company of women.

The Headband Gods sometimes witness the Maize God's encounters with the women, without partaking in them. Not surprisingly, the women take little heed of the simple boy with ugly abscesses on his face and body, much less of his companion with the jaguar pelt patches. Instead, they pour their attentions on the attractive youngster with the long profile and immaculate body, neatly clad in feathers and jewels. On Vase K7268, the Headband Gods occupy a mountainous cave—an appropriate setting for denizens of the wilds—while they watch from a distance the amorous affair that happens in water, signaled by a broad bench marked with an aquatic band, water lilies, and fish (fig. 104). Vase

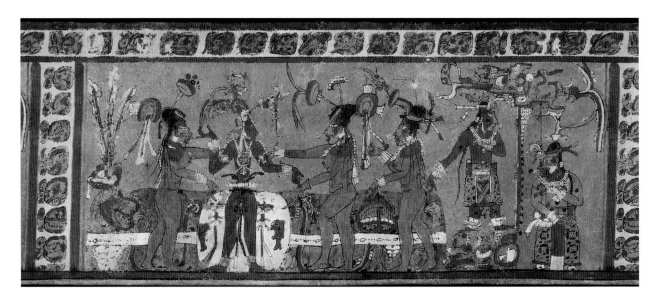

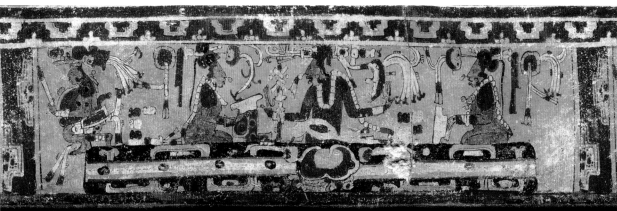

FIGURE 104

Rollout photograph of Vase K7268, Late Classic, lowland Maya area. Present location unknown. From the mouth of a cave, the Headband Gods watch the Maize God's commerce with three naked women.

FIGURE 105

Rollout photograph of Vase K4479, Late Classic, lowland Maya area. Princeton University Art Museum, Princeton, New Jersey. God S turns his back to the Maize God, who is attended by two naked women.

K4479 shows God S turning his back to the threesome, as if departing from them (fig. 105). The scene is reminiscent of mythical episodes in which the solar hero went ahead in the journey, leaving behind the lunar hero while he amused himself with the women.

THE MAIZE GOD AS A LUNAR HERO

The Maize God's affinities with water and women are key traits that bring forth his identity as a lunar hero. Such an identity is evident in portraits that show him with a moon sign, normally attached to his back or growing from his armpit (fig. 106). The god's handsome appearance and deportment in ancient Maya art are consistent with those of lunar heroes in Mesoamerican myths, while contrasting starkly with the plain and unassuming presence of God S and God CH. The Maize God's immaculate, shiny skin is the opposite of God S's pustule-ridden appearance, while his finery contrasts with the latter's generally simple attire. All of these attributes are consistent with the personality of lunar heroes in Mesoamerican myths.

FIGURE 106

The Lunar Maize God: (a) Detail of
an incised conch shell trumpet,
Late Classic, lowland Maya area;
(b) Detail of the Vase of the Stars
(see fig. 22); (c) Detail of a full-
figure glyph, Copán Structure
9M-146 bench, Late Classic, low-
land Maya area, AD 780(?); (d)
Detail of a sherd from Santa Rita
Corozal, Belize, Late Classic.

An ongoing discussion has focused on the Maize God's gender and relationship with
the Moon Goddess. Taube described the Maize God's portraits as possibly dually sexed,
combining traits of the Moon Goddess and the Maize God. Matthew Looper analyzed
them as a complementary pair of androgynous deities, while Susan Milbrath recognized
representations of a male Moon God. In fact, Linda Schele and Mary Miller identified
him as such in the Pearlman Trumpet (see fig. 106a)—where he is paired with God S—and
suggested a parallel with the Hero Twins of the Popol Vuh. They noted a frequent attri-
bute—"a downturned half-mask" that projects from the god's ear, passing by his upper lip.
This is the snout of the Water Lily Serpent, a distinctive attribute frequently worn as a
combined mask and headdress by the Maize God in his lunar aspect. In previous work, I
used the label "Lunar Maize God" to distinguish this aspect of the Maize God.[50]

The Lunar Maize God was the patron of the month Ch'en in the Maya calendar
and one of three deities (the Lunar Maize God, a skeletal god, and a jaguar god with black
spots around the eye) who alternated in Glyph C of the Lunar Series, in ways that are
not completely understood. His name glyph combined the head of the Maize God with a
moon sign, forming a compound of uncertain reading. The name appears in association
with a portrait of the Lunar Maize God on the cover of a stone box found in the cave
of Hun Nal Ye (fig. 107). In that instance, both the name phrase and the portrait include
the numeral thirty, apparently specifying a particular correspondence with a thirty-day
lunar month.[51]

At Palenque, the Lunar Maize God was a participant in a mythical event that hap-
pened in extreme antiquity. Recorded on the Temple XIV tablet, the passage described
the "taking of K'awiil," overseen by the Lunar Maize God, on a date that occurred more
than eight hundred thousand years in the past (fig. 108). Commenting on this passage,
Schele and Miller and Stuart identified the overseer as the Moon Goddess. However, the
distinctive corn curl on the back of the head and the jewels on the forehead are attributes
of the Maize God, while the postfixed moon sign completes the name glyph of the Lunar
Maize God. As usual in dynastic texts, the ensuing passages linked this primeval record
with a ritual reenactment of the "taking of K'awiil" event in historic times, performed by a
Late Classic ruler of Palenque.[52]

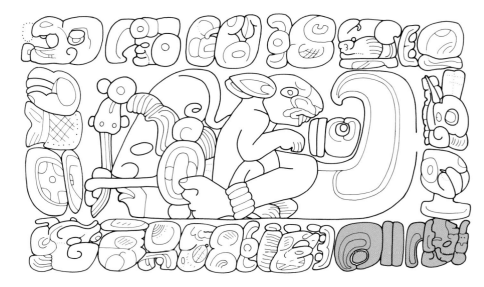

FIGURE 107

Carved relief on the lid of a stone box from the Hun Nal Ye cave, Alta Verapaz, Guatemala, Late Classic. The Lunar Maize God is holding a rabbit. The highlighted glyphs correspond to the god's name.

FIGURE 108

Detail of hieroglyphic text from Palenque Temple XIV tablet, Late Classic, lowland Maya area, AD 705. The name of the Lunar Maize God appears in the second column, third block from top to bottom.

a

b

FIGURE 109

The Water Lily Serpent: (a) Detail of Vase K5628, Late Classic, lowland Maya area; (b) Detail of the Dresden Codex, p. 13a, Postclassic, lowland Maya area.

The Water Lily Serpent mask allows recognition of the Lunar Maize God in examples that show only the god's upper body, making it difficult to determine his gender. By itself, the Water Lily Serpent was a major deity, portrayed throughout the Classic period on pottery painting, portable objects, and architectural façades. Its Postclassic manifestation reappeared in the Dresden Codex (fig. 109). The Water Lily Serpent's salient attributes include a serpentine body, spiral eyes, and a long, down-turned snout. Typically, the jawless mouth has a pointed, undulating frontal barbel or tooth, with spiral curls on either side. The headdress includes a large water lily tied by the stalk to a pad on the serpent's forehead. Fish are usually biting the flower. In addition, it commonly wears a tubular device projecting above the head, often with a small, serpentine creature with shell wings riding on top. According to Taube, the Water Lily Serpent personified terrestrial waters, including rivers, lakes, cenotes, and the sea. In numerical and calendric contexts, it served as a variant of the numeral thirteen and a variant of the *haab* sign, which designated a calendric period of 360 days.[53] The Water Lily Serpent's aquatic connotations may explain its association with the Lunar Maize God, although there were probably deeper mythical explanations that remain unknown.

The Lunar Maize God is related to the Moon Goddess, although they are distinct from one another. Like her, the Lunar Maize God sometimes holds a rabbit in his arms.

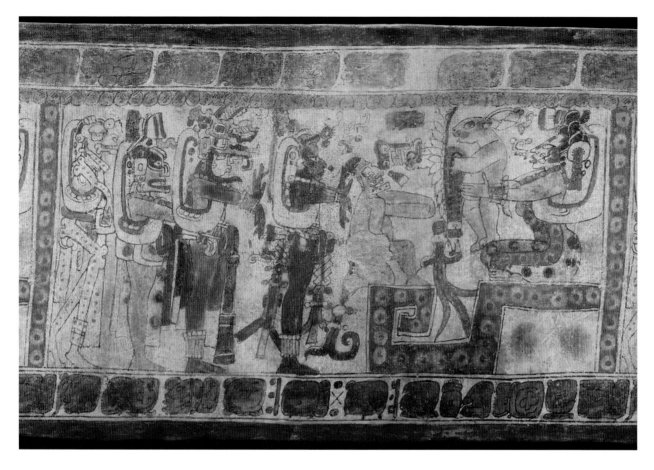

FIGURE 110

Rollout photograph of Vase K5166, Late Classic, lowland Maya area. Los Angeles County Museum of Art. Four lunar gods witness God L kneeling before the enthroned Moon Goddess. The rabbit in her arms is holding God L's cape and hat.

Vase K5166 portrays the Lunar Maize God as the first in a group that includes the Glyph C gods standing before the enthroned Moon Goddess, who presides like a queen over a lunar court (fig. 110). Each god has a moon sign in the armpit. However, there is a fourth character, standing second in line behind the Lunar Maize God. This is a human-bodied Water Lily Serpent, standing as a personified form of the Lunar Maize God's headdress behind its usual wearer. The vase shows that the Lunar Maize God was conceived as physically distinct from the Moon Goddess, and also hints at the Moon Goddess's superiority in a hierarchy of lunar gods. The scene corresponds to a passage in the story of the lunar rabbit that stole the clothes and jewels of the powerful God L.[54] The dispossessed god kneels before the Moon Goddess, who holds the thief like a child in her lap. While there is no good correspondence for this episode, a comparison with modern mythical narratives raises the question of whether the rabbit's mischief explained why it finally ended up as the moon's companion.

It should be noted that in addition to his lunar aspect, the Maize God was also identified as a stellar being. Examples appear on painted vessels and sculptures. On a Late Classic ceramic plate, an oversized ek' sign substituted for the entire body of the Maize God, denoting his identity as a star, planet, or constellation that remains unidentified (fig. 111). The scorpion tail is a frequent attribute of stellar characters in Classic

a

b

FIGURE 111

The Maize God as a stellar being, Late Classic, lowland Maya area: (a) Detail of the Maize God with a scorpion tail, pulling his arms and legs through an ek' ("star") sign, on Plate K4565; (b) Painted designs on a codex-style vase showing the Maize God and a deer as stellar beings.

Maya art. It reappears on the sculptured bench from Copán Structure 8N-11, which seemingly opposes the Lunar Maize God with a stellar counterpart, who pulls an arm through a large ek' sign (fig. 112). The opposition may relate to the cardinal directions: in Maya cosmology, the moon was opposed to the stars, as suggested by the pairing of the moon and star signs on paired variants of the **TZ'AK** logogram. Moreover, the mural paintings of Río Azul Tomb 12 show that the moon was linked with the north, while the stars belonged in the south. In this cosmic scheme, the Lunar Maize God appears to be linked with the northern sky, while the stellar Maize God is a denizen of the south.[55]

The Maize God's lunar connotations are relevant to elucidate his association with the Headband Gods. The Lunar Maize God—marked with a moon sign—was paired with God S on the Pearlman Trumpet and the Vase of the Stars (see fig. 87).[56] Elsewhere, there are other instances in which the Maize God does not display the moon sign while still paired with God S, such as the finely painted Vase K1183, on which both gods bring presents before the celestial throne of Itzamnaaj (fig. 113).

A frequent grouping consists of God S, God CH, and the Maize God. The trio appears together in representations of the Maize God's journey and his rebirth from a cleft turtle. However, God CH is missing in several examples, and it should be noted that the Maize God was never coupled with God CH alone. God CH was a frequent, but not an obligatory, participant in mythical scenes that involved God S and the Maize God. The variation may reflect different mythical versions, some of which conceded no role to God CH. They give the impression of a primary connection between the Maize God and God S, with God CH participating only as the latter's companion.

THE JOURNEY

A key rendering of the Maize God's encounter with the women appears on the Vase of the Paddlers (fig. 114). The vase presents three discrete scenes that likely correspond to

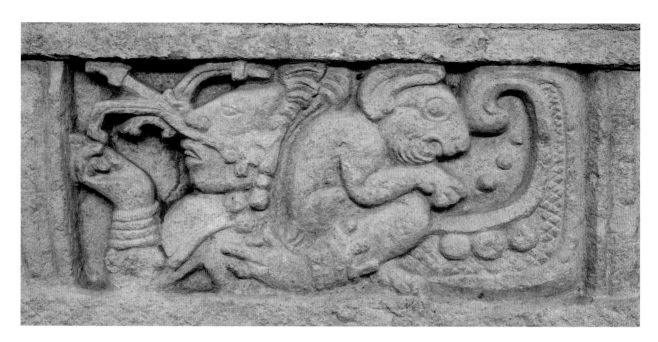

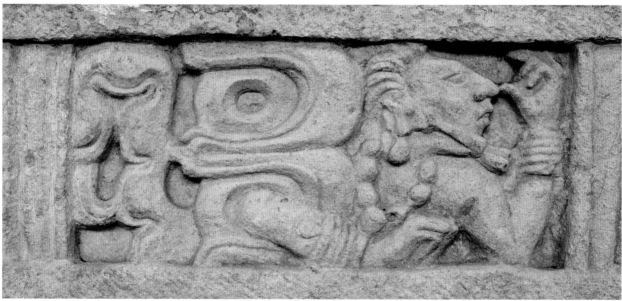

FIGURE 112

Details of the Sky Band Bench, Structure 8N-11, Copán, Late Classic, western Honduras. Museo Copán Ruinas, Instituto Hondureño de Antropología e Historia, Copán, Honduras: (a) Lunar Maize God with a rabbit; (b) Stellar Maize God with a scorpion tail.

TOP **FIGURE 113**

Rollout photograph of Vase K1183, Late Classic, lowland Maya area. Museum of Fine Arts, Boston. The Maize God and God S present a large vessel marked with a wind sign, containing a skull and other objects, to Itzamnaaj. Note the red haloes around God S's spots.

BOTTOM **FIGURE 114**

Rollout photograph of the Vase of the Paddlers (Vase K3033), Late Classic, lowland Maya area. Museo Popol Vuh, Universidad Francisco Marroquín, Guatemala City. This elaborate vase shows three episodes related to the Maize God's death and rebirth.

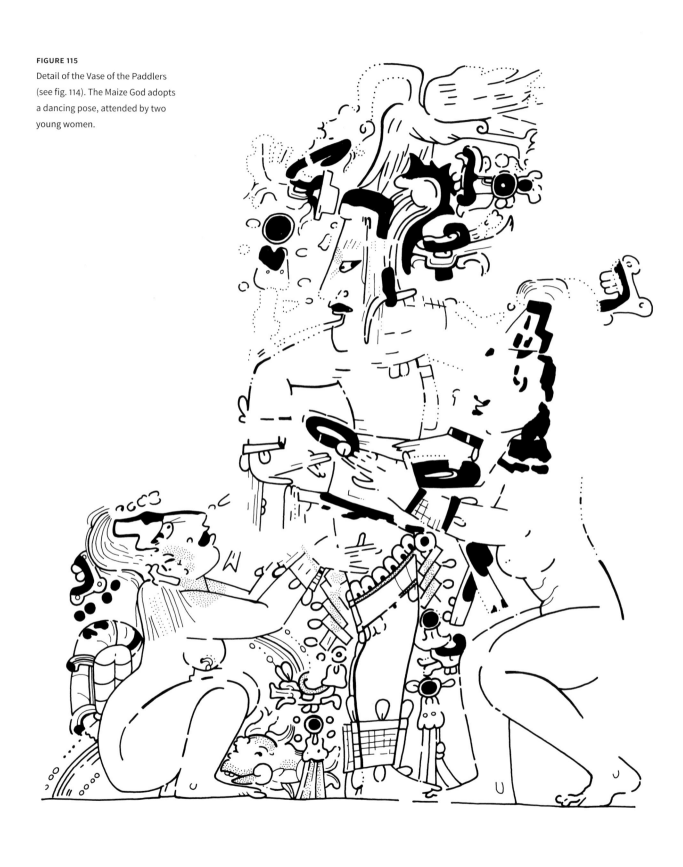

FIGURE 115
Detail of the Vase of the Paddlers
(see fig. 114). The Maize God adopts
a dancing pose, attended by two
young women.

FIGURE 116

Fragments of incised bone from Burial 116, Tikal, Late Classic, lowland Maya area, ca. AD 734. Museo Sylvanus G. Morley, Tikal, Guatemala. The Maize God and several animals ride in a sinking canoe controlled by the Jaguar Paddler God.

sequential episodes, although there is no way to determine whether other, intervening episodes were omitted from the composition. The three scenes show (a) the Maize God in a dancing pose, attended by two naked women; (b) the Maize God riding a canoe, manned by the Paddler Gods; and (c) the Maize God as a baby, emerging from the open maw of a serpent. Michel Quenon and Geneviève Le Fort argued that the narrative sequence began with the episode of the god's rebirth from the serpent, and ended with his canoe journey. However, the spatial arrangement of the three scenes and their comparison with mythical narratives suggests that the sequence began with the Maize God's affairs with the women.[57]

Two naked young women flank the graceful youngster, who stands in a dancing pose with his head turned backward (fig. 115). They extend their hands to reach the god's waist, perhaps fixing his belt and skirt. The significance of the egret that hovers above his head is uncertain, but the bird's repeated presence in related scenes suggests that it played a role in the myth. The jawbones on the women's heads may hold clues about their identity, although their meaning remains obscure. A significant detail is the turtle shell behind the hips of the woman who squats down behind the Maize God. This attribute brings her close to Xochiquetzal, the Nahua goddess of carnal love and seduction, who sometimes wore a turtle shell on her hips (see fig. 43). This woman seems to be especially associated with water, as indicated by the aquatic bands in her front and back, and the fish nibbling her leg. The scene conflates the Maize God's dancing and his commerce with women, two actions that share a common outcome—his death.

The second scene shows the Maize God riding in a canoe, carrying a large bundle tied to his neck. Schele and Miller noted the mortuary connotations of the Maize God's canoe journey, also depicted on a group of incised bones from the tomb of Jasaw Chan K'awiil, king of Tikal who may have impersonated the Maize God in his death transit (fig. 116). The excavator, Aubrey Trik, identified the waterline, which is marked by a row of aquatic symbols that conceal the bow of the canoes in some of the bones, as if to convey navigating rough waters. Schele and Miller suggested that the canoes were sinking and interpreted this as a mortuary transit, portrayed as an aquatic passage into the realm of the dead.[58] The Maize God's extended hand, with his wrist touching his forehead, is a gesture of woe commonly seen in portraits of mourners and war prisoners in Mesoamerican art. This stance denotes the god's quiet sorrow for his own demise. While making similar gestures, his animal companions on the Tikal bones voice their grief with wide-open mouths, wailing as loudly as they can. In their role as mourners,

FIGURE 117

Rollout photograph of Vase K4358, Late Classic, lowland Maya area. Present location unknown. To the observer's left, a Headband God watches the Maize God and a seated, naked woman. At center, the Headband God rides in a canoe controlled by the Jaguar Paddler God, while the Maize God turns his head toward the woman.

these animals seem to overlap with the plaintive women who surround the Maize God in other representations.

The Maize God's canoe is manned by the Paddler Gods, a pair who normally appear in contexts related to primordial events, including the initial date of the Long Count calendar. Elsewhere, the inscriptions identify them as lords of Najochan, a mythical, heavenly location where they placed a stone on that date, as recounted on Quiriguá Stela C (see figs. 15, 16). They have the appearance of old gods with distinctive attributes, one with jaguar features and the other with a stingray piercing his nose. While undeciphered, their name glyphs link the former with the night and the latter with the day. Erik Velásquez suggested a parallel with a little-known deity pair of the sixteenth-century Nahua, Yohualteuctli ("lord of the night") and Yacahuiztli ("sting on the nose," also translated as "nose thorn" or "pointed one"). As his name suggests, Yohualteuctli was a lord of the night. Yacahuiztli—sometimes identified as female—was related to the dusk. They also had stellar associations, perhaps consistent with the Paddlers' role as celestial lords.[59]

On the Vase of the Paddlers, the Maize God is the lone passenger in the canoe. A different version appears on Vase K4358 (fig. 117). The repetition of characters suggests that the vase portrays two overlapping episodes, overlooked by an unidentified lord who sits on a large mountain mask. Behind the lord, there is a kneeling young man who wears a headband and holds a blowgun. While not marked with black spots or jaguar pelt patches, the young man is likely one of the Headband Gods. He turns his head to watch the Maize God, who dances while attended by a young, naked woman sitting next to him. The Headband God reappears in the second scene, sitting on a bloated canoe. The Jaguar Paddler seems ready to push the vessel offshore, even though the Maize God has not boarded yet. He still dances, with one leg outside the canoe, and turns his face backward to the standing woman, as if unwilling to part from her. As usual, the vase

FIGURE 118

Rollout photograph of Vase K6298, Late Classic, lowland Maya area. Library of Congress, Washington, D.C. To the observer's right, three Headband Gods witness the Maize God with two naked women in a pool of water. To the left, the Headband Gods walk before a canoe manned by one of the Paddler Gods.

presents the Maize God as a flamboyant dancer, the center of attention and the companion of women. By contrast, the Headband God is an unpretentious blowgun hunter who receives no attention from the woman and sits quietly on the prow, ready to undertake the journey.

The vase shows that the Maize God was not alone on his journey. In some versions of the myth, he went together with his frequent companions, the Headband Gods. However, the latter were not always a pair; Vase K4358 shows only one of them, while the naïvely painted Vase K6298 (fig. 118) shows three Headband Gods witnessing the Maize God bathing with women and a probably subsequent episode, in which two Headband Gods appear to be waiting for the Maize God to quit his affair and jump on the canoe, where a paddler god is ready to depart.

Other examples reiterate the contrasting qualities of the travelers. A pair of stylistically related vessels show the Headband Gods walking behind the Maize God's canoe, as if forming part of his entourage. One vase features the Paddlers and an additional black-bodied jaguar god (fig. 119). The Paddlers are absent in the second, and the Headband Gods themselves take over their role, carrying paddles while they walk behind the Maize God's tiny canoes (fig. 120).

A large bundle appears to have played an important role in the Classic Maya myth. In the Vase of the Paddlers, the bundle is tied to the Maize God's neck (see figs. 92b, 114). Stuart suggested that it contained the Maize God's jewels, because it is sometimes labeled as *ikatz* ("load"), a term that is often associated with jade objects. The interpretation is compatible with Taube's interpretation of the bundle as containing maize, a precious staple that is often compared with jade.[60] Whatever its content, the bundle was not exclusive to the Maize God; on vessels K1004, K1202, K4479, and K6979 (see figs. 78, 100, 101, 105), it appears in the arms of God S. In fact, God S appears to be the preferred carrier of the bundle, which only appears in the Maize God's arms when God S is absent from

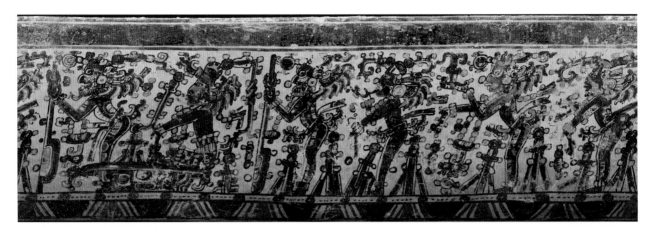

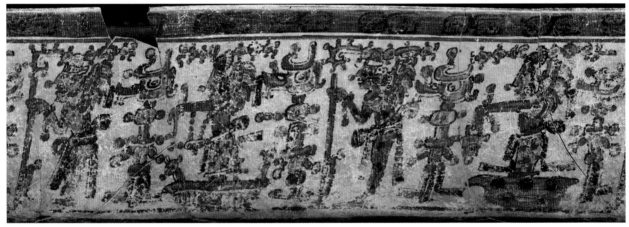

FIGURE 119

Rollout photograph of a painted
vase, Late Classic, lowland Maya
area. Present location unknown.
The Maize God rides in a canoe,
while the Headband Gods walk.
Black-skinned jaguar gods play the
role of paddlers.

FIGURE 120

Rollout photograph of the Vase of
the Small Canoes (Vase K5608),
Late Classic, lowland Maya area.
Museo Popol Vuh, Universidad
Francisco Marroquín, Guatemala
City. The Headband Gods walk,
bringing paddles, while paired
Maize Gods stand on small canoes.

the scene—perhaps reflecting variant versions of the myth that circulated in the Classic
Maya Lowlands.

The Maize God's affairs with women find no parallel in modern maize hero nar-
ratives, making it difficult to relate this episode with modern myths. However, the
Maize God's dance corresponds well to the music-making that, according to multiple sto-
ries from the Gulf Coast, distressed the god's enemies. The subsequent canoe journey of
the ancient Maya god mirrored the Gulf Coast maize heroes' passage across water to reach
the place where their father was killed. More distantly, it relates to the hero's watery death
and rebirth as an infant. As noted, both passages overlapped in the Popol Vuh, whose
authors placed the Hero Twins' watery death and rebirth during their descent to Xibalba
as young men, rather than during childhood.

REBIRTH

The third scene on the Vase of the Paddlers unfolds below the canoe—that is, underwater
(fig. 121). The Maize God's bodily posture and size correspond to a baby, who rests on
the open maw of a serpent that may be swallowing him or perhaps, more likely, letting

FIGURE 121

Detail of the Vase of the Paddlers (see fig. 114). The Maize God is shown as a baby, emerging from a serpent maw.

FIGURE 122

Detail of a rollout photograph of Bowl K3115, Late Classic, lowland Maya area. Present location unknown. The Maize God emerges from the maw of a serpent.

him out. A water band near the baby's legs and a fish nibbling at his face underscore the portent's aquatic setting. Assuming that this episode is consequent to his death, it appears that the serpent mediated the Maize God's rebirth in the mythical version that inspired this vase. Quenon and Le Fort pointed out related representations in which the Maize God emerges from the mouth of a serpentine or fishlike creature, not as a recumbent baby but rather as a fully awake youngster (fig. 122).[61]

There are numerous variants of the Maize God's rebirth, which likely corresponded to different versions of the myth. At least three distinct variants are noticeable, in which he emerges from (a) the open maw of an aquatic serpent; (b) a water lily rhizome; or (c) the cleft carapace of a turtle. The Maize God may appear as a baby or as a young man, and he may be alone or accompanied by other gods. The Headband Gods play a role on Vase K1004, which shows two scenes corresponding to the Maize God's death and his rebirth from an aquatic serpent (fig. 123). In the first scene, a woman of ghastly appearance presents the Maize God with a shell ornament—similar to the one that he sometimes wears in combination with the net skirt. The present may have erotic connotations; Mary Miller and Simon Martin suggested that the shell ornament was related with feminine genitalia.[62] From this perspective, the woman may be offering herself sexually to the

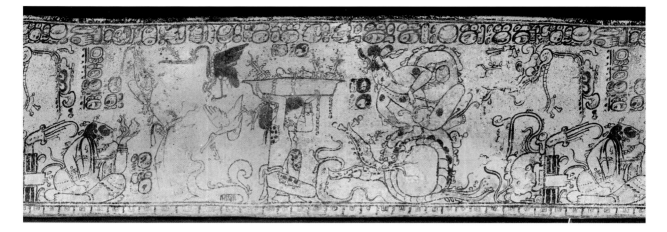

FIGURE 123

Rollout photograph of Vase K1004, Late Classic, lowland Maya area. Museum of Fine Arts, Boston. To the observer's left, the Maize God stands before a woman of ghastly appearance. At center, God CH holds up a plate that cradles the baby Maize God, while God S rests on an aquatic serpent.

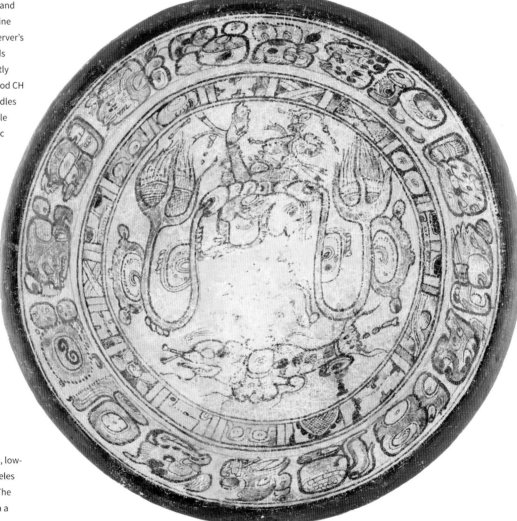

FIGURE 124

Plate K7185, Late Classic, lowland Maya area. Los Angeles County Museum of Art. The Maize God emerges from a water lily rhizome.

FIGURE 125

Detail of the Cosmic Plate (Plate K1609), Late Classic, lowland Maya area. The Metropolitan Museum of Art, New York, Promised Gift of the Mol Collection, in celebration of the Museum's 150th Anniversary, 2019. Chahk wields his axe over a water band. Below, the Maize God emerges from a water lily rhizome.

FIGURE 126

Detail of the Cosmic Plate (see fig. 125). The Maize God emerges from a water lily rhizome.

Maize God, but her offer carries dire implications. The Maize God covers his face with an arm in a sorrowful stance that anticipates the outcome of this encounter, indicated by the *och' ha'* death phrase in the associated text. On the other side of the vase, God CH holds up a large plate that cradles the baby Maize God and his jewelry, while God S sits on a coiled serpent (see fig. 78). Water signs mark the serpent as an aquatic creature, suggesting a correspondence with the aquatic serpent portrayed on the Vase of the Paddlers. Conceivably, the serpent has delivered the infant Maize God, who lies surrounded by his jewels on God CH's plate.

Another variant shows the Maize God as a baby or as a young man, emerging from a water lily rhizome—the plant's fleshy stem, buried in sediment at the bottom of shallow waters (figs. 124–26). Nicholas Hellmuth identified as rhizomes the tubular elements that are sometimes attached to submerged, prognathous skulls in Maya art. However, as the

source from which water lilies grow, the skulls themselves may have embodied the water lily rhizomes. The Maize God comes out of a cleft in the skull, together with abundant sprouts and flowers. In Maya writing, the skeletal rhizome and related water lily signs conveyed the logographic reading *nahb'* ("pool, lake"). These associations reinforce the Maize God's identification as a watery being and suggest that in certain versions, he was assimilated with a water lily and was reborn as a water lily sprout. However, it appears that the rhizome had to be split open to let the Maize God out. The Cosmic Plate offers a remarkable representation of the portent, centered on the axe-wielding god Chahk (see figs. 125, 126). Emerging from the waterline, Chahk seems to have ruptured the submerged rhizome with his axe, allowing the Maize God to come out.[63]

The Maize God's appearance as a baby, when emerging from the maw of an aquatic creature or from the submerged skeletal rhizome, brings this episode close to the mythical rebirth of Kumix in Ch'orti' narratives, and the rebirth of the Gulf Coast maize heroes from water during their early childhood. They are also close to the Hero Twins' rebirth as fish and then orphan children in the Popol Vuh. Ancient Maya versions may have featured related episodes, in which the god's watery death led to his subsequent rebirth as a baby or a handsome young man. These scenes overlap, but also differ in important ways from those that show the Maize God in a cleft turtle carapace.

THE CLEFT TURTLE

In ancient Maya art, turtles and water lilies related to each other in ways that are poorly understood today. The reticulated surface patterns of turtle shells and water lily pads suggest analogous qualities. Mary Miller and Karl Taube interpreted these patterns as representations of the earth's surface.[64] The overlap is apparent in Plate K1892, which shows a skeletal rhizome in front of the turtle's split carapace, with water lilies underneath (fig. 127). The Maize God arises from a cleft in the turtle's carapace, attended on either side by the Headband Gods. Characteristically, when appearing in a cleft turtle carapace, the Maize God takes the aspect of a handsome young man, never a baby. In this respect, the carapace scenes depart from representations of his rebirth from the maw of an aquatic serpent or fish, or from a water lily rhizome, which tend to show the Maize God as a baby. While there is considerable overlap among the three locations, the carapace scenes may belong to a different episode in the Maize God's story. There is insufficient evidence to determine whether the Maize God's rebirth as an infant and a young man were featured in the same narratives or were exclusive of each other, appearing in different versions of the myth.

In several works, Braakhuis explored the significance of modern Gulf Coast maize hero myths for the interpretation of ancient Maya representations of the Maize God in a turtle.[65] In Nahua, Totonac, and Tepehua stories from the Huastec region, a turtle incubated the remains of the maize hero—grains or ground maize dough—that were thrown

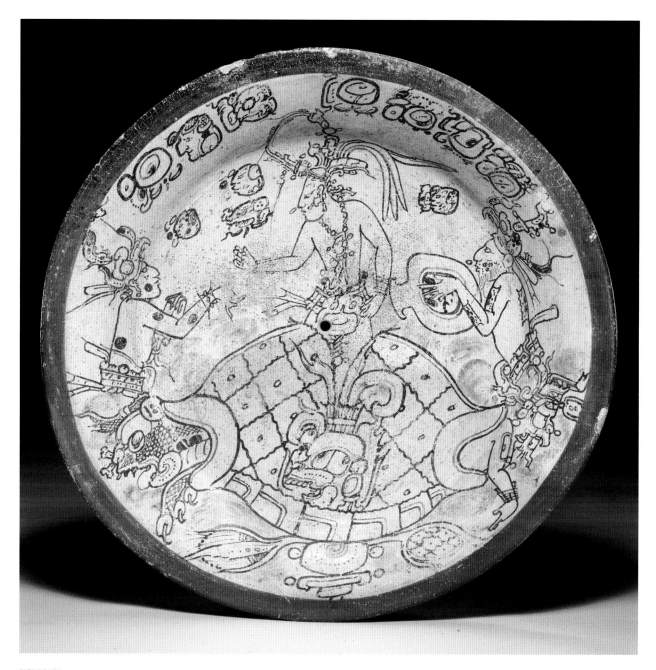

FIGURE 127

Plate K1892, Late Classic, lowland
Maya area. Princeton University Art
Museum, Princeton, N.J. The Maize
God emerges from the split cara-
pace of a turtle, attended by the
Headband Gods.

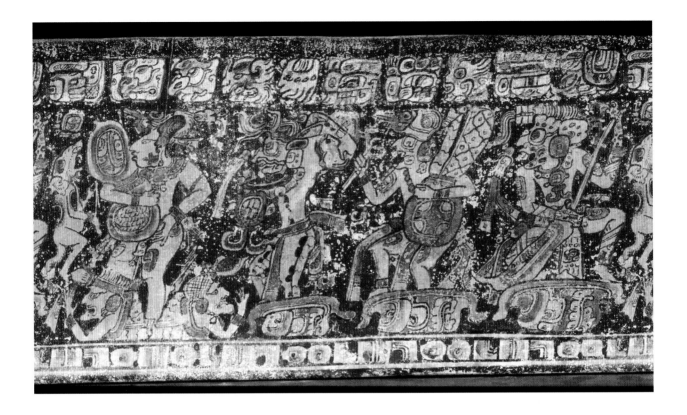

FIGURE 128

Rollout photograph of Vase K731, Late Classic, lowland Maya area. Museum of Fine Arts, Boston. The Maize God emerges from the split carapace of a turtle, while three gods ride in small canoes behind him.

into the water by his mother or grandmother. Braakhuis highlighted a version published by Ichon, in which the animal strolled through the water, carrying the despised infant like a nursemaid (*pilmama*).[66] In Nahua and Popoluca myths from southern Veracruz, the turtle appeared at a later stage in the hero's life, transporting him across water to the place where his father was killed.[67] Ancient Maya representations of rebirth from a turtle seem closer to the latter episode, because they portray the Maize God as a young man, and because they frequently involve additional participants who are largely absent in representations of the god's rebirth from a skeletal rhizome or from the maw of an aquatic creature.

The turtle is alive and animated, pulling its head and leg out of the shell's frontal opening in some representations. The turtle bears an intriguing relationship with God N, whose head can substitute for the animal's head or appear in its mouth. Two forms of God N pull out from the turtle's openings on Vase K731 (fig. 128). This is an especially rich representation, in which the split carapace doubles as the Maize God's canoe. Unique to this vase is the quadruped—perhaps a rat—that faces the Maize God. Behind him, three gods surf the water in small canoes. The first is Chahk, who wields a handstone as if ready to hit the Maize God. Next comes an unidentified god—perhaps another Chahk—playing a turtle carapace with a deer antler. The third is the Jaguar Paddler, whose presence reinforces the artist's conflation of the Maize God's canoe journey with his appearance in the carapace.

Commenting on this vase, Marc Zender noted, "The escape of the Maize God was probably a noisy affair, accompanied by the booming of thunder and torrential rain."[68]

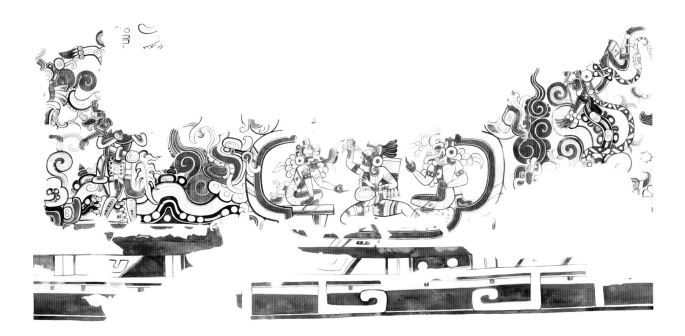

FIGURE 129

Detail of a mural painting from the
west wall of Las Pinturas Sub-1,
San Bartolo, Guatemala, Late
Preclassic, lowland Maya area, ca.
100 BC. The Maize God dances
inside the quatrefoil-shaped cara-
pace of a turtle, flanked by Chahk
and the Water Lily Serpent.

Following Taube, Zender recognized Chahk's handstone as a symbol of lightning, while
the clatter of his companion's turtle shell alluded to thunder. The Maize God himself
carries a bag of grain and a gourd that probably served as a water container.[69] The gourd,
the handstone, and the turtle shell find a significant correspondence in the objects that
belonged to Kumix's father in the Ch'orti' myth, which were stolen by his uncles until he
recovered them by cunning and magical power: Chahk's handstone corresponds to the
machete or whip with which Kumix produced lightning; the turtle shell instrument is a
counterpart for his drum, which allowed him to release thunder; and the gourd appears
in Kumix's myth, either as a gourd or a cape with which he produced rainfall. Conceivably,
Vase K731 was based on a version of the myth that featured a contestation for these objects,
as in modern Ch'orti' narratives, or explained how he eventually entrusted the rainmaking
objects to other gods, as in modern Gulf Coast myths.

Similar themes were evoked on the west wall of Las Pinturas Sub-1 at San Bartolo,
which depicts several moments in the Maize God's watery journey. To the observer's left,
the fragmentary mural shows an unidentified character carrying the Maize God
in his arms like a baby, in front of dark, convoluted waters. It is tempting to suppose
that he is about to throw the baby in the water—the usual fate of Mesoamerican rain and
maize heroes—although conversely, this character may have pulled the baby out from
the water. To the right, a long-haired Maize God dives into the water, an action that Taube
compared with the death phrase *och ha'* ("enters the water") in Classic Maya inscriptions.
The central scene unfolds inside the quatrefoil-shaped carapace of a turtle that swims over
the water (fig. 129). The Maize God dances while playing a small turtle shell hanging from
his neck, using a deer antler as a drumstick. Sitting on either side, the rain god, Chahk,

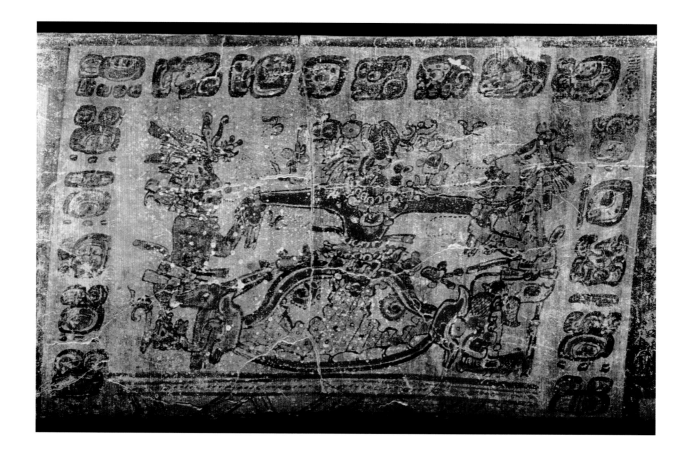

FIGURE 130

Detail of a rollout photograph of
Vase K4681, Late Classic, lowland
Maya area. Museo de América,
Madrid. The Maize God emerges
from the split carapace of a turtle,
attended by the Headband Gods.

and a human-bodied Water Lily Serpent gesticulate at him.[70]

Braakhuis related the San Bartolo mural with the Maize God's journey across water on a turtle and his subsequent encounter with pluvial deities, in modern Gulf Coast myths. The scene seems to conflate the god's journey with his music-making—which usually happened after he reached the shore in modern narratives—and his subsequent summons before the lords of those places. Braakhuis noted that the enthroned gods who flank the dancing Maize God were related to water and rains, and suggested correspondences with the hurricanes and Thunder—Homshuk's opponents in modern Popoluca myths.[71] Pluvial deities are also present in Classic representations that show the Water Lily Serpent coming out of the turtle's rear opening. Another occupant was K'awiil, perhaps in his role as an embodiment of lightning. If literally interpreted, the San Bartolo scene suggests that the turtle was not just a carrier for the Maize God—its sole function in modern Gulf Coast narratives. Instead, the turtle seems to embody the destiny of the Maize God's journey, and the place where he encountered the rain and water deities. Presumably, the Late Preclassic version portrayed at San Bartolo culminated with the submission of the pluvial deities to the Maize God.

Modern narratives contain no clear parallel for the Maize God's emergence from the carapace of a turtle, although Taube and David Freidel, Linda Schele, and Joy Parker

noted a possible analogy with the mountain that was cracked open to retrieve maize, and sometimes other crops, making them available for human sustenance.[72] Maya versions invariably refer to maize grains hidden inside the mountain, but do not describe the Maize God remaining there. However, in Nahua and Teenek narratives, the maize hero put the grains inside a mountain and, according to some versions, hid himself there to escape from his enemies. In a Nahua account from northern Veracruz, the maize heroes—brother and sister—hid in the sacred mountain Postectli. People were hungry and miserable until they noticed that ants were carrying the grain from the mountain. The spirits of thunder and lightning split the mountain open, freeing the Maize Gods and allowing people access to the grain.[73]

The analogy is not straightforward, and the precise unfolding of the ancient Maya myth cannot be reconstructed. In the turtle carapace scenes, the presence of pluvial gods seems to evoke an episode that resembled the maize hero's transit to the land of the Thunders in Nahua and Popoluca myths from southern Veracruz. Ancient Maya representations seemingly allude to an episode in which the Maize God entered the turtle and was subsequently freed, presumably when the Chahks split the carapace open. Especially intriguing is the role of the Headband Gods in the carapace scenes. They witness the portent, and on Vase K4681 they appear to be pulling the Maize God out of the cleft (fig. 130). On Plate K1892, God CH pours the contents of a large jar on the cleft, presumably watering the earth.

A prevailing interpretation of Plate K1892 and other analogous representations conceives the Headband Gods as the Maize God's sons, who are bringing their father back to life.[74] There are many reasons to question that interpretation. Mesoamerican myths consistently describe maize heroes as young and childish, and the Maize God's youthfulness seems incompatible with his supposed paternal role. Moreover, Classic Maya ceramic depictions show the Headband Gods participating in every episode of the Maize God's epic—his dealings with women, his canoe trip, his rebirth as a baby, and his emergence as a young man from a cleft turtle. The Maize God and the Headbands Gods all went together and played complementary roles in every episode of the myth. As noted, many Classic versions featured only God S, while others featured Gods S and CH as a pair, and still other versions featured three Headband Gods, always in a complementary but distinct role vis-à-vis the Maize God. Rather than belonging to two generations, the Maize God and the Headband Gods more likely fit in the same age group. They can be fruitfully compared to the siblings of Q'eqchi' myths and the Hero Twins of the Popol Vuh, but they do not correspond well to the members of separate generations, who consistently did not go together on the journeys described in colonial and modern mythical narratives. Equally relevant, and often overlooked, is the fact that the heroes' father did not come back to life—neither in the Popol Vuh nor in any of the numerous variants of this passage that are present in colonial and modern myths. Rather than rebirth, the fate of the heroes' father explains the origin of death and the veneration of the dead.

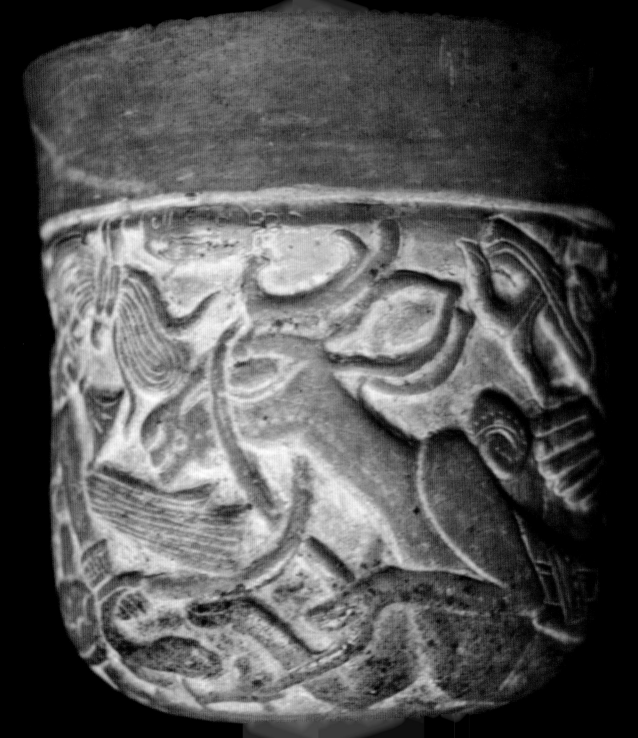

9 The Father

"I only beg you, mother, not to weep when you see my father." "Yes," said the Virgin, and the K'ox's father came to life. St. Joseph appeared. When the Virgin saw her husband she started to weep. And he disappeared. [Manuel says reproachfully:] "It is the Virgin's fault that we must die."
 —Manuel Arias Sojom

This was how people learned to die. Before, people died for three days only and then came back to life.[1] Thus Manuel Arias Sojom explained the meaning of a key episode in Mesoamerican myths, versions of which had been compiled since the sixteenth century. This is often the last episode in the quest of the heroes who went to a faraway place to avenge their father's murder. After subduing their powerful foes, they looked for their father's remains. Using magic and prayer, they were able to revive him, but unexpected circumstances intervened, and the father died again.

Mesoamerican heroes were normally orphans. Stories that featured the mother's prodigious pregnancy sometimes mentioned the father, only to describe briefly how he went away or was killed in a remote place. The father was rarely characterized in detail, although there are exceptions that include the Popol Vuh and the Legend of the Suns. Both texts portrayed the father as worth devotion and respect, but nevertheless irretrievably dead.

The father's inability to come back to life sometimes leads not to his death, but to his transformation into a deer. Both destinies are analogous, and they substitute with each other in Mesoamerican narratives. The father's transformation provides a likely explanation for Classic Maya representations of the Headband Gods interacting with a shrouded deer.

THE MISSING FATHER

Arias Sojom did not explain why the boy was left to grow up fatherless with his mother, the moon. Most modern narratives are mute on this point. In Mixe, Nahua, and Teenek myths, the disguised suitor simply left after impregnating the girl.[2] However,

DETAIL OF FIGURE 134

scattered versions contain more details. Don Frumencio, a Popoluca narrator from south-ern Veracruz, identified the girl's husband as Old Thunder and explained that he died in a war, spilling his blood over maize. In a Totonac version, the father was a musician whose noise annoyed the municipal authorities. They accused him of trying to rule the world and executed him by firearm. Even more detailed is Roberto Williams García's Tepehua ver-sion, in which the maize hero's father, a musician, was killed by a group of men who did not want to hear his music. They first tried to kill him with excess food, but he survived. Then they took him to play ball and threw their iron balls at him all at once. Unable to catch them, he died, and they threw his body away.[3] In every version, he left his wife preg-nant, and she gave birth to a fatherless boy.

The Tepehua father's death in a ball game recalls the death of One Hunahpu and Seven Hunahpu, who were summoned to play ball at Xibalba, only to be tricked and killed by the lords of death. The authors of the Popol Vuh began their account of the Hero Twins' father with an excuse: "We shall tell just half of it, just a part of the account of their father."[4] The reader is left to wonder whether the authors knew it more exten-sively, or whether they apologized for knowing so little. Despite this puzzling remark, they wrote a fairly detailed account of the heroes' father and his death. The brothers One Hunahpu and Seven Hunahpu were able craftsmen and musicians. Like their counter-parts in modern Totonac and Tepehua myths, they were summoned by powerful lords and treacherously killed. Unlike them, Hun Hunahpu did not leave a pregnant wife, and the heroes were engendered only after his death, by the spit of his skull on Xquic's hand. While arresting, this form of intercourse was a heroic subject, attested only in the Popol Vuh. Its outcome was, nevertheless, the same—the birth of the heroes who later went back to avenge their father's death.

Michel Graulich noted the parallel with sixteenth-century Nahua and Purépecha versions. In the Legend of the Suns, Ce Acatl's uncles killed his father, Mixcoatl, and buried him in the sand. Ce Acatl grew up as an orphan, until a vulture revealed his father's fate. He recovered his father's remains and placed them in a temple. The murderous uncles came after him, but Ce Acatl outwitted and sacrificed them. The Purépecha myth from the Relación de Michoacán described how the god Cúpanzieeri was sacrificed in the town of Xacona, after losing a ball game. His wife was pregnant, and his son, Sirátatápezi, grew up fatherless, until an iguana revealed the secret of his origin. He went to avenge his father's death, exhumed his corpse, and brought him on his back. Along the way, a flock of quails took flight, and the hero dropped his father to chase them. The father turned into a deer.[5]

THE ORIGIN OF DEATH

Triumphant over the lords of Xibalba, Hunahpu and Xbalanque attempted to bring their father—named in this passage as Seven Hunahpu—back to life. They went to the

ball court where he was sacrificed and put him back together, but were unable to make him speak. He could name parts of his face, but nothing else. The heroes declared that he would remain at the ball court where he was sacrificed and would receive cult there. His name would not be forgotten.[6]

Dennis Tedlock's K'iche' collaborator, Andrés Xiloj, correctly deduced that the passage concerned the veneration of the dead.[7] The father's inability to speak was a crucial failure that underscored his belonging to the world of the dead. However, in studies of ancient Maya art, this passage is frequently linked with the rebirth of the Maize God and with representations that show him emerging from a cleft turtle, assisted by the Headband Gods. While compelling, that interpretation implies a misunderstanding, exemplified by David Freidel, Linda Schele, and Joy Parker's summary statement of the Popol Vuh passage: "His twin sons went to Xibalba, defeated his killers, and brought him back to life."[8] In fact, what the authors of the Popol Vuh described was the Hero Twins' failed attempt to resuscitate their father. Hun Hunahpu did not come back to life and remained in the land of the dead. In this respect, the Popol Vuh is no different than other Mesoamerican myths, which invariably described how the father remained dead, despite his son's initial success at putting him back together.

In Arias Sojom's Tzotzil version, the K'ox brought his father back to life thrice, instructing his mother not to weep. Every time the Virgin wept, and her husband died again. In parallel, Nahua and Popoluca stories from Veracruz blamed the father's death on the mother, who cried when she saw her long-dead husband alive. A Nahua version from Pajapan, Veracruz, explains that the father's resurrection was not completed yet when his son brought him home, as if the father were drunk. Neglecting her son's advice, the woman cried and embraced her husband, who turned into a deer and ran into the fields.[9]

In Popoluca myths, Homshuk found his father's bones and revived him. He asked a lizard to tell his mother not to cry when she saw her husband, but rather to laugh and be happy. After some distance, the animal passed the message to a different kind of lizard, which delivered the wrong message and told the mother to cry and eat earth in despair when her husband arrived. She did so, and the father died again. Homshuk punished the lizard by splitting its tongue. According to Benjamín Pascual, a Zoque-Popoluca narrator, Homshuk scolded the lizard: "Because of you, humanity has lost immortality." In his Nahua version from Mecayapan, Genaro González Cruz explained, "Now they say that if it were not for the lying lizard, we would never die."[10]

In a polemical work, Alfredo López Austin noted that the confused message that led to human mortality is present in African myths, and suggested that it was grafted onto Gulf Coast narratives as a result of interaction with African slaves. The explanation is plausible, yet it does not imply that the myth was imported wholesale. López Austin agreed that the conflation was likely mediated by the thematic coincidence between African narratives and deeply rooted local myths that explained the origin of death. The confused message is absent in many versions from the Gulf Coast and elsewhere, which

nevertheless reiterate the myth's concern with human mortality. The sixteenth-century K'iche' and Purépecha versions attest the antiquity of the Mesoamerican myth that justified why human beings die and cannot come back to life, and provided a paradigm for the veneration of the dead. López Austin noted that the myth also explained the cyclical transmission of vital essences through generational cycles as the only way to transcend death.[11]

THE CURSE

In his Apologética Historia Sumaria, Bartolomé de las Casas recorded a highland Guatemalan myth about the god Exbalanquen: "Of this they tell, among other fables, that he went to wage war in hell, and fought with all the people of that place, and defeated them, and he captured the king of hell and many others of his army. Coming back to the world with his victory and prey, the king of hell begged him not to take him out, because he was already three or four degrees from light, and the victorious Exbalanquen, with much anger, kicked him, telling him: Go back and let it be yours all that is rotten, and rejected, and filthy."[12]

The curse was the same that the lords of Xibalba received in the Popol Vuh. After their leaders, One Death and Seven Death, were killed, the remaining death lords begged the Hero Twins for mercy. They were condemned to receive only shabby offerings such as broken objects and croton sap instead of clean blood. From then on, they were only allowed to snatch the wretched, instead of all kinds of people. However, Las Casas's version does not correspond entirely with the Popol Vuh, which has no parallel for Exbalanquen's attempt to bring the king of hell out of darkness. A comparison with other narratives suggests that Las Casas's version merged the defeat of the death gods with the hero's attempt to revive his dead father. The curse that the king of death received reappears in modern myths, addressed at the hero's father himself or at the animals that impeded his revival.

In Don Lucio Méndez's Ch'orti' narrative, the curse was aimed at the quails. After defeating the powerful lord who had killed him, Kumix found his father's remains and prayed over them. The earth started trembling and he was about to wake up when a flock of quails took flight. His father moved no more. Kumix tried again, and once again the quails' flight hampered his effort. He finally cursed the quails, condemning them to be hunted by people and to become food for them.[13] The quails' flight bridges the geographic, temporal, and linguistic rifts that separate modern Ch'orti' from sixteenth-century Purépecha myths, in which they instigated the father's transformation into a deer. Constant opponents of the restoration of life, quails also startled Quetzalcoatl, who stumbled and dropped the precious bones that he was bringing out of Mictlan, the realm of the dead, according to the sixteenth-century Nahua Legend of the Suns. The bones broke, and the quails pecked at them. While the bones were defective, the gods were still able

to create people from them by doing penance and mixing the ground bones with their own blood.[14]

Becoming a deer was the destiny of the father in Totonac and Tepehua narratives, in which the curse was aimed at the father himself, as a result of his failure to come back to life. The father's frailty made him unable to withstand even slight distress. The maize hero was bringing him on his back, encouraging him not to be scared. While crossing a forest, a leaf that fell from a tree startled the weakling, who jumped down. The father received the inevitable sentence, which, in Williams García's Tepehua version, was: "I told you not to open your eyes, but now it's over, the dogs are for you, the bullets are for you, and the flies too. Take this handkerchief to shoo away the flies." He turned into a deer, and the handkerchief became his tail.[15]

The father's transformation into a deer, and the curse that condemned him to be hunted for food, may appear to contradict the veneration accorded to him in the Popol Vuh. The disparity blurs upon examination of widespread beliefs that link deer with ancestors and lineage founders. Guilhem Olivier described recurrent examples from colonial and modern communities, likely related to the deer's sexual prowess, an attribute that is often remarked in Mesoamerican myths.[16]

The father's affinity with deer is prominent in the colonial Nahua myths of Mixcoatl, the father of Ce Acatl, who was a god of the hunt and was closely associated with deer. A Nahua version of the myth is alluded to in an early seventeenth-century incantation for hunting that Hernando Ruiz de Alarcón recorded among the Nahua of Guerrero. The hunter identified himself as the orphan Centeotl, the Maize God, and declared that he came in search of his father, Piltzinteuctli—identified as a male deer—to bring him to his mother, Xochiquetzal. Elsewhere in his treatise, Ruiz de Alarcón explained, "The one that is now a deer was called Piltzinteuctli in the first age."[17] The incantation was likely based on a version of the Maize God's attempt to bring his father back to life. While the incantation did not include all the details of the myth on which it was based, comparison with modern versions suggests that Xochiquetzal played the role of the mother who cried when she saw her husband alive, causing him to become a deer. The incantation cast the son's quest for his dead father as akin to a hunter's quest for game.

With characteristic subtlety, the authors of the Popol Vuh also equated the father of the Hero Twins with a deer. His shortcoming—the inability to speak—placed him at the level of the animals that were unable to speak out the names of the gods. In the narrative of the first attempt to populate the earth, the deer was always named first among the animals. Indeed, all animals were frequently subsumed within the couplet "the deer and the birds." In a thorough survey of Mesoamerican deer symbolism, Olivier compiled references from Mesoamerican languages, including Tzeltal, Teenek, Purépecha, and Nahuatl, in which terms for *deer* may also designate animals in a broad sense, especially quadrupeds. The deer thus appears to be paradigmatic of all the animals, whose inability to speak

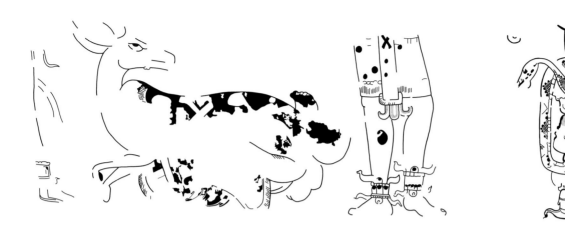

FIGURE 131

FIGURE 131

Detail of a Late Classic mural painting from Ek' Balam, Yucatán, Mexico. The Headband Gods are shown with a shrouded deer.

made them unfit to worship the gods. Their curse was the same that the father received in modern myths: "Just let your flesh be eaten."[18] Hun Hunahpu's incapacity to speak cast him as an imperfect being from a former creation, who was nonetheless venerated as a revered progenitor.

THE SHROUDED DEER

The father's transformation into a deer is not attested in modern Maya narratives. Nevertheless, episodes from a Classic Maya version of the myth were likely portrayed in scenes that Michael D. Coe characterized as "the deer ritual," which show the Headband Gods interacting with a shrouded deer. A fragmentary example was documented at Ek' Balam—a rare example of Classic Maya mural painting with a mythological subject (fig. 131).[19] The upper half of the painting is lost, but enough survives to recognize its subject matter. At center stage there is a reclining deer flanked by two characters. The animal's back is covered with a black shroud, decorated with crossed bones and eyeballs. Standing behind the deer, God S is immediately recognizable by the characteristic black spots on both legs. Little remains of his counterpart, who may or may not have had the jaguar pelt patches of God CH.

The trees that rise on either side of the scene show the head of the Pax God at the base of the trunk. The better-preserved tree behind God S has a serpent coiling out of the god's eye and around the trunk. The Pax God—so-called because of his role as the patron of the month Pax—has a jaguar paw–shaped ear and an undulating, pointed element in its jawless mouth. In the Maya script, the head of the Pax God substituted for the logogram TE' ("tree, wood").

Taube noted that trees or, more frequently, a lone tree with a coiled serpent denoted wild, forested places in ancient Maya art. Other animals may also appear, highlighting the nonhuman qualities of such locations. He and Andrea Stone compiled ethnographic data from the Maya area and elsewhere in Mesoamerica, which reveal a

basic dichotomy between the structured, orderly spaces of the house and the milpa, and the disorderly and chaotic spaces of the uncultured fields, mountains, ravines, caves, and forests. The former are moral spaces, generally conceived as four-sided, that are made inhabitable by proper ritual practices. By contrast, the wilderness that extends outside consecrated space is regarded as fearful and chaotic. Devoid of sunlight, the forests are dark and nocturnal, the province of animals and other wild beings—spooks, demons, and monsters—that threaten human existence. Spatially distant from villages, they are also conceived as remote in time and related to the savage conditions of previous eras. The vanquished but still nasty survivors from previous creations are believed to live there. The people who venture into such dangerous places should approach them with great caution and perform appropriate rituals to ask permission from their owners and inhabitants.[20]

The trees in the Ek' Balam mural mark the scene as taking place in a wild, forested setting. This is an appropriate setting for the Headband Gods, who were denizens of the forests, associated with hunting and the animal domain. However, the painting shows no indication that they are hunting the deer. This becomes evident by comparison with representations of hunters spearing deer or carrying the dead and quartered animals as prey. The deer is alive and unharmed in the Ek' Balam mural, although the shroud on its back has ominous, mortuary connotations.

Parallel scenes in lowland Maya vases reiterate the same event. The deer episode was part of a longer narrative that involved the Moon Goddess and an unidentified, enthroned god, who preside over a celestial scene—the location indicated by a sky band on the upper half of a painted ceramic vase (fig. 132). Gods S and CH kneel before the couple, apparently bringing a plate with ritual objects. In the lower plane, the Headband Gods flank a reclining, shrouded deer, but they hold leafy branches instead of hunting weapons. A small quadruped watches the scene from a monstrous maw, likely denoting a cave entrance. Like the trees in the Ek' Balam mural, the cave denotes the scene's wild setting. In a detailed study of Maya cave symbolism, Stone showed that caves and sinkholes epitomize the dark, menacing qualities of wild places on the periphery of settled communities.[21]

God CH is absent in a vase from Calcehtok, Yucatán, renowned since its early publication by Sylvanus G. Morley (fig. 133).[22] The vase shows two episodes of a version that involves twin Gods S, both marked with black, crosshatched spots. In the first scene, they flank a shrouded deer, while a white bird hovers above. They are holding spears, and one of them is blowing a conch shell trumpet. While these are hunters' attributes in Maya art, there is no indication of harm to the deer. One of the gods holds up an antler over the deer's head. He may be taking it off, as suggested by Mary Pohl, but it is equally plausible that he may be bestowing the deer with antlers, as happened—under different circumstances—in the Homshuk myth.[23] The second scene on the vase actually involves three spotted gods. One of them is the conch shell player of the first scene, now facing a Pax tree. Two small deer are sitting in human fashion at the base of the tree.

TOP **FIGURE 132**
Painted designs on a ceramic vase,
Late Classic, lowland Maya area.
Present location unknown. The
Headband Gods kneel before a
celestial couple; below, they
attend a shrouded deer.

BOTTOM **FIGURE 133**
Rollout photograph of the
Calcehtok Vase (Vase K2785),
Late Classic, lowland Maya area,
Calcehtok, Yucatán, Mexico.
Dumbarton Oaks, Washington,
D.C. Paired Gods S are shown
with a shrouded deer.

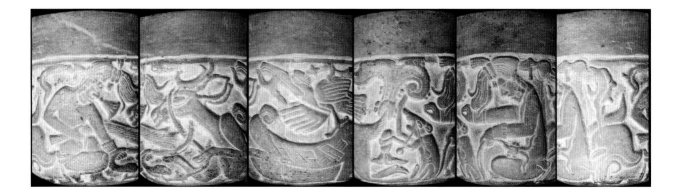

FIGURE 134

Composite photograph of a vase from Finca Esquipulitas, Escuintla, Guatemala, Late Classic, Pacific Coast of Guatemala. Private collection, Guatemala City. God CH and an unidentified companion seated with a deer and other animals.

Above them, two spotted gods sit on the branches, wearing stiff-looking white capes and raising their wrists to their foreheads in a woeful stance that reiterates the episode's mortuary qualities. The multiplicity of God S portraits in this vase is puzzling. The two that sit on the tree are mirror images of each other and may actually correspond to one individual. However, the vase may also convey a version that involved a triplet of identical Gods S.

Yet another example originated from Finca Esquipulitas, in southern Guatemala (fig. 134). It shows the reclining deer, marked with crossed bands on its back that appear to substitute for the cloak with crossed bones. A bird that perches on the back of the deer recalls the Calcehtok Vase. The jaguar-pelt patches on his legs and arms identify God CH, who sits in front of the deer, holding a serpent that winds around the deer's head. An unmarked counterpart sits in the back, next to a small, seated mammal with extruded eyeballs.[24] Once again, the heroes' bearing toward the deer is not aggressive, and possibly reverential.

The Esquipulitas Vase was likely imported from the northern highlands or lowlands. Yet the deer episode was not foreign to Pacific coastal peoples. It was portrayed in Early and Late Classic molded vessels from Escuintla.[25] The earliest examples appeared on molded cylinder tripod vases that show a man embracing a deer from behind (fig. 135). His hairy right leg resembles the deer's hide, suggesting a merge between man and deer. In Late Classic examples, the deer seems to be jumping out of the man's chest, perhaps implying a transformation. However, other examples show the man standing beside the deer, distinct from the animal that he holds with one arm (fig. 136).

Sherds found at the Late Classic city of Cotzumalhuapa provide indications about the probable origin of unprovenanced vases with deer scenes. The more elaborate coastal examples show two characters with fairly consistent features who interact with a deer. One of them has vegetation growing from his feet—a peculiar and not easily explained attribute. The same character usually holds a blowgun. His companion tends to wear a serpent belt—sometimes present in both characters—and tends to have a short sound scroll, representing discourse or chant (figs. 137–39). Arguably, these characters

FIGURE 135

correspond with the Headband Gods of lowland Maya art. The analogy is reinforced by the presence of a tree with a bird perched on top and a monkey sitting at the base. By comparison with lowland Maya vases, the tree is an indication of the scene's forest setting. While the style is markedly different, the coastal vases likely represent the same mythical episode depicted in the Ek' Balam mural painting and comparable scenes on ceramic vases.

Coe realized the "deer ritual" was not about hunting, but regarded it as "an intractable problem" in the interpretation of the Headband Gods, perhaps because the scenes find no obvious parallel in the Popol Vuh.[26] A broader look at Mesoamerican myths reveals two frequent episodes that involved the young heroes and a deer: the slaying

FIGURE 136
Molded vase, Late Classic, Pacific
Coast of Guatemala. Museo
Miraflores, Guatemala City, on loan
from Colección Santa Clara. A
kneeling character holds a deer,
seemingly merging with it.

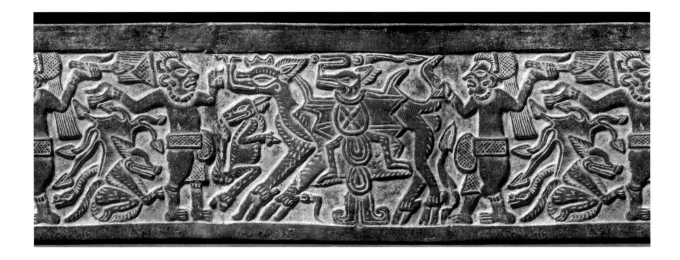

FIGURE 137

Top: Rollout photograph of Vase
K1605, Late Classic, Pacific Coast of
Guatemala. George R. Gardiner
Museum of Ceramic Art, Toronto.
Two standing characters flank a
deer, while a probable bat opens
its wings before the animal. Note
the tree and the smaller animals.
Above: A sherd from a very similar
vessel found at El Baúl,
Cotzumalhuapa, Guatemala.

of the grandmother's lover—a deer or tapir—and the father's transformation
into a deer. While not directly linked, these episodes relate to one another in
subtle ways. They both cast a forebear—real or fictitious—as akin to a game ani-
mal. The grandmother's lover was a deer in narratives from Oaxaca, Guerrero,
and Puebla. Invariably, the sun and moon heroes killed the animal and served
the meat—often the genitals—as food for the old woman. While plausible, a correla-
tion of the "deer ritual" scenes with this episode seems unlikely, as the heroes are
not killing the deer in the Classic Maya representations.

The mortuary connotations of the deer's cloak are especially suggestive
of links with the mythical episodes that describe the heroes' attempt to bring
their father back to life as well as his final transformation into a deer. As previ-
ously noted, this outcome is not present in colonial or modern Maya mythical narratives.
However, López García recorded a Ch'orti' version that is embedded in a flood myth, but
nevertheless recognizable as correspondent to the mythical hero's failed attempt to revive
the dead father. It explains that the deer was cursed because it jumped by when God (*Dios*)
was putting back together the body of Father God (*Tata Dios*). The body crumbled, and
God cursed the deer, saying, "But you will end with bullets, that is why now they finish the
deer with bullets."[27] The passage is close to Gulf Coast versions in which the father's fate
was to become a deer, an inhabitant of the forest wilds akin to the creatures of the first
creation in the Popol Vuh, which received the curse that condemned them to be hunted
and eaten.

Both episodes are merged in Don Gregorio's Nahua version. Reborn from the
ground maize flour that his evil grandmother threw into the water, the maize hero came
home and called for his grandfather. Afraid of him, the old man hid inside the house and
finally ran away to the forest. The child pronounced the usual curse: "'You really like
the forest, let you go and not return, and let the dogs be yours,' he said. When he left, it
came out of the forest there, a great deer is there."[28]

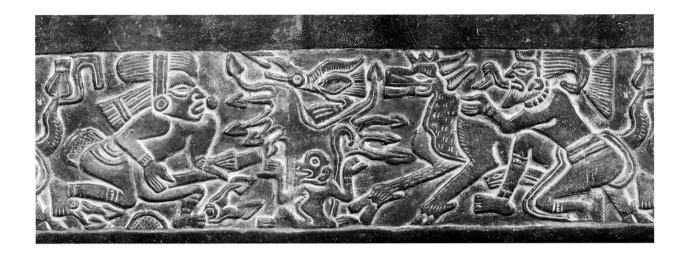

FIGURE 138

Rollout photograph of Vase K4599, Late Classic, Pacific Coast of Guatemala. Princeton University Art Museum, Princeton, N.J. A singing, bearded character holds a deer while another character approaches. Note the blowgun in the latter's hands, and the plants growing from his feet.

GOD S, FATHER OR SON?

The shrouded deer scenes seemingly cast the Headband Gods—or paired manifestations of God S—in the role of the sons who tried to revive their dead father. The scenes are apparently concerned with the heroes' reverence toward the transformed father, who is irretrievably turned into a deer. The implication is that the Headband Gods belonged to a junior generation in the mythical episode that was portrayed in the Ek' Balam mural painting and the corresponding scenes on ceramic vessels.

This interpretation seems to contradict the role of God S on the Mosquito Vase and the Bleeding Conch Vase (see figs. 37, 40). As discussed in Chapter 4, God S's demeanor on those vases has implicit sexual overtones. While the consequences are unknown, a plausible result of his actions on that vase was the impregnation of the young woman. He would thus be a potential father.

God S's actions on these vases contrast markedly with the scenes that show the Maize God's affairs with young women (see figs. 104, 105, 117, 118). Rather than joyful sexuality, these representations center on magical intercourse that presumably resulted in the woman's impregnation. However, these vases provide no clue about the outcome of these encounters, or whether the woman eventually gave birth to gods or her offspring were other kinds of creatures. One possible outcome is that the woman would eventually give birth to heroic offspring, as in the maize hero myths of the Gulf Coast and the Popol Vuh. However, another potential outcome is that the union would result in the formation of insects or animals, as in modern highland Guatemalan myths. The participation of insects in those scenes reinforces the links with modern Q'eqchi' myths, in which the young woman's remains generated biting insects and other poisonous creatures.

A progenitor role for God S seems contradictory. As noted in previous chapters, God S shares the attributes of Mesoamerican solar heroes, who are usually portrayed as orphan children, not as paternal figures. Moreover, he interacts in various ways with other young gods, notably God CH and the Maize God, who were seemingly regarded as

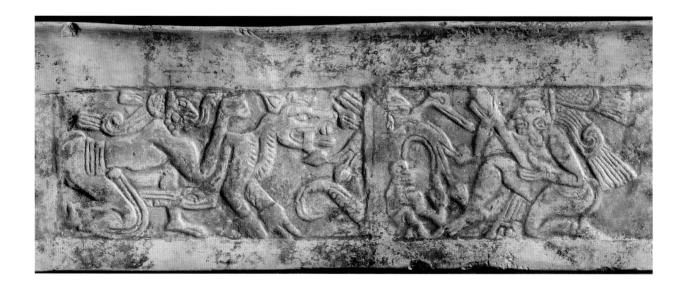

FIGURE 139

Rollout photograph of Vase
K8829, Late Classic, Pacific Coast
of Guatemala. Present location
unknown. A singing character
clutches a deer, while his com-
panion holds a blowgun.

members of the same age group. These vases raise the possibility that Classic Maya ver-
sions conceived two generations of Gods S. A "senior" God S would correspond to his rep-
resentation as progenitor on the Bleeding Conch Vase and the Mosquito Vase. A "junior"
generation would presumably correspond to his representations as a blowgun hunter and
his participation in the Maize God's journey—with or without the company of God CH.
Two generations of God S, represented with the same iconographic attributes, would be
reminiscent of the two generations of heroes with nearly identical names—Hun Hunahpu
and his son, Hunahpu—in the Popol Vuh.

There are no clear-cut answers for these problems. The available representations
are insufficient to determine kinship relations among the gods, and conjectures about
their links are untestable. However, it should be noted that God S is strongly related to
death and sacrifice. Taube highlighted the mortuary connotations of his portraits in the
Postclassic codices, while Diego de Landa identified Hunhau—a probable rendering of
Juun Ajaw—as a "prince of demons" who inhabited Mitnal, the place of the dead.[29] In
this respect, he comes close to the personality of the father in Mesoamerican myths, who
remained irremissibly in the realm of the dead, despite his son's efforts to bring him back
to life.

Epilogue

In the Popol Vuh, the Hero Twins' epic resulted in the rise of the sun and the moon, the discovery of maize, and the gods' successful creation of men and women. Their ordeal provided answers to the questions posed by the creator gods: "How should the sowing be, and the dawning? Who shall be a provider? Who shall be a sustainer?"[1] The advent of the current era and its inhabitants was the consequence of the heroes' triumph over the unseemly creatures that prevailed before the sun came out. Did the ancient Maya conceive their primordial origins in similar ways?

There is no simple answer for this question. Extant passages of the hieroglyphic inscriptions show that the foundational myths of Classic Maya royal houses did not replicate the narratives of the Popol Vuh. The comparison is problematic because of the brevity of mythical passages in the hieroglyphic texts. Nevertheless, the iconography of the Group of the Cross tablets at Palenque suggests that major subjects of Classic Maya creation myths—the rise of the sun, the origin of maize, and the origin of warfare—had much in common with those of the sixteenth-century K'iche' and other peoples of Mesoamerica.

In a broad sense, the structure and contents of the Maya inscriptions are compatible with the Popol Vuh. The mythical statements they contain stress the ancient origins of the ruling dynasties, and the ways in which the ritual performance of Maya kings replicated the creational acts of the gods. Likewise, the first couples in the Popol Vuh were the ancestors of the K'iche' ruling lineages. The Popol Vuh recounts their humble beginnings, their journey to the Guatemalan Highlands, their triumph over powerful and well-established competitors, and the establishment of their cities, their kingdom, and their ruling houses. The ascent of the K'iche' was comparable to the accomplishments of the gods who succeeded over powerful foes and finally rose as the sun and the moon. The divine and human stories were like in kind: the former provided paradigms for the latter.

Further answers can be gleaned from the study of mythical representations on Classic Maya ceramics. The preceding chapters underscored Michael D. Coe's insights about the importance of this corpus for the study of ancient Maya myths, and the relevance of the Popol Vuh for the interpretation of those representations.[2] The mythical subjects portrayed on ancient Maya ceramics—and in the Preclassic mural paintings of San Bartolo—find correspondences not only in the Popol Vuh, but also in a broad array of

mythical narratives compiled from colonial times to the present. Rather than one-to-one correlates with particular narratives, the characters and situations depicted in ancient Maya art can be related with the nodal subjects of Mesoamerican myths. This approach opens previously unexplored interpretive paths. The mosquito biting a maiden's breast, God S's pustules, or the lunar attributes of the Maize God find no precise analogues in the Popol Vuh; yet they can be explained through comparisons with broadly distributed subjects in Mesoamerican myths.

A potential problem of this approach is the oversimplification of the subjects of ancient Maya myths. The focus on nodal subjects might easily reduce a variety of mythical episodes to simplistic abstractions that would not reflect the wealth of variations present in narratives and images. In the preceding chapters, I have emphasized the variability of heroic subjects in mythical narratives and artistic representations, perhaps with fastidious detail. The aim was to make sense of broad patterns in artistic representations, without overlooking their nuanced meanings.

Key to this exploration is an understanding of the Popol Vuh, not as a definitive record of ancient Maya myths, but as an expression of the historically situated knowledge, aims, and constraints of its authors. The comparative study of the Popol Vuh revealed meanings that are not easily decoded in the K'iche' text, while highlighting its departures from widespread Mesoamerican narratives. Examples include the omission of the grandmother's death and the largely undifferentiated character of the sun and moon heroes—heroic subjects that are peculiar to the Popol Vuh, and therefore provide meager evidence about the meaning of mythical representations in ancient Maya art. Such variations can be expected from every narrative, and they do not lessen the value of the Popol Vuh as a primary source. An appreciation of its peculiar character adds to the possibility of us understanding the K'iche' book and its links with ancient Maya mythical representations.

The characters who were described in this book relate to each other in ways that suggest narrative continuities. In closing, readers might expect a synthesis that would link together the mythical episodes that were treated separately in the preceding chapters, reconcile them with artistic representations, and produce a coherent reconstruction of ancient Maya myths. We might ask, for instance, where the scene of magical seduction and sexual assault portrayed on the Bleeding Conch Vase would fit in such a sequence, or whether the maiden eventually mothered some of the characters portrayed on other vessels. Do the mythical old woman, the maiden, and the young heroes represented in Classic Maya art relate to each other as family members, like the characters of colonial and modern narratives?

There are many reasons to refrain from addressing such questions. Rather than producing an overarching synthesis, this book has highlighted the wealth of variations that prevail in ancient and modern myths. Attempts to reconstruct a coherent sequence would artificially link together an inconclusive chain of heroic subjects, forcing the images

into assumed sequences and disregarding or concealing the loose ends. Mere coincidences among mythical narratives featuring roughly similar characters are unsatisfactory. The heroic subjects of Preclassic and Classic Maya mythical representations find only mild correspondences with those of any particular narrative recorded in colonial or modern times, while they depart in significant ways. No single text recorded in colonial or modern times can be expected to preserve the heroic subjects of Preclassic and Classic Maya mythical narratives, or account for their multiple variations.

This exploration has not been exhaustive. The range of subjects depicted on Classic Maya vessels extends well beyond those that were covered in this book. I mentioned major characters such as God N or God L only in passing, although they are frequent participants in mythical scenes. The present approach invites a reexamination of previous studies about these and other gods and goddesses, the ways in which their mythical deeds were represented in ancient Maya art, and their links with the nodal subjects of Mesoamerican myths.

NOTES

INTRODUCTION

1. Chronological divisions follow generally accepted conventions in Maya archaeology, although calendar dates may vary according to different authors: Early Preclassic (1800–1000 B.C.), Middle Preclassic (1000–300 B.C.), Late Preclassic (300 B.C.–A.D. 250), Early Classic (A.D. 250–600), Late Classic (A.D. 600–900), Early Postclassic (A.D. 900–1200), and Late Postclassic (A.D. 1200–1520). See Houston and Inomata, *Classic Maya*, 15–22.
2. Just, *Dancing into Dreams*.
3. Stuart, "Hieroglyphs on Maya Vessels."
4. Carpenter, *Art and Myth;* Woodford, *Images of Myths.*
5. Coe, *Maya Scribe,* and *Lords of the Underworld.*

1 IMAGE AND TEXT

1. López Austin, *Myths of the Opossum,* 1–2.
2. Berlo, "Conceptual Categories," outlined the distinctions between "discrete" and "conjoined" texts.
3. Thompson, *Moon Goddess,* 150; Gann, *Maya Indians,* 110.
4. Braakhuis, "Sun's Voyage"; Coe, *Lords of the Underworld,* 58. The vase is number 555 in Justin Kerr's photographic database of ancient Maya vessels (www.mayavase.com). Kerr's catalog numbers, preceded by a capital K, are employed throughout this book. See Kerr, *Maya Vase Book.*
5. De la Cruz Torres, *Rubelpec,* 21–69; Braakhuis, "Sun's Voyage."
6. Panofsky, *Studies in Iconology,* 3–17.
7. De Vries, "Iconography and Iconology"; Heck, "Evolution of Meanings"; Taylor, "Introduction."
8. Thompson, *Moon Goddess,* mistakenly attributed this vase to the site of Yalloch. The error was redressed by Foncerrada de Molina and Lombardo de Ruiz, *Vasijas Pintadas Mayas,* 188, and Hammond, "Sun Is Hid," 167.
9. Parsons, Carlson, and Joralemon, *Face of Ancient America,* 106.
10. Fox and Justeson, "Polyvalence," 29; García Barrios, "Aspecto Bélico"; Schellhas, *Representations of Deities;* Taube, *Major Gods,* 17.
11. Taube, *Olmec Art,* 123.
12. Grube and Nahm, "Census of Xibalba," 698–99. The collocation **ch'a-ja CHAM-ta** on Vase K3450 may refer to the insect, but its meaning remains uncertain.
13. Martin, "Baby Jaguar"; Taube, "Birth Vase."
14. Coe, *Maya Scribe,* 98, and *Lords of the Underworld,* 34–38; Foncerrada de Molina, "Reflexiones"; Robicsek and Hales, *Maya Book of the Dead,* 41; Schele and Miller, *Blood of Kings,* 287.
15. Broda, "Fiestas Aztecas," 268–82.
16. Donnan, "Thematic Approach," and *Moche Art and Iconography;* Castillo Butlers, *Personajes Míticos;* Golte, *Iconos y Narraciones;* Hocquenghem, *Iconografía Mochica;* Quilter, "Moche Revolt," and "Narrative Approach."
17. Robicsek and Hales, *Maya Book of the Dead;* Quenon and Le Fort, "Rebirth and Resurrection"; Miller and Martin, *Courtly Art,* 58–62; Valencia Rivera and García Capistrán, "In the Place of Mist."
18. Quilter, "Narrative Approach."
19. Weitzmann, *Illustrations in Roll and Codex,* 12–33.
20. Woodford, *Images of Myths,* 28–42.
21. Weitzmann, *Illustrations in Roll and Codex,* 26–28.
22. Miller and Houston, "Classic Maya Ballgame."
23. Coe, "Hero Twins."
24. Coe, *Lords of the Underworld,* 58; Braakhuis, "Sun's Voyage."
25. Taube, "Ancient and Contemporary," 470–71.

26. Boone, "Aztec Pictorial Histories," and *Stories in Red and Black.*

27. Kubler, *Iconography,* 11–12, "Period, Style and Meaning," 143, and "Evidencia Intrínseca"; Panofsky, *Studies in Iconology,* 18–31.

28. Carlsen and Prechtel, "Flowering of the Dead"; Caso, "Religión o Religiones Mesoamericanas"; Gossen, "Temporal and Spatial Equivalents"; Hunt, *Transformation of the Hummingbird;* López Austin, "Cuando Cristo Andaba de Milagros"; Nicholson, "Preclassic Mesoamerican Iconography"; Van der Loo, *Códices, Costumbres, Continuidad;* Pury-Toumi, *De Palabras y Maravillas.*

29. Grieder, "Interpretation of Ancient Symbols," 853.

30. Houston and Taube, "Meaning in Early Maya Imagery."

31. Thompson, *Ethnology of the Mayas,* 135.

32. Braakhuis, "Xbalanque's Canoe," and "Xbalanque's Marriage"; Chinchilla Mazariegos, "Of Birds and Insects"; Kockelman "Meaning and Time."

33. Berlo, "Conceptual Categories," 8–11.

34. Guiteras Holmes, *Perils of the Soul,* 311.

35. Foster, *Sierra Popoluca,* 194–96; Thompson, *Maya History and Religion,* 330–73.

36. López Austin, "Características Generales," 37.

37. Both quotes are from López Austin, *Myths of the Opossum,* 19.

38. Ibid., 106; Thompson, *Sky Bearers,* 236.

39. López Austin, "Myth, Belief," 606; cf. López Austin, *Myths of the Opossum,* 354.

40. Quotes are from López Austin, *Myths of the Opossum,* 304 and 249, respectively.

41. Ibid., 257.

42. Passages from various narratives are compiled in Braakhuis, "Xbalanque's Marriage," 388.

43. Thompson, *Ethnology of the Mayas,* 130.

44. Chinchilla Mazariegos, "Vagina Dentada," *Imágenes de la Mitología Maya,* and "Muerte de Moquihuix."

45. Villela Flores and Glockner, "De Gemelos"; Valentina Glockner Fagetti and Samuel Villela Flores, Proyecto de Etnografía de los Pueblos Indígenas de México en el Nuevo Milenio, Instituto Nacional de Antropología e Historia, personal communications to the author, 2010 and 2013, respectively.

46. López Austin, *Myths of the Opossum,* 86.

47. Ibid., 87.

48. Ciudad Real, *Calepino Maya,* 170; Laughlin, *Great Tzotzil Dictionary,* 2:180; Wired Humanities Project, "Nahuatl Dictionary"; Covarrubias, *Parte Primera del Tesoro,* 161 (Spanish: "*La tabla en la que está pintada alguna historia de devoción*").

49. Herring, *Art and Writing,* 73–76; Stuart, *Ten Phonetic Syllables,* 2–7.

50. Christenson, *Popol Vuh,* 64; Tedlock, *Popol Vuh,* 63, 218–19.

51. Basseta, *Vocabulario de Lengua Quiché,* 168.

52. Tedlock, *Popol Vuh,* 192; Christenson, *Popol Vuh,* 287; Monaghan and Hamann, "Reading as Social Practice."

2 PICTORIAL AND TEXTUAL SOURCES

1. López García, "Restricciones Culturales," 2:15, and *Kumix,* 22 (Spanish: "*El caso viene porque dicen que existió Dios, el Niño Dios. Pues comencemos la historia; como me lo contaron a mí, me lo grabé en el sentido y lo tengo presente*").

2. Taube et al., *Murals of San Bartolo,* pt. 2, 60–69.

3. Guernsey, *Ritual and Power,* 91–117, and "Beyond 'Myth or Politics.'"

4. Coe, *Maya Scribe,* and *Lords of the Underworld.*

5. Coe and Kerr, *Art of the Maya Scribe,* 89–101.

6. Vail and Hernández, *Re-Creating Primordial Time.*

7. Beliaev and Davletshin, "Sujetos Novelísticos"; Stuart, "Breaking the Code"; Dütting and Johnson, "Regal Rabbit"; Miller and Martin, *Courtly Art,* 60–61.

8. For introductory explanations of the Maya calendar, see Morley, *Introduction;* Stuart, *Order of Days.*

9. Beliaev and Davletshin, "Sujetos Novelísticos"; Martin and Grube, *Chronicle,* 74–77.

10. Reents-Budet, "Elite Maya Pottery," 73, and "Feasting among the Classic Maya."

11. Tokovinine, "Carved Panel," 64.

12. Stuart, *Order of Days,* 218–19.

13. Freidel, Schele, and Parker, *Maya Cosmos,* 65–67; Stuart, *Order of Days,* 216–24.

14. Stuart, *Order of Days,* 209.

15. Stuart, *Inscriptions from Temple XIX,* 196–98.

16. Stuart, *Order of Days,* 209.

17. Christenson, *Popol Vuh;* Craveri, *Popol Vuh;* Edmonson, *Book of the Counsel;* Raynaud, *Les Dieux;* Recinos, *Popol Vuh;* Sam Colop, *Popol Wuj;* Schultze-Jena, *Popol Vuh;* Tedlock, *Popol Vuh.*

18. Las Casas, *Apologética Historia Sumaria;* Landa, *Relación de las Cosas;* Lizana, *Historia de Yucatán;* Cogolludo, *Historia de Yucathan.*

19. Carmack, *Quichean Civilization;* Carmack and Mondloch, *Título de Totonicapán,* and *Título de*

Yax; Knowlton, *Maya Creation Myths;* Maxwell and Hill, *Kaqchikel Chronicles;* Montoliu Villar, *Cuando los Dioses Despertaron;* Recinos, *Crónicas Indígenas;* Roys, *Book of Chilam Balam.*

20. Acuña, *Temas del Popol Vuh,* 43–46; Christenson, *Popol Vuh,* 37–39; Van Akkeren, "Authors of the Popol Vuh," 253–54.

21. Tedlock, *Popol Vuh,* 56–57, 197–98; cf. Christenson, *Popol Vuh,* 269, 305.

22. Van Akkeren, "Authors of the Popol Vuh"; cf. Lenkersdorf, "Popol Vuh."

23. Boone, *Stories in Red and Black;* Tedlock, *Popol Vuh,* 58, also compared the Popol Vuh with the Palenque tablets.

24. Acuña, "Theologia Indorum de fray Domingo de Vico," and "Theologia Indorum de Vico"; Carmack and Mondloch, "Título de Totonicapán"; Sparks, "Fill in the Middle Ground," and "Primeros Folios."

25. Recinos, *Crónicas Indígenas;* Carmack, *Quichean Civilization.*

26. Coto, *Thesavrvs verborv̄,* 35 (Spanish: "*antigüe-dades que se cuentan o refieren*").

27. Sparks, "Primeros Folios"; Christenson, *Popol Vuh,* 35; Rivera Dorado, "Influencia del Cristianismo"; Van Akkeren, "Authors of the Popol Vuh." For a different perspective, see Acuña, *Temas del Popol Vuh.*

28. Sparks, "Primeros Folios." Quote from Tedlock, *Popol Vuh,* 63. Compare with Christenson's translation: "This account we shall now write under the law of God and Christianity" (in Christenson, *Popol Vuh,* 64).

29. Christenson, *Popol Vuh,* 36; Tedlock, *Popol Vuh,* 30. Megged, "Right from the Heart," reviewed aspects of the Dominican campaign in Chiapas and Guatemala.

30. Acuña, *Temas del Popol Vuh,* 62; quote from Remesal, *Historia General,* 1:419–20. Jack Himelblau effectively rebuffed Acuña's contention that the Popol Vuh was a collection of heterogeneous materials, artificially stitched together by Spanish friars with missionizing aims; see Himelblau, *Quiché Worlds.*

31. Acuña, "Theologia Indorum de fray Domingo de Vico," and "Theologia Indorum de Vico"; Van Akkeren, "Fray Domingo de Vico"; Sparks, "Primeros Folios," and "Fill in the Middle Ground."

32. Chinchilla Mazariegos, "Francisco Antonio de Fuentes y Guzmán"; Las Casas, *Apologética Historia Sumaria.*

33. Carmack and Mondloch, *Título de Yax,* 11–13.

34. Acuña, *Temas del Popol Vuh,* 30–31.

35. For interpretations of this term, see Christenson, *Popol Vuh,* 64–65; and Tedlock, *Popol Vuh,* 218.

36. Tedlock, *Popol Vuh,* 28–29; Christenson, *Popol Vuh,* 32–35. The term *pictorial* is used in reference to semasiographic scripts, which do not record elements of a spoken language. Glottographic scripts are those that record elements of a spoken language using logograms, syllables, or alphabetic signs. Both kinds of scripts were used in Postclassic Mesoamerica.

37. Boone, "Web of Understanding"; Carmack, *Historia Social,* 93–130; Hill, *Pictograph to Alphabet;* Lacadena, "Regional Scribal Traditions."

38. Acuña, *Temas del Popol Vuh;* Himelblau, *Quiche Worlds;* Quiroa, "Popol Vuh"; Recinos, *Popol Vuh;* Woodruff, "Most Futile and Vain."

39. Translation from Quiroa, "Popol Vuh," 478–79.

40. Ximénez's prologue was published in Estrada Monroy, *Empiezan las Historias,* 10–11; Woodruff, "Most Futile and Vain," 121.

41. Acuña, *Temas del Popol Vuh,* 35; Ximénez, *Historia de la Provincia,* 5.

42. For discussions of the later history of the manuscript and its copies, see Acuña, *Temas del Popol Vuh;* Himelblau, *Quiche Worlds;* Recinos, *Popol Vuh;* and Woodruff, "Most Futile and Vain."

43. Christenson, *Popol Vuh,* 59, 305; Tedlock, *Popol Vuh,* 63, 198.

44. Carmack and Mondloch, *Título de Totonicapán,* 174.

45. Chinchilla Mazariegos, *Imágenes de la Mitología Maya,* 143–45.

46. Freidel, Schele, and Parker, *Maya Cosmos,* 43.

47. Christenson, *Popol Vuh,* 33.

48. Bricker and Bricker, "Linearity and Cyclicity," 177.

49. For a detailed review, see Graulich, *Myths of Ancient Mexico,* 13–45.

50. Bierhorst, *History and Mythology,* 7; Tena, *Mitos e Historias,* 170.

51. Bierhost, *History and Mythology,* 142.

52. Tena, *Mitos e Historias,* 174–75; López Austin, *Myths of the Opossum,* 204.

53. Carlsen and Prechtel, "Flowering of the Dead"; López Austin, *Human Body,* 176.

54. Graulich, "Metaphor of the Day," "Reyes de Tollan," and *Myths of Ancient Mexico,* 180.

55. Alcalá, *Relación de Michoacán,* 243; Graulich,

Myths of Ancient Mexico, and "Reyes de Tollan."

56. Castellón Huerta, *Relatos Ocultos;* Monjarás-Ruiz, *Mitos Cosmogónicos;* Thompson, *Maya History and Religion.*

57. López Austin, *Myths of the Opossum,* 304.

58. López Austin, "Cuando Cristo Andaba de Milagros," 207.

59. Van Akkeren, "How Our Mother."

60. Braakhuis, "Xbalanque's Marriage"; on Q'eqchi' ethnography and history, see Wilson, *Resurgimiento Maya.*

3 MESOAMERICAN COSMOGONY

1. Fought, "Translation of Recordings."

2. Tedlock, *Popol Vuh,* 223.

3. Christenson, *Popol Vuh,* 66; Henne, "Untranslation."

4. Basseta, *Vocabulario de Lengua Quiché,* 115; Covarrubias, *Parte Primera del Tesoro,* 169; Coto, *Thesavrvs verborṽ,* 106, 118; Ximénez, *Primera Parte del Tesoro,* 593.

5. Guiteras Holmes, *Perils of the Soul,* 311; Tedlock, *Popol Vuh,* 215; Christenson, *Popol Vuh,* 60.

6. Graulich, *Myths of Ancient Mexico,* 63–95; Moreno de los Arcos, "Cinco Soles."

7. Laughlin, *Of Cabbages and Kings,* 2.

8. Gossen, "Tiempo Cíclico," 454.

9. Graulich "Mitos Mexicanos," and *Myths of Ancient Mexico.*

10. Las Casas, *Apologética Historia Sumaria,* 3:1456–57.

11. Graulich, *Myths of Ancient Mexico,* 46–49.

12. Mendieta, *Historia Eclesiástica,* 1:49.

13. Tena, *Mitos e Historias,* 24–27.

14. Earle, "Metaphor of the Day," 168–69.

15. Christenson, *Popol Vuh,* 60; "bearer, begetter" according to Tedlock, *Popol Vuh,* 63.

16. Tedlock, *Popol Vuh,* 65. Compare with Christenson, *Popol Vuh,* 71: "How shall it be sown? When shall there be a dawn for anyone? Who shall be a provider? Who shall be a sustainer? Then be it so. You are conceived. May the water be taken away, emptied out, so that the plate of the earth may be created—may it be gathered and become level. Then may it be sown; then may dawn the sky and the earth. There can be no worship, no reverence given by what we have framed and what we have shaped, until humanity has been created, until people have been made, they said."

17. Tedlock, *Popol Vuh,* 225–26.

18. Ibid.; Carlsen and Prechtel, "Flowering of the Dead," 31–32.

19. For the Chamula myth, see Gossen, "Two Creation Texts," 139–45. For the Chenalhó myth, see Guiteras Holmes, *Perils of the Soul,* 186. For the Huichol myth, see Neurath and Gutiérrez, "Mitología y Literatura," 295. For the Mam, see Hostnig and Vásquez Vicente, *Nab'ab'l Qtanam Mam,* 6. For the Ch'orti' myth, see Hull, "The Ch'orti' Maya Myths." For the Q'eqchi' myth, see Thompson, *Ethnology of the Mayas,* 119.

20. Tena, *Mitos e Historias,* 29.

21. Graulich, "Double Immolations"; Matos Moctezuma, "Tlaltecuhtli"; Matos Moctezuma and López Luján, *Escultura Monumental;* Tena, *Mitos e Historias,* 150–53.

22. Craine and Reindorp, *Codex Pérez,* 117–18.

23. Milbrath, *Star Gods,* 277–82; Stuart, *Inscriptions from Temple XIX,* 71; Taube, *Itzam Cab Ain,* and *Major Gods,* 128–31.

24. Guiteras Holmes, *Perils of the Soul,* 289.

25. Bricker and Bricker, "Linearity and Cyclicity," 176–78; Stuart, *Inscriptions from Temple XIX,* 68–77; Velásquez García, "Maya Decapitation Myth."

26. On the Mixtec codices, see Byland and Pohl, *In the Realm of 8 Deer,* 114–19; Furst, *Codex Vindobonensis,* 63, 215–27; Heyden, "Uno Venado"; and Hamann, "Social Life." On the Nahua sources, see Bierhorst, *History and Mythology;* Graulich, *Myths of Ancient Mexico,* 63–95, and "Reyes de Tollan"; Moreno de los Arcos "Cinco Soles"; and Tena, *Mitos e Historias.*

27. For the Lacandon, see Boremanse, *Cuentos y Mitología,* 99–102; and Bruce, *Libro de Chan K'in.* For the Tzotzil, see Gossen, "Tiempo Cíclico," and *Four Creations;* and Holland, *Medicina Maya,* 71–72. For the Mam, see Hostnig and Vásquez Vicente, *Nab'ab'l Qtanam Mam,* 3–6; and Wagley, *Social and Religious Life,* 51. For the Tz'utujil, see Tarn and Prechtel, *Scandals,* 291–92. For the Yucatec, see Tozzer, *Comparative Study,* 153–54; and Villa Rojas, "Prólogo," 12. See also the compilations by De la Garza, "Mayas"; and Thompson, *Maya History and Religion,* 336–48.

28. Guiteras Holmes, *Perils of the Soul,* 186; Gossen, "Temporal and Spatial Equivalents"; La Farge, *Santa Eulalia;* López Austin, "Cuando Cristo Andaba de Milagros"; Stanzione, *Rituals of Sacrifice;* Stresser-Péan, *Sol-Dios y Cristo,* 523–24; Tax, "Folk Tales."

29. Tarn and Prechtel, *Scandals,* 291.

30. Stanzione, *Rituals of Sacrifice,* offered a detailed version of the Jesus Christ story as understood

in Santiago Atitlán.

31. For the Mam, see Hostnig and Vásquez Vicente, *Nab'ab'l Qtanam Mam,* 3–6. For the Chamula, see Gossen, *Four Creations,* 222–33.

32. For the Tzotzil, see Holland, *Medicina Maya,* 71–72. For the Yucatec, see Montoliú Villar, *Cuando los Dioses Despertaron,* 82. For the Q'eqchi', see Thompson, *Ethnology of the Mayas,* 119.

33. Tedlock, *Popol Vuh,* 66–73; Christenson, *Popol Vuh,* 70–90.

34. Ibid. For the Chamula, see Gossen, *Four Creations,* 171–73; for Andean myths, see Quilter, "Moche Revolt of the Objects."

35. Hull, "Grand Ch'orti' Epic," 136; López García, "Restricciones Culturales," 2:8.

36. Horcasitas, "Analysis of the Deluge Myth"; Bierhorst, *History and Mythology,* 144.

37. For the Tepehua, Tzeltal, and Ch'ol, see Horcasitas, "Analysis of the Deluge Myth," 198. For the Tzotzil, see Hermitte, *Poder Sobrenatural,* 27. For the Ch'orti', see Hull, "Grand Ch'orti' Epic," 136. For the Mazahua, see Galinier, "Panoptikon Mazahua," 55. For the Nahua, see Sandstrom and Sandstrom, "Those Who Were Lost." For the Teenek, see *Relatos Huastecos,* 99; and Van 't Hooft and Cerda Zepeda, *Lo que Relatan de Antes,* 94.

38. Horcasitas, "Analysis of the Deluge Myth," 185–86. See also Morales Fernández, "Algunos Mitos del Diluvio." For the Huichol, see Furst, "Huichol Cosmology." For the Totonac, see Horcasitas, "Dos Versiones Totonacas"; and Oropeza Escobar, "Mitos Cosmogónicos," 200–201. For the Tzotzil, see Cruz Coutiño, "Integración de Secuencias," 294–96, 325–27; and Mondragón, Tello, and Valdez, *Relatos Tzotziles,* 17–18.

39. For the Q'anjob'al, see La Farge, *Santa Eulalia,* 64–65. For the Tzotzil, see Laughlin, *Of Cabbages and Kings,* 76–77. For the Mazatec, see Pérez Moreno, *Xujun Én Ntáxjo,* 61–62. For the Mam, see Siegel, "Creation Myth." For the Totonac, see Horcasitas, "Dos Versiones Totonacas."

40. For the Ch'orti', see Fought, "Translation of Recordings." For the Mixtec, see Monaghan, *Covenants,* 32, 49.

41. Ariel de Vidas, *Thunder,* 133–35, 139, and "What Makes a Place Ethnic?" 177–79.

42. Gutiérrez Estévez, "Mayas y Mayeros"; Tozzer, *Comparative Study,* 153–54.

43. Gutiérrez Estévez, "Mayas y Mayeros"; Hamann, "Social Life"; Ligorred Perramón, *Consideraciones,* 126–27; Sullivan, "Yucatec Maya."

44. Earle, "Metaphor of the Day," 168.

45. Bricker, *Humor Ritual;* Gossen, "Variaciones del Mal"; Monod-Becquelin and Breton, "Carnaval de Bachajón"; Nájera C., "Imágenes del Inframundo"; Vogt and Bricker, "Zinacanteco Fiesta"; La Farge, *Santa Eulalia,* 64–68.

46. Feldman, *Lost Shores.*

47. Schackt, "Savage Other"; Wilson, *Resurgimiento Maya,* 73.

48. Knowlton, *Maya Creation Myths,* 55–56.

49. Roys, *Book of Chilam Balam,* 64.

50. Velásquez García, "Maya Decapitation Myth," 5. Initially, Knowlton translated the term as "Buried One of the World," but later opted for the usual interpretation of the Ah Mucen Cab as bee gods. Compare Knowlton, "Dialogism," 77, with Knowlton, *Maya Creation Myths,* 56.

51. Tedlock, *Popol Vuh,* 161, 304–5; Christenson, *Popol Vuh,* 229–30.

52. Tedlock, *Popol Vuh,* 158–60; Christenson, *Popol Vuh,* 223–27.

53. Sahagún, *Florentine Codex,* book 7, 7; Graulich, *Myths of Ancient Mexico,* 118–19; León-Portilla, "Those Made Worthy"; Tena, *Mitos e Historias,* 182–85.

54. Bierhorst, *History and Mythology,* 149.

55. Gossen, "Variaciones del Mal."

56. Brady, "Settlement Configuration and Cosmology"; Prufer and Brady, *Stone Houses;* Schele, "Iconography"; Stone, *Images from the Underworld,* 23, 35–36; Vogt, "Ancient Maya Concepts"; Vogt and Stuart, "Some Notes on Ritual Caves," 156; Taube, "Flower Mountain."

57. Christenson, *Popol Vuh,* 193–95; Maxwell and Hill, *Kaqchikel Chronicles,* 9–11; Tedlock, *Popol Vuh,* 145–46.

58. Cogolludo, *Historia de Yucathan,* 193; Beliaev and Davletshin, "It Was Then."

59. Christenson, *Popol Vuh,* 71.

60. Graulich and Olivier, "Deidades Insaciables," 125; Dupiech-Cavalieri and Ruz, "Deidad Fingida," 245–47.

61. Graulich, "Autosacrifice"; Joralemon, "Ritual Blood-Sacrifice"; Schele and Miller, *Blood of Kings;* Stuart, "Royal Autosacrifice"; Thompson, "Blood-Drawing Ceremony." On phalanges, see Becker, "Earth Offerings," 63; Cuevas García, *Incensarios Efigie,* 80–81; and Dillon, Brunker, and Pope, "Ancient Maya Autoamputation?"

62. Tedlock, *Popol Vuh,* 157; cf. Christenson, *Popol Vuh,* 219.

63. Tedlock, *Popol Vuh,* 149, 300–301; in Christenson's translation, "bloodletters,

sacrificers" (*Popol Vuh,* 203).

64. Tedlock, *Popol Vuh,* 164–66; Christenson, *Popol Vuh,* 235–39.

65. Graulich and Olivier, "Deidades Insaciables," 132; Tedlock, *Popol Vuh,* 155–56, 299; Christenson, *Popol Vuh,* 216–18.

66. Molina, *Vocabulario,* 71v (Spanish: "*Sacrificio de sangre, que ofrecían a los ydolos, sajándose u hora-dando alguna parte del cuerpo*"); López Austin, *Human Body,* 377.

67. Köhler, "Debt-Payment"; cf. Clendinnen, *Aztecs,* 74–75; Graulich and Olivier "Deidades Insaciables," 144.

68. Shaw, *According to Our Ancestors,* 52–53.

69. For the Ch'orti', see López García, "Restricciones Culturales," 2:5. For the Nahua, see Broda, Carrasco, and Matos Moctezuma, *Great Temple,* 107, citing a personal communication from Timothy Knab. For the Mixtec, see Monaghan, *Covenants,* 204–7. For the Chuj, see Shaw, *According to Our Ancestors,* 104.

70. Girard, *Mayas Eternos,* 153–54; López García, "Restricciones Culturales," 2:5, 172–73, and *Kumix,* 79–121; Wisdom, *Chorti Indians,* 439.

71. Earle, "Metaphor of the Day," 63

72. Monaghan, *Covenants,* and "Theology and History," 38.

73. Monaghan, *Covenants,* 225; Vogt, *Tortillas for the Gods,* 52–55.

74. Graulich, *Myths of Ancient Mexico,* 158–64.

75. Modified from Maxwell and Hill, *Kaqchikel Chronicles,* 8.

76. Basseta, *Vocabulario de Lengua Quiché,* 232; cf. Coto, *Thesavrvs verborv̄,* 367; Kaufman and Justeson, "Preliminary Maya Etymological Dictionary," 442.

77. Maxwell and Hill, *Kaqchikel Chronicles,* 17.

78. Tena, *Mitos e Historias,* 36–39.

79. Bierhorst, *History and Mythology,* 150.

80. Tedlock, *Popol Vuh,* 81–85; cf. Christenson, *Popol Vuh,* 101–7.

81. Seler, "Myths and Religion," 41–46.

82. Chinchilla Mazariegos, "Cosmos and Warfare," and *Imágenes de la Mitología Maya,* 180–221.

83. Bassie-Sweet, *From the Mouth,* 200–210; Clancy, "Text and Image"; Freidel, Schiele, and Parker, *Maya Cosmos;* Houston, "Symbolic Sweatbaths"; Lounsbury, "Some Problems," and "Identities of the Mythological Figures"; Robertson, *Sculpture of Palenque;* Schele, "Accession Iconography"; Stuart, *Inscriptions from Temple XIX,* and *Sourcebook;* Stuart and

Stuart, *Palenque.*

84. Berlin, "Palenque Triad"; Kelley, "Birth of the Gods."

85. Stuart, *Inscriptions from Temple XIX,* 161–70; Stuart and Stuart, *Palenque,* 198.

86. Stuart, *Inscriptions from Temple XIX,* 167–68; Stuart and Stuart, *Palenque,* 53–56; Taube, "Womb of the World."

87. Stuart and Stuart, *Palenque,* 210.

88. Genet, "Symbolic Glyphs"; Miller, "Meaning and Function"; Chinchilla Mazariegos, "Cosmos and Warfare," 119–21.

89. Stuart and Stuart, *Palenque,* 209.

90. Martin, "Baby Jaguar," and "Cacao in Ancient Maya Religion"; Stuart, *Ten Phonetic Syllables;* Taube, *Major Gods,* 69–79; Thompson, *Maya History and Religion,* 224–27; Valencia Rivera, "Abundancia."

91. Stuart, *Inscriptions from Temple XIX,* 68–77; Velásquez García, "Maya Decapitation Myth."

92. Förstemann, *Commentary,* 266; Taube, *Ancient Yucatec,* 219–20, and "Where Earth and Sky Meet"; Vail and Hernández, *Re-Creating Primordial Time,* 155–74.

4 THE MAIDEN

1. Kockelman "Meaning and Time," 349, translation of a Q'eqchi' myth narrated by Juan Caal and recorded by Pablo Wirsig.

2. Braakhuis, "Xbalanque's Marriage"; Chinchilla Mazariegos, "Of Birds and Insects."

3. Woodruff, "Most Futile and Vain," 124; see a variant version in Ximénez, *Historia de la Provincia,* 62.

4. Graulich, "Myths of Paradise Lost," 578.

5. Modified from Quiñonez Keber, *Codex Telleriano-Remensis,* 268.

6. Heyden, "Diosa Madre"; McCafferty and McCafferty, "Metamorphosis"; Quiñones Keber, *Codex Telleriano-Remensis,* 162; Sullivan, "Tlazolteotl-Ixcuina."

7. Acuña, *Relaciones Geográficas,* 202–3; Graulich, *Myths of Ancient Mexico,* 56–57; Tena, *Mitos e Historias,* 155.

8. Quiñones Keber, *Codex Telleriano-Remensis,* 260, 265–66; Graulich, "Myths of Paradise Lost."

9. Burkhardt, *Slippery Earth,* 87–98; Galinier, "L'Homme Sans Pied"; Laughlin, "Through the Looking Glass"; López Austin, *Myths of the Opossum,* 66–67; Sigal, *From Moon Goddesses to Virgins,* 53–61, and *Flower and the Scorpion,* 38–40.

10. López Austin, *Myths of the Opossum,* 62–67, and

Tamoanchan, Tlalocan, 84–100; Graulich, "Myths of Paradise Lost," and *Myths of Ancient Mexico,* 52–59.

11. Tedlock, *Popol Vuh,* 98; Christenson, *Popol Vuh,* 128.

12. Chinchilla Mazariegos, "Human Sacrifice"; Henne, "Quiche Food"; López García, "Restricciones Culturales," 2:39; Petrich, *Alimentación Mochó,* 106–7.

13. Tarn and Prechtel, "Comiéndose la Fruta"; Laughlin, "Through the Looking Glass," 170–71.

14. Christenson, *Popol Vuh,* 128–34; Tedlock, *Popol Vuh,* 98–102.

15. Carlsen and Prechtel, "Flowering of the Dead"; López Austin, *Tamoanchan, Tlalocan,* 205–6.

16. Aguirre Beltrán, *Medicina y Magia,* 173–75; Benson, "In Love and War"; Quezada, *Amor y Magia Amorosa,* 96–106. Braakhuis, "Xbalanque's Marriage," summarized numerous variants of hummingbird myths from Guatemala, Chiapas, and Belize.

17. Coe, *Lords of the Underworld,* 52; On courtly scenes, see Houston, "Classic Maya Depictions"; Chinchilla Mazariegos, "Of Birds and Insects," 46.

18. Redfield, "Notes on San Antonio Palopó," 292; Thompson, *Ethnology of the Mayas,* 126; Yurchenko, "Música de los Mayas-Quichés." See the glosses in Basseta, *Vocabulario de Lengua Quiché,* 444; Coto, *Thesavrvs verborv,* 403; and Feldman, *Dictionary of Poqom,* 110.

19. Braakhuis, "Xbalanque's Marriage," 116–20; Collier, "Courtship and Marriage," 151.

20. Palomino, "Patrones Matrimoniales," 129–49.

21. Maxwell, "Yarns Spun by Ixils," 65; see also Colby and Colby, *Daykeeper,* 180–83.

22. Kockelman "Meaning and Time," 347–82; Thompson, *Ethnology of the Mayas,* 119–40; De la Cruz Torres, *Rubelpec,* 17–70.

23. Ávila, "Xul-E'"; Braakhuis, "Xbalanque's Canoe."

24. Mayers, *Pocomchí Texts,* 6; Schumann, "Origen del Maíz"; Thompson, *Ethnology of the Mayas,* 128–29.

25. Braakhuis, "Xbalanque's Canoe," 174.

26. Cordry and Cordry, *Mexican Indian Costumes,* 46; Delgado, "Figurines"; Miller, *Cuentos Mixes,* 75–76, 79, 86–87.

27. Klein, "Fighting with Femininity"; Sullivan, "Tlazolteotl-Ixcuina"; McCafferty and McCafferty, "Spinning and Weaving."

28. Thompson, *Ethnology of the Mayas,* 127.

29. Ávila, "Xul-E,'" 26–27; De la Cruz Torres, *Rubelpec,* 35.

30. Miller, *Cuentos Mixes,* 75–88.

31. Navarrete, "Cuentos del Soconusco," 422.

32. Neff, "Sources of Raw Material."

33. Seler, "Animal Pictures," 237.

34. Craine and Reindorp, *Codex Pérez,* 120.

35. Cogolludo, *Historia de Yucathan,* 196; Knowlton, *Maya Creation Myths,* 80; Thompson, *Maya History and Religion,* 313.

36. Segre, *Metamorfosis de lo Sagrado,* 173; Taube, "Ancient and Contemporary," 123.

37. On Nahua versions, see Greco, "Naissance du Maïs"; Sandstrom, "Cave-Pyramid Complex," 47; Van 't Hooft and Cerda Zepeda, *Lo que Relatan de Antes,* 41–55; and *Cuerpos de Maíz,* 182, 191. On the Totonac version, see Münch Galindo, "Acercamiento al Mito." On Teenek versions, see Ochoa Peralta, "Aventuras de Dhipaak"; *Cuerpos de Maíz,* 150; and Van 't Hooft and Cerda Zepeda, *Lo que Relatan de Antes,* 34–39 (Grackle [*zanate* in Mexico and Guatemala]: *Quiscalus mexicanus*).

38. *Cuerpos de Maíz,* 182 (Spanish: "*esa cuestión blanca*").

39. On the Totonac version, see Ichon, *Religión de los Totonacas,* 73. On the Nahua version, see Olguín, "Cómo Nació Chicomexóchitl," 120; and Van 't Hooft and Cerda Zepeda, *Lo que Relatan de Antes,* 43. On the Otomí version, see Oropeza Escobar, "Mitos Cosmogónicos," 186; and *Cuerpos de Maíz,* 159.

40. Olguín, "Cómo Nació Chicomexóchitl"; Maxwell, "Yarns Spun by Ixils," 65.

41. Coe, "Hero Twins"; Taube, *Major Gods,* 115–19.

42. Chinchilla Mazariegos, "Of Birds and Insects," 54.

43. Sandstrom, "Cave-Pyramid Complex," 47.

44. *Cuerpos de Maíz,* 159–64.

45. Anderson and Schroeder, *Codex Chimalpahin,* 121.

46. Ibid., 119–23; Chinchilla Mazariegos, "Of Birds and Insects," 55–56; Gillespie, *Aztec Kings,* 128–30.

47. Heyden, "La Diosa Madre," 7; De la Cruz Torres, *Rubelpec,* 33.

48. Galinier, *World Below,* 63.

49. Monaghan, "Physiology," 293; Katz, "Recovering after Childbirth," 101.

50. Braakhuis "Xbalanque's Canoe," and "Xbalanque's Marriage," 197–98. On the Mopan story, see Shaw, *According to Our Ancestors,* 178.

51. Paul and Paul, "Changing Marriage Patterns," 135, quoting Lothrop, *Atitlán,* 30; Paul, "Mastery of Work," 292; Tarn and Prechtel, *Scandals,* 79.

52. Quiñones Keber, *Codex Telleriano-Remensis,* 261; cf. Corona Núñez, "Palabra Creadora"; and

Kelley, "Birth of the Gods."

53. Stuart, "Ideology," 69; and *Inscriptions from Temple XIX,* 169.

54. Tovalín Ahumada, Velázquez de Leon Collins, and Ortíz Villareal, "Cuenco de Alabastro."

55. Taube, "Ritual Humor," 368.

56. Ibid.

57. Braakhuis, "Xbalanqué's Canoe"; Burkhardt, *Slippery Earth,* 88–89; Montoliú Villar, "Mito del Origen."

58. Báez-Jorge, "Kauymáli," and *Lugar de la Captura;* Chinchilla Mazariegos, "Vagina Dentada."

5 THE GRANDMOTHER

1. Petrich and Ochoa García, *Tzijonïk,* 140–45.

2. Hurtado and Sáenz de Tejada, "Relations," 228.

3. Las Casas, *Apologética Historia Sumaria,* 2:882–83. (Spanish: "*El padre se llamaba Izona, que había criado los hombres y todas las cosas; el Hijo tenía por nombre Bacab, el cual nació de una doncella siempre virgen llamada Chibirias*" and "*La madre de Chibirias, llamada Hischen, que nosotros decimos haber sido Santa Ana*".)

4. Seler, "Quetzalcoatl-Kukulcan," 199; Landa, *Relación de las Cosas,* 7, 58, 93.

5. Las Casas, *Apologética Historia Sumaria,* 3:1456–57; Coe, "Supernatural Patrons," 329; Taube, *Major Gods,* 99.

6. Ciaramella, *Weavers;* Taube, *Major Gods,* 99–105; Vail and Hernández, *Re-Creating Primordial Time,* 155, 172.

7. Knowlton, "Maya Goddess"; Taube, *Major Gods,* 64–69.

8. Tedlock, *Popol Vuh,* 104–5; Christenson, *Popol Vuh,* 140–42.

9. Fagetti, "Nacimiento," and a related version in Moedano, "Temazcal."

10. Gutiérrez Estévez, "Lógica Social"; Stephens, *Incidents,* 2:423–25.

11. On the Cora myth, see Guzmán, *Mitote,* 146–47. On the Tepehua myth, see Williams García, *Mitos Tepehuas,* 112–14.

12. On the Mixtec story, see Dyk, *Mixteco Texts,* 14–15. On the Chatino story, see Bartolomé, *Ciclo Mítico;* and De Cicco and Horcasitas, "Cuates." On the Totonac story, see Münch Galindo, "Acercamiento," 289. On the Nahua story, see Barón Larios, *Tradiciones,* 155; Olguín, "Cómo Nació Chicomexóchitl," 124; Oropeza Escobar, "Mitos Cosmogónicos," 220; Segre, *Metamorfosis de lo Sagrado,* 174; and Van 't Hooft and Cerda Zepeda, *Lo que Relatan de Antes,* 53. On the

Otomí story, see *Cuerpos de Maíz,* 163. On the origin of disease, see Braakhuis, "Xbalanque's Canoe."

13. On the Tz'utujil narratives, see Prechtel, *Grandmother Sweat Bath;* and Shaw, *According to Our Ancestors,* 239. On the Kaqchikel narratives, see Redfield, "Notes on San Antonio Palopó," 253–54.

14. On the Q'eqchi' myths, see Braakhuis, "Xbalanque's Marriage," 371; Cruz Torres, *Rubelpec,* 28; Grandia, *Stories,* 5; and Thompson, *Ethnology of the Mayas,* 120.

15. On the Ch'orti' narratives, see Fought, "Kumix," 464; Hull, "Grand Ch'orti' Epic," 134; and Pérez Martínez, *Leyenda Maya Ch'orti',* 46. On the Popoluca narratives, see Blanco Rosas, "Erosión de la Agrodiversidad," 72; Elson, "Homshuk," 202; and Foster, *Sierra Popoluca,* 192. On the Pipil narratives, see Campbell, *Pipil Language,* 910. On the Chinantec narratives, see Carrasco and Weitlaner, "Sol y la Luna," 171. On the Teenek narratives, see Van 't Hooft and Cerda Zepeda, *Lo que Relatan de Antes,* 38.

16. Hollenbach, "Origen del Sol," 164. For opossum myths, see López Austin, *Myths of the Opossum,* 3–9.

17. Nicholson, "Religion," 420–22; Sahagún, *Florentine Codex,* book 1, 15; cf. Carr and Gingerich, "Vagina Dentata"; Clendinnen, *Aztecs,* 174–80; Klein, "Rethinking Cihuacoatl"; Matos Moctezuma, "Tlaltecuhtli."

18. Graulich, *Ritos Aztecas,* 89–143, 233–52.

19. Sahagún, *Florentine Codex,* book 1, 15; Tena, *Mitos e Historias,* 153; Olivier, "Tlantepuzilama."

20. Bierhorst, *History and Mythology,* 153; Braakhuis, "Xbalanque's Marriage," 413–17; Tena, *Mitos e Historias,* 191.

21. Bartolomé, *Ciclo Mítico,* 11; Bartolomé and Barabas, *Tierra de la Palabra,* 198; cf. De Cicco and Horcasitas, "Cuates," 76.

22. Storey, "Perinatal Mortality," and "Children of Copan"; cf. Moedano, "Temazcal"; Alcina Franch, Ciudad Ruiz, and Iglesias Ponce de León, "Temazcal"; Groark, "To Warm the Blood."

23. Tedlock, *Popol Vuh,* 111–12; Christenson, *Popol Vuh,* 152–53.

24. Preuss, *Gods of the Popol Vuh,* 11.

25. Basseta, *Vocabulario de Lengua Quiché,* 101, 379, 424, entries for *chile,* and *iε;* cf. Coto, *Thesavrvs verborv,* 117, 235, glosses for *costumbre tener la mujer, estar con su regla,* and *flor de la mujer.* Compare with modern glosses in Ajpacajá Tum,

Diccionario K'iche', 79–80.

26. Ávila, "Xul-E," 24; Paul, "Mastery of Work," 298. On the noxious properties attributed to menstrual blood in Mesoamerica, see, López Hernández, "Representaciones," 238–43.

27. On the K'iche' narrative, see Carmack, *Historia Social,* 353–71. On the Ch'orti' narrative, see Pérez Martínez, *Leyenda,* 41–42. On the Tzotzil narrative, see Gossen, *Four Creations,* 796–807; and Laughlin, *Of Cabbages and Kings,* 278–87. On the Tzeltal narrative, see Guiteras Holmes, *Perils of the Soul,* 261.

28. Braakhuis, "Xbalanque's Marriage," 386–87; Cruz Torres, *Rubelpec,* 48–55; Thompson, *Ethnology of the Maya,* 129–30.

29. Redfield, "Notes on San Antonio Palopó," 253–54 (Güisquil or chayote: *Sechium edule*).

30. Prechtel, *Grandmother Sweat Bath;* Shaw, *According to Our Ancestors,* 239.

31. Tedlock, *Popol Vuh,* 112; Christenson, *Popol Vuh,* 152–53.

32. Gutiérrez Estévez, "Lógica Social," 68, 106.

33. Law, "Tamakasti," 348. On the Otomí version, see Oropeza Escobar, "Mitos Cosmogónicos," 187. On the Tepehua version, see Williams García, *Mitos Tepehuas,* 89. On the Totonac version, see Ichon, *Religión de los Totonacas,* 76. On Nahua versions, see Chevalier and Buckles, *Land without Gods,* 312–14; García de León, *Pajapan,* 83; González Cruz and Anguiano, "Historia," 217; and Oropeza Escobar, "Mitos Cosmogónicos," 232 (Nance, also known as nanchi or nanche: *Byrsonima crassifolia*).

34. On Popoluca versions, see Münch Galindo, *Etnología del Istmo Veracruzano,* 167; and Técnicos Bilingües, *Agua, Mundo, Montaña,* 22. On the Q'eqchi' version, see Thompson, *Ethnology of the Mayas,* 125.

35. Prechtel, *Grandmother Sweat Bath.* On the Popoluca story, see Blanco Rosas, "Erosión de la Agrodiversidad," 73; and Münch Galindo, *Etnología del Istmo Veracruzano,* 166.

36. On the Ch'orti' myth, see Fought, "Kumix." On the Q'eqchi' myth, see Braakhuis, "Xbalanque's Marriage," 371; Grandia, *Stories,* 5; and Thompson, *Ethnology of the Mayas,* 120. On the Mochó myth, see Petrich, *Alimentación Mochó.* On the Amazonian myth, see Gregor, *Anxious Pleasures,* 19; and Lévi-Strauss, *Raw and the Cooked,* 265.

37. Coto, *Thesavrvs verborv,* 503 (Spanish: "*después de sacrificar los antiguos a algún hombre,*

despedazándolo, si era de los que habían cogido en guerra, que guardaban el miembro genital y testículos del tal sacrificado, y se los daban a una vieja que tenían por profeta para que se los comiesse"). Cited in Olivier, "Tlantepuzilama," 253.

38. Braakhuis, "Xbalanque's Marriage," 374; Grandia, *Stories,* 7–8; Thompson, *Ethnology of the Mayas,* 122.

39. De la Cruz Torres, *Rubelpec,* 27–28; Seler, "Animal Pictures," 289.

40. López García, "Restricciones Culturales," 2:17 (Spanish: "*estaba la mujer desnuda, abierta dentro del agua y tenía una piedra larga y se estaba afilando los dientes… era cosa para comer al niño*"). In an edited version, the wording was modified to suggest that the woman had her mouth opened inside the water ("*abierta la boca dentro del agua*"). The unedited text included in his dissertation made no mention of her mouth. See López García, *Kumix,* 30.

41. Dary, *Estudio Antropológico,* 266 (Spanish: "*Ay m'hijo… tan duro tu hueso*").

42. Girard, *Mayas Eternos,* 226. Chilate is a ritual drink made of maize and cacao.

43. Guiteras Holmes, *Peligros del Alma,* 153 (Spanish "*se puso como una piedra dura grande*"). Compare with the English version in Guiteras Holmes, *Perils of the Soul,* 183: "Ohoroxtotil then turned to stone, a hard stone." For an alternative version, see Arias, *San Pedro Chenalhó,* 31.

44. Báez-Jorge, *Lugar de la Captura.* Some examples include Carneiro, "Amahuaca," 10; Gifford, "Northeastern," 388–90; Gregor, *Anxious Pleasures,* 71; Malotki, "Story"; and Vega Fallas, "Variantes del Mito," 80 –81.

45. Báez-Jorge, "Seductoras Macabras." On the Otomí and Mazahua, see Galinier, *Mitad del Mundo,* 260, and "Panoptikon Mazahua." On the Huave, see Lupo, "Vientre"; and Millán, *Cuerpo de la Nube.* On the Zoque, see Báez-Jorge, "Cosmovisión." On the Mixtec, see Monaghan, *Covenants,* 145; and Villela Flores and Glockner, "De Gemelos."

46. Monaghan, *Covenants,* 139, 144–45.

47. Báez-Jorge, "Seductoras Macabras," 10, and *Lugar de la Captura,* 158–60 (Mazacoate: *Boa constrictor*).

48. Báez-Jorge, "Kauymáli"; Neurath, "Ambivalent Character," 87; Zingg, *Huicholes,* 1:512 and 2:188.

49. Chirimoya: *Annona cherimola.* Zapote refers to various edible fruits, including *Pouteria sapota, Pouteria champechiana, Pouteria viridis,* and *Manikara sapota.*

50. Villela Flores and Glockner, "De Gemelos,"

245–47.

51. On the Chatino episode, see De Cicco y Horcasitas, "Cuates." On the Tlapanec episode, see Van der Loo, *Códices*, 142–43. On the Trique episode, see Hollenbach, "Origen del Sol."

52. On the Tlapanec myth, see Van der Loo, *Códices*, 144. On the Trique myth, see Hollenbach, "Origen del Sol," 131.

53. On the Chatino story, see De Cicco y Horcasitas, "Cuates," 78.

54. Ichon, *Religión de los Totonacas*, 108; Stiles, "Creation," 108–10; Velásquez Gallardo, "Dioses Tarascos," 84; Vega Fallas, "Variantes del Mito," 74–77.

55. Olivier, "Venados Melómanos," 152; De la Garza et al., *Relaciones*, 217. On the Huave accounts, see Millán, *Cuerpo de la Nube*, 161; and Rita, "Concepción y Nacimiento."

56. Quote from Galinier, "Epílogo," 315; Matos Moctezuma, "Tlaltecuhtli"; Báez-Jorge, *Lugar de la Captura*.

57. Boone, "Coatlicues"; Chinchilla Mazariegos, "Where Children Are Born"; Graulich, "Grands Statues," 391; Matos Moctezuma and López Luján, *Escultura*, 223–26; Miller, *Art of Mesoamerica*, 252.

58. Taube, "Birth Vase," 659–60.

59. Carlsen and Prechtel, "Weaving and the Cosmos"; Chinchilla Mazariegos, "Of Birds and Insects"; Klein, "Fighting with Femininity"; Sullivan, "Tlazolteotl-Ixcuina."

60. Taube, "Birth Vase," 661–62; Chinchilla Mazariegos, "Where Children Are Born."

61. Coggins, "Classic Maya Metaphors"; Stuart and Stuart, *Palenque*, and "Arqueología e Interpretación," 175; Martin, "Baby Jaguar."

62. Houston and Stuart, *Way Glyph*, 7; Stuart, "Royal Autosacrifice," 19.

63. Stuart, "Kinship Terms," 7–8; Mathews, *Sculpture of Yaxchilan*, 209.

64. Stuart, "Royal Autosacrifice"; Schele and Miller, *Blood of Kings*. For further discussion of the relation of centipedes with feminine sexuality and childbirth, see Chinchilla Mazariegos, "Where Children Are Born."

65. Stuart, "Ideology," 273, 277; cf. Stuart, "Royal Autosacrifice."

66. Braakhuis, "Xbalanque's Canoe"; Montoliú Villar, "Mito del Origen"; Burkhart, *Slippery Earth*, 88–89; Shaw, *According to Our Ancestors*, 178.

67. Neurath and Gutiérrez, "Mitología y Literatura,"

311. On the Yucatec myth, see Montoliú Villar, "Mito del Origen."

68. Taube, "Birth Vase," 657–58.

6 THE SUN'S OPPONENTS

1. Lizana, *Historia de Yucatán*, 56, 69.

2. Norman, *Izapa Sculpture*, 132.

3. Lowe, "Izapa Religion," 297; Freidel, Schele, and Parker, *Maya Cosmos*, 88; Guernsey, *Ritual and Power*, 111–12; Houston and Inomata, *Classic Maya*, 98.

4. Christenson, *Popol Vuh*, 89–97; Tedlock, *Popol Vuh*, 73–79.

5. Taube et al., *Murals of San Bartolo*, pt. 2, 35–36.

6. Fash, "Dynastic Architectural Programs"; Fash and Fash, "Building a World-View," and "Teotihuacan and the Maya"; Taube, *Major Gods*, 115–19; Coe, "Hero Twins."

7. Chinchilla Mazariegos, "Vagina Dentada."

8. Graulich, *Myths of Ancient Mexico*, 192–99; López Austin, *Human Body*, 293.

9. Bricker, *Humor Ritual*, 112–13; Galinier, "L'Homme Sans Pied"; Klein, "None of the Above," 235.

10. Mendelson, *Escándalos de Maximón*, 128–35; Stanzione, *Rituals of Sacrifice*, 39, 59; Tarn and Prechtel, *Scandals*, 74–83.

11. Braakhuis, "Xbalanque's Marriage," 389; De la Cruz Torres, *Rubelpec*, 63; Mayén, "Análisis Estructural," 133; Thompson, *Ethnology of the Mayas*, 131. On the moon suffering toothache, see King, *Ethnographic Notes*, 35.

12. Montoliú Villar, "Mito del Origen"; Braakhuis, "Xbalanque's Marriage"; Ávila, "Xul-E," 25–27.

13. Braakhuis, "Jaguar Slayer," 144; Guiteras Holmes, *Perils of the Soul*, 337.

14. Bierhorst, *History and Mythology*, 153; Carr and Gingerich, "Vagina Dentata."

15. Bricker, *Humor Ritual*, 115–16; Chinchilla Mazariegos, "Muerte de Moquihuix"; Graulich, "Más sobre la Coyolxauhqui"; Klein, "Fighting with Femininity."

16. Bierhorst, *History and Mythology*, 153; Velásquez, *Códice Chimalpopoca*, 124; Johansson, "Mocihuaquetzqueh."

17. Klein, "None of the Above," 186.

18. Nielsen and Helmke, *Fall of the Great Celestial Bird*; Chinchilla Mazariegos, *Imágenes de la Mitología Maya*, 112–23.

19. Hull and Fergus, "Eagles." On the Mam, see Hostnig and Vásquez Vicente, *Nab'ab'l Qtanam Mam*, 6. On the Jakaltek, see Equipo de Promotores, *Cuentos*, 23–24. On the Poqomam,

see *Ojer Taq Tzijonik,* 71–72. On the Ixil, see Shaw, *According to Our Ancestors,* 118–19.

20. On the Chinantec version, see Bartolomé, *Ciclo Mítico,* 14–15; Portal, *Cuentos y Mitos,* 51–52; Rupp and Rupp, *Ozumacín Chinantec Texts,* 30–32; and Weitlander and Castro, *Usila,* 198–200. On the Cuicatec version, see Bartolomé, *Ciclo Mítico,* 7; and Weitlaner, *Relatos,* 58–59 (Tepescuintle: *Agouti paca*).

21. On the Chatino version, see Bartolomé, *Ciclo Mítico,* 12; and De Cicco and Horcasitas, "Cuates," 77. On the Tlapanec version, see Van der Loo, *Códices,* 141. On the Trique version, see Hollenbach, "Origen del Sol," 142. On Mixtec versions, see Villela Flores and Glockner, "De Gemelos," 245.

22. Miller, *Cuentos Mixes,* 82–83, 92–93. Other versions with a single opponent include Hoogshagen, "Creación del Sol," 344–45; and Lipp, *Mixe of Oaxaca,* 75–76.

23. De Cicco and Horcasitas, "Cuates," 77.

24. Oropeza Escobar, "Mitos Cosmogónicos," 220–21.

25. On the Trique myth, see Hollenbach, "Origen del Sol," 140; and García Alcaraz, *Tinujei,* 295–98. On the Zapotec myth, see Parsons, "Zapoteca and Spanish Tales," 280–81.

26. Villela Flores and Glockner, "De Gemelos," 245–47.

27. Jäcklein, *Pueblo Popoloca,* 276–77; Weitlaner and Castro, *Usila,* 200.

28. Ochoa Peralta, "Aventuras de Dhipaak"; *Relatos Huastecos,* 100–107.

29. Báez-Jorge, *Lugar de la Captura,* 182; Faust, "Cacao Beans," 616.

30. Bierhorst, *History and Mythology,* 151–52; Tena, *Mitos e Historias,* 189. Quote from Molina, *Aqui Comiença,* folio 3, recto: "*Abrojo grande que sale de la tierra. Teocomitl.*"

31. Heyden, "Diosa Madre," 7. On the *teocomitl,* see García Zambrano, "Ancestral Rituals," 198; and López Austin and López Luján, *Monte Sagrado,* 399.

32. Fash and Fash, "Teotihuacan and the Maya." On feathered serpents in Preclassic Maya art, see Saturno, Taube, and Stuart, *Murals of San Bartolo,* pt. 1, 22–23.

33. Taube, "Representaciones del Paraíso," 40–41; Zingg, *Huicholes,* 1:512 and 2:188.

34. Nielsen and Helmke, *Fall of the Great Celestial Bird.*

35. The known examples are (a) Banco Industrial collection, Guatemala, published in Chinchilla Mazariegos, *Imágenes de la Mitología Maya,* 120; (b) Princeton University Museum, catalog number 1998–221A-B; and (c) Los Angeles County Museum of Art, catalog number M.2010.115.1025a-b.

36. Christenson, *Popol Vuh,* 97–98; Tedlock, *Popol Vuh,* 79.

37. Koontz, "Iconographic Interaction"; Matadamas Díaz, "Jaltepetongo"; Taube, "Representaciones del Paraíso"; Urcid, "Ancient Story of Creation."

38. Escobedo et al., "Exploraciones."

39. Zender, "Raccoon Glyph," 9; Thompson, *Maya History and Religion,* 240. According to Marc Zender (personal communication, 2019), the first glyph block (*bahlam*) does not belong here and was placed incorrectly during restoration. The tentative reading *winikil(?)* is suggested by David Stuart (personal communication, 2021).

40. Guernsey, *Ritual and Power;* Bardawil, "Principal Bird Deity"; Cortez, "Principal Bird Deity"; Hellmuth, *Monster und Menschen;* Taube, *Representation of Principal Bird Deity.*

41. Taube et al., *Murals of San Bartolo,* pt. 2, 35–36.

42. Stuart, "Shining Stones," 291.

43. The numbering of Kaminaljuyú sculptures follows Henderson, *Bodies Politic,* 576–87.

44. Hellmuth, *Monster und Menschen,* 365; Bassie-Sweet, *Maya Sacred Geography,* 140; Guernsey, *Ritual and Power,* 100.

45. Taube et al., *Murals of San Bartolo,* pt. 2, 19, 52; Nielsen and Helmke, *Fall of the Great Celestial Bird,* 8.

46. Hellmuth, *Monster und Menschen,* 363; Houston, Stuart, and Taube, *Memory of Bones,* 234–38; Stone and Zender, *Reading Maya Art,* 47. For an alternative reading, see Boot, "At the Court."

47. Guernsey, "Beyond the 'Myth or Politics' Debate."

48. Taube et al., *Murals of San Bartolo,* pt. 2, 33.

7 THE SUN

1. Díaz de Salas, *San Bartolomé de los Llanos,* 156, 164.

2. Díaz de Salas, "Notas," 260.

3. Coe, *Lords of the Underworld,* 58–60, and "Hero Twins."

4. Díaz de Salas, *San Bartolomé de los Llanos,* 167–68; Rubel, "Two Tzotzil Tales."

5. Atienza de Frutos, "Hunahpu, Ixbalanqué y Xut"; Cruz Coutiño, "Integración de Secuencias," 251–74; Gómez Ramírez, *Ofrenda de los Ancestros,* 40–53; Guiteras Holmes, *Perils of the Soul,* 183–86; Hermitte, *Poder Sobrenatural,* 23–25;

Mondragón, Tello, and Valdez, *Relatos Tzotziles*, 53–57; *Relatos Tzeltales y Tzotziles*, 101–15; Slocum, "Origin of Corn"; Whittaker and Warkentin, *Chol Texts*, 13–61. For the Q'anjob'al, see La Farge, *Santa Eulalia*, 50–56.

6. Ara, *Vocabulario de Lengua Tzeldal*, 418–19; Laughlin, *Great Tzotzil Dictionary*, 1:304–5.

7. Atienza de Frutos, "Hunahpu, Ixbalanqué y Xut," 269 (jigger [nigua]: *Tunga penetrans*).

8. Paul, "Symbolic Sibling Rivalry."

9. On the Kaqchikel myths, see Redfield, "Notes on San Antonio Palopó," 253. On the Tz'utujil myths, see Prechtel, *Grandmother Sweat Bath*, 31–37. On the Q'eqchi' myths, see Grandia, *Stories*, 6; and Thompson, *Ethnology of the Mayas*, 122–23.

10. Tedlock, *Popol Vuh*, 104–8; Christenson, *Popol Vuh*, 142–47.

11. Las Casas, *Apologética Historia Sumaria*, 3:1456–57. In earlier editions of the Apologética Historia, the name of Hunahau was misspelled as "Hunahan." Examination of high resolution images from Las Casas's manuscript, kindly provided by the Royal Academy of History, Madrid, shows that the spelling is compatible with "Hunahau" (see p. 30); cf. Braakhuis, "Artificers of the Days," 31.

12. Coe, "Supernatural Patrons"; Beliaev and Davletshin, "It Was Then."

13. Guiteras Holmes, *Perils of the Soul*, 186; Gómez Ramírez, *Ofrenda de los Ancestros*, 47; Mondragón, Tello, and Valdez, *Relatos Tzotziles*, 54–57.

14. Christenson, *Popol Vuh*, 150. In Tedlock's translation: "Gardening is not your job, but there is something that is" (*Popol Vuh*, 111).

15. Grandia, *Stories*, 5; Thompson, *Ethnology of the Mayas*, 120.

16. López García, "Restricciones Culturales," 2:16; cf. Hull, "Grand Ch'orti' Epic," 134.

17. Incháustegui, *Relatos del Mundo Mágico*, 29. The bird messenger reappears in Chinantec myths; see Bartolomé, *Ciclo Mítico*, 13.

18. Coe, "Hero Twins"; Guernsey, *Ritual and Power*, 111; Nielsen and Helmke, *Fall of the Great Celestial Bird*; Taube, *Representation of Principal Bird Deity*.

19. Bassie-Sweet, *Maya Sacred Geography*, 140–41; Zender, "Raccoon Glyph"; cf. Houston, Stuart, and Taube, *Memory of Bones*, 229–50.

20. Lumholtz, *Unknown Mexico*, 107–8; McIntosh, "Cosmogonía Huichol"; Mondragón, Tello, and Valdez, *Relatos Huicholes*, 11; Neurath and

21. Gutiérrez, "Mitología y Literatura," 308–9. Hermitte, *Poder Sobrenatural*, 25; *Relatos Tzeltales y Tzotziles*, 115; Slocum, "Origin of Corn," 17; Whittaker and Warkentin, *Chol Texts*, 38–39. For the Q'eqchi' myth, see Thompson, *Ethnology of the Mayas*, 132.

22. Montoliú Villar, *Cuando los Dioses Despertaron*, 82.

23. On the Mixe myths, see Hoogshagen, "Creación del Sol"; and Miller, *Cuentos Mixes*, 79–97. On the Chinantec myths, see Bartolomé, *Ciclo Mítico*, 13–16; Rupp and Rupp, *Ozumacín Chinantec Texts*, 21–43; and Weitlaner and Castro, *Usila*, 197–202. On the Zapotec myths, see Parsons, "Zapoteca and Spanish Tales"; and Stubblefield and Stubblefield, "Story of Läy and Gisaj."

24. On the Chatino myths, see Bartolomé, *Ciclo Mítico*, 10–12; and De Cicco and Horcasitas, "Cuates." On the Mixtec myths, see Dyk, *Mixteco Texts*, 10–16; Villela Flores and Glockner, "De Gemelos." On the Trique myths, see Hollenbach, "Origen del Sol"; Bartolomé, *Ciclo Mítico*, 17–21; and García Alcaraz, *Tinujei*, 295–98. On the Tlapanec myths, see Van der Loo, *Códices*, 138–44.

25. De Cicco and Horcasitas, "Cuates," 78–79.

26. Lupo, "Sol en Jerusalén." A related Nahua version appears in Barlow and Ramírez, "Tonatiw Iwan Meetstli."

27. Galinier, *Mitad del Mundo*, 693–99.

28. Ichon, *Religión de los Totonacas*, 63–67.

29. Münch Galindo, "Acercamiento al Mito"; Oropeza Escobar, "Mitos Cosmogónicos," 202–8.

30. Ariel de Vidas, *Thunder*, 139.

31. Sahagún, *Florentine Codex*, book 7, 3–4.

32. Quote from Ruiz de Alarcón, *Treatise*, 71; Molina, *Vocabulario*, 22; Powell and Cook, *Myth of Syphilis*.

33. Sahagún, *Florentine Codex*, book 7, 5–6; Tena, *Mitos e Historias*, 182–85; cf. Bierhorst, *History and Mythology*, 148–49.

34. Sahagún, *Florentine Codex*, book 7, 7; Bierhorst, *History and Mythology*, 149; Seler, "Wall Sculptures," 269.

35. Tedlock, *Popol Vuh*, 125–29; Christenson, *Popol Vuh*, 175–76.

36. Incháustegui, *Relatos*, 27–34; Weitlaner Johnson and Basset Johnson, "Mito y los Mazatecas."

37. Thompson, *Maya Hieroglyphic Writing*, 218; Milbrath, *Star Gods*, 96–97; Tedlock, *Popol Vuh*, 287; Van Akkeren, *Xib'alb'a*, 122–23.

38. Christenson, *Popol Vuh*, 179; cf. Tedlock, *Popol*

Vuh, 131: "Then they faced each other. They grabbed each other by the hands and went head first into the oven."

39. Carmack and Mondloch, *Título de Totonicapán*, 174, 213–14n74.

40. Van Akkeren, "Authors of the Popol Vuh," 247–48; Christenson, *Popol Vuh*, 256–59; Tedlock, *Popol Vuh*, 179–80.

41. Carmack and Mondloch, *Título de Totonicapán*, 181.

42. Van Akkeren, "Authors of the Popol Vuh," 247–48.

43. Coe, *Lords of the Underworld*, 58.

44. Ibid., 83; Coe, "Hero Twins"; Taube, "Classic Maya Maize God."

45. Miller and Martin, *Courtly Art*, 56; cf. Bassie-Sweet, *Maya Sacred Geography*, 158, 219–20; Carrasco, "From Field to Hearth," 621; Freidel, Schele, and Parker, *Maya Cosmos*; Looper, *To Be Like Gods*, 115; Vail and Hernández, *Re-Creating Primordial Time*, 65; Stone and Zender, *Reading Maya Art*, 45.

46. Braakhuis, "Bitter Flour," and "Tonsured Maize God"; Chinchilla Mazariegos, *Imágenes de la Mitología Maya*.

47. López Austin, *Myths of the Opossum*, and "Núcleo Duro"; Taube, *Major Gods*, 112–19.

48. Fields, "Iconographic Heritage"; Schele and Miller, *Blood of Kings*, 112; Stuart, "Royal Headband."

49. Coe, "Hero Twins"; Mathews and Justeson, "Patterns of Sign Substitution," 208–9; Taube, *Major Gods*, 115.

50. Stuart, "Name of Paper," 121. For Poqomchi' day names, see Thompson, *Maya Hieroglyphic Writing*, 68.

51. López Austin, "Cuando Cristo Andaba de Milagros."

52. Coe, "Hero Twins."

53. Ibid.; Freidel, Schele, and Parker, *Maya Cosmos*, 367–68; Stone, *Images from the Underworld*, 148–51.

54. Kowalski, *Mythological Identity*, 17.

55. Bierhorst, *History and Mythology*, 29–30, 147 (quote); Sahagún, *Florentine Codex*, book 3, 14.

56. Quote from Coe, *Maya Scribe*, 83; Taube, *Major Gods*, 11, 116; Chinchilla Mazariegos, *Imágenes de la Mitología Maya*, 133–39.

57. Coe, *Maya Scribe*, 13–14, 83.

58. Schele and Freidel, *Forest of Kings*, 465–66n81; Miller and Martin, *Courtly Art*, 281n13.

59. Zender, "On the Reading"; also Boot, "Maya Ball Game," 166.

60. Taube, *Major Gods*, 61–63.

61. Taube, "Ancient and Contemporary," 472; Chinchilla Mazariegos, *Imágenes de la Mitología Maya*, 105; Guernsey, "Beyond the 'Myth or Politics' Debate."

62. Taube, *Major Gods*, 60–64; Thompson, *Ethnology of the Mayas*, 124–25.

63. Slocum, "Origin of Corn," 15–18; *Relatos Tzeltales y Tzotziles*, 112; Tedlock, *Popol Vuh*, 110–11; Christenson, *Popol Vuh*, 150.

64. Christenson, *Popol Vuh*, 95.

65. Las Casas, *Apologética Historia Sumaria*, 2:884; Kockelman, "Meaning and Time."

66. Milbrath, *Star Gods*, 130–35.

8 THE PERFECT YOUTH

1. Lopez García, "Restricciones Culturales," 2:12. Spanish: "*Dios sangró para alegrar el mundo; regó la sangre en la Cruz para grano de todos nosotros*" and "*Ya no era sangre era maíz, era grano de maíz; frijol también, maíz y 'pisto' también.*"

2. For the K'iche' myth, see Tax, "Folk Tales," 127. For the Tepehua myth, see Williams García, *Mitos Tepehuas*, 68. On the Histoire du Mechique, see Tena, *Mitos e Historias*, 155.

3. Tedlock, *Popol Vuh*, 65; cf. Christenson, *Popol Vuh*, 71.

4. Lopez García "Restricciones Culturales," 2:12; Girard, *Mayas Eternos*, 225–26. Spanish: "*Cuando derramó su sangre al pie del árbol de la cruz, entonces bajó el milagro (lluvias, maíz). No llovía antes, el dió el invierno. Ellos mismos (los malos hombres) le enterraron después de matarlo. El Señor con su Poder revivió. De allí nació el Niño (maicito). En la otra vuelta éste es el que reina. Al revivir levantó una plantación. . . . El hijo del Señor . . . mató a todos los hombres malos y estos se fueron al infierno.*"

5. Girard, *Mayas Eternos*, 226.

6. Ibid., 155–62; Sandstrom, "Nene Lloroso"; Braakhuis and Hull, "Pluvial Aspects"; on the destiny of the drowned, see Sahagún, *Florentine Codex*, book 3, 47; and López Austin, *Tamoanchan, Tlalocan*, 216–17, and *Human Body*, 335.

7. See Chapter 5. López García, "Restricciones Culturales," 2:15–22, and *Kumix*, 20–55. Other versions can be found in *Ojer Taq Tzijonik*, 26–30; Dary, *Estudio Antropológico*, 263–69; Fought, "Kumix"; Girard, *Mayas Eternos*, 226–27; Hull, "Grand Ch'orti' Epic"; Metz, *Ch'orti' Maya Survival*, 105–6; and Pérez Martínez, *Leyenda*

Maya Ch'orti', 46–48.

8. Metz, *Ch'orti' Maya Survival,* 105–6; López García, "Restricciones Culturales."

9. Hull, "Grand Ch'orti' Epic," 138.

10. Van 't Hooft and Cerda Zepeda, *Lo que Relatan de Antes,* 41–55; cf. Greco, "Naissance du Maïs."

11. Blanco Rosas, "Erosión de la Agrodiversidad," 68–76; Elson, "Homshuk"; Foster, *Sierra Popoluca,* 191–96; Münch Galindo, *Etnología del Istmo Veracruzano,* 163–69.

12. Foster, *Sierra Popoluca,* 193.

13. Hull, "Grand Ch'orti' Epic," 134; Elson, "Homshuk," 197.

14. Girard, *Mayas Eternos,* 226; Hull, "Grand Ch'orti' Epic," 139; López García, *Kumix,* 43; Braakhuis and Hull, "Pluvial Aspects."

15. *Cuerpos de Maíz,* 177; Greco, "Naissance du Maïs"; Ichon, *Religión de los Totonacas,* 73–86; Williams García, *Mitos Tepehuas,* 87–92.

16. Girard, *Maya Eternos,* 226.

17. *Cuerpos de Maíz,* 153–57; Kelly, "World View," 395–96; Münch Galindo, "Acercamiento al Mito."

18. Foster, *Sierra Popoluca,* 195; Ichon, *Religión de los Totonacas,* 86–91; Girard, *Mayas Eternos,* 226–27.

19. Tedlock, *Popol Vuh,* 93; cf. Christenson, *Popol Vuh,* 117.

20. Williams García, *Mitos Tepehuas,* 89.

21. Ibid.; Tedlock, *Popol Vuh,* 138; Christenson, *Popol Vuh,* 186. For the Ch'orti' versions, see Fought, "Kumix," 465; Hull, "Grand Ch'orti' Epic," 137; López García, "Restricciones Culturales," 2:21.

22. Tedlock, *Popol Vuh,* 119–27; Christenson, *Popol Vuh,* 163–74. On Popoluca versions, see Foster, *Sierra Popoluca,* 195; and Münch Galindo, *Etnología del Istmo Veracruzano,* 167. On the Nahua version, see González Cruz and Anguiano, "Historia de Tamakastsiin," 223.

23. Christenson, *Popol Vuh,* 177–78; cf. Tedlock, *Popol Vuh,* 130.

24. Carlsen and Prechtel, "Flowering of the Dead," 32.

25. Braakhuis, "Bitter Flour," 128. On the Totonac version, see Oropeza Escobar, "Mitos Cosmogónicos," 208–9. On the Ch'orti' version, see Girard, *Mayas Eternos,* 226.

26. Christenson, *Popol Vuh,* 137; Tedlock, *Popol Vuh,* 103.

27. Guiteras Holmes, *Perils of the Soul,* 192–93; cf. Gossen, *Four Creations,* 348–73.

28. Furst, "Maiden Who Ground Herself"; Neurath and Gutiérrez, "Mitología y Literatura," 322–26.

29. On the Q'eqchi' myth, see Thompson, *Ethnology of the Mayas,* 132–34. On the Poqomchi', see Búcaro Moraga, "Leyendas de los Pueblos Indígenas," 69–72; Mayers, *Pocomchi Texts,* 3–11; Schumann, "Origen del Maíz"; and Shaw, *According to Our Ancestors,* 207–9.

30. Christenson, *Popol Vuh,* 193–95; Tedlock, *Popol Vuh,* 145–46.

31. Báez-Jorge, "Cosmovisión"; Bierhorst, *History and Mythology,* 147; Búcaro Moraga, "Leyendas de los Pueblos Indígenas"; Ko7w et al., "El Descubrimiento del Maíz"; Navarrete, *Relatos Mayas;* Sandstrom and Gómez Martínez, "Petición a Chicomexóchitl"; Van 't Hooft and Cerda Zepeda, *Lo que Relatan de Antes,* 67–79.

32. Quote from Schellhas, *Representations of Deities,* 24; Spinden, *Study of Maya Art,* 88–89.

33. Taube, "Classic Maya Maize God," *Major Gods,* 41–50, "Olmec Maize God," "Symbolism of Jade," and "Maya Maize God"; Fields, "Iconographic Heritage"; Pérez Suárez, "Olmecas"; Saturno, Taube, and Stuart, *Murals of San Bartolo,* pt. 1; Joralemon, *Study of Olmec Iconography.*

34. Miller and Martin, *Courtly Art,* 52; Schellhas, *Representations of Deities,* 24; Tiesler, *Bioarchaeology,* 227–28.

35. Taube, "Classic Maya Maize God," and "Olmec Maize God," 59–62; Saturno, Taube, and Stuart, *Murals of San Bartolo,* pt. 1, 25–31.

36. Stuart, "Language of Chocolate," 197.

37. Looper, "Women-Men," 178; Miller, "Notes on a Stela Pair"; Miller and Martin, *Courtly Art,* 97. On the mecaayatl, see Aguilera, "Of Royal Mantles"; Chinchilla Mazariegos, *Imágenes de la Mitología Maya,* 92.

38. Taube, "Symbolism of Jade," and "Maya Maize God"; Martin, "Cacao in Ancient Maya Religion."

39. Taube, "Maya Maize God"; Looper, *To Be Like Gods,* 114–25.

40. Williams García, *Mitos Tepehuas,* 89.

41. Tedlock, *Popol Vuh,* 91; Christenson, *Popol Vuh,* 154. On music and the Classic Maya ball game, see Stöckli, "Trumpets."

42. Boot, "Annotated Overview"; Houston, Stuart, and Taube, "Image and Text"; Reents-Budet, "Holmul Dancer."

43. Saturno, Taube, and Stuart, *Murals of San Bartolo,* pt. 1, 34.

44. Bierhorst, *History and Mythology,* 151–52; Neurath and Gutiérrez, "Mitología y Literatura," 310–12. On sexuality, see López Austin, *Cuerpo Humano,* 293–96, and *Tamoanchan,* 204–5; Burkhart, *Slippery Earth,* 87–98; Sigal, *Flower and the*

Scorpion.

45. Graulich, *Myths of Ancient Mexico,* 178–79; Christenson, *Popol Vuh,* 240–44; Tedlock, *Popol Vuh,* 166–69.

46. Christenson, *Popol Vuh,* 241; Tedlock, *Popol Vuh,* 310.

47. Grube, "Akan," 70; Lounsbury, "Inscription"; Stuart, "Fire Enters His House," 388.

48. Grube and Gaida, *Die Maya,* 117–31; Taube, "Flower Mountain," 79–82.

49. See Chapter 4.

50. Taube, *Major Gods,* 64–69; Looper, "Women-Men," 177–84; Milbrath, *Star Gods,* 135–38; Schele and Miller, *Blood of Kings,* 309; Chinchilla Mazariegos, *Imágenes de la Mitología Maya,* 199–203; Zender and Skidmore, "Unearthing the Heavens," 9.

51. Woodfill, Guenter, and Monterroso, "Changing Patterns."

52. Schele and Miller, *Blood of Kings,* 272–73; Stuart, "Sourcebook," 99. On the Maize God's name glyph, see Zender, "On the Reading."

53. Hellmuth, *Monster und Menschen,* 160–65; Taube, "Water Lily Serpent"; Robertson, "Celestial God."

54. See Chapter 2.

55. Chinchilla Mazariegos, "Cosmos and Warfare," and *Imágenes de la Mitología,* 222–26; Milbrath, *Star Gods,* 73; Stuart, "On the Paired Variants"; Webster et al., "Skyband Group."

56. Chinchilla Mazariegos, *Imágenes de la Mitología Maya,* 199–203.

57. Quenon and Le Fort, "Rebirth and Resurrection."

58. Schele and Miller, *Blood of Kings,* 270–71; Trik, "Splendid Tomb."

59. Mathews, "Notes on the Inscription"; Velásquez, "Dioses Remeros."

60. Stuart, "Language of Chocolate"; Taube, "Classic Maya Maize God," 177.

61. Quenon and Le Fort, "Rebirth and Resurrection," 886–87.

62. Miller and Martin, *Courtly Art,* 97.

63. Hellmuth, *Monster und Menschen,* 191; Houston, "Living Waters," 74; Stone and Zender, *Reading Maya Art,* 173; Stuart, *Inscriptions from Temple XIX,* 151; Carrasco, "From Field to Hearth," 617 (water lily: *Nymphae* spp).

64. Miller and Taube, *Gods and Symbols,* 184.

65. Braakhuis, "Bitter Flour," "Tonsured Maize God," and "Challenging the Lightnings."

66. Braakhuis, "Bitter Flour," 129; Ichon, *Religión de los Totonacas,* 74–75. On the Tepehua myth, see Williams García, *Mitos Tepehuas,* 88. On the Nahua myth, see Van 't Hooft and Cerda Zepeda, *Lo que Relatan de Antes,* 47; and Greco, "Naissance du Maïs."

67. On the Popoluca myth, see Blanco Rosas, "Erosión de la Agrodiversidad," 72–73; and Foster, *Sierra Popoluca,* 193. On the Nahua myth, see González Cruz and Anguiano, "Historia de Tamakastsiin," 221.

68. Zender, "Teasing the Turtle," 10.

69. Taube, *Major Gods,* 22; Saturno, Taube, and Stuart, *Murals of San Bartolo,* pt. 1, 34.

70. Taube et al., *Murals of San Bartolo,* pt. 2, 72–73, 81–83.

71. Braakhuis, "Challenging the Lightnings."

72. Taube, "Teotihuacan Cave of Origin," 57; Freidel, Schele, and Parker, *Maya Cosmos,* 283–84.

73. Braakhuis, "Tonsured Maize God," 8; Sandstrom and Gómez Martínez, "Petición a Chicomexóchitl," 345; cf. Segre, *Metamorfosis de lo Sagrado,* 174. On the Teenek narrative, see Alcorn, *Huastec Maya Ethnobotany,* 62; and Alcorn, Edmonson, and Hernández Vidales, "Thipaak and the Origins of Maize," 603.

74. Freidel, Schele, and Parker, *Maya Cosmos,* 281–84; Miller and Martin, *Courtly Art,* 56–57; Stross, "Maize in Word and Image," 589; Taube, "Classic Maya Maize God," 175; Zender, "Teasing the Turtle."

9 THE FATHER

1. Guiteras Holmes, *Perils of the Soul,* 187–88.

2. On the Mixe myth, see Miller, *Cuentos Mixes,* 75. On the Nahua myth, see Greco, "Naissance du Maïs"; Law, "Tamakasti," 345; and Olguín, "Cómo Nació Chicomexóchitl," 121. On the Teenek myth, see Alcorn, Edmonson, and Hernández Vidales, "Thipaak and the Origins of Maize," 601; Ochoa Peralta, "Aventuras de Dhipaak"; and Van 't Hooft and Cerda Zepeda, *Lo que Relatan de Antes,* 35.

3. On the Popoluca myth, see Blanco Rosas, "Erosión de la Agrodiversidad," 68. On the Totonac myth, see Ichon, *Religión de los Totonacas,* 73–74. On the Tepehua myth, see Williams García, *Mitos Tepehuas,* 87.

4. Tedlock, *Popol Vuh,* 91; Christenson, *Popol Vuh,* 112.

5. Alcalá, *Relación,* 243; Bierhorst, *History and Mythology,* 154–55; Graulich, "Mitos Mexicanos," 315.

6. Tedlock, *Popol Vuh,* 141; Christenson, *Popol Vuh,* 190–91.

7. Tedlock, *Popol Vuh,* 286.

8. Freidel, Schele, and Parker, *Maya Cosmos*, 65. Echoing this view, both Christenson (*Popol Vuh*, 190) and Tedlock (*Popol Vuh*, 140) illustrated this passage in their respective editions of the Popol Vuh with drawings of Classic Maya plate K1892 (see fig. 127).

9. Chevalier and Buckles, *Land without Gods*, 318; García de León, *Pajapan*, 84.

10. On the Popoluca myth, see Técnicos Bilingües, *Agua, Mundo, Montaña*, 23; Blanco Rosas, "Erosión de la Agrodiversidad," 75–76; and Elson, "Homshuk," 213–14. On the Nahua myth, see González Cruz and Anguiano, "Historia de Tamakastsiin," 223–25; and Segre, *Metamorfosis de lo Sagrado*.

11. López Austin, "Homshuk."

12. Las Casas, *Apologética Historia Sumaria*, 2:884. Spanish: "*Déste cuentan, entre otras fábulas, que fue a hacer guerra al infierno y peleó con toda la gente de allá y los venció y prendió al rey del infierno y a muchos de su ejército. El cual, vuelto al mundo con su victoria y la presa, rogóle el rey del infierno que no le sacase porque estaba ya tres o cuatro grados de la luz, y el vencedor Exbalanquén, con mucha ira, le dio una coce, diciéndole: Vuélvete y sea para tí todo lo podrido y desechado y hidiondo.*"

13. López García, "Restricciones Culturales," 2:21–22.

14. Bierhorst, *History and Mythology*, 145–46. On the Purépecha myth, see Alcalá, *Relación*, 243.

15. On the Tepehua myth, see Williams García, *Mitos Tepehuas*, 91. On the Totonac myth, see Ichon, *Religión de los Totonacas*, 75–76.

16. Olivier, *Cacería, Sacrificio y Poder*, 268–77, 302–6; Braakhuis, "Way of All Flesh."

17. Ruíz de Alarcón, *Treatise*, 105–6, 206; Dehouve, "Ritual de Cacería"; Olivier, "Venados Melómanos," 133–34.

18. Christenson, *Popol Vuh*, 76–77; Tedlock, *Popol Vuh*, 67–68; Olivier, *Cacería, Sacrificio y Poder*, 144.

19. Coe, "Hero Twins," 175–76; Vargas de la Peña and Castillo Borges, "Pintura Mural Prehispánica," 409.

20. Stone, *Images from the Underworld*, 15–18; Taube, "Ancient and Contemporary Contemporary."

21. Stone, *Images from the Underworld*, 15–18.

22. Chinchilla Mazariegos, "Painted Vessel"; Coe, "Hero Twins," 175.

23. Elson, "Homshuk," 206–7; Pohl, "Ritual Continuity."

24. Chinchilla Mazariegos, *Imágenes de la Mitología Maya*, 158–59.

25. Ibid., 152–55, 172–77.

26. Coe, "Hero Twins," 175–76.

27. López García, "Restricciones Culturales," 2:13.

28. Van 't Hooft and Cerda Zepeda, *Lo que Relatan de Antes*, 50–51.

29. Taube, *Major Gods*, 115–19; Landa, *Relación de las Cosas*, 60.

EPILOGUE

1. Christenson, *Popol Vuh*, 70–71; Tedlock, *Popol Vuh*, 65.

2. Coe, *Maya Scribe*, and *Lords of the Underworld*.

BIBLIOGRAPHY

Acuña, René, ed. *Relaciones Geográficas del Siglo XVI: Tlaxcala, Tomo 1.* Mexico City: Universidad Nacional Autónoma de México, 1984.

———. *Temas del Popol Vuh.* Mexico City: Universidad Nacional Autónoma de México, 1998.

———. "La Theologia Indorum de fray Domingo de Vico." *Tlalocan* 10 (1985): 281–307.

———. "La Theologia Indorum de Vico en Lengua Quiché." *Estudios de Cultura Maya* 24 (2004): 17–45.

Aguilera, Carmen. "Of Royal Mantles and Blue Turquoise: The Meaning of the Mexica Emperor's Mantle." *Latin American Antiquity* 8 (1997): 3–19.

Aguirre Beltrán, Gonzalo. *Medicina y Magia: El Proceso de Aculturación en la Estructura Colonial.* Mexico City: Instituto Nacional Indigenista, 1963.

Ajpacajá Tum, Pedro Florentino. *Diccionario K'iche'.* Guatemala City: Cholsamaj, 1996.

Alcalá, Jerónimo de. *Relación de Michoacán.* Zamora, Michoacán, Mexico: Colegio de Michoacán, 2008.

Alcina Franch, José, Andrés Ciudad Ruiz, and María Josefa Iglesias Ponce de León. "El Temazcal en Mesoamérica: Evolución, Forma y Función." *Revista Española de Antropología Americana* 10 (1980): 93–132.

Alcorn, Janis B. *Huastec Maya Ethnobotany.* Austin: University of Texas Press, 1984.

Alcorn, Janis B., Barbara Edmonson, and Cándido Hernández Vidales. "Thipaak and the Origins of Maize in Northern Mesoamerica." In *Histories of Maize: Multidisciplinary Approaches to the Prehistory, Linguistics, Biogeography, Domestication, and Evolution of Maize,* edited by John Staller, Robert Tykot, and Bruce Benz, 599–609. Walnut Creek, Calif.: Left Coast, 2006.

Anderson, Arthur J. O., and Susan Schroeder. *Codex Chimalpahin.* Vol. 1. Norman: University of Oklahoma Press, 1997.

Ara, Domingo de. *Vocabulario de Lengua Tzeldal según el Orden de Copanabastla.* Edited by Mario Humberto Ruz. Mexico City: Universidad Nacional Autónoma de México, 1986.

Ardren, Traci. "Mending the Past: Ix Chel and the Invention of a Modern Pop Goddess." *Antiquity* 80 (2006): 25–37.

Arias, Jacinto. *San Pedro Chenalhó: Algo de su Historia, Cuentos y Costumbres.* Tuxtla Gutiérrez, Chiapas, Mexico: Instituto Chiapaneco de Cultura, 1990.

Ariel de Vidas, Anath. *Thunder Doesn't Live Here Anymore: The Culture of Marginality among the Teeneks of Tantoyuca.* Boulder: University Press of Colorado, 2004.

———. "What Makes a Place Ethnic? The Formal and Symbolic Spatial Manifestations of Teenek Identity (Mexico)." *Anthropological Quarterly* 81 (2008): 161–205.

Arts Mayas du Guatemala. Paris: Ministère d'État Affaires Culturelles, Reunion des Musées Nationaux, 1968.

Atienza de Frutos, Miguel. "Hunahpu, Ixbalanqué y Xut: Análisis de la Estructura de un Mito Tzeltal en el Tiempo." *Revista Española de Antropología Americana* 33 (2003): 253–76.

Ávila, César Augusto. "'El Xul-E'. Creencias Populares sobre la Etiología de la Caries y del Dolor Dental en Grupos de Indígenas Kekchies." *Guatemala Indígena* 12, nos. 1–2 (1977): 4–51.

Báez-Jorge, Félix. "La Cosmovisión de los Zoques de Chiapas (Reflexiones sobre su Pasado y Presente)." In *Antropología e Historia de los Mixe-Zoques y Mayas. Homenaje a Frans Blom,* edited by Lorenzo Ochoa and Thomas A. Lee, Jr., 383–412. Mexico City: Universidad Nacional Autónoma de México/ Brigham Young University, 1983.

———. "Kauymáli y las Vaginas Dentadas (Aproximación a la Mitología Huichola desde la

Perspectiva de Un Héroe Civilizatorio)." *La Palabra y el Hombre: Revista de la Universidad Veracruzana* 100 (1996): 101–19.

———. *El Lugar de la Captura (Simbolismo de la Vagina Telúrica en la Cosmovisión Mesoamericana).* Jalapa, Mexico: Gobierno del Estado de Veracruz, 2008.

———. "Las Seductoras Macabras (Imágenes Numinosas de la Sexualidad Femenina en Mesoamérica)." *La Palabra y el Hombre: Revista de la Universidad Veracruzana* 73 (1990): 5–28.

Bardawil, Lawrence W. "The Principal Bird Deity in Maya Art: An Iconographic Study of Form and Meaning." In *Segunda Mesa Redonda de Palenque: The Art, Iconography, and Dynastic History of Palenque,* pt. 3, edited by Merle Greene Robertson, 195–209. Pebble Beach, Calif.: Robert Louis Stevenson School, 1976.

Barlow, Robert H., and Valentín Ramírez. "Tonatiw Iwan Meetstli: El Sol y la Luna." *Tlalocan* 4, no. 1 (1962): 55–57.

Barón Larios, José. *Tradiciones, Cuentos, Ritos y Creencias Nahuas.* Pachuca, Mexico: Gobierno del Estado de Hidalgo/Consejo Estatal para la Cultura y las Artes de Hidalgo, 1994.

Bartolomé, Miguel Alberto. *El Ciclo Mítico de los Gemelos Sol y Luna en las Tradiciones de las Culturas Oaxaqueñas.* Oaxaca, Mexico: Instituto Nacional de Antropología e Historia, Centro Regional de Oaxaca, 1984.

Bartolomé, Miguel Alberto, and Alicia M. Barabas. *Tierra de la Palabra: Historia y Etnografía de los Chatinos de Oaxaca.* Oaxaca, Mexico: Instituto Oaxaqueño de las Culturas/Instituto Nacional de Antropología e Historia, 1996.

Basseta, Domingo de. *Vocabulario de Lengua Quiché.* Edited by René Acuña. Mexico City: Universidad Nacional Autónoma de México, 2005.

Bassie-Sweet, Karen. *From the Mouth of the Dark Cave: Commemorative Sculpture of the Late Classic Maya.* Norman: University of Oklahoma Press, 1991.

———. *Maya Sacred Geography and the Creator Deities.* Norman: University of Oklahoma Press, 2008.

Becker, Marshall J. "Earth Offerings among the Classic Period Lowland Maya: Burial and Caches as Ritual Deposits." In *Perspectivas Antropológicas en el Mundo Maya,* edited by María Josefa Iglesias Ponce de León and Francesc Ligorred Perramón, 45–74. Madrid: Sociedad Española de Estudios Mayas, 1993.

Beliaev, Dmitri, and Albert Davletshin. "'It Was Then That That Which Had Been Clay Turned into a Man': Reconstructing Maya Anthropogenic Myths." *Axis Mundi: Journal of the Slovak Association for the Study of Religions* 1 (2014): 2–12.

———. "Los Sujetos Novelísticos y las Palabras Obscenas: Los Mitos, los Cuentos y las Anécdotas en los Textos Mayas sobre la Céramica del Período Clásico." In *Sacred Books, Sacred Languages: Two Thousand Years of Ritual and Religious Maya Literature,* Acta Mesoamericana 18, edited by Rogelio Valencia Rivera and Geneviève Le Fort, 21–44. Markt Schwaben, Germany: Anton Saurwein, 2006.

Benson, Elizabeth P. "In Love and War: Hummingbird Lore." In *"In Love and War: Hummingbird Lore" and Other Selected Papers from LAILA/ALILA's 1988 Symposium,* edited by Mary H. Preuss, 3–8. Culver City, Calif.: Labyrinthos, 1989.

Berlin, Heinrich. "The Palenque Triad." *Journal de la Societé des Américanistes* 52 (1963): 91–99.

Berlo, Janet C. "Conceptual Categories for the Study of Texts and Images in Mesoamerica." In *Text and Image in Pre-Columbian Art: Essays in the Interrelationship of the Verbal and Visual Arts,* edited by Janet C. Berlo, 1–39. Oxford: BAR International Series, 1983.

Bierhorst, John, ed. *History and Mythology of the Aztecs: The Codex Chimalpopoca.* Tucson: University of Arizona Press, 1992.

Blanco Rosas, José Luis. "Erosión de la Agrodiversidad en la Milpa de los Zoque Popoluca de Soteapan: Xutuchincon y Aktevet." PhD diss., Universidad Iberoamericana, Mexico, 2006. http://www.bib. uia.mx/tesis/pdf/014791.

Boone, Elizabeth. "Aztec Pictorial Histories: Records without Words." In *Writing without Words: Alternative Literacies in Mesoamerica and the Andes,* edited by Elizabeth Hill Boone and Walter Mignolo, 50–76. Durham, N.C.: Duke University Press, 1994.

———. "The 'Coatlicues' at the Templo Mayor." *Ancient Mesoamerica* 10 (1999): 189–206.

———. *Stories in Red and Black: Pictorial Histories of the Aztecs and Mixtecs.* Austin: University of Texas Press, 2000.

———. "A Web of Understanding: Pictorial Codices and the Shared Intellectual Culture of Late Postclassic Mesoamerica." In *The Postclassic Mesoamerican World,* edited by Michael E. Smith and Frances Berdan, 207–21. Salt Lake City: University of Utah Press, 2003.

Boot, Erik. "An Annotated Overview of 'Tikal Dancer Plates.'" Mesoweb, 2003. http://www.mesoweb. com/features/boot/TIkalDancerPlates.pdf.

———. "At the Court of Itzam Nah Yax Kokaj Mut: Preliminary Iconographic and Epigraphic Analysis of a Late Classic Vessel." Maya Vase Database, 2008. http://www.mayavase.com/God-D-Court-Vessel.pdf.

———. "The Maya Ball Game and the Maize God: Notes on the Codex Style Ballgame Vessel in the Collection of the Museum of Ethnology, Leiden, the Netherlands." In *A Celebration of the Life and Work of Pierre Robert Colas*, edited by Christophe Helmke and Frauke Sachse, 163–73. Markt Schwaben, Germany: Anton Saurwein, 2014.

Boremanse, Didier. *Cuentos y Mitología de los Lacandones: Contribución al Estudio de la Tradición Oral Maya.* Guatemala City: Academia de Geografía e Historia de Guatemala, 2006.

Braakhuis, Edwin, and Kerry Hull. "Pluvial Aspects of the Mesoamerican Culture Hero." *Anthropos* 109, no. 2 (2014): 449–66.

Braakhuis, H. E. M. "Artificers of the Days: Functions of the Howler Monkey Gods among the Mayas." *Bijdragen tot de Taal-, Land- en Volkenkunde* 143, no. 1 (1987): 25–53.

———. "The Bitter Flour: Birth-Scenes of the Tonsured Maize God." In *Mesoamerican Dualism,* edited by Rudolf van Zantwijk, R. de Ridder, and H. E. M. Braakhuis, 125–47. Utrecht: ISOR Universiteit Utrecht, 1990.

———. "Challenging the Lightnings: San Bartolo's West Wall Mural and the Maize Hero Myth." *Wayeb Notes* 46 (2014). http://www.wayeb.org/notes/wayeb_notes0046.pdf.

———. "Jaguar Slayer and Stone Trap Man: A Tzotzil Myth Reconsidered." In *The Maya and Their Sacred Narratives: Text and Context in Maya Mythologies,* Acta Mesoamericana 20, edited by Geneviève Le Fort, Raphaël Gardiol, Sebastian Matteo, and Christophe Helmke, 141–48. Markt Schwaben, Germany: Anton Saurwein, 2009.

———. "Sun's Voyage to the City of the Vultures: A Classic Mayan Funerary Theme." *Zeitschrift für Ethnologie* 112 (1987): 237–60.

———. "The Tonsured Maize God and Chixome-Xochitl as Maize Bringers and Culture Heroes: A Gulf Coast Perspective." *Wayeb Notes* 32 (2009). http://www.wayeb.org/notes/wayeb_notes0032.pdf.

———. "The Way of All Flesh: Sexual Implications of the Mayan Hunt." *Anthropos* 96 (2001): 391–409.

———. "Xbalanque's Canoe: The Origin of Poison in Q'eqchi'-Mayan Hummingbird Myth." *Anthropos* 100 (2005): 173–91.

———. "Xbalanque's Marriage: A Commentary on the Q'eqchi' Myth of Sun and Moon." PhD diss., Leiden University, 2010. https://openaccess.leidenuniv.nl/handle/1887/16064.

Brady, James E. "Settlement Configuration and Cosmology: The Role of Caves at Dos Pilas." *American Anthropologist* 99 (1997): 602–18.

Bricker, Victoria R. *Humor Ritual en la Altiplanicie de Chiapas.* Mexico City: Fondo de Cultura Económica, 1986.

Bricker, Victoria R., and Harvey M. Bricker. "Linearity and Cyclicity in Pre-Columbian Maya Time Reckoning." In *The Measure and Meaning of Time in Mesoamerica and the Andes,* edited by Anthony F. Aveni, 165–82. Washington, D.C.: Dumbarton Oaks, 2015.

Broda de Casas, Johanna. "Las Fiestas Aztecas de los Dioses de la Lluvia." *Revista Española de Antropología Americana* 6 (1971): 245–327.

Broda, Johanna, David Carrasco, and Eduardo Matos Moctezuma. *The Great Temple of Tenochtitlan: Center and Periphery in the Aztec World.* Berkeley: University of California Press, 1988.

Bruce, Robert D. *El Libro de Chan K'in.* Mexico City: Instituto Nacional de Antropología e Historia, 1974.

Búcaro Moraga, Jaime Ismael. "Leyendas de los Pueblos Indígenas: Leyendas, Cuentos, Mitos y Fábulas Indígenas." *Tradiciones de Guatemala* 35/36 (1991): 55–127.

Burkhardt, Louise M. *The Slippery Earth: Nahua-Christian Moral Dialogue in Sixteenth-Century Mexico.* Tucson: University of Arizona Press, 1987.

Byland, Bruce E., and John M. D. Pohl. *In the Realm of 8 Deer: The Archaeology of the Mixtec Codices.* Norman: University of Oklahoma Press, 1994.

Campbell, Lyle. *The Pipil Language of El Salvador.* Berlin: Mouton, 1985.

Carlsen, Robert S., and Martin Prechtel. "The Flowering of the Dead: An Interpretation of Highland Maya Culture." *Man* 26 (1991): 23–42.

———. "Weaving and the Cosmos amongst the Tzutujil Maya of Guatemala." *Res: Anthropology and Aesthetics* 15 (1988): 122–32.

Carmack, Robert M. *Historia Social de los Quichés.* Guatemala City: Seminario de Integración Social Guatemalteca, 1979.

———. *Quichean Civilization: The Ethnohistoric, Ethnographic, and Archaeological Sources.* Berkeley: University of California Press, 1973.

Carmack, Robert M., and James L. Mondloch, eds. *El Título de Totonicapán*. Mexico City: Universidad Nacional Autónoma de México, 1983.

———. *El Título de Yax y Otros Documentos Quichés de Totonicapán, Guatemala*. Mexico City: Universidad Nacional Autónoma de México, 1989.

Carneiro, Robert L. "The Amahuaca and the Spirit World." *Ethnology* 3 (1964): 6–11.

Carpenter, Thomas H. *Art and Myth in Ancient Greece*. London: Thames and Hudson, 1991.

Carr, Pat, and Willard Gingerich. "The Vagina Dentata Motif in Nahuatl and Pueblo Mythic Narratives: A Comparative Study." In *Smoothing the Ground: Essays on Native American Oral Literature*, edited by Brian Swann, 187–203. Berkeley: University of California Press, 1983.

Carrasco, Davíd. "Cosmic Jaws: We Eat the Earth and the Earth Eats Us." *Journal of the American Academy of Religion* 63 (1995): 429–63.

———. *Religions of Mesoamerica*. 2nd ed. Long Grove, Ill.: Waveland, 2014.

Carrasco, Michael D. "From Field to Hearth: An Earthly Interpretation of Maya and Other Mesoamerican Creation Myths." In *Pre-Columbian Foodways: Interdisciplinary Approaches to Food, Culture, and Markets in Ancient Mesoamerica*, edited by John E. Staller and Michael D. Carrasco, 601–34. New York: Springer, 2010.

Carrasco, Pedro, and Roberto J. Weitlaner. "El Sol y la Luna." *Tlalocan* 3 (1952): 168–73.

Caso, Alfonso. "¿Religión o Religiones Meso-americanas?" In *Verhandlungen des XXXVIII Internationalen Amerikanisten Kongresses*, vol. 3, 189–206. Munich: Kommissionsverlag Klaus Renner, 1971.

Castellón Huerta, Blas Román, ed. *Relatos Ocultos en la Niebla y el Tiempo: Selección de Mitos y Estudios*. Mexico City: Instituto Nacional de Antropología e Historia, 2007.

Castillo Butlers, Luis Jaime. *Personajes Míticos, Escenas y Narraciones en la Iconografía Mochica*. Lima: Pontificia Universidad Católica del Perú, 1989.

Chevalier, Jacques M., and Daniel Buckles. *A Land without Gods: Process Theory, Maldevelopment, and the Mexican Nahuas*. Halifax, Nova Scotia: Fernwood, 1995.

Chinchilla Mazariegos, Oswaldo. "Cosmos and Warfare on a Classic Maya Vase." *Res: Anthropology and Aesthetics* 47 (2005): 107–34.

———. "Francisco Antonio de Fuentes y Guzmán, Precursor de la Arqueología Americana." *Anales de la Academia de Geografía e Historia de Guatemala* 74 (1999): 39–69.

———. "Human Sacrifice and Divine Nourishment in Mesoamerica: The Iconography of Cacao on the Pacific Coast of Guatemala." *Ancient Mesoamerica* 27 (2016): 361–75.

———. *Imágenes de la Mitología Maya*. Guatemala City: Museo Popol Vuh, Universidad Francisco Marroquín, 2011.

———. "La Muerte de Moquíhuix: Los Mitos Cosmogónicos Mesoamericanos y la Historia Azteca." *Estudios de Cultura Náhuatl* 42 (2011): 77–108.

———. "Of Birds and Insects: The Hummingbird Myth in Ancient Mesoamerica." *Ancient Mesoamerica* 21 (2010): 45–61.

———. "Painted Vessel." In *Ancient Maya Art at Dumbarton Oaks*, edited by Joanne Pillsbury, Miriam Dutriaux, Reiko Ishihara-Brito, and Alexandre Tokovinine, 390–93. Washington, D.C.: Dumbarton Oaks, 2012.

———. "The Stars of the Palenque Sarcophagus." *Res: Anthropology and Aesthetics* 49/50 (2006): 40–58.

———. "Tecum, the Fallen Sun: Mesoamerican Cosmogony and the Spanish Conquest of Guatemala." *Ethnohistory* 60 (2013): 693–719.

———. "La Vagina Dentada: Una Interpretación de la Estela 25 de Izapa y las Guacamayas del Juego de Pelota de Copán." *Estudios de Cultura Maya* 36 (2010): 117–44.

———. "Where Children Are Born: Centipedes and Feminine Sexuality in Ancient Maya Art." In *Sorcery in Mesoamerica*, edited by Jeremy D. Coltman and John M. D. Pohl, 206–35. Louisville: University Press of Colorado, 2020.

Christenson, Allen J. *Popol Vuh: The Sacred Book of the Maya*. New York: O Books, 2003.

Ciaramella, Mary. *The Weavers in the Codices*. Research Reports on Ancient Maya Writing 44. Washington, D.C.: Center for Maya Research, 1999.

Ciudad Real, Antonio de. *Calepino Maya de Motul*. Edited by René Acuña. Mexico City: Plaza y Valdés, 2001.

Clancy, Flora S. "Text and Image in the Tablets of the Cross Group at Palenque." *Res: Anthropology and Aesthetics* 11 (1986): 17–32.

Clendinnen, Inga. *Aztecs: An Interpretation*. Cambridge: Cambridge University Press, 1985.

Coe, Michael D. "The Hero Twins: Myth and Image." In *The Maya Vase Book: A Corpus of Rollout Photographs of Maya Vases*, by Justin Kerr, 1: 161–84. New York: Kerr Associates, 1989.

———. *Lords of the Underworld: Masterpieces of Classic Maya Ceramics*. Princeton, N.J.: Art Museum, Princeton University, 1978.

———. *The Maya Scribe and His World*. New York: Grolier

Club, 1973.

———. "Supernatural Patrons of Maya Scribes and Artists." In *Social Process in Maya Prehistory*, edited by Norman Hammond, 327–47. New York: Academic, 1977.

Coe, Michael D., and Justin Kerr. *The Art of the Maya Scribe.* London: Thames and Hudson, 1997.

Coggins, Clemency. "Classic Maya Metaphors of Death and Life." *Res: Anthropology and Aesthetics* 16 (1988): 64–84.

Cogolludo, Diego López de. *Historia de Yucathan.* Madrid: Juan García Infanzón, 1688.

Colby, Benjamin N., and Lore M. Colby. *The Daykeeper: The Life and Discourse of an Ixil Diviner.* Cambridge, Mass.: Harvard University Press, 1981.

Collier, Jane F. "Courtship and Marriage in Zinacantán, Chiapas, Mexico." In *Contemporary Latin American Culture*, Middle American Research Institute, Publication 25, edited by Munro S. Edmonson, 139–201. New Orleans: Tulane University, 1968.

Cordry, Donald, and Dorothy Cordry. *Mexican Indian Costumes.* Austin: University of Texas Press, 1968.

Corona Núñez, José. "La Palabra Creadora Representada por el Joyel del Viento." In *Summa Anthropologica en Homenaje a Roberto J. Weitlaner*, 187–92. Mexico City: Instituto Nacional de Antropología e Historia, 1966.

Cortez, Constance. "The Principal Bird Deity in Late Preclassic and Early Classic Maya Art." Master's thesis, University of Texas, Austin, 1986.

Coto, Thomás de. *[Thesavrvs verborv] Vocabvlario de la Lengua Cakchiquel v[el] Guatemalteca, Nueuamente Hecho y Recopilado con Summo Estudio, Trauajo y Erudición.* Edited by René Acuña. Mexico City: Universidad Nacional Autónoma de México, 1983.

Covarrubias, Sebastián de. *Parte Primera del Tesoro de la Lengua Castellana o Española.* 2nd ed., with additions by Benito Remigio Noydens. Madrid: Melchor Sánchez, 1674.

Craine, Eugene R., and Reginald C. Reindorp, eds. *The Codex Pérez and the Book of Chilam Balam of Maní.* Norman: University of Oklahoma Press, 1979.

Craveri, Michela, ed. *Popol Vuh: Herramientas para una Lectura Crítica del Texto K'iche'.* Mexico City: Universidad Nacional Autónoma de México, 2013.

Cruz Coutiño, José Antonio. "Integración de Secuencias Discursivas. El Caso de los Mitos y Leyendas de Ascendencia Maya en Chiapas (México) Vinculadas a la Creación del Hombre y Su Entorno." PhD diss., University of Salamanca, 2008. http://hdl.handle.net/10366/22433.

Cuerpos de Maíz: Danzas Agrícolas de la Huasteca. Mexico City: Programa de Desarrollo Cultural de la Huasteca, 2000.

Cuevas García, Marta. *Los Incensarios Efigie de Palenque: Deidades y Rituales Mayas.* Mexico City: Universidad Nacional Autónoma de México, 2007.

Dary, Claudia. *Estudio Antropológico de la Literatura Oral en Prosa del Oriente de Guatemala.* Guatemala City: Editorial Universitaria, Universidad de San Carlos de Guatemala, 1986.

De Cicco, Gabriel, and Fernando Horcasitas. "Los Cuates: Un Mito Chatino." *Tlalocan* 4, no. 1 (1962): 74–79.

Dehouve, Danièle. "Un Ritual de Cacería. El Conjuro para Cazar Venados de Ruiz de Alarcón." *Estudios de Cultura Náhuatl* 40 (2009): 299–331.

De la Cruz Torres, Mario. *Rubelpec: Cuentos y Leyendas de Senahú, Alta Verapaz.* Guatemala City: Editorial del Ejército, 1978.

De la Garza, Mercedes. "Los Mayas. Antiguas y Nuevas Palabras sobre el Origen." In *Mitos Cosmogónicos del México Indígena*, edited by Jesús Monjarás-Ruiz, 15–86. Mexico City: Instituto Nacional de Antropología e Historia, 1985.

De la Garza, Mercedes, Ana Luisa Izquierdo, María del Carmen León, and Tolita Figueroa, eds. *Relaciones Histórico-Geográficas de la Gobernación de Yucatán (Mérida, Valladolid y Tabasco).* Vol. 2. Mexico City: Universidad Nacional Autónoma de México, 1983.

Delgado, Hilda S. "Figurines of Backstrap Loom Weavers from the Maya Area." In *Verhandlungen des XXXVIII Amerikanisten Kongresses, Stuttgart-München*, vol. 1, 139–49. Munich: Kommissionsverlag Klaus Renner, 1969.

De Vries, Lyckle. "Iconography and Iconology in Art History: Panofsky's *Prescriptive* Definitions and Some Art-Historical Responses to Them." In *Picturing Performance: The Iconography of the Performing Arts in Concept and Practice*, edited by Thomas F. Heck, 42–64. Rochester, N.Y.: University of Rochester Press, 1999.

Díaz de Salas, Marcelo. "Notas sobre la Visión del Mundo entre los Tzotziles de Venustiano Carranza, Chiapas." *La Palabra y el Hombre: Revista de la Universidad Veracruzana* 26 (1963): 253–67.

———. *San Bartolomé de los Llanos en la Escritura de un Etnógrafo, 1960–61: Diario de Campo, Venustiano Carranza, Chiapas.* Tuxtla Gutiérrez, Chiapas, Mexico: Universidad de Ciencias y Artes del Estado de Chiapas, 1995.

Dillon, Brian D., Lynda Brunker, and Kevin O. Pope.

"Ancient Maya Autoamputation? A Possible Case from Salinas de los Nueve Cerros, Guatemala." *Journal of New World Archaeology* 5, no. 4 (1985): 24–38.

Donnan, Christopher B. *Moche Art and Iconography.* Los Angeles: UCLA Latin American Center, University of California, 1976.

———. "The Thematic Approach to Moche Iconography." *Journal of Latin American Lore* 1 (1975): 147–62.

Dupiech-Cavalieri, Daniele, and Mario Humberto Ruz. "La Deidad Fingida: Antonio Margil y la Religiosidad Quiché del 1704." *Estudios de Cultura Maya* 17 (1988): 213–67.

Dütting, Dieter, and Richard Johnson. "The Regal Rabbit, the Night Sun and God L: An Analysis of Iconography and Texts on a Classic Maya Vase." *Baessler-Archiv, Neue Folge* 41 (1993): 167–205.

Dyk, Anne. *Mixteco Texts.* Norman: Summer Institute of Linguistics, University of Oklahoma, 1959.

Earle, Duncan M. "The Metaphor of the Day in Quiche: Notes on the Nature of Everyday Life." In *Symbol and Meaning Beyond the Closed Community: Essays in Mesoamerican Ideas,* edited by Gary H. Gossen, 155–72. Albany: Institute of Mesoamerican Studies, State University of New York, 1986.

Edmonson, Munro S., ed. *The Book of the Counsel: The Popol Vuh of the Quiché Maya of Guatemala. Middle American Research Institute, Publication 35.* New Orleans: Tulane University, 1971.

Elson, Ben. "The Homshuk: A Sierra Popoluca Text." *Tlalocan* 2, no. 3 (1947): 193–214.

Equipo de Promotores Étnico-Culturales. *Cuentos que Parecen Historia, Historias que Parecen Leyenda.* Mexico City: Editorial Praxis, 1996.

Escobedo, Héctor L., Jorge Mario Samayoa, Oswaldo Gómez, and Irma Rodas. "Exploraciones en el Sitio Las Pacayas, Sayaxche." In *Atlas Arqueológico de Guatemala, Reporte 7,* edited by Juan Pedro Laporte, 203–22. Guatemala City: Ministerio de Cultura y Deportes, 1993.

Estrada Monroy, Agustín, ed. *Empiezan las Historias del Origen de los Indios de Esta Provincia de Guatemala: Popol Vuh.* Facsimile ed. Guatemala City: Editorial José de Pineda Ibarra, 1973.

Fagetti, Antonella. "El Nacimiento de Huitzilopochtli-Santiago: Un Mito Mexica en la Tradición Oral de San Miguel Acuexcomac." *Cuicuilco* 10, no. 29 (2003): 183–95.

Fash, William L. "Dynastic Architectural Programs: Intention and Design in Classic Maya Buildings at Copan and Other Sites." In *Function and Meaning in Classic Maya Architecture,* edited by Stephen D. Houston, 222–70. Washington, D.C.: Dumbarton Oaks, 1998.

Fash, William L., and Barbara Fash. "Building a World-View: Visual Communication in Classic Maya Architecture." *Res: Anthropology and Aesthetics* 29/30 (1996): 127–47.

———. "Teotihuacan and the Maya: A Classic Heritage." In *Mesoamerica's Classic Heritage: From Teotihuacan to the Great Aztec Temple,* edited by David Carrasco, Lindsay Jones, and Scott Sessions, 433–63. Boulder: University Press of Colorado, 2000.

Faust, Betty Bernice. "Cacao Beans and Chili Peppers: Gender Socialization in the Cosmology of a Yucatec Maya Curing Ceremony." *Sex Roles* 39 (1998): 603–42.

Feldman, Lawrence H. *A Dictionary of Poqom Maya in the Colonial Era.* Lancaster, Calif.: Labyrinthos, 2004.

———. *Lost Shores, Forgotten Peoples: Spanish Explorations of the South East Maya Lowlands.* Durham, N.C.: Duke University Press, 2000.

Fields, Virginia M. "The Iconographic Heritage of the Maya Jester God." In *Sixth Palenque Round Table, 1986,* edited by Virginia M. Fields, 167–74. Norman: University of Oklahoma Press, 1991.

Foncerrada de Molina, Marta. "Reflexiones sobre la Decoración de un Vaso Maya." *Anales del Instituto de Investigaciones Estéticas* 39 (1970): 79–86.

———. "El Vaso Maya de Yalloch." *Anales del Instituto de Investigaciones Estéticas* 37–38 (1968): 23–35.

Foncerrada de Molina, Marta, and Sonia Lombardo de Ruiz. *Vasijas Pintadas Mayas en Contexto Arqueológico (Catálogo).* Mexico City: Universidad Nacional Autónoma de México, 1979.

Förstemann, Ernst. *Commentary on the Maya Manuscript in the Royal Public Library of Dresden.* Papers of the Peabody Museum of American Archaeology and Ethnology, vol. 4, no. 2. Cambridge, Mass.: Harvard University, 1906.

Foster, George M. *Sierra Popoluca Folklore and Beliefs.* University of California Publications in American Archaeology and Ethnology, vol. 42, no. 2, 177–250. Berkeley: University of California Press, 1945.

Fought, John. "Kumix, the Ch'orti' Hero." In *General and Amerindian Ethnolinguistics, in Remembrance of Stanley Newman,* edited by Mary Ritchie Key and Henry M. Hoenigswald, 461–68. Berlin: Mouton de Gruyter, 1989.

———. "Translation of Recordings 3." Mayan Languages

Collection, resource CAA004R003. Archive of the Indigenous Languages of Latin America, University Libraries, the University of Texas at Austin.

Fox, James A., and John S. Justeson. "Polyvalence in Mayan Hieroglyphic Writing." In *Phoneticism in Mayan Hieroglyphic Writing,* Institute of Mesoamerican Studies Publication No. 9., edited by John S. Justeson and Lyle Campbell, 17–76. Albany: State University of New York, 1984.

Freidel, David, Linda Schele, and Joy Parker. *Maya Cosmos: Three Thousand Years on the Shaman's Path.* New York: Quill, 1993.

Furst, Jill Leslie. *Codex Vindobonensis Mexicanus I: A Commentary.* Albany: Institute for Mesoamerican Studies, State University of New York, 1978.

Furst, Peter T. "Huichol Cosmology: How the World Was Destroyed by a Flood and Dog-Woman Gave Birth to the Human Race." In *South and Meso-American Native Spirituality,* edited by Gary Gossen and Miguel León-Portilla, 303–23. New York: Crossroad, 1993.

——. "The Maiden Who Ground Herself: Myths of the Origin of Maize from the Sierra Madre Occidental, Mexico." *Latin American Indian Literatures Journal* 10, no. 2 (1994): 101–55.

Galinier, Jacques. "L'Homme Sans Pied: Métaphores de la Castration et Imaginaire en Mésoamérique." *L'Homme* 24, no. 2 (1984): 41–58.

——. *La Mitad del Mundo: Cuerpo y Cosmos en los Rituales Otomíes.* Mexico City: Universidad Nacional Autónoma de México, Centro de Estudios Mexicanos y Centroamericanos e Instituto Nacional Indigenista, 1990.

——. "El Panoptikon Mazahua: Visiones, Sustancias, Relaciones." *Estudios de Cultura Otopame* 5 (2006): 53–69.

——. "Epílogo." In *El Lugar de la Captura (Simbolismo de la Vagina Telúrica en la Cosmovisión Mesoamericana),* by Félix Báez-Jorge, 312–25. Jalapa, Mexico: Gobierno del Estado de Veracruz, 2008.

——. *The World Below: Body and Cosmos in Otomí Indian Ritual.* Boulder: University Press of Colorado, 1997.

Gann, Thomas W. F. *The Maya Indians of Southern Yucatan and Northern British Honduras.* Bureau of American Ethnology, Bulletin 64. Washington, D.C.: Smithsonian Institution, 1918.

García Alcaraz, Agustín. *Tinujei: Los Triquis de Copala.* Mexico City: Centro de Investigaciones y Estudios Superiores en Antropología Social, 1997.

García Barrios, Ana. "El Aspecto Bélico de Chaahk, el Dios de la Lluvia, en el Periodo Clásico Maya." *Revista Española de Antropología Americana* 39 (1998): 7–29.

García de León, Antonio. *Pajapan: Un Dialecto Mexicano del Golfo.* Mexico City: Instituto Nacional de Antropología e Historia, 1976.

García Zambrano, Ángel Julián. "Ancestral Rituals of Landscape Exploration and Appropriation among Indigenous Communities in Early Colonial Mexico." In *Sacred Gardens and Landscapes: Ritual and Agency,* edited by Michel Conan, 193–220. Washington, D.C.: Dumbarton Oaks, 2007.

Genet, Jean. "Symbolic Glyphs in Maya-Quiche Writing: The Symbolic Glyph for War." In *The Decipherment of Ancient Maya Writing,* edited by Stephen D. Houston, Oswaldo Chinchilla Mazariegos, and David Stuart, 285–90. Norman: University of Oklahoma Press, 2001.

Gifford, E. W. "Northeastern and Western Yavapai Myths." *Journal of American Folklore* 46 (1933): 347–415.

Gillespie, Susan D. *The Aztec Kings: The Construction of Rulership in Mexica History.* Tucson: University of Arizona Press, 1989.

Girard, Rafael. *Los Mayas Eternos.* Mexico City: Antigua Librería Robredo, 1962.

Golte, Jürgen. *Iconos y Narraciones: La Reconstrucción de Una Secuencia de Imágenes Moche.* Lima: Instituto de Estudios Peruanos, 1994.

Gómez Ramírez, Martín. *Ofrenda de los Ancestros en Oxchuc: Xlimoxma Neel Jme'tatik Oxchujk'.* Tuxtla Gutiérrez, Chiapas, Mexico: Instituto Chiapaneco de Cultura, 1991.

González Cruz, Genaro, and Marina Anguiano. "La Historia de Tamakastsiin." *Estudios de Cultura Nahuatl* 17 (1984): 205–25.

Gossen, Gary H. *Four Creations: An Epic Story of the Chiapas Mayas.* Norman: University of Oklahoma Press, 2002.

——. "Temporal and Spatial Equivalents in Chamula Ritual Symbolism." In *Reader in Comparative Religion: An Anthropological Approach,* edited by William A. Lessa and Evon Z. Vogt, 126–29. New York: Harper and Row, 1979.

——. "El Tiempo Cíclico en San Juan Chamula: ¿Mistificación o Historia Viva?" *Mesoamérica* 18 (1989): 441–59.

——. "Two Creation Texts from Chamula, Chiapas." *Tlalocan* 8 (1980): 131–65.

——. "Las Variaciones del Mal en Una Fiesta Tzotzil." In *De Palabra y Obra en el Nuevo Mundo,* vol. 1, *Imágenes Interétnicas,* edited by Miguel León-Portilla, Manuel Gutiérrez Estévez, Gary H. Gossen, and J. Jorge

Klor de Alva, 195–235. Madrid: Siglo XXI, 1992.

Grandia, Lisa. *Stories from the Sarstoon-Temash: Traditional Q'eqchi' Tales by the Elders from Crique Sarco, Sunday Wood, Conejo, and Midway Villages (Toledo District, Belize)*. Berkeley: Krishna Copy Center, 2004.

Graulich, Michel. "Autosacrifice in Ancient Mexico." *Estudios de Cultura Náhuatl* 36 (2005): 301–29.

——. "Double Immolations in Ancient Mexican Sacrificial Ritual." *History of Religions* 27 (1988): 393–404.

——. "Les Grands Statues Aztèques Dites de Coatlicue et Yollotlicue." In *Cultures et Sociétés: Andes et Méso-Amérique. Melanges en Hommage à Pierre Duviols*, vol. 1, edited by Raquel Thiercelin, 375–419. Aix-en-Provence: Université de Provence, 1991.

——. "Human Sacrifice as Expiation." *History of Religions* 39 (2000): 352–71.

——. "Más sobre la Coyolxauhqui y las Mujeres Desnudas de Tlatelolco." *Estudios de Cultura Nahuatl* 31 (2000): 77–94.

——. "The Metaphor of the Day in Ancient Mexican Myth and Ritual." *Current Anthropology* 22 (1981): 45–60.

——. *Ritos Aztecas: Las Fiestas de las Veintenas*. Mexico City: Instituto Nacional Indigenista, 1999.

——. "Los Mitos Mexicanos y Mayas-Quichés de la Creación del Sol." *Anales de Antropología* 24 (1987): 289–325.

——. *Myths of Ancient Mexico*. Norman: University of Oklahoma Press, 1997.

——. "Myths of Paradise Lost in Pre-Hispanic Central Mexico." *Current Anthropology* 24 (1983): 575–88.

——. "Los Reyes de Tollan." *Revista Española de Antropología Americana* 32 (2002): 87–114.

Graulich, Michel, and Guilhem Olivier. "¿Deidades Insaciables? La Comida de los Dioses en el México Antiguo." *Estudios de Cultura Nahuatl* 35 (2004): 121–55.

Greco, Danielle. "La Naissance du Maïs: Conte Nahuatl de la Huasteca (Mexique)." *Amerindia* 14 (1989): 171–88.

Gregor, Thomas. *Anxious Pleasures: The Sexual Lives of an Amazonian People*. Chicago: University of Chicago Press, 1985.

Grieder, Terence. "The Interpretation of Ancient Symbols." *American Anthropologist* 77 (1975): 849–55.

Groark, Kevin. "To Warm the Blood, to Warm the Flesh: The Role of the Steambath in Highland Maya (Tzeltal-Tzotzil) Ethnomedicine." *Journal of Latin American Lore* 20 (1997): 3–96.

Grube, Nikolai. "Akan—The God of Drinking, Disease, and Death." In *Continuity and Change: Maya Religious Practices in Temporal Perspective*, edited by Daniel Graña Behrens, Nikolai Grube, Christian M. Prager, Frauke Sachse, Stephanie Teufel, and Elisabeth Wagner, 59–76. Munich: Verlag Anton Saurwein, 2004.

Grube, Nikolai, and Marie Gaida. *Die Maya: Schrift und Kunst*. Berlin: Ethnologisches Museum, Staatliche Museen zu Berlin, 2006.

Grube, Nikolai, and Werner Nahm. "A Census of Xibalba: A Complete Inventory of Way Characters on Maya Ceramics." In *The Maya Vase Book: A Corpus of Rollout Photographs of Maya Vases*, by Justin Kerr, vol. 4, 686–715. New York: Kerr Associates, 1994.

Guernsey, Julia. "Beyond the 'Myth or Politics' Debate: Reconsidering Late Preclassic Sculpture, the Principal Bird Deity, and the Popol Vuh." In *The Myths of the Popol Vuh in Cosmology, Art, and Ritual*, edited by Holley Moyes, Allen J. Christenson, and Frauke Sachse, 268–94. Louisville: University Press of Colorado, 2021.

——. *Ritual and Power in Stone: The Performance of Rulership in Mesoamerican Izapan Style Art*. Austin: University of Texas Press, 2006.

Guiteras Holmes, Calixta. *Los Peligros del Alma: Visión del Mundo de Un Tzotzil*. Mexico City: Fondo de Cultura Económica, 1986.

——. *Perils of the Soul: The World View of a Tzotzil Indian*. New York: Free Press of Glencoe, 1961.

Gutiérrez Estévez, Manuel. "Lógica Social en la Mitología Maya-Yucateca: La Leyenda del Enano de Uxmal." In *Mito y Ritual en América*, edited by Manuel Gutiérrez Estévez, 60–110. Madrid: Editorial Alhambra, 1988.

——. "Mayas y 'Mayeros': Los Antepasados como Otros." In *De Palabra y Obra en el Nuevo Mundo*, vol. 1, *Imágenes Interétnicas*, edited by Manuel Gutiérrez Estévez, Gary H. Gossen, and J. Jorge Klor de Alva, 417–42. Madrid: Siglo XXI de España, 1992.

Guzmán, Adriana. *Mitote y Universo Cora*. Mexico City: Instituto Nacional de Antropología e Historia/Universidad de Guadalajara, 2002.

Hamann, Byron. "The Social Life of Pre-Sunrise Things: Indigenous Mesoamerican Archaeology." *Current Anthropology* 43 (2002): 351–82.

Hammond, Norman. "The Sun Is Hid: Classic Depictions of a Maya Myth." In *Fourth Palenque Round Table, 1980*, edited by Merle Greene Robertson and Elizabeth P. Benson, 167–73. San Francisco: Pre-Columbian Art Research Institute,

1985.

Heck, Thomas F. "The Evolution of Meanings of Iconology and Iconography: Toward Some *Descriptive* Definitions." In *Picturing Performance: The Iconography of the Performing Arts in Concept and Practice*, edited by Thomas F. Heck, 7–41. Rochester, N.Y.: University of Rochester Press, 1999.

Hellmuth, Nicholas. *Monster und Menschen in der Maya Kunst*. Graz, Austria: Akademische Druck- u. Verlagsanstalt, 1987.

Henderson, Lucia. *Bodies Politic, Bodies in Stone: Imagery of the Human and the Divine in the Sculpture of Late Preclassic Kaminaljuyú, Guatemala*. Ph.D. diss., University of Texas, Austin, 2013.

Henne, Marilyn G. "Quiche Food: Its Cognitive Structure in Chichicastenango, Guatemala." In *Cognitive Studies in Southern Mesoamerica*, edited by Helen L. Neuenswander and Dean E. Arnold, 67–92. Dallas: Summer Institute of Linguistics, 1977.

Henne, Nathan C. "Untranslation: The Popol Wuj and Comparative Methodology." *CR: The New Centennial Review* 12, no. 2 (2012): 107–50.

Hermitte, M. Esther. *Poder Sobrenatural y Control Social en un Pueblo Maya Contemporáneo*. Mexico City: Instituto Indigenista Interamericano, 1970.

Herring, Adam. *Art and Writing in the Maya Cities, A.D. 600–800: A Poetics of Line*. Cambridge: Cambridge University Press, 2005.

Heyden, Doris. "La Diosa Madre: Itzpapalotl." *Boletín del Instituto Nacional de Antropología e Historia, Época II* 11 (1974): 3–14.

——. "'Uno Venado' y la Creación del Cosmos en las Crónicas y los Códices de Oaxaca." In *Mitos Cosmogónicos del México Indígena*, edited by Jesús Monjarás-Ruiz, 87–124. Mexico City: Instituto Nacional de Antropología e Historia, 1987.

Hill, Robert M, II. *Pictograph to Alphabet—and Back: Reconstructing the Pictographic Origins of the Xahil Chronicle*. Philadelphia: American Philosophical Society, 2012.

Himelblau, Jack J. *Quiche Worlds in Creation: The Popol Vuh as a Narrative Work of Art*. Lancaster, Calif.: Labyrinthos, 1989.

Hocquenghem, Anne Marie. *Iconografía Mochica*. Lima: Pontificia Universidad Católica del Perú, 1987.

Holland, William R. *Medicina Maya en los Altos de Chiapas: Un Estudio del Cambio Socio-Cultural*. Mexico City: Instituto de Antropología e Historia, 1963.

Hollenbach, Elena E. de. "El Origen del Sol y de la Luna: Cuatro Versiones en el Trique de Copala."

Tlalocan 7 (1977): 123–70.

Hoogshagen, Searle. "La Creación del Sol y la Luna Según los Mixes de Coatlán, Oaxaca." *Tlalocan* 6, no. 4 (1971): 337–46.

Horcasitas, Fernando. "An Analysis of the Deluge Myth in Mesoamerica." In *The Flood Myth*, edited by Alan Dundes, 183–219. Berkeley: University of California Press, 1988.

——. "Dos Versiones Totonacas del Mito del Diluvio." *Tlalocan* 4, no. 1 (1962): 53–54.

Hostnig, Rainer, and Luis Vásquez Vicente, eds. *Nab'ab'l Qtanam: La Memoria Colectiva del Pueblo Mam de Quetzaltenango*. Quetzaltenango, Guatemala: Centro de Capacitación e Investigación Campesina, 1994.

Houston, Stephen. "Classic Maya Depictions of the Built Environment." In *Function and Meaning in Classic Maya Architecture*, edited by Stephen D. Houston, 333–72. Washington, D.C.: Dumbarton Oaks, 1998.

——. "Living Waters and Wondrous Beasts." In *Fiery Pool: The Maya and the Mythic Sea*, edited by Daniel Finamore and Stephen D. Houston, 66–79. New Haven, Conn.: Yale University Press, 2010.

——. "Symbolic Sweatbaths of the Maya: Architectural Meaning in the Cross Group at Palenque, Mexico." *Latin American Antiquity* 7 (1996): 132–51.

Houston, Stephen D., and Takeshi Inomata. *The Classic Maya*. Cambridge: Cambridge University Press, 2009.

Houston, Stephen, and David Stuart. *The Way Glyph: Evidence for "Co-Essences" among the Classic Maya*. Research Reports on Ancient Maya Writing 30. Washington, D.C.: Center for Maya Research, 1989.

Houston, Stephen D., David Stuart, and Karl Taube. "Image and Text on the 'Jauncy Vase.'" In *The Maya Vase Book: A Corpus of Rollout Photographs of Maya Vases*, by Justin Kerr, vol. 3, 499–512. New York: Kerr Associates, 1992.

——. *The Memory of Bones: Body, Being, and Experience among the Classic Maya*. Austin: University of Texas Press, 2006.

Houston, Stephen D., and Karl Taube. "Meaning in Early Maya Imagery." In *Iconography without Texts*, edited by Paul Taylor, 127–44. London: Warburg Institute; Turin: Nino Aragno Editore, 2008.

Hull, Kerry. "The Grand Ch'orti' Epic: The Story of the Kumix Angel." In *The Maya and Their Sacred Narratives: Text and Context in Maya Mythologies*, Acta Mesoamericana 20, edited by Geneviève Le Fort, Raphaël Gardiol, Sebastian Matteo, and Christophe Helmke, 131–40. Markt Schwaben,

Germany: Anton Saurwein, 2009.

——. "The Ch'orti' Maya Myths of Creation." *Oral Tradition* 30/1 (2016): 3–26. http://journal.oraltradition.org/issues/30i/hull.

Hull, Kerry, and Rob Fergus. "Eagles in Mesoamerican Thought and Mythology." *Reitaku Review* 15 (2009): 83–134.

Hunt, Eva. *The Transformation of the Hummingbird: Cultural Roots of a Zinacantecan Mythical Poem.* Ithaca, N.Y.: Cornell University Press, 1977.

Hurtado, Elena, and Eugenia Sáenz de Tejada. "Relations between Government Health Workers and Traditional Midwives in Guatemala." In *Mesoamerican Healers,* edited by Brad R. Hubert and Alan R. Sandstrom, 211–42. Austin: University of Texas Press, 2001.

Ichon, Alain. *La Religión de los Totonacas de la Sierra.* Mexico City: Instituto Nacional Indigenista, 1973.

Incháustegui, Carlos. *Relatos del Mundo Mágico Mazateco.* Mexico City: Instituto Nacional de Antropología e Historia, 1977.

Jäcklein, Klaus. *Un Pueblo Popoloca.* Mexico City: Instituto Nacional Indigenista, 1974.

Johansson K., Patrick. "Mocihuaquetzqueh: ¿Mujeres Divinas o Mujeres Siniestras?" *Estudios de Cultura Nahuatl* 37 (2006): 193–230.

Joralemon, David. "Ritual Blood-Sacrifice among the Ancient Maya: Part I." In *Primera Mesa Redonda de Palenque,* pt. 2, edited by Merle Greene Robertson, 59–75. Pebble Beach, Calif.: Robert Louis Stevenson School, 1974.

——. *A Study of Olmec Iconography.* Studies in Pre-Columbian Art and Archaeology 7. Washington, D.C.: Dumbarton Oaks, 1971.

Just, Bryan. *Dancing into Dreams: Maya Vase Painting of the Ik' Kingdom.* New Haven, Conn.: Yale University Press, 2012.

Katz, Esther. "Recovering after Childbirth in the Mixtec Highlands (Mexico)." In *Médicaments et Aliments, Approche Ethnopharmacologique: Actes du 2e Colloque Européen d'Ethnopharmacologie et de la 11e Conférence Internationale d'Ethnomédecine.* Paris: Societé Francaise d'Ethnopharmacologie, 1996.

Kaufman, Terrence, and John Justeson. "A Preliminary Maya Etymological Dictionary." Report submitted to the Foundation for the Advancement of Mesoamerican Studies, 2003. http://www.famsi.org/reports/01051/index.html.

Kelley, David H. "The Birth of the Gods at Palenque."
Estudios de Cultura Maya 5 (1965): 93–134.

Kelly, Isabel. "World View of a Highland-Totonac Pueblo." In *Summa Anthropologica en Homenaje a Roberto J. Weitlaner,* 395–411. Mexico City: Instituto Nacional de Antropología e Historia, 1966.

Kerr, Justin. *The Maya Vase Book.* 6 vols. New York: Kerr Associates, 1989–2000.

King, J. C. H. *Ethnographic Notes on the Maya of Belize, Central America.* Working Papers 19, Centre of Latin American Studies. Cambridge: University of Cambridge, 1975.

Klein, Cecelia F. "Fighting with Femininity: Gender and War in Aztec Mexico." *Estudios de Cultura Nahuatl* 24 (1994): 219–53.

——. "None of the Above: Gender Ambiguity in Nahua Ideology." In *Gender in Pre-Hispanic America,* edited by Cecelia F. Klein, 183–253. Washington, D.C.: Dumbarton Oaks, 2001.

——. "Rethinking Cihuacoatl: Aztec Political Imagery of the Conquered Woman." In *Smoke and Mist: Mesoamerican Studies in Memory of Thelma D. Sullivan,* BAR International Series 402(i), edited by J. Katherine Josserand and Karen Dakin, 237–77. Oxford: British Archaeological Reports, 1988.

Knowlton, Timothy W. "Dialogism in the Languages of Colonial Maya Creation Myths." Ph.D. diss., Tulane University, 2004.

——. *Maya Creation Myths: Words and Worlds of the Chilam Balam.* Boulder: University Press of Colorado, 2010.

——. "The Maya Goddess of Painting, Writing, and Decorated Textiles." *PARI Journal* 16, no. 2 (2015): 31–41.

Ko7w, Shas, Glenn Ayres, Benjamin Colby, and Lore Colby. "El Descubrimiento del Maíz en Paxil: The Discovery of Maize inside Paxil Mountain." *Tlalocan* 11 (1989): 301–25.

Kockelman, Paul. "Meaning and Time: Translation and Exegesis of a Mayan Myth." *Anthropological Linguistics* 49 (2007): 308–87.

Köhler, Ulrich. "'Debt-Payment' to the Gods among the Aztec: The Misrendering of a Spanish Expression and Its Effects." *Estudios de Cultura Náhuatl* 32 (2001): 125–33.

Koontz, Rex. "Iconographic Interaction between El Tajín and South-Central Veracruz." In *Classic Period Cultural Currents in Southern and Central Veracruz,* edited by Philip J. Arnold III and Christopher A. Pool, 323–59. Washington, D.C.: Dumbarton Oaks, 2008.

Kowalski, Jeff Karl. *The Mythological Identity of the Figure on the La Esperanza ("Chinkultik") Ball Court Marker.* Research Reports on Ancient Maya Writing 27.

Washington, D.C.: Center for Maya Research, 1989.

Kubler, George. "La Evidencia Intrínseca y la Analogía Etnológica en el Estudio de las Religiones Mesoamericanas." In *Religión en Mesoamérica: XII Mesa Redonda*, edited by Jaime Litvak King and Noemí Castillo Tejero, 1–24. Mexico City: Sociedad Mexicana de Antropología, 1972.

———. *The Iconography of the Art of Teotihuacan.* Studies in Pre-Columbian Art and Archaeology 4. Washington, D.C.: Dumbarton Oaks, 1967.

———. "Period, Style, and Meaning in Ancient American Art." *New Literary History* 1 (1970): 127–44.

Lacadena, Alfonso. "Regional Scribal Traditions: Methodological Implications for the Decipherment of Nahuatl Writing." *PARI Journal* 8, no. 4 (2008): 1–37.

La Farge, Oliver. *Santa Eulalia: The Religion of a Cuchumatán Indian Town.* Chicago: University of Chicago Press, 1947.

Landa, Diego de. *Relación de las Cosas de Yucatán.* Edited by Angel María Garibay K. Mexico City: Editorial Porrúa, 1982.

Las Casas, Bartolomé de. *Apologética Historia Sumaria.* 3 vols. Edited by Vidal Abril Castelló, Jesús A. Barreda, Berta Ares Queija and Miguel J. Abril Stoffels. Madrid: Alianza Editorial, 1992.

Laughlin, Robert M. *The Great Tzotzil Dictionary of Santo Domingo Zinacantán.* Washington, D.C.: Smithsonian Institution, 1988.

———. *Of Cabbages and Kings: Tales from Zinacantán.* Washington, D.C.: Smithsonian Institution, 1977.

———. "Through the Looking Glass: Reflections on Zinacantan Courtship and Marriage." Ph.D. diss., Harvard University, 1962.

Law, Howard. "Tamakasti: A Gulf Nahuat Text." *Tlalocan* 3, no. 4 (1957): 344–60.

Lenkersdorff, Gudrun. "El Popol Vuh: Algunas Consideraciones Históricas." *Estudios de Cultura Maya* 24 (2004): 47–60.

León-Portilla, Miguel. "Those Made Worthy by Divine Sacrifice: The Faith of Ancient Mexico." In *South and Meso-American Native Spirituality*, edited by Gary Gossen and Miguel León-Portilla, 41–64. New York: Crossroad, 1993.

Lévi-Strauss, Claude. *The Raw and the Cooked: Introduction to a Science of Mythology.* New York: Harper and Row, 1969.

Ligorred Perramón, Francisco de Asís. *Consideraciones sobre la Literatura Oral de los Mayas Modernos.* Mexico City: Instituto Nacional de Antropología e Historia, 1990.

Lipp, Frank. *The Mixe of Oaxaca: Religion, Ritual, and Healing.* Austin: University of Texas Press, 1991.

Lizana, Bernardo de. *Historia de Yucatán.* Edited by Félix Jiménez Villalba. Madrid: Historia 16, 1988.

Looper, Matthew G. *To Be Like Gods: Dance in Ancient Maya Civilization.* Austin: University of Texas Press, 2010.

———. "Women-Men (and Men-Women): Classic Maya Rulers and the Third Gender." In *Ancient Maya Women*, edited by Traci Ardren, 171–202. Walnut Creek, Calif.: Altamira, 2002.

López Austin, Alfredo. "Características Generales de la Religión de los Pueblos Nahuas del Centro de México en el Posclásico Tardío." In *La Religión de los Pueblos Nahuas*, Enciclopedia Iberoamericana de Religiones, vol. 7, edited by Silvia Limón Olvera, 31–72. Madrid: Editorial Trotta, 2008.

———. "Cuando Cristo Andaba de Milagros: La Innovación de un Mito Colonial." In *De Hombres y Dioses*, edited by Xavier Noguez and Alfredo López Austin, 203–24. 2nd ed. Toluca, Mexico: Gobierno del Estado de México, 2013.

———. "Homshuk. Análisis Temático del Relato." *Anales de Antropología* 29 (1992): 261–83.

———. *The Human Body and Ideology: Concepts of the Ancient Nahuas.* Vol. 1. Translated by Thelma Ortiz de Montellano and Bernard R. Ortiz de Montellano. Salt Lake City: University of Utah Press, 1988.

———. *Los Mitos del Tlacuache: Caminos de la Mitología Mesoamericana.* Mexico City: Universidad Nacional Autónoma de México, 1996.

———. "Myth, Belief, Narration, Image: Reflections on Mesoamerican Mythology." *Journal of the Southwest* 46 (2004): 601–20.

———. *The Myths of the Opossum: Pathways of Mesoamerican Mythology.* Translated by Bernard R. Ortiz de Montellano and Thelma Ortiz de Montellano. Albuquerque: University of New Mexico Press, 1993.

———. "El Núcleo Duro, la Cosmovisión y la Tradición Mesoamericana." In *Cosmovisión, Ritual e Identidad de los Pueblos Indígenas de México*, edited by Johanna Broda and Félix Báez-Jorge, 47–65. Mexico City: Consejo Nacional para la Cultura y las Artes/Fondo de Cultura Económica, 2001.

———. *Tamoanchan, Tlalocan: Places of Mist.* Translated by Bernard R. Ortiz de Montellano and Thelma Ortiz de Montellano. Boulder: University Press of Colorado, 1997.

López Austin, Alfredo, and Leonardo López Luján. *Monte Sagrado, Templo Mayor.* Mexico City:

Universidad Nacional Autónoma de México, 2009.

López García, Julián. *Kumix: La Lluvia en la Mitología y el Ritual Maya-Ch'orti'.* Guatemala City: Cholsamaj, 2010.

———. "Restricciones Culturales en la Alimentación de los Mayas-Chortis y Ladinos del Oriente de Guatemala." 2 vols. PhD diss., Universidad Complutense, Madrid, 2002. http://eprints.ucm.es/2397/1/AH0021201.pdf.

Lothrop, Samuel K. *Atitlán: An Archaeological Study of Ancient Remains on the Borders of Lake Atitlán, Guatemala.* Washington D.C.: Carnegie Institution of Washington, 1933.

Lounsbury, Floyd G. "The Identities of the Mythological Figures in the 'Cross Group' of Inscriptions at Palenque." In *Fourth Palenque Round Table, 1980,* edited by Merle Greene Robertson and Elizabeth Benson, 45–58. San Francisco: Pre-Columbian Art Research Institute, 1985.

———. "The Inscription on the Sarcophagus Lid at Palenque." In *Primera Mesa Redonda de Palenque,* pt. 2, edited by Merle Greene Robertson, 5–19. Pebble Beach, Calif.: Robert Louis Stevenson School, 1974.

———. "Some Problems in the Interpretation of the Myhtological Portion of the Hieroglyphic Text of the Temple off the Cross at Palenque." In *Third Palenque Round Table, 1978,* pt. 2, edited by Merle Greene Robertson, 99–115. Austin: University of Texas Press, 1980.

Lowe, Gareth W. "Izapa Religion, Cosmology, and Ritual." In *Izapa: An Introduction to the Ruins and Monuments,* by Gareth W. Lowe, Thomas A. Lee, and Eduardo Martínez Espinosa, 269–306. Provo, Utah: Brigham Young University, 1982.

Lumholtz, Carl. *Unknown Mexico.* New York: Charles Scribner, 1902. Reprint, Glorieta, N.M.: Río Grande, 1973.

Lupo, Alessandro. "El Sol en Jerusalén." *La Palabra y el Hombre: Revista de la Universidad Veracruzana* 80 (1991): 197–206.

———. "El Vientre que Nutre y Devora: Representaciones de la Tierra en la Cosmología de los Huaves del Istmo de Tehuantepec." In *Anuario 2002,* 357–79. Tuxtla Gutiérrez, Chiapas, Mexico: Centro de Estudios Superiores de México y Centro América, 2004.

Malotki, Ekkehart. "The Story of the 'Tsimonmamant' or Jimson Weed Girls: A Hopi Narrative Featuring the Motif of the Vagina Dentata." In *Smoothing the Ground: Essays on Native American Oral Literature,* edited by Brian Swann, 204–20. Berkeley: University of California Press, 1983.

Martin, Simon. "The Baby Jaguar: An Exploration of Its Identity and Origin in Maya Art and Writing." In *La Organización Social entre los Mayas: Memoria de la Tercera Mesa Redonda de Palenque,* vol. 1, edited by Vera Tiesler Blos, Rafael Cobos, and Merle Greene Robertson, 49–78. Mexico City: Instituto Nacional de Antropología e Historia, 2002.

———. "Cacao in Ancient Maya Religion: First Fruit from the Maize Tree and other Tales from the Underworld." In *Chocolate in Mesoamerica: A Cultural History of Cacao,* edited by Cameron L. McNeil, 154–83. Gainesville: University Press of Florida, 2006.

Martin, Simon, and Nikolai Grube. *Chronicle of the Maya Kings and Queens.* London: Thames and Hudson, 2008.

Matadamas Díaz, Raúl. "Jaltepetongo, Tumba 1." In *La Pintura Mural Prehispánica en México III: Oaxaca Tomo II, Catálogo,* edited by Beatriz de la Fuente and Bernd Fahmel Beyer, 392–409. Mexico City: Universidad Nacional Autónoma de México, 2005.

Mathews, Peter. "Notes on the Inscription on the Back of Dos Pilas Stela 8." In *The Decipherment of Ancient Maya Writing,* edited by Stephen D. Houston, Oswaldo Chinchilla Mazariegos, and David Stuart, 394–415. Norman: University of Oklahoma Press, 2001.

———. *The Sculpture of Yaxchilan.* PhD diss., Yale University, 1988.

Mathews, Peter, and John S. Justeson. "Patterns of Sign Substitution in Maya Hieroglyphic Writing: 'The Affix Cluster.'" In *Phoneticism in Mayan Hieroglyphic Writing,* Institute of Mesoamerican Studies Publication No. 9, edited by John S. Justeson and Lyle Campbell, 185–231. Albany: State University of New York, 1984.

Matos Moctezuma, Eduardo. "Tlaltecuhtli, Señor de la Tierra." *Estudios de Cultura Nahuatl* 27 (1997): 15–40.

Matos Moctezuma, Eduardo, and Leonardo López Luján. *Escultura Monumental Mexica.* Mexico City: Fondo de Cultura Económica, 2012.

Maudslay, Alfred P. *Biologia Centrali-Americana, or, Contributions to the Knowledge of the Fauna and Flora of Mexico and Central America: Archaeology.* 4 vols. Edited by Frederick DuCane Godman and Osbert Salvin. London: R. H. Porter and Dulau, 1889–1902.

Maxwell, Judith M. "Yarns Spun by Ixils." In *Mayan Texts III,* International Journal of American Linguistics, Native American Texts Series, Monograph 5, edited by Louanna Furbee, 60–68.

Chicago: University of Chicago Press, 1980.

Maxwell, Judith M., and Robert M. Hill II, eds. *Kaqchikel Chronicles: The Definitive Edition.* Austin: University of Texas Press, 2006.

Mayén de Castellanos, Guisela. "Análisis Estructural de un Mito Kekchi 'Historia del Sol y de la Luna.'" *Cultura de Guatemala* 1 (1980): 127–55.

Mayers, Marvin. *Pocomchí Texts, with Grammatical Notes.* Norman, Okla.: Summer Institute of Linguistics, 1958.

McCafferty, Sharisse D., and Geoffrey G. McCafferty. "Engendering Tomb 7 at Monte Alban: Respinning and Old Yarn." *Current Anthropology* 35 (1994): 143–66.

——. "The Metamorphosis of Xochiquetzal: A Window on Womanhood in Pre- and Post-Conquest Mexico." In *Manifesting Power: Gender and the Interpretation of Power in Archaeology*, edited by Tracey L. Sweely, 103–25. London: Routledge, 1999.

——. "Spinning and Weaving as Female Gender Identity in Post-Classic Mexico." In *Textile Traditions in Mesoamerica and the Andes*, edited by Margot B. Schevill, Janet C. Berlo, and Edward B. Dwyer, 19–44. Austin: University of Texas Press, 1991.

McIntosh, John. "Cosmogonía Huichol." *Tlalocan* 3, no. 1 (1949): 14–21.

Megged, Amos. "'Right from the Heart': Indian's Idolatry in Mendicant Preachings in Sixteenth-Century Mesoamerica." *History of Religions* 35 (1995): 61–82.

Mendelson, E. Michael. *Los Escándalos de Maximón.* Guatemala City: Seminario de Integración Social Guatemalteca, 1965.

Mendieta, Jerónimo de. *Historia Eclesiástica Indiana.* 2 vols. Edited by Francisco Solano y Pérez-Lila. Biblioteca de Autores Españoles 260–61. Madrid: Ediciones Atlas, 1973.

Merrifield, William R. "When the Sun Rose for the First Time: A Chinantec Creation Myth." *Tlalocan* 5, no. 3 (1967): 193–97.

Metz, Brent. *Ch'orti' Maya Survival in Eastern Guatemala.* Albuquerque: University of New Mexico Press, 2006.

Milbrath, Susan. *Star Gods of the Maya: Astronomy in Art, Folklore, and Calendars.* Austin: University of Texas Press, 1999.

Millán, Saúl. *El Cuerpo de la Nube: Jerarquía y Simbolismo Ritual en la Cosmovisión de un Pueblo Huave.* Mexico City: Instituto Nacional de Antropología e Historia, 2007.

Miller, Jeffrey H. "Notes on a Stelae Pair Probably from Calakmul, Campeche, Mexico." In *Primera Mesa Redonda de Palenque*, pt. 1, edited by Merle Greene Robertson, 149–62. Pebble Beach, Calif.: Robert Louis Stevenson School, 1974.

Miller, Mary. *The Art of Mesoamerica, From Olmec to Aztec.* 5th ed. London: Thames and Hudson, 2012.

——. "The History of the Study of Maya Vase Painting." In *The Maya Vase Book: A Corpus of Rollout Photographs of Maya Vases*, by Justin Kerr, vol. 1, 128–45. New York: Kerr Associates, 1989.

——. "The Meaning and Function of the Main Acropolis, Copan." In *The Southeast Classic Maya Zone*, edited by Elizabeth Hill Boone and Gordon R. Willey, 149–94. Washington, D.C.: Dumbarton Oaks, 1988.

——. "Rethinking Jaina: Goddesses, Skirts, and the Jolly Roger." *Record of the Art Museum, Princeton University* 64 (2005): 63–70.

Miller, Mary, and Stephen D. Houston. "The Classic Maya Ballgame and Its Architectural Setting." *Res: Anthropology and Aesthetics* 14 (1987): 46–65.

Miller, Mary, and Simon Martin. *Courtly Art of the Ancient Maya.* New York: Thames and Hudson, 2004.

Miller, Mary, and Karl Taube. *The Gods and Symbols of Ancient Mexico and the Maya.* London: Thames and Hudson, 1997.

Miller, Walter. *Cuentos Mixes.* Mexico City: Instituto Nacional Indigenista, 1956.

Moedano N., Gabriel. "El Temazcal y su Deidad Protectora en la Tradición Oral." *Boletín del Departamento de Investigación de las Tradicions Populares* 4 (1977): 5–32.

Molina, Alonso de. *Aqui Comiença Vn Vocabulario en la Lengua Castellana y Mexicana.* Mexico, 1555. Modern transcription: http://www.mesolore.org/viewer/viewbook/3/The-Molina-Vocabulario.

——. *Vocabulario en Lengua Castellana y Mexicana.* Mexico City: Antonio de Spinosa, 1571.

Monaghan, John D. *The Covenants with Earth and Rain: Exchange, Sacrifice, and Revelation in Mixtec Sociality.* Norman: University of Oklahoma Press, 1995.

——. "Physiology, Production, and Gender Difference: The Evidence from Mixtec and Other Mesoamerican Societies." In *Gender in Pre-Hispanic America*, edited by Cecelia F. Klein, 285–304. Washington, D.C.: Dumbarton Oaks, 2001.

——. "Theology and History in the Study of Mesoamerican Religions." In *Supplement to the Handbook of Middle American Indians*, vol. 6, *Ethnology*, edited by John D. Monaghan, 24–49.

Austin: University of Texas Press, 2000.

Monaghan, John, and Byron Hamann. "Reading as Social Practice and Cultural Construction." *Indiana Journal of Spanish Literatures* 13 (1998): 131–40.

Mondragón, Lucila, Jacqueline Tello, and Argelia Valdez. *Relatos Huicholes: Wixarika' Ɨxatsikayari.* Lenguas de México 11. Mexico City: Consejo Nacional para la Cultura y las Artes, 1995.

———. *Relatos Tzotziles: A 'yej lo'il ta sot'ilk 'op.* Lenguas de México 10. Mexico City: Consejo Nacional para la Cultura y las Artes, 1995.

Monjarás Ruiz, Jesús, ed. *Mitos Cosmogónicos del México Indígena.* Mexico City: Instituto Nacional de Antropología e Historia, 1987.

Monod-Becquelin, Aurore, and Alain Breton. "Le Carnaval de Bachajón." *Journal de la Societé des Américanistes* 62 (1973): 89–130.

Montoliú Villar, María. *Cuando los Dioses Despertaron: Conceptos Cosmológicos de los Antiguos Mayas de Yucatán Estudiados en el Chilam Balam de Chumayel.* Mexico City: Universidad Nacional Autónoma de México, 1989.

———. "Un Mito del Origen de las Enfermedades en Izamal, Yucatán (Análisis Social de Sus Símbolos y Contenido Social)." In *Historia de la Religión en Mesoamérica y Áreas Afines: II Coloquio,* edited by Barbro Dahlgren de Jordán, 81–88. Mexico City: Universidad Nacional Autónoma de México, 1990.

Morales Fernández, Jesús. "Algunos Mitos del Diluvio en Mesoamérica." In *XIII Mesa Redonda: Balance y Perspectiva de la Antropología de Mesoamérica y del Norte de México,* 303–14. Mexico City: Sociedad Mexicana de Antropología, 1975.

Moreno de los Arcos, Roberto. "Los Cinco Soles Cosmogónicos." *Estudios de Cultura Nahuatl* 7 (1967): 183–210.

Morley, Sylvanus G. *An Introduction to the Study of the Maya Hieroglyphs.* 1915. Reprint, New York: Dover, 1975.

Münch Galindo, Guido. "Acercamiento al Mito y Sus Creadores." *Anales de Antropología* 29 (1992): 285–99.

———. *Etnología del Istmo Veracruzano.* Mexico City: Universidad Nacional Autónoma de México, 1983.

Nájera C., Martha Ilia. "Imágenes del Inframundo en las Danzas Rituales." *Estudios Mesoamericanos* 3–4 (2001–2): 134–41.

Navarrete, Carlos. "Cuentos del Soconusco, Chiapas." In *Summa Anthropologica en Homenaje a Roberto J. Weitlaner,* 421–28. Mexico City: Instituto Nacional de Antropología e Historia, 1966.

———. *Relatos Mayas de Tierras Altas sobre el Origen del Maíz: Los Caminos de Paxil.* Mexico City: Universidad Nacional Autónoma de México, 2002.

Neff, Hector. "Sources of Raw Material Used in Plumbate Pottery." In *Incidents of Archaeology in Central America and Yucatan: Essays in Honor of Edwin M. Shook,* edited by Michael Love, Marion P. Hatch, and Hector Escobedo, 217–31. Lanham, Md.: University Press of America, 2002.

Neurath, Johannes. "The Ambivalent Character of Xurawe: Venus-Related Ritual and Mythology among West Mexican Indians." *Archaeoastronomy* 19 (2005): 74–102.

Neurath, Johannes, and Arturo Gutiérrez. "Mitología y Literatura del Gran Nayar (Coras y Huicholes)." In *Flechadores de Estrellas: Nuevas Aportaciones a la Etnología de Coras y Huicholes,* edited by Jesús Jáuregui and Johannes Neurath, 289–337. Mexico City: Instituto Nacional de Antropología e Historia/Universidad de Guadalajara, 2003.

Nicholson, Henry B. "Preclassic Mesoamerican Iconography from the Perspective of the Post-classic: Problems in Interpretational Analysis." In *Origins of Religious Art and Iconography in Preclassic Mesoamerica,* edited by H. B. Nicholson, 157–75. Los Angeles: UCLA Latin American Center Publications/Ethnic Arts Council of Los Angeles, 1976.

———. "Religion in Pre-Hispanic Mexico." In *Handbook of Middle American Indians,* vol. 10, *The Archaeology of Northern Mesoamerica,* pt. 1, edited by Gordon F. Ekholm and Ignacio Bernal, 395–446. Austin: University of Texas Press, 1971.

Nielsen, Jesper, and Christophe Helmke. *The Fall of the Great Celestial Bird: A Master Myth in Early Classic Central Mexico.* Ancient America 13. Austin: Mesoamerica Center, University of Texas, 2015.

Norman, V. Garth. *Izapa Sculpture,* pt. 2, *Text.* Papers of the New World Archaeological Foundation 30. Provo, Utah: Brigham Young University, 1976.

Ochoa Peralta, María Angela. "Las Aventuras de Dhipaak o Dos Facetas del Sacrificio en la Mitología de los Teenek (Huastecos)." *Dimensión Antropológica* 20 (2000). http://www.dimensionan-tropologica.inah.gob.mx/?p=951.

———. "Significado de Algunos Nombres de Deidad y de Lugar Sagrado entre los Teenek Potosinos." *Estudios de Cultura Maya* 23 (2003): 73–94.

Ojer Taq Tzijonik Mayab' taq komon Ch'ab'äl rech paxil Kayala'/Tradición oral comunidades lingüísticas mayas de Guatemala. Guatemala City: Academia de

Lenguas Mayas de Guatemala, 2006.

Olguín, Enriqueta. "Cómo Nació Chicomexóchitl." In *Huasteca II: Prácticas Agrícolas y Medicina Tradicional: Arte y Sociedad: Selección de Trabajos Pertenecientes al V y VI Encuentros de Investigadores de la Huasteca,* edited by Jesús Ruvalcaba y Graciela Alcalá, 115–39. Mexico City: Centro de Investigaciones y Estudios Superiores en Antropología Social, 1993.

Olivier, Guilhem. *Cacería, Sacrificio y Poder en Mesoamérica: Tras las Huellas de Mixcóatl, "Serpiente de Nube."* Mexico City: Fondo de Cultura Económica, 2015.

——. "Tlantepuzilama: Las Peligrosas Andanzas de Una Deidad con Dientes de Cobre en Mesoamérica." *Estudios de Cultura Nahuatl* 36 (2005): 245–71.

——. "Venados Melómanos y Cazadores Lúbricos: Cacería, Música y Erotismo en Mesoamérica." *Estudios de Cultura Nahuatl* 47 (2013): 121–68.

Oropeza Escobar, Minerva. "Mitos Cosmogónicos de las Culturas Indígenas de Veracruz." In *Relatos Ocultos en la Niebla y el Tiempo: Selección de Mitos y Estudios,* edited by Blas Román Castellón Huerta, 163–259. Mexico City: Instituto Nacional de Antropología e Historia, 2007.

Palomino, Aquiles. "Patrones Matrimoniales entre los Ixiles de Chajul." *Guatemala Indígena* 7 (1972): 5–159.

Panofsky, Erwin. *Renaissance and Renascences in Western Art.* New York: Harper and Row, 1972.

——. *Studies in Iconology: Humanistic Themes in the Art of the Renaissance.* New York: Harper and Row, 1962.

Parsons, Elsie Clews. "Zapoteca and Spanish Tales from Mitla, Oaxaca." *Journal of American Folklore* 45 (1932): 277–317.

Parsons, Lee A., John B. Carlson, and Peter David Joralemon. *The Face of Ancient America: The Wally and Brenda Zollman Collection of Precolumbian Art.* Indianapolis: Indianapolis Museum of Art, 1988.

Paul, Benjamin D. "Symbolic Sibling Rivalry in a Guatemalan Village." *American Anthropologist* New Series 52 (1950): 205–18.

Paul, Lois. "The Mastery of Work and the Mystery of Sex in a Guatemalan Village." In *Woman, Culture, and Society,* edited by Michelle Zimbalist Rosaldo and Louise Lamphere, 281–99. Palo Alto, Calif.: Stanford University Press, 1974.

Paul, Lois, and Benjamin D. Paul. "Changing Marriage Patterns in a Highland Guatemalan Community." *Southwestern Journal of Anthropology* 19 (1963): 131–48.

——. "The Maya Midwife as a Sacred Specialist: A Guatemalan Case." *American Ethnologist* 2 (1975): 707–26.

Pérez Martínez, Vitalino. *Leyenda Maya Ch'orti'.* Guatemala City: Proyecto Lingüístico Francisco Marroquín, 1996.

Pérez Moreno, Froylán. *Xujun Én Ntáxjo: Narraciones Mazatecas con Glosario Mazateco de Jalapa de Díaz y Español.* Mexico City: Instituto Lingüístico de Verano, 2009.

Pérez Suárez, Tomás. "Los Olmecas y los Dioses del Maíz en Mesoamérica." In *De Hombres y Dioses,* edited by Xavier Noguez and Alfredo López Austin, 15–49. Toluca, Mexico: Gobierno del Estado de México, 2013.

Petrich, Perla. *La Alimentación Mochó: Acto y Palabra (Estudio Etnolingüístico).* San Cristóbal de Las Casas, Chiapas, Mexico: Universidad Autónoma de Chiapas, 1985.

Petrich, Perla, and Carlos Ochoa García, eds. *Tzijonïk: Cuentos del Lago.* Guatemala City: Cholsamaj, 2003.

Pohl, Mary. "Ritual Continuity and Transformation in Mesoamerica: Reconstructing the Ancient Maya Cuch Ritual." *American Antiquity* 46 (1981): 513–29.

Portal, María Ana. *Cuentos y Mitos en una Zona Mazateca.* Mexico City: Instituto Nacional de Antropología e Historia, 1986.

Powell, Mary Lucas, and Della Collins Cook, eds. *The Myth of Syphilis: The Natural History of Treponematosis in North America.* Gainesville: University Press of Florida, 2005.

Prechtel, Martin. *Grandmother Sweat Bath.* Santa Fe: Weaselsleeves, 1990.

Preuss, Mary H. *Gods of the Popol Vuh: Xmukane', K'ucumatz, Tojil, and Jurakan.* Culver City, Calif.: Labyrinthos, 1988.

Prufer, Keith M., and James E. Brady, eds. *Stone Houses and Earth Lords: Maya Religion in the Cave Context.* Boulder: University Press of Colorado, 2005.

Pury-Toumi, Sybille de. *De Palabras y Maravillas: Ensayo Sobre la Lengua y Cultura de los Nahuas (Sierra Norte de Puebla).* Mexico City: Consejo Nacional para la Cultura y las Artes, 1997.

Quenon, Michel, and Geneviève Le Fort. "Rebirth and Resurrection in Maize God Iconography." In *The Maya Vase Book: A Corpus of Rollout Photographs of Maya Vases,* by Justin Kerr, vol. 5, 884–99. New York: Kerr Associates, 1997.

Quezada, Noemí. *Amor y Magia Amorosa entre los Aztecas.* Mexico City: Universidad Nacional Autónoma de México, 1989.

Quilter, Jeffrey. "The Moche Revolt of the Objects."

Latin American Antiquity 1 (1990): 42–65.

———. "The Narrative Approach to Moche Iconography." *Latin American Antiquity* 8 (1997): 113–33.

Quiñones Keber, Eloise. *Codex Telleriano-Remensis: Ritual, Divination, and History in a Pictorial Aztec Manuscript.* Austin: University of Texas Press, 1995.

Quiroa, Nestor Iván. "The Popol Vuh and the Dominican Religious Extirpation in Highland Guatemala: Prologues and Annotations of Fr. Francisco Ximénez." *The Americas* 67 (2011): 467–94.

Raynaud, Georges, ed. *Les Dieux, les Héros et les Hommes de l'Ancien Guatemala, D'après le Livre du Conseil.* Paris: Éditions Ernest Leroux, 1925.

Recinos, Adrián, ed. *Crónicas Indígenas de Guatemala.* Guatemala City: Editorial Universitaria, 1957.

———. *Popol Vuh. Las Antiguas Historias del Quiché.* Mexico City: Fondo de Cultura Económica, 1984.

Redfield, Robert. "Notes on San Antonio Palopó," 1945. Microfilm Collection of Manuscripts of Middle American Cultural Anthropology, no. 4. University of Chicago Library.

Reents-Budet, Dorie. "Elite Maya Pottery and Artisans as Social Indicators." In *Craft and Social Identity,* vol. 8, edited by C. L. Costin and R. P. Wright, 71–89. Arlington, Va.: American Anthropological Association, 1998.

———. "Feasting among the Classic Maya: Evidence from the Pictorial Ceramics." In *The Maya Vase Book: A Corpus of Rollout Photographs of Maya Vases,* by Justin Kerr, vol. 6, 1022–38. New York: Kerr Associates, 2000.

———. "The 'Holmul Dancer' Theme in Maya Art." In *Sixth Palenque Round Table, 1986,* edited by Merle Greene Robertson and Virginia Fields, 217–22. Norman: University of Oklahoma Press, 1991.

Relatos Huastecos: An T'ilabti Tenek. Lenguas de México 4. Mexico City: Consejo Nacional para la Cultura y las Artes, 1994.

Relatos Tzeltales y Tzotziles. Mexico City: Consejo Nacional para la Cultura y las Artes, Dirección General de Culturas Populares/Editorial Diana, 1994.

Remesal, Antonio de. *Historia General de las Indias Occidentales y Particular de la Gobernación de Chiapa y Guatemala.* Vol. 1. Edited by Carmelo Sáenz de Santa María. Biblioteca de Autores Españoles 175. Madrid: Ediciones Atlas, 1964.

Rita, Carla. "Concepción y Nacimiento." In *Los Huaves de San Mateo del Mar,* edited by Italo Signorini, 263–314. Mexico City: Instituto Nacional Indigenista, 1979.

Rivera Dorado, Miguel. "¿Influencia del Cristianismo en el Popol Vuh?" *Revista Española de Antropología Americana* 30 (2000): 137–62.

Robertson, Merle Greene. "The Celestial God of Number 13." *PARI Journal* 12, no. 1 (2011): 1–6.

———. *The Sculpture of Palenque.* Vol. 4, *The Cross Group, the North Group, the Olvidado, and Other Pieces.* Princeton, N.J.: Princeton University Press, 1991.

Robicsek, Francis, and Donald M. Hales. *The Maya Book of the Dead: The Ceramic Codex: The Corpus of Codex Style Ceramics of the Late Classic Period.* Charlottesville: University of Virginia Art Museum, 1981.

Roys, Ralph. *The Book of Chilam Balam of Chumayel.* Norman: University of Oklahoma Press, 1967.

Rubel, Arthur J. "Two Tzotzil Tales from San Bartolomé de los Llanos (Venustiano Carranza), Chiapas." *América Indígena* 24, no. 1 (1964): 49–57.

Ruiz de Alarcón, Hernando. *Treatise on the Heathen Superstitions and Customs That Today Live among the Indians Native to This New Spain, 1629.* Translated and edited by J. Richard Andrews and Ross Hassig. Norman: University of Oklahoma Press, 1984.

Rupp, James E., and Nadine Rupp, eds. *Ozumacín Chinantec Texts.* Dallas: Summer Institute of Linguistics, 1994.

Sahagún, Bernardino de. *Florentine Codex, General History of the Things of New Spain.* 13 vols. Edited by Arthur J. O. Anderson and Charles E. Dibble. Santa Fe: School of American Research, 1950–82.

Sam Colop, Luis Enrique, ed. *Popol Wuj.* Guatemala City: F y G Editores, 2011.

Sandstrom, Alan R. "The Cave-Pyramid Complex among the Contemporary Nahua of Northern Veracruz." In *In the Maw of the Earth Monster: Mesoamerican Ritual Cave Use,* edited by James E. Brady and Keith M. Prufer, 35–68. Austin: University of Texas Press, 2005.

———. "El Nene Lloroso y el Espírituo Nahua del Maíz: El Cuerpo Humano como Símbolo Clave en la Huasteca Veracruzana." In *Nuevos Aportes al Conocimiento de la Huasteca: Selección de Trabajos Pertenecientes al VIII Encuentro de Investigadores de la Huasteca,* edited by J. Ruvalcaba Mercado, 59–94. Mexico City: Centro de Investigaciones y Estudios superiores en Antropología Social, 1998.

Sandstrom, Alan R., and Arturo Gómez Martínez. "Petición a Chicomexóchitl: Un Canto al Espíritu del Maíz por la Chamana Nahua Silveria

Hernández Hernández." In *La Huasteca, un Recorrido por su Diversidad*, 343–65. Mexico City: Centro de Investigaciones y Estudios Superiores en Antropología Social, El Colegio de San Luis, El Colegio de Tamaulipas, 2004.

Sandstrom, Pamela Effrein, and Alan R. Sandstrom. "Those Who Were Lost a Long Time Ago: Nahuatl Collection." Archive of the Indigenous Languages of Latin America, resource NAWA001R012. University Libraries, the University of Texas at Austin.

Saturno, William A., Karl A. Taube, and David Stuart. *The Murals of San Bartolo, El Petén, Guatemala*, pt. 1, *The North Wall*. Ancient America 7. Barnardsville, N.C.: Center for Ancient American Studies, 2005.

Schackt, Jon. "Savage Other or Noble Ancestor? The Ch'olwinq of Q'eqchi' Maya Folklore." *Journal of Latin American Lore* 22 (2004): 3–14.

Schele, Linda. "Accession Iconography of Chan Bahlum in the Group of the Cross." In *The Art, Iconography, and Dynastic History of Palenque*, pt. 3, edited by Merle Greene Robertson, 9–34. Pebble Beach, Calif.: Robert Louis Stevenson School, 1976.

———. "The Iconography of Maya Architectural Façades during the Late Classic Period." In *Function and Meaning in Classic Maya Architecture*, edited by Stephen D. Houston, 479–517. Washington D.C.: Dumbarton Oaks, 1998.

Schele, Linda, and David Freidel. *A Forest of Kings: The Untold Story of the Ancient Maya.* New York: William Morrow, 1990.

Schele, Linda, and Mary Ellen Miller. *The Blood of Kings: Dynasty and Ritual in Maya Art.* Fort Worth, Tex.: Kimbell Art Museum, 1986.

Schellhas, Paul. *Representations of Deities in the Maya Manuscripts.* Papers of the Peabody Museum of Archaeology and Ethnology 4(1). Cambridge, Mass.: Harvard University, 1904.

Schultze-Jena, Leonhard. *Popol Vuh. Das Heilige Buch der Quiché indianer von Guatemala.* Stuttgart: W. Kohlhammer, 1944.

———. *La Vida y las Creencias de los Indígenas Quichés de Guatemala.* Guatemala City: Editorial del Ministerio de Educación Pública, 1957.

Schumann, Otto. "El Origen del Maíz (Versión K'ekchi')." In *La Etnología: Temas y Tendencias. I Coloquio Paul Kirchhoff*, 213–18. Mexico City: Instituto de Investigaciones Antropológicas, Universidad Nacional Autónoma de México, 1988.

Segre, Enzo. *Metamorfosis de lo Sagrado y lo Profano: Narrativa Náhuat de la Sierra Norte de Puebla.* Mexico City: Instituto Nacional de Antropología e Historia, 1990.

Seler, Eduard. "The Animal Pictures of the Mexican and Maya Manuscripts." In *Collected Works in Mesoamerican Linguistics and Archaeology*, vol. 5, edited by Frank Comparato, 165–340. Lancaster, Calif.: Labyrinthos, 1996.

———. "Myths and Religion of the Ancient Mexicans." In *Collected Works in Mesoamerican Linguistics and Archaeology*, vol. 5, edited by Frank Comparato, 1–99. Lancaster, Calif.: Labyrinthos, 1996.

———. "Quetzalcoatl-Kukulcan in Yucatan." In *Collected Works in Mesoamerican Linguistics and Archaeology*, vol. 1, edited by Frank Comparato, 198–218. Lancaster, Calif.: Labyrinthos, 1990.

———. "Wall Sculptures in the Temple of the Pulque Gods at Tepoztlan." In *Collected Works in Mesoamerican Linguistics and Archaeology*, vol. 4, edited by Frank Comparato, 266–80. Lancaster, Calif.: Labyrinthos, 1993.

Shaw, Mary, ed. *According to Our Ancestors: Folk Texts from Guatemala and Honduras.* Norman: Summer Institute of Linguistics of the University of Oklahoma, 1971.

Siegel, Morris. "The Creation Myth and Acculturation in Acatán, Guatemala." *Journal of American Folklore* 56 (1943): 120–26.

Sigal, Peter. *The Flower and the Scorpion: Sexuality and Ritual in Early Nahua Culture.* Durham, N.C.: Duke University Press, 2011.

———. *From Moon Goddesses to Virgins: The Colonization of Yucatecan Maya Sexual Desire.* Austin: University of Texas Press, 2000.

Slocum, Marianna C. "The Origin of Corn and Other Tzeltal Myths." *Tlalocan* 5, no. 1 (1965): 1–45.

Sparks, Garry. "Fill in the Middle Ground: Intertextuality and Inter-Religious Dialogue in 16th Century Guatemala." *Journal of Interreligious Dialogue* 5, pt. 2 (Winter 2011): 14–42.

———. "Primeros folios, folios primeros: Una breve aclaración acerca de la Theologia Indorum y su relación intertexual con el Popol Wuj." *Voces: Revista Semestral del Instituto de Lingüística e Interculturalidad* 9, no. 2 (2014): 91–142.

Spinden, Herbert J. *A Study of Maya Art: Its Subject Matter and Historical Development.* 1913. Reprint, New York: Dover, 1975.

Stanzione, Vincent. *Rituals of Sacrifice: Walking the Face of the Earth on the Sacred Path of the Sun.* Albuquerque: University of New Mexico Press, 2003.

Stephens, John L. *Incidents of Travel in Central America, Chiapas, and Yucatan.* 2 vols. 1841. Reprint, New

York: Dover, 1969.

Stiles, Neville. "The Creation of the Coxtecame, the Discovery of Corn, the Rabbit and the Moon, and Other Nahuatl Folk Narratives." *Latin American Indian Literatures Journal* 1, no. 2 (1985): 97–121.

Stöckli, Matthias. "Trumpets in Classic Maya Vase Painting: The Iconographic Identification of Instrumental Ensembles." *Music in Art* 36 (2011): 219–30.

Stone, Andrea. *Images from the Underworld: Naj Tunich and the Tradition of Maya Cave Painting.* Austin: University of Texas Press, 1995.

Stone, Andrea, and Marc Zender. *Reading Maya Art: A Hieroglyphic Guide to Ancient Maya Painting and Sculpture.* New York: Thames and Hudson, 2011.

Storey, Rebecca. "The Children of Copán: Issues in Paleopathology and Paleodemography." *Ancient Mesoamerica* 3 (1992): 161–67.

——. "Perinatal Mortality at Pre-Columbian Teotihuacan." *American Journal of Physical Anthropology* 69 (1986): 541–48.

Stresser-Péan, Guy. *El Sol-Dios y Cristo: La Cristianización de los Indios de México Vista desde la Sierra Norte de Puebla.* Mexico City: Fondo de Cultura Económica, 2011.

Stross, Brian. "Maize in Word and Image in Southeastern Mesoamerica." In *Histories of Maize: Multidisciplinary Approaches to the Prehistory, Linguistics, Biogeography, Domestication, and Evolution of Maize,* edited by John Staller, Robert Tykot, and Bruce Benz, 577–98. Walnut Creek, Calif.: Left Coast, 2006.

Stuart, David. "'The Arrival of Strangers': Teotihuacan and Tollan in Classic Maya History." In *Mesoamerica's Classic Heritage: From Teotihuacan to the Aztecs,* edited by Davíd Carrasco, Lindsay Jones, and Scott Sessions, 465–513. Boulder: University Press of Colorado, 2000.

——. "Breaking the Code: Rabbit Story." In *Lost Kingdoms of the Maya,* by George E. Stuart and Gene S. Stuart, 170–71. Washington, D.C.: National Geographic Society, 1993.

——. "'The Fire Enters His House': Architecture and Ritual in Classic Maya Texts." In *Function and Meaning in Classic Maya Architecture,* edited by Stephen D. Houston, 373–425. Washington, D.C.: Dumbarton Oaks, 1998.

——. "Hieroglyphs on Maya Vessels." In *The Maya Vase Book: A Corpus of Rollout Photographs of Maya Vases,* by Justin Kerr, vol. 1, 149–60. New York: Kerr Associates, 1989.

——. "The Hills Are Alive: Sacred Mountains in the Maya Cosmos." *Symbols* (Spring 1997): 13–17.

——. "Ideology and Classic Maya Kingship." In *A Catalyst for Ideas: Anthropological Archaeology and the Legacy of Douglas Schwartz,* edited by Vernon L. Scarborough, 257–85. Santa Fe: School of American Research Press, 2005.

——. *The Inscriptions from Temple XIX at Palenque: A Commentary.* San Francisco: Pre-Columbian Art Research Institute, 2005.

——. "Jade and Chocolate: Bundles of Wealth in Classic Maya Economics and Ritual." In *Ritual Acts of Wrapping and Binding in Mesoamerica,* edited by Julia Guernsey and F. Kent Reilly, 127–44. Barnardsville, N.C.: Boundary End Archaeology Research Center, 2006.

——. "Kinship Terms in Maya Inscriptions." In *The Language of Maya Hieroglyphs,* edited by Martha J. Macri and Anabel Ford, 1–11. San Francisco: Pre-Columbian Art Research Institute, 1997.

——. "The Language of Chocolate: References to Cacao on Classic Maya Drinking Vessels." In *Chocolate in Mesoamerica: A Cultural History of Cacao,* edited by Cameron L. McNeil, 184–201. Gainesville: University Press of Florida, 2006.

——. "The Name of Paper: The Mythology of Crowning and Royal Nomenclature on Palenque's Palace Tablet." In *Maya Archaeology 2,* edited by Charles Golden, Stephen Houston, and Joel Skidmore, 117–42. San Francisco: Precolumbia Mesoweb, 2012.

——. "On the Paired Variants of TZ'AK." Mesoweb, 2003. http://www.mesoweb.com/stuart/notes/tzak.pdf.

——. *The Order of Days: The Maya World and the Truth about 2012.* New York: Harmony, 2011.

——. "Royal Autosacrifice among the Maya: A Study in Image and Meaning." *Res: Anthropology and Aesthetics* 7/8 (1984): 6–20.

——. "The Royal Headband: A Pan-Mesoamerican Hieroglyph." Maya Decipherment: Ideas on Ancient Maya Writing and Iconography, 2015. https://decipherment.wordpress.com/2015/01/26/the-royal-headband-a-pan-mesoamerican-hieroglyph-for-ruler/.

——. "Shining Stones: Observations on the Ritual Meaning of Early Maya Stelae." In *The Place of Stone Monuments: Context, Use, and Meaning in Mesoamerica's Preclassic Transition,* edited by Julia Guernsey, John E. Clark, and Barbara Arroyo, 283–98. Washington, D.C.: Dumbarton Oaks, 2010.

——. *Sourcebook for the 30th Maya Meetings, March 14–19, 2006.* 2nd ed. Austin: Maya Meetings,

University of Texas, 2007.

——. *Ten Phonetic Syllables.* Research Reports on Ancient Maya Writing 14. Washington, D.C.: Center for Maya Research, 1987.

Stuart, David, and Stephen D. Houston. *Classic Maya Place Names.* Studies in Pre-Columbian Art and Archeology 33. Washington, D.C.: Dumbarton Oaks, 1994.

Stuart, David, and George Stuart. "Arqueología e Interpretación del Templo de las Inscripciones de Palenque, 1922–2005." In *Misterios de un Rostro Maya: La Máscara Funeraria de K'inich Janaab' Pakal de Palenque,* edited by Laura Filloy Nadal, 43–67. Mexico City: Instituto Nacional de Antropología e Historia, 2010.

——. *Palenque: Eternal City of the Maya.* London: Thames and Hudson, 2008.

Stubblefield, Morris, and Carol Stubblefield. "The Story of Läy and Gisaj: A Zapotec Sun and Moon Myth." *Tlalocan* 6, no. 1 (1969): 46–62.

Sullivan, Paul. "The Yucatec Maya." In *Supplement to the Handbook of Middle American Indians,* vol. 6, edited by John Monaghan, 207–23. Austin: University of Texas Press, 2000.

Sullivan, Thelma D. "Tlazolteotl-Ixcuina: The Great Spinner and Weaver." In *The Art and Iconography of Late Post-Classic Central Mexico,* edited by Elizabeth Hill Boone, 7–35. Washington, D.C.: Dumbarton Oaks, 1982.

Tarn, Nathaniel, and Martin Prechtel. "'Comiéndose la Fruta': Metáforas Sexuales e Iniciaciones en Santiago Atitlán." *Mesoamérica* 19 (1990): 73–82.

——. *Scandals in the House of Birds: Shamans and Priests in Lake Atitlán.* New York: Marsilio, 1997.

Taube, Karl. "Ancient and Contemporary Maya Conceptions about the Field and Forest." In *The Lowland Maya Area: Three Millennia at the Human-Wildland Interface,* edited by A. Gómez-Pompa, M. F. Allen, S. L. Fedick, and J. J. Jiménez-Osorino, 461–92. Binghampton, N.Y.: Haworth, 2003.

——. "The Ancient Yucatec New Year Festival: The Liminal Period in Maya Ritual and Cosmology." PhD diss., Yale University, 1988.

——. "The Birth Vase: Natal Imagery in Ancient Maya Myth and Ritual." In *The Maya Vase Book: A Corpus of Rollout Photographs of Maya Vases,* by Justin Kerr, vol. 4, 650–85. New York: Kerr Associates, 1994.

——. "The Classic Maya Maize God: A Reappraisal." In *Fifth Palenque Round Table, 1983,* edited by Virginia M. Fields, 171–81. San Francisco: Pre-Columbian Art Research Institute, 1985.

——. "Flower Mountain: Concepts of Life, Beauty, and Paradise among the Classic Maya." *Res: Anthropology and Aesthetics* 45 (2004): 69–98.

——. *Itzam Cab Ain: Caimans, Cosmology, and Calendrics in Postclassic Yucatan.* Research Reports on Ancient Maya Writing 26. Washington, D.C.: Center for Maya Research, 1989.

——. "The Jade Hearth: Centrality, Rulership, and the Classic Maya Temple." In *Function and Meaning in Classic Maya Architecture,* edited by Stephen D. Houston, 427–78. Washington, D.C.: Dumbarton Oaks, 1998.

——. *The Major Gods of Ancient Yucatan.* Studies in Pre-Columbian Art and Archaeology 32. Washington, D.C.: Dumbarton Oaks, 1992.

——. "The Maya Maize God and the Mythic Origins of Dance." In *The Maya and Their Sacred Narratives: Text and Context in Maya Mythologies,* Acta Mesoamericana 20, edited by Geneviève Le Fort, Raphaël Gardiol, Sebastian Matteo, and Christophe Helmke, 41–52. Markt Schwaben: Anton Saurwein, 2009.

——. *Olmec Art at Dumbarton Oaks.* Washington, D.C.: Dumbarton Oaks, 2004.

——. "The Olmec Maize God: The Face of Corn in Formative Mesoamerica." *Res: Anthropology and Aesthetics* 29/30 (1996): 39–81.

——. "Representaciones del Paraíso en el Arte Cerámico del Clásico Temprano de Escuintla, Guatemala." In *Iconografía y Escritura Teotihuacana en la Costa Sur de Guatemala y Chiapas,* U Tz'ib, Serie Reportes, vol. 1, no. 5, edited by Oswaldo Chinchilla Mazariegos and Bárbara Arroyo, 35–54. Guatemala City: Asociación Tikal, 2005.

——. *A Representation of the Principal Bird Deity in the Paris Codex.* Research Reports on Ancient Maya Writing 6. Washington, D.C.: Center for Maya Research, 1987.

——. "Ritual Humor in Classic Maya Religion." In *Word and Image in Maya Culture: Explorations in Language, Writing, and Representation,* edited by William F. Hanks and Don S. Rice, 351–82. Salt Lake City: University of Utah Press, 1989.

——. "The Symbolism of Jade in Classic Maya Religion." *Ancient Mesoamerica* 16 (2005): 23–50.

——. "The Teotihuacan Cave of Origin: The Iconography and Architecture of Emergence Mythology in Mesoamerica and the American Southwest." *Res: Anthropology and Aesthetics* 12 (1986): 51–82.

——. "The Water Lily Serpent Stucco Masks at

Caracol, Belize." In *Research Reports in Belizean Archaeology*, vol. 3, edited by John Morris, Sherilyne Jones, Jaime Awe, and Christophe Helmke, 213–23. Belmopan, Belize: Institute of Archaeology, 2006.

———. "Where Earth and Sky Meet: The Sea in Ancient and Contemporary Maya Cosmology." In *Fiery Pool: The Maya and the Mythic Sea*, edited by Daniel Finamore and Stephen D. Houston, 202–19. New Haven, Conn.: Yale University Press, 2010.

———. "The Womb of the World: The *Cuauhxicalli* and Other Offering Bowls of Ancient and Contemporary Mesoamerica." In *Maya Archaeology 1*, edited by Charles Golden, Stephen Houston, and Joel Skidmore, 86–106. San Francisco: Precolumbia Mesoweb, 2009.

Taube, Karl, William Saturno, David Stuart, and Heather Hurst. *The Murals of San Bartolo, El Petén, Guatemala*, pt. 2, *The West Wall*. Ancient America 10. Barnardsville, N.C.: Boundary End Archaeology Research Center, 2010.

Tax, Sol. "Folk Tales in Chichicastenango: An Unsolved Puzzle." *Journal of American Folklore* 62 (1949): 125–35.

Taylor, Paul. "Introduction." In *Iconography without Texts*, edited by Paul Taylor, 1–14. London: Warburg Institute; Turin: Nino Aragno Editore, 2008.

Técnicos Bilingües de la Unidad Regional de Acayucan. *Agua, Mundo, Montaña: Narrativa Nahua, Mixe y Popoluca del Sur de Veracruz*. Mexico City: Premià, 1985.

Tedlock, Dennis, ed. *Popol Vuh: The Mayan Book of the Dawn of Life*. New York: Touchstone, 1996.

Tena, Rafael, ed. *Mitos e Historias de los Antiguos Nahuas*. Mexico City: Consejo Nacional para la Cultura y las Artes, 2002.

Thompson, J. Eric S. "A Blood-Drawing Ceremony Painted on a Maya Vase." *Estudios de Cultura Maya* 1 (1961): 13–20.

———. *Ethnology of the Mayas of Southern and Central British Honduras*. Anthropological Series 17, no. 2. Chicago: Field Museum of Natural History, 1930.

———. *Maya Hieroglyphic Writing: An Introduction*. 3rd ed. Norman: University of Oklahoma Press, 1971.

———. *Maya History and Religion*. Norman: University of Oklahoma Press, 1970.

———. *The Moon Goddess in Mesoamerica with Notes on Related Deities*. Contributions to American Anthropology and History, no. 29. Washington, D.C.: Carnegie Institution, 1939.

———. *Sky Bearers, Colors, and Directions in Maya and Mexican Religion*. Contributions to American Archaeology, no. 10. Washington, D.C.: Carnegie

Institution, 1934.

Tiesler, Vera. *The Bioarchaeology of Artificial Cranial Modifications: New Approaches to Head Shaping and Its Meanings in Pre-Columbian Mesoamerica and Beyond*. New York: Springer Science and Business, 2013.

Tokovinine, Alexandre. "Carved Panel." In *Ancient Maya Art at Dumbarton Oaks*, edited by Joanne Pillsbury, Miriam Dutrieux, Reiko Ishihara-Brito, and Alexandre Tokovinine, 58–67. Washington, D.C.: Dumbarton Oaks, 2012.

Tovalín Ahumada, Alejandro, J. Adolfo Velázquez de Leon Collins, and Víctor M. Ortíz Villareal. "Cuenco de Alabastro con Decoración Incisa Procedente de Bonampak." *Mexicon* 31 (1999): 75–80.

Tozzer, Alfred M. *A Comparative Study of the Mayas and the Lacandones*. New York: Archaeological Institute of America, 1907.

Trik, Aubrey S. "The Splendid Tomb of Temple I at Tikal, Guatemala." *Expedition* 6, no. 1 (1963): 2–18.

Trik, Helen, and Michael Kampen. *The Graffiti of Tikal*. Tikal Report no. 31. Philadelphia: University of Pennsylvania, 1983.

Urcid, Javier. "An Ancient Story of Creation from San Pedro Jaltepetongo." In *Mixtec Writing and Society/Escritura de Ñuu Dzaui*, edited by Maarten Jansen and Laura van Broekhoven, 145–96. Amsterdam: Koninklijke Nederlandse Akademie van Wetenschappen, 2008.

Vail, Gabrielle, and Christine Hernández. *Re-Creating Primordial Time: Foundation Rituals and Mythology in the Postclassic Maya Codices*. Boulder: University Press of Colorado, 2013.

Valencia Rivera, Rogelio. "La Abundancia y el Poder Real: El Dios K'awiil en el Posclásico." In *De Hombres y Dioses: Creencias y Rituales Mesoamericanos y Sus Supervivencias*, edited by Katarzyna Mikulska Dabrowska and José Contel, 67–96. Warsaw: Instituto de Estudios Ibéricos e Iberoamericanos, Universidad de Varsovia, 2011.

Valencia Rivera, Rogelio, and Hugo García Capistrán. "In the Place of the Mist: Analysing a Maya Myth from a Mesoamerican Perspective." In *The Maya in a Mesoamerican Context: Comparative Approaches to Maya Studies*, Acta Mesoamericana 26, edited by Jesper Nielsen and Christophe Helmke, 35–50. Markt Schwaben, Germany: Anton Saurwein, 2013.

Valey, Alberto, and Benedicto Valey. *Tzijobal pa Kach'abal: Leyendas de Rabinal*. Guatemala City:

Instituto Lingüístico de Verano, 1979.

Van Akkeren, Ruud. "Authors of the Popol Vuh." *Ancient Mesoamerica* 14 (2003): 237–56.

———. "Fray Domingo de Vico, Maestro de Autores Indígenas." *The Mayan Studies Journal/Revista de Estudios Mayas* 2, no. 7 (2010): 1–61.

———. "How Our Mother Beloved Maiden Was Saved from an Untimely Death: A Christianized Version of the Xkik' Tale of the Popol Wuj." Report submitted to the Foundation for the Advancement of Mesoamerican Studies, 2001. http://www.famsi. org/reports/00010/index.html.

———. *Place of the Lord's Daughter: Rab'inal, Its History, Its Dance-Drama.* Leiden: CNWS, 2000.

———. *Xib'alb'a y el Nacimiento de Un Nuevo Sol: Una Visión Posclásica del Colapso Maya.* Guatemala City: Editorial Piedra Santa, 2012.

Van der Loo, Peter L. *Códices, Costumbres, Continuidad: Un Estudio de la Religión Mesoamericana.* Leiden: Archeologisch Centrum R. U. Leiden, 1987.

Van 't Hooft, Anuschka, and José Cerda Zepeda. *Lo que Relatan de Antes: Kuentos Tének y Nahuas de la Huasteca.* Pachuca de Soto, Hidalgo, Mexico: Programa de Desarrollo Cultural de la Huasteca, 2003.

Vargas de la Peña, Leticia, and Víctor R. Castillo Borges. "La Pintura Mural Prehispánica en Ek' Balam, Yucatán." In *La Pintura Mural Prehispánica en México,* vol. 2, *Área Maya, Tomo IV,* edited by Beatriz de la Fuente and Leticia Staines Cicero, 403–18. Mexico City: Universidad Nacional Autónoma de México, 2001.

Vega Fallas, Alejandra. "Variantes del Mito del Origen de la Menstruación (A 1335) en Pueblos Indígenas Sudamericanos." *Filología y Lingüística* 25 (1999): 73–88.

Velásquez, Primo Feliciano, ed. *Códice Chimalpopoca, Anales de Cuauhtitlán y Leyenda de los Soles.* Mexico City: Universidad Nacional Autónoma de México, 1975.

Velásquez Gallardo, Pablo. "Dioses Tarascos de Charapan." *Revista Mexicana de Estudios Antropológicos* 9 (1947): 79–106.

Velásquez García, Erik. "Los Dioses Remeros Mayas y Sus Posibles Contrapartes Nahuas." In *The Maya and Their Neighbors: Internal and External Contacts through Time,* edited by Laura van Broekhoven, Rogelio Valencia Rivera, Benjamin Vis, and Frauke Sachse, 115–31. Markt Schwaben, Germany: Verlag Anton Saurwein, 2010.

———. "The Maya Flood Myth and the Decapitation of the Cosmic Caiman." *PARI Journal* 7, no. 1 (2006):

1–10.

Villa Rojas, Alfonso. "Prólogo." In *Mayas y Lacandones: Un Estudio Comparativo,* by Alfred M. Tozzer. Mexico City: Instituto Nacional Indigenista, 1982.

Villela Flores, Samuel, and Valentina Glockner. "De Gemelos, Culebras y Tesmósforos: Mitología en la Montaña de Guerrero." In *Creando Mundos, Entrelazando Realidades: Cosmovisiones y Mitologías en el México Indígena,* vol. 1, edited by Catharine Good Eshelman and Marina Alonso Bolaños, 227–340. Mexico City: Instituto Nacional de Antropología e Historia, 2015.

Vogt, Evon Z. "Ancient Maya Concepts in Contemporary Zinacantan Religion." In *VIe Congrès Internationale des Sciences Anthropologiques et Ethnologiques, Paris 30 Juillet–6 Août 1960,* vol. 2, 497–502. Paris: Musée de l'Homme, 1964.

———. *Tortillas for the Gods: A Symbolic Analysis of Zinacanteco Rituals.* Cambridge, Mass.: Harvard University Press, 1976.

Vogt, Evon Z., and Victoria R. Bricker. "The Zinacanteco Fiesta of San Sebastian: An Essay in Ethnographic Interpretation." *Res: Anthropology and Aesthetics* 29/30 (1996): 203–22.

Vogt, Evon Z., and David Stuart. "Some Notes on Ritual Caves among the Ancient and Modern Maya." In *In the Maw of the Earth Monster: Mesoamerican Ritual Cave Use,* edited by James E. Brady and Keith M. Prufer, 155–85. Austin: University of Texas Press, 2005.

Wagley, Charles. *The Social and Religious Life of a Guatemalan Village.* Menasha, Wis.: American Anthropological Association, 1949.

Webster, David, Barbara Fash, Randolph Widmer, and Scot Zeleznik. "The Skyband Group: Investigation of a Classic Maya Elite Residential Compound at Copán, Honduras." *Journal of Field Archaeology* 25 (1998): 319–43.

Weitlaner, Roberto J., ed. *Relatos, Mitos, y Leyendas de la Chinantla.* Mexico City: Consejo Nacional para la Cultura y las Artes, 1977.

Weitlaner, Roberto J., and Carlo Antonio Castro. *Usila, Morada de Colibries.* Papeles de la Chinantla, vol. 7. Mexico City: Museo Nacional de Antropología, 1973.

Weitlaner Johnson, Irmgard, and Jean Basset Johnson. "Un Mito y los Mazatecas." *Revista Mexicana de Estudios Antropológicos* 3 (1939): 217–26.

Weitzmann, Kurt. *Illustrations in Roll and Codex: A Study of the Origin and Method of Text Illustration.*

Princeton, N.J.: Princeton University Press, 1947.

Whittaker, Arabelle, and Viola Warkentin. *Chol Texts on the Supernatural.* Norman: Summer Institute of Linguistics of the University of Oklahoma, 1965.

Williams García, Roberto. *Mitos Tepehuas.* Mexico City: Secretaría de Educación Pública, 1972.

Wilson, Richard. *Resurgimiento Maya en Guatemala (Experiencias Q'eqchi'es).* Guatemala City: Centro de Investigaciones Regionales de Mesoamérica, 1999.

Wired Humanities Project. "Nahuatl Dictionary." University of Oregon, 2015. http://whp.uoregon.edu/dictionaries/nahuatl/.

Wisdom, Charles. *The Chorti Indians of Guatemala.* Chicago: University of Chicago Press, 1940.

Woodfill, Brent K. S., Stanley Guenter, and Mirza Monterroso. "Changing Patterns of Ritual Activity in an Unlooted Cave in Central Guatemala." *Latin American Antiquity* 23 (2012): 93–119.

Woodford, Susan. *Images of Myths in Classical Antiquity.* Cambridge: Cambridge University Press, 2003.

Woodruff, John M. "The 'Most Futile and Vain' Work of Father Francisco Ximénez: Rethinking the Context of the Popol Vuh." PhD diss., University of Alabama, Tuscaloosa, 2009.

Ximénez, Francisco. *Historia de la Provincia de San Vicente de Chiapa y Guatemala de la Orden de Predicadores, Libros I y II.* Edited by Carmelo Sáenz de Santa María. Guatemala City: Academia de Geografía e Historia, 1977.

———. *Primera Parte del Tesoro de las Lenguas Cakchiquel, Quiché y Zutuhil, en que las Dichas Lenguas Se Traducen a la Nuestra Española.* Edited by Carmelo Sáenz de Santa María. Guatemala City: Academia de Geografía e Historia, 1985.

Yurchenko, Henrietta. "Música de los Mayas-Quichés de Guatemala: El Rabinal-Achi y el Baile de Canastas." *Tradiciones de Guatemala* 66 (2006): 83–98.

Zender, Marc. "On the Reading of Three Classic Maya Portrait Glyphs." *PARI Journal* 15, no. 2 (2014): 1–14.

———. "The Raccoon Glyph in Classic Maya Writing." *PARI Journal* 5, no. 4 (2005): 6–16.

———. "Teasing the Turtle from Its Shell: Ahk and Mahk in Maya Writing." *PARI Journal* 6, no. 3 (2005): 1–14.

Zender, Marc, and Joel Skidmore. "Unearthing the Heavens: Classic Maya Murals and Astronomical Tables at Xultún, Guatemala." Mesoweb, 2012. http://www.mesoweb.com/reports/Xultun.pdf.

Zingg, Robert M. *Los Huicholes, Una Tribu de Artistas.* 2 vols. Mexico City: Instituto Nacional Indigenista, 1982.

ILLUSTRATION CREDITS

Figs. 1, 13, 40, 42, 76, 90, 125; Page 184. Photos: Nicholas Hellmuth, copyright © Dumbarton Oaks, Pre-Columbian Collection, Washington, D.C.

Figs. 2, 3b, 6, 8–10, 20, 31b, 32, 34, 36, 41, 43, 45, 49, 54, 56, 65, 77b, 78, 81, 86, 88, 91b–c, 92, 97b–c, 106, 107, 109, 111, 115, 121, 126, 131. Drawings: Oswaldo Chinchilla.

Fig. 3a. Drawing: Oswaldo Chinchilla, after Thompson, *Moon Goddess*.

Figs. 4, 5, 11, 21, 29, 48, 63, 75, 93, 96, 100–102, 104, 105, 110, 113, 117, 118, 122, 123, 127, 128, 130, 133, 137–39; Page 8. Photos: Justin Kerr.

Figs. 7, 19, 33, 57, 89, 112, 134–36, 137 (inset). Photos: Oswaldo Chinchilla.

Fig. 12. Drawing: Oswaldo Chinchilla Villacorta.

Fig. 14. Drawing: David Stuart, with additions by Alexandre Tokovinine.

Fig. 15. Photo: Alberto Valdeavellano.

Fig. 16. Drawing: E. Lambert and Annie Hunter, from Maudslay, *Biologia Centrali-Americana,* vol. 2, pl. 19.

Figs. 17, 124. Photo © Museum Associates/LACMA.

Fig. 18. Photo: Alfred P. Maudslay, copyright © Trustees of the British Museum.

Figs. 22, 31a, 37, 84, 87, 95, 114, 119, 120. Photos: Nicholas Hellmuth, FLAAR Photo Archive.

Figs. 23, 26, 38, 108. Photos: Jorge Pérez de Lara. Figs. 24,

25, 27. Drawings: Annie Hunter, from Maudslay, *Biologia Centrali-Americana,* vol. 4, pl. 76, 81, 88.

Figs. 28, 44, 67; Page 104. Photos: SLUB Dresden Mscr. Dresd.R.310.

Figs. 30, 116. Photos: Dmitri Beliaev.

Fig. 35. Photo: Inés de Castro.

Fig. 39. Drawing: Norberto García, courtesy of Alejandro Tovalín Ahumada, digital rendering by Alejandra Campos.

Figs. 46, 47. Photos: By permission from Ministero dei beni e delle attività culturali e del turismo/Biblioteca Nazionale Centrale, Firenze.

Figs. 50, 52. Photos: Dennis G. Jarvis, Creative Commons License.

Fig. 51. Drawing: Eric von Euw, © President and Fellows of Harvard College, Peabody Museum of Archaeology and Ethnology, PM# 2004.15.6.5.13 (digital file# 99320101).

Fig. 53. Drawing: Ian Graham, © President and Fellows of Harvard College, Peabody Museum of Archaeology and Ethnology, PM# 2004.15.15.1.144 (digital file# 99280023).

Fig. 55. Photo: Hernando Gómez Rueda.

Figs. 58, 59. Drawings: Christophe Helmke.

Fig. 60. Photo: Inga Calvin.

Fig. 61. Photo: Mauricio Acevedo.

Fig. 62. Photo: Princeton University Art Museum/Art Resource, NY.

Fig. 64. Photo: Museo Nacional de Arqueología y Etnología, Ministerio de Cultura y Deportes, Guatemala.

Fig. 66. Photo: Michel Zabé, Archivo Fotográfico Manuel

Toussaint, Instituto de Investigaciones Estéticas, UNAM.

Figs. 68, 69, 97a. Drawings: Lucia Henderson.

Figs. 70, 72. Photo: Bruce Love, Parque Arqueológico Nacional Tak'alik Ab'aj, Ministerio de Cultura y Deportes, Guatemala.

Figs. 71, 73. Drawing: Oswaldo Chinchilla, Parque Arqueológico Nacional Tak'alik Ab'aj, Ministerio de Cultura y Deportes, Guatemala.

Figs. 74, 91a, 98, 129. Illustrations of San Bartolo murals by Heather Hurst, © 2003, 2007.

Figs. 77a, 83. Drawings: Andrea Stone, *Images from the Underworld,* © 1995 by University of Texas Press.

Figs. 79, 80. Drawings: Alejandra Campos.

Fig. 82. Photo: Sebastian Matteo.

Fig. 85. Drawing: Oswaldo Chinchilla, after Joralemon, "Ritual Blood-Sacrifice," fig. 14.

Fig. 94. Photo: *Arts Mayas du Guatemala,* fig. 120.

Fig. 99. Drawing: Oswaldo Chinchilla, after Trik and Kampen, *Grafitti of Tikal,* fig. 83g.

Fig. 103. Photo: Florence, Biblioteca Medicea Laurenziana, Ms. Med. Palat. 220, c. 41v. By permission from MiBACT. Further reproduction by any means is forbidden.

Fig. 132. Drawing: Diane Griffiths Peck, courtesy of Michael D. Coe.

Page 30. Photo: © Real Academia de la Historia, España.

INDEX